D1116985

Tattooing in the Marquesas, Volumes 1-4

TATTOOING IN THE MARQUESAS

BY

WILLOWDEAN CHATTERSON HANDY

BERNICE P. BISHOP MUSEUM
BULLETIN I

WITH 38 PLATES

BAYARD DOMINICK EXPEDITION
PUBLICATION NUMBER 3

HONOLULU, HAWAII
PUBLISHED BY THE MUSEUM
1922

Willowdean Chatterson Handy served as Volunteer Associate with the Marquesas party of the Bayard Dominick Expedition, 1920-1921. She has taken skillful advantage of her opportunity to obtain what is believed to be an unusually complete and intimate record of tattooing designs.

Tattooing in the Marquesas

By Willowdean Chatterson Handy

INTRODUCTION

Drawings and photographs of tattooing patterns on the bodies of natives were made by the author during a residence in the Marquesas Islands in 1921. As tattooing is now forbidden by the laws of the country and the art is consequently dying out, this collection of the last specimens of tattooing patterns which exist today in the Marquesas has seemed to demand a complementary collection of information regarding the practice of the art, to the end that the beautiful motives might at least be partly accounted for and might some day take their merited place in the history of art. The data have been drawn from natives who have been decorated, from one old *tuhuna*, or artist, who has practised tattooing, and from literary sources, thus piecing together a fairly accurate picture of the practice. Discussion of the design itself, of which the natives know nothing today beyond the nomenclature, is undertaken in a spirit of appreciation and with the hope that the suggestions offered regarding the evolution and significance of this form of decoration may uncover other possibilities and lead to a more conclusive interpretation of the art.

THE PRACTICE OF THE ART

It would appear that this form of body decoration was not confined to certain ranks or classes in the Marquesas, though what might be called a property qualification limited somewhat the complete covering and finer work to the wealthy who could afford to employ the best artists and stand the attendant expense of feeding them and their assistants as well as the large band of *ka'ioi* who erected the special house for the occasion. A father prepared long in advance for the payment for tattooing of his firstborn, raising pigs, and planting *ute*, paper mulberry (*Broussonetia papyrifera*), for the making of tapa as gifts for both the *ka'ioi* and the *tuhuna*. Payment also took the form of ornaments, war clubs, and more recently, guns. Langsdorff says that they paid for their decorations according to the greater or less quantity of them, and to the trouble the figures required; that during the thirty or forty years when the body was gone over again and again with the tattooing bones until the skin was completely covered, the cost became considerable; and that such all-over decoration necessarily indicated a person of great wealth (10 p. 120)[1]. It follows

[1] Throughout this paper the numbers in parentheses refer to the bibliography on page 26.

naturally that it also appeared only upon people of advanced years (6, p. 130; 13, p. 102-103), a circumstance which undoubtedly led to Captain Chanal's conclusion that the marks had no relation to anything but age (11, p. 111).

While the *tuhuna* was paid generously for work on an *opou*, the eldest son of a wealthy man, no payment was asked of the *ka'ioi*, a more or less unorganized group of younger sons and daughters, who took such part in the preparations as raiding for food and building the special house, and who slipped in to have designs punctured upon them gratis when the *opou* was resting or recuperating from the effects of the operation. It is perhaps these *ka'ioi* to whom Melville (12, p. 49) refers in speaking of the common fellows who were practiced on. Langsdorff was apparently unaware of this custom, for he says that those who could not afford tattooing went without:

> The poorer islanders who have not a superabundance of hogs to dispose of in luxuries, but live chiefly themselves upon breadfruit, are operated upon by novices in the art, who take them at a very low price as subjects for practice. The lowest class of all, the fishermen principally, are often not able to afford even the pay required by a novice, and are therefore not tattooed at all. (10, p. 120.)

With the lower classes noticeably less tattooed than the higher, the conclusion was often drawn by early visitors that this form of decoration pointed out noble or distinguished persons (8, p. 155 and 13, p. 84). Berchon, writing in 1859, avows that all classes were tattooed at that time, but that formerly it was a sign of nobility and distinction. From what is to be gathered today from living informants, this is a misconception, in the main, based on the fact that wealth was in the hands of chiefs and distinguished men.

Melville (13, p. 102) at one time assigns tattooing to the warrior class, but present information states that the untattooed as well as the tattooed went to war. That warriors, as well as other groups, wore special designs as badges is stated by modern informants as true in a few instances, and is frequently suggested by the early voyagers to the Marquesas. Spirals over the eyes (Pl. v, 7) are today described as belonging to all warriors in ancient times, while spirals called *kokoata* on cheeks and hips indicated chiefs, as do the tiny pinlike marks (Pl. xxxviii, G. d) to be seen today on the inside of the left ankle. After a battle these marks—according to the informants—were sought for by the priest of a victorious army on the ankles of the slain to determine whether a chief had been killed and a great battle fought. Beyond these distinguishing marks, living informants make no mention of the badges described

by early visitors, such as the *mata-komoe* distinguishing a hero (10, Pl. VIII, fig. 9; p. xv), the marks of high birth put upon the arms of women in families of chiefs (18, p. 222-223), the tattooed right hand and left foot of women as a sign of wedlock (13, p. 221-222). Mr. Linton was told that only chiefs had their feet tattooed; but this is not borne out in the late practice of the art nor corroborated by other informants. The confusion probably arises either from the distinguishing chiefly marks being upon the ankle, or from the custom of tattooing the body of the *opou* from the feet up, contrary-wise to that of the *ka'ioi.*

The only distinguishing feature of the tattooing of a *ka'ioi,* as reported today, is the order in which the designs were put on, the face being decorated first. The reason assigned by a Pua Ma'u informant for the custom of beginning with the feet of the *opou* was that the face if tattooed first was liable to become infected and cause a stoppage of the operation. It is possible that the reverse order in the case of the *ka'ioi* was the result of indifference as to their fortunes, but it is also possible that there was here a fundamental class distinction. There is no proof today that the work was not of the same pattern as that of the *opou,* though Melville thought he distinguished a difference in the quality of the work put upon "inferior natives," their designs appearing to him like daubs of a house-painter's brush (13, p. 250).

Berchon says that tattooing was an obligation rather than a mark of distinction for women, that the right hand must be tattooed by the age of twelve so that it might be used in making *popoi,* in making *pakoko* (the circular movement of two fingers in taking up *popoi* to eat it) and in rubbing dead bodies with coconut oil (1, p. 114-115). Natives today say that an untattooed hand could not make *popoi* nor eat it from the same bowl as a tattooed hand, that a tattooed man could not eat with a woman, and that a man with all his designs finished could not eat with a man whose designs were unfinished; but any reason for these requisites beyond their being "pretty" is unknown. Women would not marry untattooed men, probably because the decoration represented either wealth, endurance of pain, style, or all three.

A special effort was made to find some trace of banqueting societies distinguished by marks tattooed on the chest, which Krusenstern, Langsdorff, and Melville[2] describe (8, p. 159-160; 10, p. 121-122; 12, p. 50-51); but no memory of anything in the nature of such fraternal orders supported by the chief and tattooed gratis is discoverable today. With Berchon's con-

[2] All of the detailed information of Krusenstern and Langsdorff came from two white sailors living among the natives, whose accounts are in many instances unmistakably erroneous and exaggerated. It would not surprise me in the least if

clusion that the fact reported must have been "quite exceptional" we must agree. It was customary, however, during famine times, for people to seek the service of chiefs in order to be fed, and it may have been the whim of some chief to have a particular mark tattooed upon them, but this was certainly not a general custom. Indeed, Melville relates the "Hanamanoo" episode as an especial and unusual case; and it does not seem unlikely that the same story is at the basis of both his and the Russians' accounts. They have probably misinterpreted the ordinary custom of the father of the *opou* during the period of tattooing feeding the *ka'ioi*, who were no more closely organized as a society than is our own "younger set," to whom they were somewhat analogous. This would fit, too, with the custom of the *tuhuna*'s giving them samples of their art gratis during the rest periods of the *opou*.

A careful search for any possible significance of face designs as tribal marks, corroborative of Porter's statement to this effect (14, p. 114), calls forth today, except in one instance only, vociferous refutation. However, that face patterns were insular during a later period of the art is certain, the oblique *paheke* belonging to Nuku Hiva, the horizontal bands called *ti'ati'apu* being worn by Hiva Oans, and the latter's variant, the *ihuepo*, whose central band covers the nostrils themselves, being prevalent on Fatu Hiva. Lacassagne (9, p. 79) quotes Lombroso as declaring that face tattooing on Nuku Hiva distinguished two enemy factions, the one being marked by a triangle, the other by a circle. Triangles are associated with the tattooing of the inhabitants of Tai-pi Valley by Melville and Berchon, and these Tai-pi were powerful enemies of the tribes of Tai o Hae Valley. More than one present-day informant has stated that men of a certain tribe living in Tai o Hae were marked with a great black circle on the face (Pl. v, 10). Seeing the two styles and finding them associated with two enemy factions, it might be natural to conclude that face decoration was to distinguish enemies; but this is the one instance in which a tribal significance is assigned today to a face design.

That the operation of tattooing was performed during propitious seasons or at times of importance in the life of the individual to be decorated has been reported by Desgraz (18, p. 223). Living Marquesas informants place its practice during the dry season when there was no breadfruit to be harvested, during the months of October, November, December and early January. The women, whose tattooing may still be examined, place the beginning of their work at from seven to twelve years of age; the

Melville made up his story of the "Hanamanoo" episode after having read Langsdorff or Krusenstern.

men, from fifteen to twenty. Within these limits fall the more or less definite statements of such early writers as Garcia, Desgraz, and Berchon, Porter interpreting the time as "when they are able to bear the pain." All imply—and Krusenstern (8, p. 155) definitely states—that the beginning of the operation was connected with the period of adolescence. Berchon (1, p. 113) tells us that pregnancy would hinder the success of the work and that it was never undertaken for a woman when she was in that condition, from which we may again infer that the coming of puberty was the time for starting the bodily decoration. There seems, at the present time to be no definite connection in the mind of the Marquesan between the two, and the fact that tattooing was practiced during the growing or maturing season of the land just before harvest-time seems also to have no significance at present. However, the celebrations associated with the harvest and with the completion of the tattooing of the adolescent youth of the land were united in a great *ko'ina* or feast. It may be remarked, too, that there is at present no indication that important times in the life of the individual, other than adolescence, were the occasions for tattooing, although Langsdorff, in a description of the *enata* design, says that it was put on when an enemy had been killed or eaten (10, p. xv).

As has been stated, preparations for the tattooing of an *opou* began with the raising of pigs and planting of *ute* for gifts and payment for *tuhuna* and *ka'ioi*. Several days before the beginning of the operation, the father announced that the *oho'au tiki*, or special house for the occasion, was to be built. About one o'clock on the morning on which the erection of this structure was to take place, two great drums (*pahu*) and two small ones (*hutu*) were beaten on the public festival place, to declare the beginning of the *tapu* and to summon the *ka'ioi*. These, usually from forty to eighty in number, immediately gathered at the festival place and together proceeded, under direction of the *tuhuna*, to raid the place of the *opou's* father. They demolished his houses and those of his relatives, with the exception of the sleeping houses; they seized not only material for the building of the *oho'au*, but that for making tapa, or the tapa itself in the event of its already having been made. Enough pigs and other food, sufficient to last for the entire period of the operation, its length depending upon the sickness of the *opou*, were taken for the feeding of the *ka'ioi, tuhuna,* and all those who were to stay in the *oho'au*. Not only was the father of the *opou* the victim of this *fao* or seizure of food, but also his father's sisters and even other relatives of the father and mother, if the duration of the operation was extended; and it was these relatives who cooked the food during the entire time.

The *oho'au tiki*, together with a sleeping house and a cook house, which were placed on a stone *paepae* near a *me'ae* (sacred place), or a *tohua* (public place), was erected for the first-born or adopted boy *(matahiapo)*, other sons usually being *ka'ioi* and achieving their tattooing piecemeal and gratis in the *oho'au* of the *opou*. This house, which belonged with all its appurtenances to the *opou* and not to the *ka'ioi* who built it—although they slept in it during the period of the operation—was carefully built, though it was lashed with the coarse strips of hibiscus bark rather than with the finely braided *pu'ukaha* or coconut fiber cord usual in other dwellings. Melville might seem to suggest a different custom in Hiva Oa from that of Nuku Hiva in the description of the tattooing's being performed in large houses belonging to the *tuhuna* themselves (12, p. 48-49); but all modern recollection in Hiva Oa is of the similar custom of building the special *oho'au* for the *opou*. It may be said in passing that neither Melville's descriptions of the spacious houses of the *tuhuna* with their numerous small apartments set apart by screens of tapa for private patients and of the small tents of coarse tapa erected by itinerant *tuhuna* for patients at the times of religious festivals, nor Langsdorff's account of the operation for persons in middling station being performed in houses erected for the purpose by the tattooers and tabooed by authority (10, p. 120), are corroborated in the information gathered last year in the Marquesas. The Russian says further that the women were not, like the men, shut up in a tabooed house during the operation, but that it was performed without ceremony in their own houses or in those of relatives. This is corroborated today, particularly on Nuku Hiva; though sometimes, we are told, a small house called the *fa'e po'a (po'a,* coconut thatching*)* was built alongside the family dwelling for the tattooing of a girl and in it lived the whole family during the entire period of the operation, the main house being *tapu*, though the *fa'e po'a* was not.

The *oho'au tiki*, itself, which we must take as the usual scene of the operation, was very *tapu* to outsiders. Those who entered it could have nothing to do with women, who were spoken of at this time as *vehine pu'atea (pu'atea,* a kind of tree with soft wood*)*. Indeed these men must hide if a woman were even sighted at a distance, and it was necessary for them to cook for themselves. The men who held the legs and arms of the *opou*, and who fanned flies during the work, were especially *tapu* and had to be served with special food. There seems to have been no regular food *tapu* for the patients during the period of the operation, though according to early visitors, there were dietary restrictions apparently for the sake of health. Garcia says the patients were forbidden for several days to take certain kinds of nourishment, such as pig and

kava, and Melville speaks of the small portions of food that were pushed under the curtain by unseen hands to the *tapu* patients within the apartments, the restriction in food being intended to reduce the blood and so diminish inflammation; Langsdorff reports that the patient must drink very little for fear of inflammation, and must not eat early in the morning.

The work was performed by *tuhuna patu tiki (patu,* to mark or strike; *tiki,* designs), artists, evidently trained in the school of experience, some of them coming to enjoy great vogue on more than one island. Although Garcia states that the office was hereditary, each great family having its family of tattooers trained from generation to generation for its use, nothing of the sort can be traced today. According to modern informants, skill alone was qualification for practice and requisite for patronage. Langsdorff tells of novices who, for practice, operated upon poor people at very small charge, and Melville reports even the hiring of "vile fellows" as models on whom they could practice.

All present-day information denies Melville's statement that there were orders of tattooing artists. It is more likely that there were itinerant members of the profession, as he states. All seem to have practiced quite independently, although there was probably the kind of bond between them that followers of any profession feel. It is said in Ua Pou that there were different *tuhuna* for men and women because of the rule of *tapu* which ascribed to men greater sacredness than to women, but this was not true during the latter days of the art. No woman *tuhuna* was ever heard of. There were evidently contests between *tuhuna*, two or three working at the same time in an *oho'au*, attempting to excel one another in rapidity of execution and delicacy of designs. In the light of knowledge about the ancient native training in other artistic lines, it is possible to hazard the guess that to be accepted at all as a *tuhuna*, a thorough acquaintance with all the conventional units of the art was requisite; for, although individual *tuhuna* certainly varied and elaborated designs at will, yet they did not stray from the basic units.

A *tuhuna* was aided in his work by four or five assistants called *ou'a* (or *kou'a*—translated by Dordillon, pupil, disciple—meaning also shrimp). He was consulted as to the choice of designs, his decision apparently being usually accepted, although the *opou* was free to select his patterns. He outlined the designs upon the body with a piece of charcoal. But it was the *ou'a* who held the arms and legs of the patient, who stretched the skin to make a smooth surface upon which to work, who fanned the flies from the bleeding wounds, and who often, it is reported, filled in the outlined designs.

Before the coming of the *tuhuna,* the father of the *opou* had pre-
pared the pigment *(hinu).* The preparation of this was a very *tapu*
operation, the man making it being forbidden all relationship with women
during the period; and, according to Lesson (1, p. 107-108), it was
necessary for a virgin to aid him in the work. The shells of the *ama* nut
(Aleurites triloba) were heated so as to open easily (7, p. 45), and the
kernels placed over a fire in a kind of pocket of stones which allowed
the smoke to ascend through a small passageway in order to collect on a
smooth stone *(pa'e hinu).* Upon this stone a constant tapping was kept
up while the soot collected to the depth of about an inch. This process,
according to Berchon, was called *amahi ama.* The soot-covered *pa'e hinu*
was then placed on a banana leaf and left in the sun to dry, being kept
thus until the *tuhuna* arrived for his work. Thereupon, the father, ac-
cording to present-day information, mixed the soot with plain water in
a small coconut shell *(ipu hinu)* and gave it to the artist. Marchand
Langsdorff, and Porter agree upon water as the solvent; but Berchon
further reports that the ink, which he calls *kaahi,* was made by mixing the
soot with coconut oil; while Melville (13, p. 246) gives vegetable juice
as the liquid. He and Langsdorff describe the use of the ashes, rather
than the soot, of this nut kernel, and Porter thought burnt and powdered
coconut shell was used, but apparently no other pigment save carbon was
ever employed in the Marquesas, as all early voyagers remark only the
dark blue or blackish coloring. (See 15, p. 16; 14, p. 78; 10, p. 118;
8, p. 155; 13, p. 158). Jardin (7) speaks of carbonizing and pulverizing the
kernels of the *ama* and mixing the powder with water to trace the de-
signs on the body, and it may be that the residue of the burnt nuts was
so used.

When the *tuhuna* arrived, bringing his instruments in a bamboo case
seven or eight inches long *(pukohe fau hinu),* stoppered with a wad of
tapa, he spread them out upon a piece of tapa on the ground, ready for
use. The instrument is generally known as *ta* (to strike), but Berchon
(1, p. 110) gives the following nomenclature for its various parts: *ta'a*
(a point) for the toothed end, *kakaho* (reed or cane) for the horizontal
support of the teeth, and *ta-tiki* (strike-*tiki*) for the baton (Berchon, p.
110). There was always an assortment of these toothed ends of varying
fineness or coarseness appropriate for all grades of work from the delicate
hair lines to solid patches. The flat instruments for straight lines and
gradual curves were of human bone, sometimes of the bones of enemy
sacrifices *(ivi heana).* They were about three inches long, flat and
slightly wedge-shaped, and toothed or comblike at the end. Instruments
for the smaller curves were of the bones of the *kena (Sula piscatrix),*

or of a *tapu* bird on the small island of Fatu Uku, the leg bones having been used (at least they are used for the instruments seen today), and according to Langsdorff, wing bones also. Marchand describes these *ta* as sometimes of tortoise-shell; Berchon adds, of fish bone; and Melville mentions sharks' teeth: but no trace of combs other than of human or bird bone remains today. The number of teeth varied from three to about twenty—Melville saw some with a single fine point—according to the size and use of the instrument. Melville says that some had points disposed in small figures, so that the whole design was printed at a single blow.

These bone combs were inserted into a slit in a piece of reed stalk, bamboo (10, p. 118), or ironwood (11, p. 110; 1, p. 109), six or seven inches long, which acted as a horizontal handle (see, however, 12, p. 51, note), held, while in use, in the left hand of the *tuhuna*. This was, as far as could be ascertained today, straight, though Melville speaks of curved ones. The baton, about three quarters of an inch thick and from a foot to eighteen inches long, was of hibiscus wood.

Although everything connected with the operation itself was extremely *tapu*, tattooers in general, in Nuku Hiva at least, being under the auspices of the god Hamatakee (2), Tahu being the god of the *tuhuna* and the *ka'ioi*, Pupuke of the *ou'a*, yet there are no records of opening ceremonies. The patient, clad only in a girdle, was simply laid upon the floor, arms and legs held by four *ou'a*. When a design had been sketched in charcoal upon the body, the *tuhuna*, or an assistant, held in his left hand the toothed hammer and a piece of tapa, with which by a dextrous twist of this hand he wiped away the blood as it flowed from the punctures made in the skin by the gentle tapping on the top of the comb with the baton held in the right hand. As he worked, he kept a sufficient supply of pigment upon the teeth by dipping two fingers of his right hand into the ink and rubbing them upon the comb. Garcia, Marchand, and Berchon agree with this procedure; but Langsdorff and Krusenstern declare that the punctures were made in the skin until the blood oozed out and then the dye was rubbed in. While the tapping went on, the operator chanted in rhythm to his strokes the following words to allay the pain of the *opou*:

Ua tuki-e, ua tuki-e, ua tuki-e,	It is struck, it is struck, it is struck,
Ua tuki-a, to tiki-e,	It is struck, your design,
Poparara* to tiki-e,	Tap-tapping your design,
O te tunane o te kui-a,	The brother of the mother,
O te tuehine o te kui-a,	The sister of the mother,
To'u tiki-e.	My design.

* Poparara is onomatopoetic, the sound of tapping.

Chants for women do not seem to be general. At some time during the operation, the *opou* was given a new name, referred to as *patiki.* This was taken from some personal defect of his own, such as a blind eye, for example, or from some imaginary peculiarity of the genital organs of his father or mother.

The operation, as may be imagined, was extremely painful and the patient cried and screamed without restraint. Berchon notes that after each sitting, there were from eight to twelve days of local inflammation, followed by fever and sometimes swellings, which were at times fatal. Light inflammation and swelling and ulcers lasting for several days (6, p. 132; 11, p. 110; 10, p. 118) seem to have been usually the most serious results of the rigorous treatment. The juice of the banana stem was used as an ointment *(paku)* to hasten healing. Berchon says an emollient of hibiscus leaves was applied to relieve the inflammation.

The duration of the operation depended largely upon the fortitude and health of the patient. A Nuku Hiva man is reported to have been completely covered in three days; the legs and back of one man of Hanamenu were done in seven days; but as a rule the designs were put on in more leisurely fashion, a section of the body being covered at a sitting, with three-day rest periods called days of blood *(a toto)* after each, so that the operation covered from two weeks to four months. Under such conditions a woman's lips and shoulder might be decorated in a day, a man's legs from knees to ankles, or perhaps his thighs and buttocks. Langsdorff says that the first sitting usually lasted from three to four weeks and that only the groundwork of the principal figures upon the breast, arms, back, and thighs, was laid the first year, additions, however, being made for years at intervals of from three to six months.

After the operation, fruits of noni *(Morinda citrofolia)* the most usual healing agent, were offered at the *me'ae* or sacred place; the *tuhuna* was paid; and, when the *tapu* was lifted, the sacred *oho'au tiki* was burned (though not the common house of women); and all those participating in the operation, who had not been allowed to bathe during the entire time, now went first to the sea to bathe, afterwards to the river. This accomplished, they covered themselves with fragrant ointment, which turned the skin yellow so that their new patterns showed brilliantly. Meanwhile, relatives had prepared such ornaments as tortoise-shell crowns, girdles of tapa, feather head ornaments, earrings, and the like. These they left outside their houses on the night before the festival *(Ko'ina tuhi tiki; Ko'ina,* feast; *tuhi,* show; *tiki,* design), which was always given to celebrate the completion of the work, and the newly decorated girls and boys donned them before their appearance on the paved floor of the

festival place where admiring friends and relatives were gathered to view them. There, two large drums *(pahu anaana)* and three small ones *(tutu)* were beaten, the *opou* marching with the *ka'ioi* around the paved area to show his designs. While two men and two women danced, the *ka'ioi* accompanied them with handclapping and the chanting of a *putu* or special chant for the *oho'au patu tiki*. In an unpublished manuscript Dordillon and Père Pierre state that at this feast a human victim was sacrificed and eaten. When a man gave a feast in celebration of his wife's acquisition of a bit of tattooing, as Langsdorff reports was sometimes done (10, p. 121), she was allowed to eat hog's flesh as a very special privilege.

THE DESIGN

Any attempt today to make a first-hand study of tattooing design must be based upon the examination of not more than a hundred and twenty-five persons who are the only living examples of the practice and whose designs represent for the most part a late development of the art, and upon their explanations and descriptions, and those of the single surviving practitioner of the art, whose actual practice ceased many years ago. The practice was forbidden by the French in 1884 and the edict was enforced as strictly as possible from that time on in the group of Nuku Hiva and Ua Pou, where the government was in occupation. On Hiva Oa, Tahu Ata, Fatu Hiva, and Ua Huka, the practice continued some years thereafter in the absence of authority to abolish it. As a consequence, one finds in the northwestern group that the majority of examples is the work of *tuhuna* of the southeastern islands, a few very old people, alone, representing that of the former islands. Just as these northwestern natives now living went surreptitiously to *tuhuna* of the other group to be tattooed upon parts of the body that would not show beneath their clothes, so in the southeastern group those who continued the practice after the prohibition was actually enforced there, about twenty-five years later than in the more closely espionaged islands, were decorated chiefly upon the legs from hips to ankles where dress or trousers would cover the pattern. Gradually, even this practice ceased, and today the only tattooing that is done is now and then of names in print upon the arm. It will be seen from this, that only upon very old people can anything approaching a full suit of tattooing be seen. Though there is but one man living who, as far as I know, might be called fully tattooed, still there are to be found on different subjects designs for practically all parts of the body originally covered. There still remain several women fully tattooed, probably for the reason that their designs are less conspicuous. The plates herewith

represent about as full a collection as could be obtained today of the tattoo designs of the Marquesas. What may be learned of the history and meaning of the art from the study of these designs may be of interest.

The parts of the body ornamented differ today, as they have always, for men and women, a complete suit of tattooing for the men (Pl. 1) covering the crown of the head (Pl. v, 9), face (Pls. III, IV, v) including the eyelids, often the inside of the nostrils, tongue, palms and back of the hand (Pls. VIII, *A;* XI, *C),* arms (Pls. XII-XIII), legs (Pls. XXIX-XXXVIII), and the entire trunk (Pl. XIV) but not the penis, which all save one of our modern informants deny ever to have been tattooed. (See also: 15, p. 16; 4, p. 14; 5, p. 232; 14, pp. 78, 114; 11, p. 111; 10, pp. 122-123; 8, p. 155; 17, p. 306; 13, pp. 83-84, 90-91; 18, p. 222.) At the present day, the one man who might be said to be fully tattooed or *moho,* is lacking the crown piece, save for a section, and the tongue and palm coverings. From the earliest times accounts such as those of Cook, Marchand, Langsdorff, Krusenstern, Melville, Berchon and Porter note the simpler decoration of the women, G. Forster observing none on them. On the bodies of women observed today, patterns are found on the lips running back to the base of the gums (Pls. II, *A;* VI, *A),* on the ear lobes, behind the ears (Pl. VI, *C; Porter,* p. 114), on the curve of the shoulder (Pl. VI, *B;* see also 13, p. 95; 6, p. 132), on the lower back of which but one example remains, as far as known (Pl. xv), on the hands (Pls. VII-XI) and on the legs from the buttocks down (Pls. XVI-XXVIII). One old woman of Nuku Hiva describes the tattooing on women as covering also, formerly, the whole length of the arms on the inside, the buttocks, and the abdomen. She, as well as all others living today, declares that the vulva was never tattooed, although one woman reports a girdle that came around in front.

Various reasons are given for covering different parts of the body. The decorated hand was noticeable in kneading and eating *popoi.* The under-arm pattern made a fine showing when the arms were uplifted to strike with the war club. Shoulder and chest decorations were displayed when men walked with arms crossed behind the back. Circular motives on the inside of the knees were in evidence when men sat cross-legged. The inside thighs where the loin cloth hung and covered them were often left vacant.

There are numerous indications both in the types of design to be seen today and in descriptions and stories of natives and of visitors to the islands, that fashion in this mode of decoration was no exception to the rule of fashion's fickleness. There are to be seen naturalistic, geometric, and conventional motives, both symmetrically and irregularly arranged; there are stories of inter-island exchange of motives and of

the teaching of the *tuhuna* of the northwestern group by those of the southeastern; there are to be found in literary sources accounts of the vogue of different artists and statements from which may be deduced complete changes in the type of design. With a view to discovering how dependent style was upon the taste and originality of individual artists, the names of all artists who executed the designs recorded were noted. When two pieces of work done by the same *tuhuna* were found, the choice of pattern seemed sometimes to be identical (Pl. xi, *C)*, sometimes altogether different (Pls, ix, *B* and x, *A)*, while the work of different *tuhuna* was sometimes identical (Pl. xiii, *B)*. It would seem that all *tuhuna* drew, more or less at their will, from a single body of design.

In the hope of making as clear as possible the probable evolution of this art in the Marquesas towards the elaborate conventional design that prevailed when it was forbidden thirty-eight years ago, the following details are set down.

Quiros records in his description of Mendaña's visit to the southeastern islands in 1595, the observation of "fish and other patterns painted" upon the faces and bodies of the natives. This is corroborated by a living informant who says that formerly women had birds and fish behind their ears and on their legs, and men are reported to have had lizards on their faces. The next word from a voyager that comes to us of this group is dated nearly two centuries later when Forster observes in 1772 that the motives in Tahu Ata are not naturalistic but geometric, taking the form of "blotches, spirals, bars, chequers, and lines;" while J. R. Forster confirms this analysis, adding however, "circles," and Marchand in 1790 reiterates the two lists and swells them with "parts of circles square or oval figures inclined and variously crossed lines." It would appear, then, that in the southeastern islands during these hundred and eighty-odd years, there had been in the type of design a change from the naturalistic to the geometric.

We have no similar statements regarding what was happening in the northwestern group during the early period, the first observations there being set down by Marchand in 1790, who visited both groups. Though Marchand touched for a short time at only two bays in the northwestern islands, still it is valuable to have his statement that he finds in Ua Pou the same custom of tattooing as in Tahu Ata but not so general, few tattooed individuals being seen (ii, p. 167). Unfortunately he does not define the types of motives there as he does in Tahu Ata. Just a few years later, however, in 1803, Langsdorff gives a number of drawings from the northwestern group with explanations of them (10: Pl. vi, p. 117; Pl. vii, p. 119; Pl. viii, p. 122; pp. xiv, xv, xvi). which show that

by the beginning of the nineteenth century, designs in Nuku Hiva were a combination of purely geometric figures with all save two of the principal conventional units of the latest phase of the art that at the present day is universally attributed by the natives to the southeastern islands, which for convenience may be referred to as the Hiva Oa development. Dordillon (3) gives the names of many motives which have completely disappeared today, most of them recorded in the northwestern group. Of these, several would indicate naturalistic treatment: *a'akiva*, line of sea builders; *aukohuhu*, a seaweed; *haha'ua*, a kind of ray fish; *homae*, a fish; *koao*, a fish; *matuku*, a bird; *keeheu*, wing; *tikau'e*, fly; *toetoe*, crab. Furthermore, in 1843 Melville saw fish and birds and an *artu*(?) tree tattooed on natives of Nuku Hiva (13, p. 157); Desgraz, the same year, describes fish and shells (18, p. 223); Garcia in 1845, fish; Berchon, in 1859, boots, gloves, suns, sharks, cockroaches, coconuts, lizards. In addition to these naturalistic motives, all these visitors also saw geometric patterns, showing that in the northwestern group as long as we have any record of tattooing there, the two types have existed side by side as they do today. (For naturalistic motives see Pls. xviii; xx, *B, c;* xi, *D;* xxx, *j;* for geometric, Pls. xviii, xix, xx, *A, b;* xxi, *D, a).*

On the other hand the earliest drawings obtainable that are known to be of the Hiva Oa type are those drawn by Proiho and an old *tuhuna patu tiki* of Fatu Hiva (Pls. ix, *A;* xii, *C;* xiv, *B;* xvi; xxx). These are impossible to place chronologically and are no longer found upon the body in exactly these forms. Among them is found but one genuinely naturalistic motive (Pl. xxx, *j*) but a combination of geometric figures such as squares (Pl. xii, *C, b* and *c*), bars (Pl. xxx, *C*), oblique (Pl. xxx, *d)* and variously crossed lines (Pl. xvi, *d;* xxx, *a;* xxx, *k),* with simple forms of all the modern conventional motives save the *matakomoe* of Langsdorff, now called *po'i'i* (Pl. xxxiii, *e*) and the flower-like or sunlike disk variously called *puahitu, puahue* and *huetai* (Pl. xxxiv, *e*), both of which are to be found in primitive form in the early Nuku Hiva art (Pl. xxix, *f, c*). Today three naturalistic designs, and these very crude, are to be found in the southeastern group, and these are all the work of the same artist. (Pls. x, *A, 2, a;* xxviii, *D, E).* The designs described as belonging to former Nuku Hiva and Fatu Hiva styles have in common several units, many of them in primitive form which are to be found today in the Hiva Oa style: for example, the *koheta* (Pls. xxx, *a;* xxix, *a* and *b;* xxxiv, *a* and *b);* the *ka'ake* (Pls. xxx, *i;* xxix, *h;* xxxiv, *g* insets); the *hikuhiku atu* (Pls. xxix, *b;* xxx, *g;* xxxiii, *h);* and the *mata hoata* (Pls. xxx, *e,* lower *a;* xxix, *g;* i, *D,* thigh); and what I

conceive to be the forerunner of the underarm *ipuoto,* the original *po'i'i* or shellfish motive (Pl. ix, *A, a;* xii, *A, B, D*).

An examination of the extant examples of the art shows a distinct cleavage between the two groups in their conception of design, that of the southeastern being purely conventional with but minor relics of the geometric and the slightest trace of the naturalistic; that of the northwestern showing several examples of naturalistic art, many of the geometric, and a simpler form of the conventional than the other. Marquesans are all agreed, that, as far as tattooing customs went, the islands were divided into two groups: Nuku Hiva and Ua Pou forming one; Hiva Oa, Tahu Ata, Fatu Hiva and Ua Huka—because of its close intercourse with the north and west coast of Hiva Oa—forming the other. It may be remarked that Fatu Hiva is accepted as the home of carving and modern tattooing; but, being regarded as a kind of suburb of Hiva Oa, the latter island is referred to as the center. Several trustworthy informants declare that before the whites came, *tuhuna patu tiki* went from Hiva Oa to Nuku Hiva to teach them the art there, as before this time the Nuku Hivans used only "dirty black patches." We know that, by Melville's time, a transfer from the one to the other group was taking place, for he says that when he was in Nuku Hiva in 1843 (12, p. 48), Hiva Oa enjoyed a reputation for tattooing in the whole group. At the time of its discontinuance as a practice, it was certainly Hiva Oa tattooing that prevailed over the whole group.

Face patterns seem to have followed the same general lines of development, with a period at least of divergent styles in the two groups. Some Hiva Oa natives say that lizard motives were anciently used on the face; but early voyagers indicate only geometric figures, Marchand—the first to attempt to define them—speaking vaguely of various lines on the forehead representing kinds of hieroglyphics or characters of Chinese writing (16, Vol. II, Pl. 133; 10, Pl. vi, p. 117). Langsdorff pictures a man with a spiral on his cheek (10, Pl. vi, p. 117) and this convention is confirmed by living informants who describe these *kokoata* (Pl. v, 7) on the faces of warriors and chiefs. Today, naturalistic motives are not to be seen upon the face, but what may be a descendant of the spiral occurs on Ua Pou in a fine design on the nostril (Pl. iv, 7, 10; *V,* 4). The prevalent style called *ti'ati'apu,* to encircle several times, consists of three solid stripes, sometimes seen as unfinished half-stripes, banding the face horizontally, one across the forehead, one across the eyes and the third across the mouth. (See Pls. iii-v.) This is everywhere declared to be a Hiva Oa style and there is a variant where the mouth band covers the nostrils,

said to belong to Fatu Hiva. Of this but one living example could be found (Pl. v, 8). Of the old Nuku Hiva *paheke*, distinguished by an oblique band running from the right center of the forehead across the left eye and cheek (Pl. v, 5), there remain today but two examples. What form the transition from spiral to band may have taken can only be conjectured. A reliable Hiva Oa informant describes a former convention of that island which seems to be a combination of over-eye arcs—perhaps a relic of the spiral—, of *peheke* and *ti'ati'apu* (Pl. v, 6; see also Langsdorff's description and Pl. viii, figs. 10, 11, p. xi). In Melville's time, both the modern styles were seen on Nuku Hiva, and in the tattooing to be seen today, the Hiva Oa has replaced the Nuku Hiva design completely. In the fine inset and inter-band motives are to be found both geometric and conventional motives, never naturalistic.

How may this divergence between groups and the growth from the naturalistic through the geometric to the conventional—as seems to be the probable development—be accounted for?

Perhaps it may be postulated that before the seventeenth century naturalistic motives were used in both groups, that during the two unrecorded centuries geometric figures appeared in the southeastern group, that these gradually replaced the naturalistic there or transformed them into the conventional, and that at each stage of development the new styles were carried to the northwest where they did not so completely obliterate or amalgamate the native patterns, some of which persist to this day in their old form.

Influences which may have contributed to such a development are suggested by an examination of adzing and carving motives. Ornamental adzing in simple geometric patterns seems to have been the primitive form of wood decoration. Imitation of its technique as well as the use of its motives on the body is evident. The former is seen in the filling of spaces, ordinarily made solid in color, with parallel, oblique, zigzag or wavy lines (Pl. iii, 7, inset in eye band; xxi, B, b; xxxvi, insets in *e* and *g;* xxxv, inset barred teeth in *f;* xxx, *d*); in the use of the intersection of adzing lines to form the motive called *kopito* (Pl. xxiii, A, d; possibly also the inset in the forehead band in Pl. iii, 8). In tattooing are found such housepost motives as the cross formed by adzing off the corners of a square (Pl. xii, C, b), concentric circles (Pl. xii-E, b) and concentric half-ovals (Pl. xxviii, E; xviii, a). It is possible that the use of four triangles in a square or oblong, as well as the conception of design in bands may have come from this art of adzing wood. When it is remembered that wood was scorched before a pattern was adzed or carved upon it, so that the design was in natural wood color, the back-

ground in black, the conclusion suggests itself that such motives as the *pahito* (Pl. xxiii, *A, j* and *k,* left and right) and the flamelike ends of triangles (xviii, xix *A)* may be copies of the black background left by gouging alongside a line in the one case and by cutting short lines vertically out from a straight line in the other. It seems as if the checkerboard pattern, of which but one example is extant, must have originally been carved on wood (Pl. xxi, *D, a).* Parallel and wavy lines and other adzing and carving concepts are used on the body, as seen in the preceding example. It will be noticed that most of these coincidences are found in Nuku Hiva, Ua Pou or early Fatu Hiva types, rather than in the prevalent modern patterns, though among these are two examples of the scroll so prominent in carving (see also Pls. xxxviii, *D;* xxxv, *c).*

Wood carving, as distinguished from adzing, which decorated bowls, paddles, clubs, etc., seems to be a mixture of adzing patterns, geometric squarish spirals and a few of the conventional motives usual in tattooing. Of carving technique copies such as the veining along a midrib (Pl. xxviii *E)* are found in tattooing; of carving design, (similarities to old war club patterns (Pl. vi, *B;* x, *A,* 2, *a;* the *tava,* which was formerly burned on a plank in the house of the inspirational priest (Pl. xvi, *m)* ; and such small units as the *tiki* in forehead and mouth bands of Plate iii, 7. Common to both carving and tattooing are such conventional motives as the *honu kea* or woodlouse, the *mata hoata* or brilliant eye, the *ka'ake* or underarm curve, the *poka'a* or wooden block for carrying a load on the shoulder, the *enata* or man. Whether these motives originated as wood carving patterns or as body decoration and in which direction the transfer and adaption was made it is impossible to say definitely.

Several interesting possibilities are suggested by an analysis of the various motives called *kea* today. It would appear that the *kea* of common occurrence on wood is really a conventionalization of the *honu kea* or woodlouse with its six legs and two antennae. This was seen but once in tattooing, on the wrist of an old woman of Fatu Hiva (Pl. vii, *A,* 1, *a)* and was drawn by an artist of Fatu Hiva as a former unit there (Pl. xvi, *K).* On the other hand, the usual body *kea* (Pl. xxii, *B, b* center) may very well be a simple conventionalization of one of the carved tortoise-shell plaques of the *paekea* or crown—a carved product of Hiva Oa—the motive having been borrowed from shell rather than from wood carving. There is a motive found today in tattooing on Ua Pou (Pl. xx, *A, e;* xxi, *D, b)* and depicted also as an early Fatu Hiva unit (Pl. ix, *A, b)* which resembles the *e honu,* tortoise, drawn by Langsdorff, and this, which has disappeared from Hiva Oa tattooing, may perhaps be said

to be the only conventional derivative of a naturalistic portrayal of the tortoise and probably the (only pure body motive among the variants called *kea.* \The southeastern carving motive is the *kea* which prevails today.

Another usual conventional motive appearing both in carving and tattooing, the *mata hoata, or brilliant eye* (Pl. xxvi, *A. e)*, would appear to have originated in neither, being, in its simplest form, a copy of the eyes, ears and nostrils of a *tiki* or image face. Only on wood is this simple copy found today, and on wood we find all the transition stages of its development to the highly conventionalized unit common in tattooing today; whence it would appear that the *mata hoata* (originated in sculpture, was copied upon wood, and transferred to the body, where it gradually was elaborated and more highly conventionalized. (For development see Pl. xxx, *b,* which is found only on wood today; xi, *A, c;* xviii, *b;* xxxiv, *b;* xxxiii, *c;* xxiii, *B, f, a;* xxiii, *A, a,* center.)

Of conventional motives the *ka'ake* is perhaps the most widely used. Dordillon gives *kakekake* as one of the words used to designate tattooing which is entirely finished. He spells the word *"kake,"* but it seems better to adopt the spelling *"ka'ake"* for the following reasons: The distinguishing feature of the motive is its never varying curve which seems to correspond to the line of the under-arm curve or arm-pit for which the native term is *ka'ake.* The assumption that this curve of the body originally gave the name to the motive is borne out by several lines of reasoning. In the first place, Langsdorff assigns the placing of this motive originally to the inside arm and ribs (10, p. xv); in the second place, we have described for us this simple under-arm curve as its earliest form (Pl. xxix, *h;* xxx, *i);* and in the third place, the elaborations of this curve, as the motive grew in complexity, are representations of the *(enata* or man with upraised arms) (Pl. vi, *B,* center bottom), and of the *(poka'a* (Pl. ix, *B* at base of fingers) or curved wooden object placed on the shoulders on which to rest a pole in carrying a heavy load. The association of ideas seems obvious and we find them associated today as minor decorations in the under-arm pattern (Pl. xiii, *B, a, b;* xiii, *C, c* and *d;* xiv, *A).* This combination is especially marked in the simpler forms of the *ka'ake* as found on Ua Pou (Pl. xx, *B, b)* and Nuka Hiva (Pl. xv, *a).* Although this unit appears upon wood, it seems reasonable to suggest that it was originally a body pattern.

There are certain body motives which seem never or rarely to have been used upon wood, such as the *huetai* (Pl. xxxiv, *e)* and the *po'i'i* (Pl. xxxiii, *e;* xxvi, *A, d,* center), which are associated with early Nuku Hiva, not Hiva Oa, art; and there are some which are just beginning to be transferred to wood at the present time, as the *ipu'oto,* another unit

found in early Nuku Hiva design (Pl. xiii); but it seems impossible definitely to assign particular conventional motives to the one medium or the other. However, it may perhaps be stated that geometric elements did originate on wood, and that the influence of geometric adzing and carving appears in tattooing both in certain transferred elements and in a general conventionalization of the primitive naturalistic motives. Inasmuch as Fatu Hiva is known to be the carving center, we may further define the geometric influence as springing directly from wood-carvers of the southeastern group.

The use of solid patches may be traced with interest, as here again we find a different treatment in the two groups. Some modern informants describe the men of Nuku Hiva as formerly having half of the body entirely black (Pl. xii, B); one remembers seeing a man with solid-black legs; several testify that when a man was completely tattooed in design, if he could bear it, the spaces were gone over and filled in until all pattern was obliterated and he was completely black. In corroborating this custom in Nuku Hiva, Langsdorff says that he saw some old men who were punctured over and over to such a degree that the outlines of each separate figure were scarcely to be distinguished and the body had an almost negro-like appearance. (See also 14, p. 78; 8, p. 155; 17, p. 306; 1, p. 106.) There are no accounts of such a practice in the southeastern islands, and this seems to point to an aesthetic sense there, which was lacking in the northwest, for certainly people with sufficient artistic sense to originate these beautiful patterns would not have covered them afterwards and considered the results the "height of perfection in ornament," as did the *tuhuna* of Nuku Hiva, according to Langsdorff and the other early voyagers.

Desgraz, who was in Nuku Hiva at approximately the same time as Melville, when Hiva Oa tattooing was the vogue, describes the use there of black bands containing delicate figures. These are today the fundamentally distinguishing feature of the Hiva Oa type of body design as well as of the face pattern. On the other hand, both from descriptions of natives today and from examination of the tattooing of the only old man and old woman to be found, whose patterns were put on by Nuku Hiva *tuhuna*, the basic principle of the Nuku Hiva type seems to have been solid patches. Leg patterns for women found today fall into three distinct types: that of Nuku Hiva (Pls. xvii-xix), Ua Pou (Pls. xx-xxi), and Hiva Oa (Pls. xxii-xxviii). The first is distinguished by triangular patches of different sizes fitted together with half inch spaces between them, the only regularity of arrangement being their placing so as to form a straight line down the center front of the leg. Flamelike edges, inset teeth, and

geometric linings, with here and there a naturalistic unit, break up the heavy patches and add to their irregular and fancy appearance. Examination of the leg motives of this very *tapu* Nuku Hiva chiefess, who must have employed the best artist obtainable, provokes the suggestion that these insets were crude and inartistic attempts at a style from the southeast which had perhaps just been introduced into Nuku Hiva and with which the Nuku Hiva *tuhuna* was not acquainted or perhaps to which he was not equal. The second type, that of Ua Pou, is put on below the knee only, in horizontal bands of delicately lined patterns, the motives on either side of the center, front and back, being exactly alike. The whole may be conceived of in front and back longitudinal sections of symmetrical halves, which meet in the middle of either side of the leg. Naturalistic, geometric and conventional treatments are all present. The third type, that of Hiva Oa, which was the prevalent style at the time of the discontinuance of the art, is similar in arrangement to that of Ua Pou, extending however high up onto the thigh, and presents a mean between the two former in heaviness of treatment, the fine lines swelling into black curves. The mode is almost purely conventional. The two latter may be characterized as curvilinear; the former, as angular in design.

The leg patterns to be seen on living men fall into two types, a single example representing that of Nuku Hiva (Pl. xxxi), all the rest being of the Hiva Oa type (Pls. xxxii-xxxviii). The former is characterized by unadorned heavy patches, triangular and oblong in shape, fitted together obliquely with no plan of arrangement save the formation of a straight intersection down the front of the leg. Teeth are the only insets. The Hiva Oa examples show the style to be of horizontal bands extending around three quarters of the leg, the inside front quarter being filled with triangles in the Nuku Hiva style (Pl. xxxiv, *e-j*), indicating, perhaps, a borrowing from the heavy black patches of that group. The thigh band and the underknee band are always composed either of four triangles or of triangles and parallelograms with insets of teeth; but beyond this, this style is totally different from the Nuku Hiva example, variations of the same fine line motives used in Hiva Oa for women being set into *pahito* so that the heavy bands become merely a framework for them. The Nuku Hiva pattern drawn from life stands quite apart from that pictured by early navigators (10, pp. 117, 119; 16, Pl. 132) and described by a modern informant on Fatu Hiva (See Pl. xxix). It is a pity that no other living example of the work of a Nuku Hiva artist could be found, as it is unsafe to make any general statement about it.

At the present time, there is but one type of back decoration for men (Pl. xiv, *C*): eight heavy rectangular patches arranged in pairs along the

back bone with fine line insets and a girdle. These are called *peka tua*, back cross, by an informant of Nuku Hiva and may be an outgrowth of the cross on the back described by Langsdorff (10, p. 123), though the present mode bears no resemblance to a cross, being rather another example of band construction.

With the band construction of the present day, then, are associated exact technique, perfect symmetry, an evident understanding of anatomy and fitting of design to the body, and motives which are akin in name and formation to those carved on bowls, paddles, canoes, and similar objects. The distinguishing features accompanying the oblique patch type are irregularity, no sense of the design as a whole, no fitting of the motives to the body, naturalistic units, fussy, elaborate, non-aesthetic, fine-line insets.

A survey of these two types of body decoration leads naturally to the suggestion that there was a fundamental difference of concept between the two groups regarding the reason for its use. Plainly, there was an emphasis upon endurance and fortitude in the mind of the northwesterner when he braved the pain of a completely perforated skin; while the southeasterner looked upon the art as more purely decorative. Dordillon gives the word *ne'one'o* as meaning "what inspires horror (in speaking of a wound)," and "to cry a long time;" and this word with the addition of the phrase, "*i te tiki*" means "completely covered with tattooing." It is the pain of which the people of the Marquesas speak today when displaying their decorations, and it must be admitted that this is as true in the one group as in the other.

The only practical reason for tattooing that was suggested by living informants came from a man of Nuku Hiva, who, in describing an old mode of the northwestern group of tattooing half of the entire body solid black, accounts for this style by saying that such a one turned his black side towards the enemy during a battle, so that he could not be distinguished or recognized.

Inquiry into the naming of motives may throw some light upon their significance in the native mind. Appreciation of the anatomy of the body is often of such paramount importance as to give the name of the body part to the motive which is fitted to it, the *fatina* (joint) or knee jointure pattern (Pl. xxxiv, *f*) being a case in point. The same sense of body form is approached from a slightly different angle, as in the naming of the buttock pattern, *tifa* (cover) (Pl. xxxv, *c*), the convex of the body part resembling the cover of a calabash. Motives are sometimes referred to in purely technical terms of form: such as *paka* (Pl. xxxv, *h*) a splinter; *kopito* (Pl. xxiii, *A, d*, left and right) zigzag; or in terms of

the parts they play in the pattern as a whole, such as the *ka'ava* (Pl. x, B, 1, *g*); beam supporting the timbers of a house, which performs just this function in the hand pattern; or the *ih'iti'i* (Pl. xxvi, B, *h*) which encircles the leg, binding together the side motives.

Many of the design names [4] then, are names given by artists in terms of their particular medium; but motives are also named for objects in nature or in the material culture, of which they were probably originally naturalistic copies. Prominent among these are the *enata* (Pl. xxiii, B, *h*) or man; the *nihoniho peata* (Pl. iii, 6, *c*) or shark's teeth; the *hikuhiku atu* (Pl. xxxiv, *k*) or bonito tails; the *pakiei* (Pl. xx, B, *f*) or crab; the *fa'amana* (Pl. xvi, *h*) or pandanus branches; the *makamaka* (Pl. xx, A, *c*), branches; the *kaka'a* (Pl. xx, B, *c*), lizard; the *poka'a* (Pl. ix, B at base of fingers) or shoulder rest for a carrying pole, which is sometimes represented with the carrying pole in the socket as in the finger motives of Pl. ix, C, 1.

A third department of names seems to relate to legends and beliefs; such being the *vai o Kena* (Pl. xxvi, A, *g*, center) water of Kena; the *vai ta keetu* (Pl. xvi, *c*), sacred bathing place of chiefs; the *vai me'ama* (Pl. xx, A, *d*), water moon; the Pohu (Pl. xxii, B, *g*, center), a legendary hero; the *peke'oumei* and the *fanaua* (Pl. xv, *c*), or evil spirits.

Whether these and the naturalistic motives had magical significance is not known today, though there is reason to believe that the *fanaua* were put upon the back of this one woman to protect her from these evil spirits. The only positive statement regarding the significance of tattooing design in the Marquesas that can be made upon the basis of the data available today is that it was considered purely decorative at the time of the cessation of the practice of the art. And it is as pure design that it should be studied and appreciated.

[4] In the explanation of the plates the names of the motives are those given by the persons on whose bodies they are found. It is impossible to secure accurate translations of the majority of design names from natives today, since these have become simply names to them. The names given here are only those which a knowledge of the language and information from natives and from Dordillon seem to make reliable.

TRANSLATIONS OF DESIGN NAMES

aa fanaua	row of evil spirits (of a certain kind)
akaaka fa'a enata	pandanus roots man
fa'a mana	pandanus branches
fanaua	a kind of evil spirit
fatina	jointure
hei ta'avaha	a diadem of cock's plumes
hei po'i'i	shellfish (of a certain circular kind) wreath
hikuhiku atu	tails of the bonito fish
honu	tortoise
hue ao	calabash bottom
hue epo	dirty calabash
hue tai	compass
ihu epo	dirty nose
ikeike	a kind of shrub
ipu ani	sky bowl
ipu ao	bowl bottom
ipu oto	inside the bowl
iti'iti'i	binding
ka'ake	armpit
ka'ava	ridge pole
-kaka'a	lizard
kea	woodlouse, or tortoise or a carved plaque of tortoise shell
kikipu	lips
kikomata	eyes
kikutu	lips
kohe ta	sword
kohe tua	back knife
kopiko	zigzag
koua'ehi	coconut leaves
makamaka	branches
mata	eyes
mata hoata	brilliant eye
niho or nihoniho	teeth
nihoniho peata	shark's teeth
nutu kaha	mouth or muzzle
omuo puaina	a kind of carved bone earring
pahito	ancient patch
paka	splinter

paka oto	inside places
pakiei	crab
pana'o	cut in small slices, traced
papua	enclosure or garden
papua au ti	enclosure of ti leaves
papua enata	native enclosure
peata	shark
peka tua	back cross
peke ou mei	a kind of evil spirit
pia'o tiu	to fold or make into bundles
Pohu	a legendary character
po'i'i	a kind of coiled shell fish
poka'a	a shaped wooden shoulder rest for a carrying pole
pu	conch shell
puaina, puainga	ear
pua hitu	flower of olden times
pua hue	flower calabash
puha puaka	pig's thigh
puto'o	buttocks
tamau	ring
tapu vae	sacred foot
ti'ati'a pu	to encircle several times
tifa	cover
tiki	image
tiki ae	forehead image
tou pae	three head ornaments
tumu ima	hand tree
vahana ae	half a forehead
vai me'ama	water moon
vai o Kena	water of Kena, a legendary hero
vai ta keetu	sacred bathing place of chiefs
veo	tail
vi'i po'i'i	to turn the shell fish

BIBLIOGRAPHY

1. BERCHON, Le tatouage aux Iles Marquises: Bull. Soc. d'Anthr., vol. 1, pp. 99-117, Paris, 1860.

2. CHAULET, PIERRE, Manuscript in possession of the Catholic Mission in the Marquesas.

3. DORDILLON, I. R., Grammaire et dictionnaire de la langue des Iles Marquises, Paris, 1904.

4. FORSTER, G., A Voyage round the World: vol. 2, London, 1777.

5. FORSTER, J. R., Observations made during a voyage round the World, London, 1778.

6. GARCIA [GRACIA?], MATHIAS, Le P., Letters sur les Iles Marquises: Paris, 1843.

7. JARDIN, Edélestant, Essai sur l'histoire naturelle de l'archipel des Marquises, Paris et Cherbourg, 1862.

8. KRUSENSTERN, A. J. von, Voyage round the world in the years 1803, 1804, 1805, and 1806, vol. 1, translated from the original German by Richard Belgrave Hoppner, London, 1813.

9. LACASSAGNE, A., Les Tatouages, étude anthropologique et médico-légale: Paris 1881.

10. LANGSDORFF, G. H. von, Voyages and travels in various parts of the world during the years 1803, 1804, 1805, 1806, and 1807, London, 1813.

11. MARCHAND, ETIENNE, Voyage autour du Monde pendant les annees 1790, 1791 et 1792, vol. 1, Paris an VI-VIII [6th to 8th years of the Republic—1797-1800].

12. MELVILLE, HERMAN, Omoo, a narrative of adventure in the South Seas: New York, 1863.

13. MELVILLE, HERMAN, Typee, A peep at Polynesian life during a four months' residence in a valley of the Marquesas, New York, 1876.

14. PORTER, DAVID, A voyage in the South Seas, London, 1823.

15. QUIROS, PEDRO FERNANDEZ de, The Voyages of Pedro Fernandez de Quiros, 1595 to 1606: Hakluyt Soc., 2nd ser., vols. 14, 15, translated and edited by Sir Clements Markham, London, 1904.

16. RIENZI, M. G. L. Domeny de, Océanie ou cinquième partie du Monde, vol. 2, Paris, 1863.

17. STEWART, C. S., A visit to the South Seas in the U. S. Ship Vincennes during the years 1829 and 1830, vol. 1, New York, 1831.

18. VINCENDON-DUMOULIN and DESGRAZ, C., Iles Marquises ou Nouka-Hiva, histoire, geographie, moeurs, Paris, 1843.

EXPLANATION OF PLATES

(From drawings by the author except where otherwise indicated.)

PLATE I.—PHOTOGRAPHS OF A TATTOOED MAN OF THE MARQUESAS.

The patterns on half the body of Eotafa of Ta'a Oa, Hiva Oa—the most fully tattooed man seen in the Marquesas by the author—the motives being brought out by painting them with black paint. Identical patterns on the unpainted half of the man's body do not appear in the photograph.

PLATE II.—PHOTOGRAPHS OF A TATTOOED WOMAN OF THE MARQUESAS.

Typical modern patterns for women, on the body of Tuuakena at Atu Ona, Hiva Oa: *A.* Front and side view of face, showing lip and ear patterns. *B-E.* Front and rear views of legs showing patterns on the painted portions.

PLATE III.—FACE PATTERNS FOR MEN.

Examples of the Hiva Oa style of three horizontal face bands, *ti'a ti'a pu:* 1. An unfinished example from Pua Ma'u, Hiva Oa.—2. From Haka Hetau, Ua Pou, showing *enata* motive *(a)*.—3. From Haka Hetau, Ua Pou, showing a half band on the forehead.—4. From Hokatu, Ua Huka, showing the motives *tiki ae (a)*, *kikomata (b)*, *tiki pu (c)*, and *pariho* (inset in *c)*.—5. From Pua Ma'u, Hiva Oa, showing a band over one eye, *mata (a)*, and a mouth band, *nutu kaha (b)*.—6. From Vai Paee, Ua Huka, showing the motives *vahana ae (a)*, *mata (b)*, *nihoniho peata (c* left), name unknown *(c,* right), detail of *c* right *(e)*, and the *kikutu (d)*.—7. from Vai Paee, Ua Huka.—8. From Hane, Ua Huka.

PLATE IV.—FACE PATTERNS FOR MEN.

Examples of the Hiva Oa style of three horizontal face bands, *ti'ati'a pu:* 1. From Omoa, Fatu Hiva.—2. From Hanavava, Fatu Hiva, showing on inter-band the *nihoniho peata* motive.—3. From Hatiheu, Nuku Hiva (after a sketch by E. S. Handy).—4. From A'akapa, Nuku Hiva (after a sketch by E. S. Handy).—5. From Hana Vave, Fatu Hiva, showing detail of a chainlike design *(a)*.—6. From Hana Vave, Fatu Hiva, the three bands here called as a whole *tou pae*.—7. From Haka Hetau, Ua Pou, showing *mata (a)*, *veo (b)*, *kiki pu (c)*, *enata (d)*, detail of *b (e)*, detail of *d (f)*.—8. From Hooumi, Nuku Hiva (after a sketch by E. S. Handy).—9. From Haapa, Nuku Hiva (after a sketch by E. S. Handy).—10 and 11. From Haka Hau, Ua Pou.

PLATE V.—FACE AND HEAD PATTERNS FOR MEN.

Examples of various styles of different periods: 1. From Hana Iapa, Hiva Oa, showing an unusually shaped eye band and an unfinished mouth band.—2. From Atu Ona, Hiva Oa, showing shoulder and chest patterns mounting the neck to join the face bands.—3. From Haka Hau, Ua Pou: an unfinished pattern, showing the probable sequence of execution—one eye being allowed to heal while half of the mouth was done, and so on.—4 From Ha'a Kuti, Ua Pou (after a sketch by E. S. Handy).—5. From Tai o Hae, Nuku Hiva, one of two extant examples showing the Nuku Hiva style of an oblique band *(pa heke)* crossing the face.—6. A former Hiva Oa pattern (after a description by an Atuona informant).—7. An old pattern for warriors of all the islands (after a description by an informant of Fatu Hiva.—8. A variant of the *ti'ati'a pu*, with nostrils covered, belonging to Fatu Hiva and called *ihu epo* (after a sketch by E. S. Handy).—9. A pattern formerly used on the crown of the head (after a painting on a sculptured figure which once served as a house post in Ta'a Oa, Hiva Oa, and is now in possession of M. Chadourne of Papeete, Tahiti.—10. The *hue epo* pattern, an example of a former style of the people of Tai o Hae, Nuku Hiva (after a description by a Nuku Hiva informant).—11. An old Nuku Hiva pattern (after a description by an informant of Fatu Hiva).

PLATE VI.—HEAD AND SHOULDER PATTERNS FOR WOMEN.

A. Typical face patterns for women: lip marks, *koniho*, and an ear pattern, *omua puaina.*

B. A band across the arm just below the fall of the shoulder, on a woman of Tai-pi Vai, Nuku Hiva (after a sketch by E. S. Handy).

C. Ear patterns: 1. On a woman of Hakaui, Nuku Hiva.—2. Of Atu Ona, Hiva Oa, showing the *omuo puaina* design around the lobe and the *kea* design at the back of the ear.—3. Of Tai-pi Vai, showing the *puainga* design (after a sketch by E. S. Handy).—4. Of Pua Ma'u, Hiva Oa, showing around the lobe the *aniatiu (anihaupeka,* Dordillon) motive and back of the ear the *po'opito ua puaina.*—5. Of Hiva Oa.—6. A woman's pattern on a man of Pua Ma'u, Hiva Oa—a rare occurrence.

PLATE VII.—HAND PATTERNS. MOTIVES FROM FATU HIVA AND TAHU ATA.

A. On a woman of Fatu Hiva: 1. The back of the hand.—2. The palm, showing the *pariho* motive on the underwrist around the palm, the *mata (a),* the *tamau (b),* and the *pariho (c).*

B. On a woman of Tahu Ata: 1. The back, showing the *poka'a* motive at the base of the middle finger, the *pihau (tumu ima,* Langsdorff) *(a)* and the *mata (b).*—2. The underwrist

PLATE VIII.—HAND PATTERNS. MOTIVES FROM NUKU HIVA AND HIVA OA.

A. On a man of Nuku Hiva.

B. On a woman of Hiva Oa, showing the *taina vau* motive between the thumb and index finger, *e tua poou (a), ti'i kao (b),* and the *paa niho (c)* around the palm.

PLATE IX.—HAND PATTERNS. MOTIVES FROM FATU HIVA AND TAHU ATA.

A. An old pattern of Fatu Hiva called *kohi'u* (after a drawing made by an old *tuhana* of Fatu Hiva), showing finger motives, *mata va'u;* finger and upper hand units inclusive, *nutu kaha; po'i'i (a); kea po'i'i (b); hei po'i'i (c)* and *hei ta'avaha (d)* around the palm.

B. On the left hand of a woman of Tahu Ata (for the design on her right hand see Plate X, A), showing the *poka'a* motive at the base of the fingers; the *po'i'i (a), Pohu (b),* and the *eia va'u (c).*

C. On a woman of Hiva Oa, done by a *tuhuna* of Fatu Hiva: 1. The back of the hand showing the central oval, the *po'i'i* motive; the *poka'a* at the base of the fingers and the thumb; *matua hee moa (a), ama opea* between the thumb and index finger; and the *fanaua (b, c.).*—2. The palm showing the *fanaua* motive around the palm, the *po'i'i (a),* and the *piaotiu (b).*

PLATE X.—HAND PATTERNS. MOTIVES FROM TAHU ATA.

A. On a woman of Tahu Ata: 1. The back of the hand, showing the *ka'ava* motive at the base of the middle finger to the wrist, *kou'u (a), poka'a (b), mohovaha (c),* and the *mata (d).*—2. The underwrist, *koua'ehi (a).*

B. On a woman of Tahu Ata. (The tattooing was done by the same *tuhuna* whose work is shown in Plates X, A and IX, B.) 1. The back, showing the motives *papua (a), e tua poou (b), paka (c), ka'ava* (center), *fanaua (e), Pohu (f),* and *ka'ake (g).*—2 Underwrist, showing the motives *paa niho* around the palm; *papua au ti (b),* and the *vai o Kena (c).*

PLATE XI.—HAND PATTERNS. VARIANT MOTIVES.

A. Principal units on the hand of a woman of Nuku Hiva, showing the motives *mata putona (a), kea (b),* and the *mata io (c).* (After a sketch by E. S. Handy.)

B. A representation of a bird on the underwrist of a woman of Nuku Hiva.

C. Pattern on two men of Ua Pou.
D. On a man of Hiva Oa, tattooing done by a *tuhuna* of Fatu Hiva (after a sketch by E. S. Handy).
E. On the underwrist of a woman of Hiva Oa, an unusual *kea* motive.

PLATE XII.—ARM AND BREAST PATTERNS FOR MEN. EVOLUTIONARY TYPES.

A. An old style of Fatu Hiva (after a drawing by a *tuhuna* of Fatu Hiva) showing breast stripes, *ti'i heke.*
B. An old style of Nuku Hiva (after a sketch by E. S. Handy from the description of an artist of Fatu Hiva).
C. Detailed drawing of *A*, showing the motives *kea (a)*, the *etua pooi (b)*, the *poka'a* or *pahito (c)*, *fa'amana (d)*, *ipu ao (e)*, and the *vi'i po'i'i (d* and *e)*.
D. The present style: under-arm, *ipu oto;* shoulder disk, *puha puaka;* chest, *ka mo'ehu.*
E. Detailed drawings of *B* showing the motives *nihoniho (a)*, *po'i'i (b, c)*.

PLATE XIII.—ARM PATTERNS FOR MEN. TYPICAL MODERN MOTIVES, *ipu oto.*

A. On a man of Ua Huka.
B. On three men of Ua Pou showing a variant of the armpit motive, the *poka'a (a)*, and the *enata (b)*. Three pairs of squarish ovals, similar to those in *A* complete this arm pattern.
C. On a man of Fatu Hiva showing the motives *puaina (a); ti'i o'oka (b);* the three pairs of ovals, *ipu oto;* the arm-pit unit, *ipu ao; poka'a (c);* and *enata (d)*.

PLATE XIV.—BODY PATTERNS FOR MEN. OLD AND NEW TYPES.

A. An unfinished example from Nuku Hiva, typical of all islands at the present time, showing the arm-pit design, *ipu katu* and chest, *teeva.*
B. An old style in back and side patterns from Fatu Hiva (after a drawing by a *tuhuna* of Fatu Hiva) showing back patches, *pahito; ipu oto (a); pahito (b); mata (c); mata (d); kohe tua (e)*, a girdle and leg stripe.
C. An unfinished back pattern, *peka tua*, from Nuku Hiva but common to all the Marquesas islands. On Ua Pou this pattern is called *moho.*

PLATE XV.—A BACK PATTERN FOR WOMEN.

A girdle on a chiefess of Nuku Hiva, showing the motives *ka'ake (a)*, *mata (b)*, and *fanaua (c).*

PLATE XVI.—LEG MOTIVES FOR WOMEN.

Motives formerly used in Fatu Hiva: *koniho (a)*, *mata hoata (b)*, *vai ta keetu (c)*, *pana'o (d)*, *ikeike (e)*, *hei po'i'i (f)*, *akaaka fa'a (g)*, *fa'a mana (h)* worn on the inner ankle, *mata omo'e (i)* worn on the inside of the knee, like the present *pahito*, *puha tahi (j)* worn below the knee on the inside of the leg, *eia va'u (k)* worn on the inside of the calf, *nutu kaha (l)*, *tava (m)* worn on the inside of the leg above the ankle (after drawings by a *tuhuna* of Fatu Hiva).

PLATE XVII.—A LEG PATTERN FOR WOMEN.

The only surviving example, so far as known, of an old style of Nuku Hiva.
A. Front and side views of the left leg.
B. Back and side views of the right leg.

PLATE XVIII.—A LEG PATTERN FOR WOMEN.

Detail of the motives shown in Plate XVII, *A.*

PLATE XIX.—DETAILED STUDIES OF A LEG PATTERN FOR WOMEN.

A. Of motives in Plate XVII, B.

B. Back thigh units of both legs of patterns in Plate XVII.

C. Ankle motives of the right leg of pattern in Plate XVII, the rest of the ankle and foot pattern being identical with those of the left.

PLATE XX.—A LEG PATTERN FOR WOMEN.

Detail of the right leg motives of an old style of Ua Pou, the only surviving example to be found today.

A. Front: *paka (a), mata io (b), makamaka (c), vai me'ama (d), honu (e)*.

B. Back: *po'i'i (a), ka'ake (b), kaka'a (c), mata io (d), vai me'ama (e), pakiei (f), pu (g)*.

PLATE XXI.—A LEG PATTERN FOR WOMEN.

Detail of the left leg motives of the preceding example:

A. Front, knee to ankle: *mata (a), ka'ake (b), pakiei (c), vai me'ama (d)*.

B. Back, knee to ankle: *ka'ake (a), mata io (b), vai me'ama (c)*.

C. General view of the left leg.

D. Ankle band.

E. General view of the right leg, of which detail is shown in Plate XX.

PLATE XXII.—A LEG PATTERN FOR WOMEN. THE MODERN TYPE.

Typical motives indicating the color of the tattooing as it appears on the skin.

A. Back pattern: *vai pahu (a, left), ka'ake (a, center), mata hoata (b), ka'ake (c), mata hoata (d), ipu ani (e), vai o Kena (f), mata hoata (g), ka'ake (h) and (j), Pohu (i), ipu ani (k, center), ka'ake (k, left and right)*.

B. Front pattern: *mata hoata (a), po'okohe (b, left and right), kea (b, center), ka'ake (c, left and right), pahito (d, left and right), ipu ani (d, center), mata mei nei (e), ka'ake (f, left and right), vai o Kena*, sometimes called *potia hue* or *peke ou mei (f, center), Pohu (g, center), mata hoata (h), pahito (i and j, left and right), ka'ake (i and j, center), ipu ani (k), mata hoata (l), etua poou*, sometimes *Pohu (m)*.

PLATE XXIII.—A LEG PATTERN FOR WOMEN. A VARIANT ARRANGEMENT ON A WOMAN OF PUA MA'U, HIVA OA.

A. Front pattern: *ka'ake (a, left and right), mata hoata (a, center), aniatiu (b, left and right), ka'ake (b, center), kopiko (d, left and right), po'i'i (d, center), ka'ake (e, left and right), mata hoata (f, center), ka'ake (g), etua poou (h), mata hoata (i), pahito (j, left and right), pahito (k, left and right), ka'ake (j and k, center), po'i'i (l), mata hoata (m)*.

B. Back pattern: *mata hoata (a), ka'ake (b), mata hoata (c), po'i'i (d), ka'ake (e), mata hoata (f), ka'ake (g), paa niho (h, around the foot)*.

PLATE XXIV.—LEG MOTIVES FOR WOMEN.

A and C. Detail of upper thigh motives omitted from the leg but burned instead upon bamboo.

B. A general view showing how the motives in Plate XXIII are arranged on the leg.

PLATE XXV.—A LEG PATTERN FOR WOMEN.

Front and rear views of an elaborate leg pattern from Pau Ma'u, showing a combination of the fine motives and heavy patches usually worn by men.

PLATE XXVI.—A LEG PATTERN FOR WOMEN.

A. Detailed study of the motives in the front pattern of Plate XXV: *nutu kaha (a-c inclusive), kea (a, center), ka'ake (b), kea (c, center), pahito (d, left*

and right), *po'i'i (d*, center), *mata hoata (e), tu'u po'o,* sometimes *vai o Kena* on Fatu Hiva *(f), vai o Kena (g, center), ka'ake (g*, left and right), *mata hoata (h), pahito (i* and *j*, left and right), *ka'ake* and *peke ou mei (i* and *j*, center), *po'i'i (k), mata hoata (l), tu'u po'o (m).*

B. Back pattern: *oniho (a), paka (b), pahito (c), papua (d), pahito (e), mata hoata (f), po'i'i (g), iti'iti'i (h), mata hoata (i), ka'ake (j* and *l), peke ou mei (k), ka'ake (m*, left and right), *po'i'i (m*, center).

PLATE XXVII.—LEG MOTIVES FOR WOMEN. VARIANTS.

A, B, and C. *Nutu kaha,* variations of the thigh pattern.
D. A band encircling the ankle of a woman of Nuku Hiva.
E. A band encircling the ankle of a woman of Tahu Ata.
F. *Oniho,* a band outlining the sole of the foot of a woman of Ua Huka.

PLATE XXVIII.—LEG MOTIVES FOR WOMEN. OTHER VARIATIONS.

A. An elaborate *po'i'i* on the knee of a woman of Tahu Ata.
B. A front shin pattern of unusual arrangement and combination.
 [Note the use of the *vai o Kena* on its side *(a*, center), and the combination of *mata* and *vai o Kena (b).*]
C. A variant of the *aniatiu* of Plate XXIII, *A:* left and right *(b* and *c).*
D. Crude representations of the *pa'a'oa* (fish) found on the knees of a woman of Tahu Ata.
E. An upper thigh motive, *puhi,* on a woman of Tahu Ata.
F. An unusual extension of the *ka'ake (a),* a variant of Plate XXIII, *A, h,* found on a woman of Ua Huna; a binding motive *(b)* from Ua Huka, a variant of the *iti'iti'i* of Plate XXVI, *B, h.*

PLATE XXIX.—LEG MOTIVES FOR MEN.

Motives formerly used in Nuku Hiva: the *kohe ta,* or sword motive, consisting of a girdle across the back and a stripe down the side of the leg *(a, b), hikuhiku atu (b), pua hitu (c), pahito (d), huetai (e), po'i'i (f), mata hoata (g),* and the *ka'ake (h).* (After drawings by an artist of Fatu Hiva).

PLATE XXX.—LEG MOTIVES FOR MEN.

Motives formerly used in Fatu Hiva (after drawings by a *tuhuna* of Fatu Hiva): *aa fanaua,* worn on the upper front thigh *(a); mata hoata (b); pahito (c), vai o Kena (b* and *c),* worn on the back of the leg below the bend of the knee; *papua enata (d),* worn on the inside calf just above the ankle; *mata hoata (e),* worn on the upper thigh alongside the *aa fanaua; ti'i hoehoe (f),* worn on the bend of the knee; *paka'a (g),* worn on the back of the calf; *nihoniho (h),* worn on the inside calf; *ka'ake (i), pua hue* and *ikeike (j); pia'o tiu (k),* worn around the ankle; *ti'i kakao (l),* worn on the foot.

PLATE XXXI.—A LEG PATTERN FOR MEN.

The Nuku Hiva style of leg pattern, done by a *tuhuna* of Nuku Hiva and found on only one man: ornamental band on the thigh, *puhi puha;* the heavy patches, *pai-pai io.*

PLATE XXXII.—LEG PATTERNS FOR MEN.

The Hiva Oa style, in vogue on all the islands at the time of the discontinuance of the art:
A. Side view of a leg with motives from Ua Huka. The buttock and inside front quarter of the leg pattern are lacking, as is usual in modern examples.
B. Front and side views of a leg with motives from Fatu Hiva, the inside front quarter of the leg pattern, below the knee, being present.

C. Back view of a leg with motives from Ua Pou, the buttock pattern being present.

PLATE XXXIII.—A LEG PATTERN FOR MEN.

Detailed study of Plate XXXII, *A: kohe ta (a, b,* and *c), kea (b), mata io (c), puto'o (d), kautupa (e), fatina (f), pahito* with *po'i'i* inset *(g), hikuhiku atu (h), pahito (i* and *j), auhoi (k), tapu vae (k* and *l).*

PLATE XXXIV.—A LEG PATTERN FOR MEN.

Detailed study of motives on Plate XXXII, *B: kohe ta (a* and *b); puto'o (c); pahito* with *mata hoata, ka'ake,* and *tiki* insets *(d); mata vaho,* the half oval; *pua hue (e); fatina (f); pahito* with *po'i'i* and *ka'ake* insets *(g); paka oto (h, i, j); hikuhiku atu (k); pahito,* with *mata* and *ka'ake* insets *(l), tapu vae (m).*

PLATE XXXV.—A LEG PATTERN FOR MEN.

A detailed study of the motives of Plate XXXII, *C: kohe ta (a* and *b); tifa (c),* containing a *mata hoata, enata,* and a *kea* in the center at the bottom; *puto'o (d); pahito (e); fatina* with elaborate double rows of cross-barred teeth inset *(f); pahito (g); paka (h),* in place of the usual *hikuhiku atu; pahito (i); tapu vae (j); auhoi (k).*

PLATE XXXVI.—A LEG PATTERN FOR MEN.

An elaborated pattern of the Hiva Oa style found at Ua Huka: *kohe tine (a-c),* complicated by two *meta io (b* and *c), puto'o,* lightened by a *mata io* inset *(d), pahito* broken by a *ka'ake* and a *po'i'i* inset *(f).*

PLATE XXXVII.—A LEG PATTERN FOR MEN.

A more complicated pattern from Hiva Oa, rendered almost as lacelike as those for women by the numerous fine-line insets in the heavy patches: *puto'o (a, b, c,)* with insets of cross-barred teeth, double rows of *tiki,* and a *vai o Kena; pahito* with *mata hoata, ka'ake,* and *po'i'i* insets *(d); fatina* with *mata* inset *(e); pahito* with *po'i'i* and *ka'ake* insets *(f); hikuhiku atu (g)* with flourishes at the points; *pahito (h),* whose simple lines are almost lost in the elaborate insets of *vai o Kena* and *mata.*

PLATE XXXVIII.—LEG MOTIVES FOR MEN.

A. Kohe ta from Fatu Hiva.

B. A thigh pattern from Nuku Hiva (after a sketch by E. S. Handy): *mata (a), hue ao (b).*

C. Two bands for the foot: *pia'otiu* and *kakao.*

D. An inside knee motive, *mata vaho,* from Fatu Hiva.

E. and *F.* Ankle bone decorations, *auhoi.*

G. An ankle band from Fatu Hiva: *Tapu vae (a); hikuhiku atu (b); pahito* with *ka'ake, mata io,* and *tiki* insets *(c).*

H. An elaborated *pahito* from Fatu Hiva with *ka'ake, enata,* and *mata io* insets.

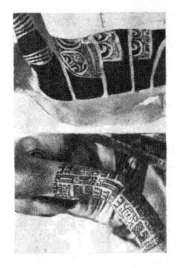

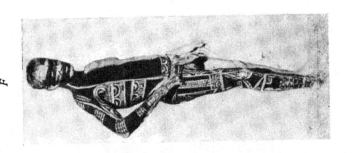

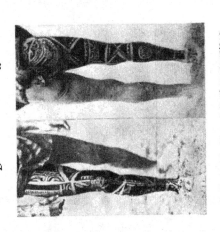

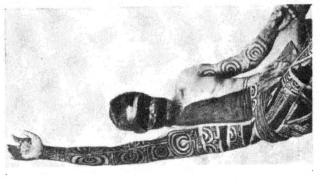

TATTOO DESIGNS IN THE MARQUESAS

A

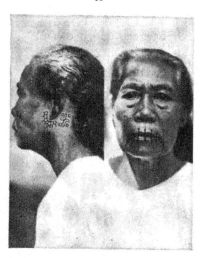

B *C* *D* *E*

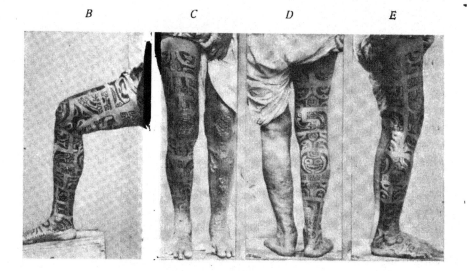

TATTOO DESIGNS IN THE MARQUESAS

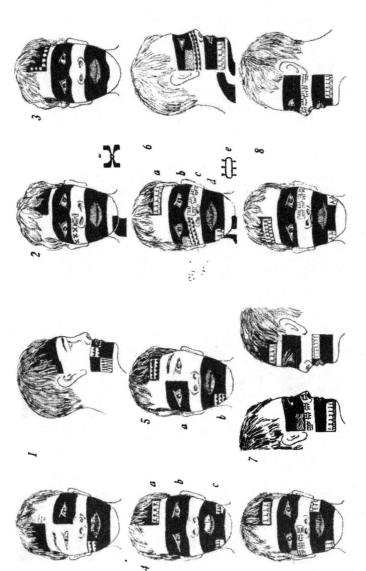

TATTOO DESIGNS IN THE MARQUESAS

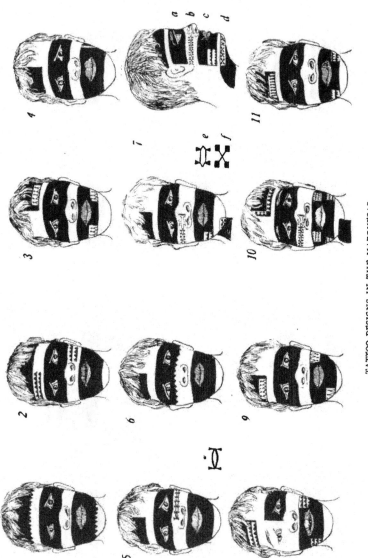

TATTOO DESIGNS IN THE MARQUESAS

TATTOO DESIGNS IN THE MARQUESAS

A

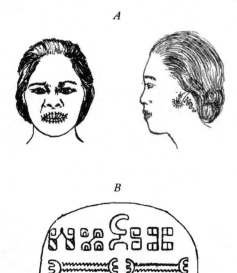

B

C

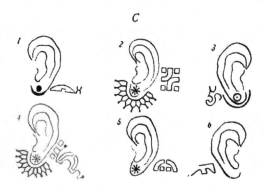

TATTOO DESIGNS IN THE MARQUESAS

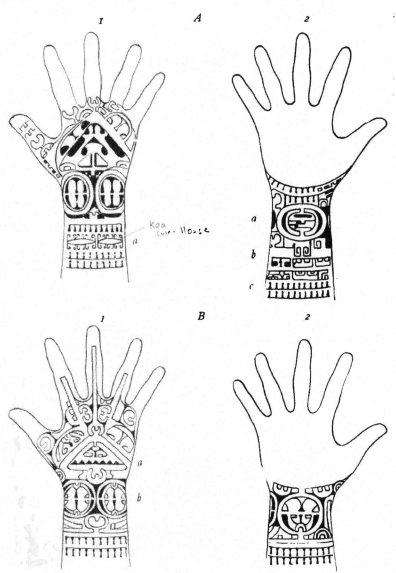

TATTOO DESIGNS IN THE MARQUESAS

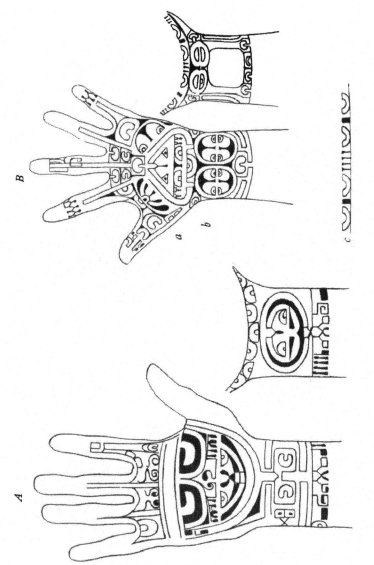

TATTOO DESIGNS IN THE MARQUESAS

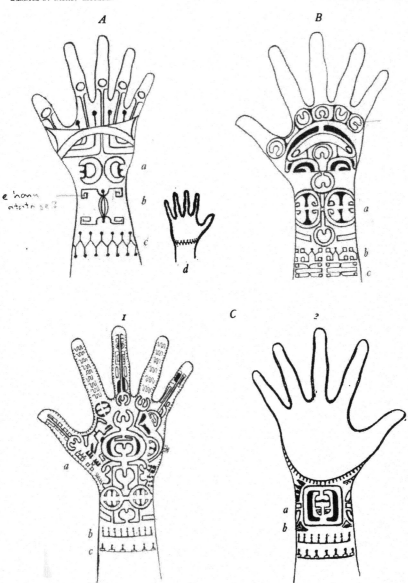

TATTOO DESIGNS IN THE MARQUESAS

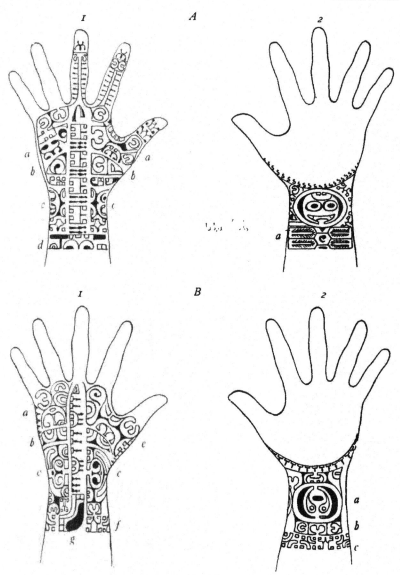

TATTOO DESIGNS IN THE MARQUESAS

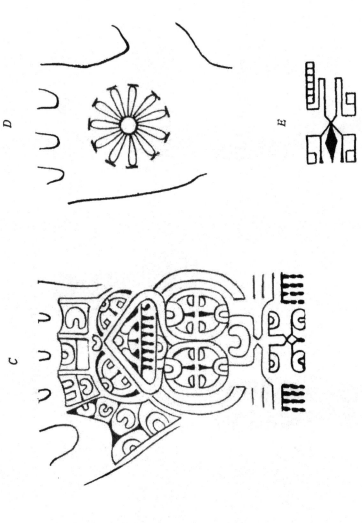

TATTOO DESIGNS IN THE MARQUESAS

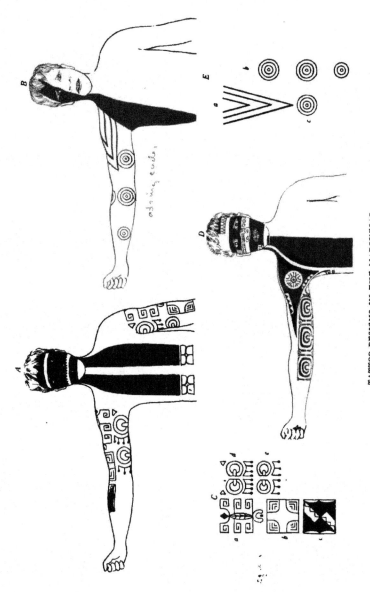

TATTOO DESIGNS IN THE MARQUESAS

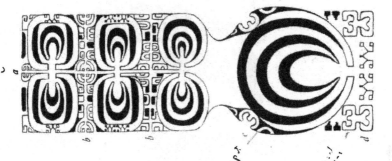

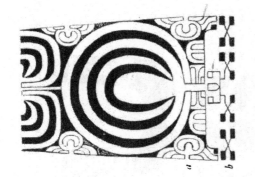

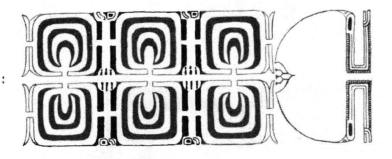

TATTOO DESIGNS IN THE MARQUESAS

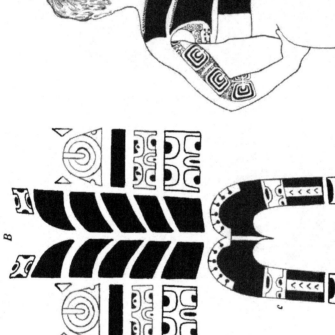

TATTOO DESIGNS IN THE MARQUESAS

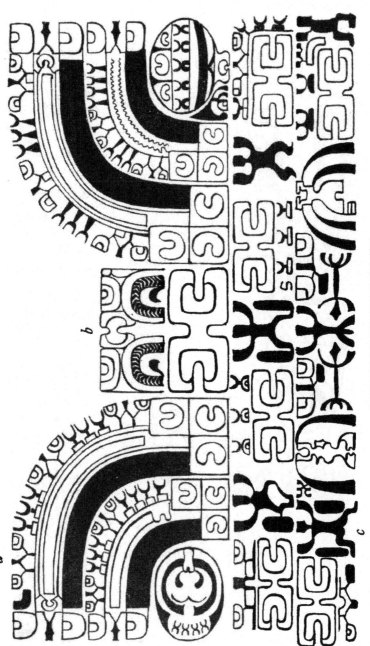

TATTOO DESIGNS IN THE MARQUESAS

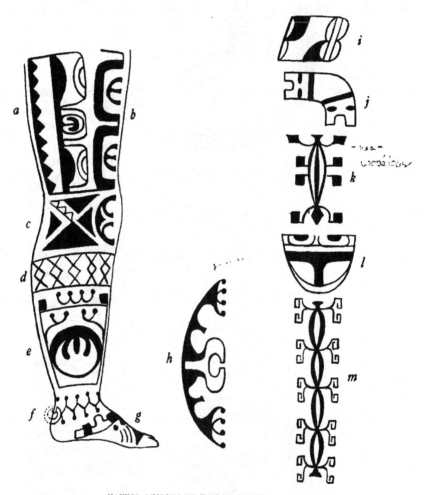

TATTOO DESIGNS IN THE MARQUESAS

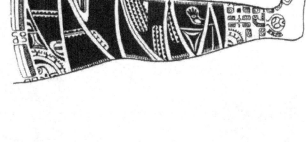

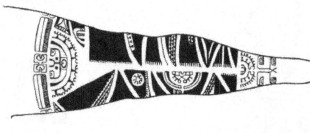

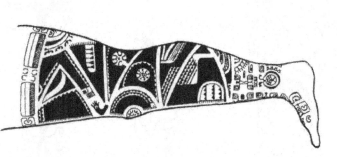

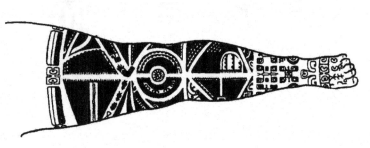

A

B

TATTOO DESIGNS IN THE MARQUESAS

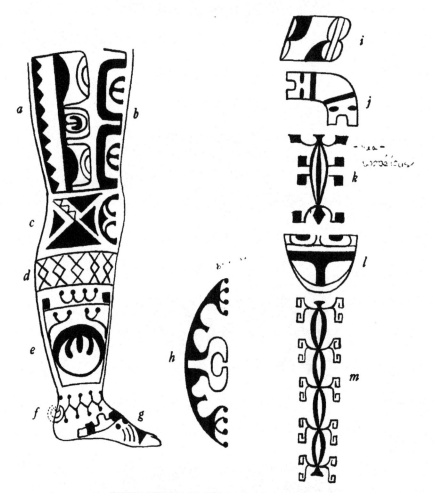

TATTOO DESIGNS IN THE MARQUESAS

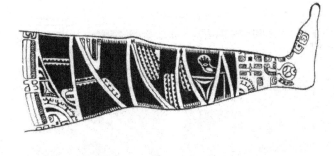

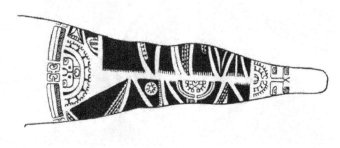

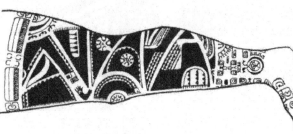

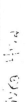

A

B

TATTOO DESIGNS IN THE MARQUESAS

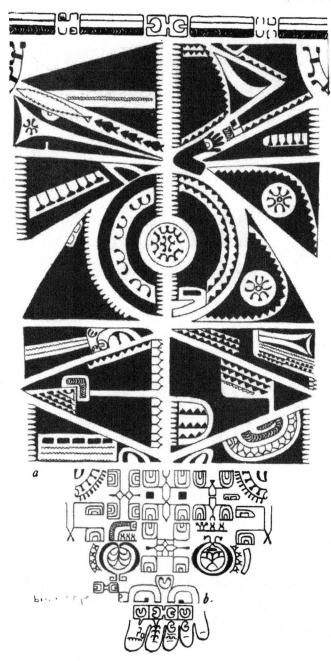

TATTOO DESIGNS IN THE MARQUESAS

A

B

C

TATTOO DESIGNS IN THE MARQUESAS

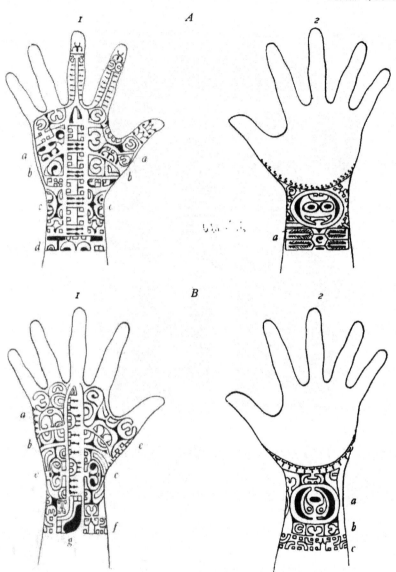

TATTOO DESIGNS IN THE MARQUESAS

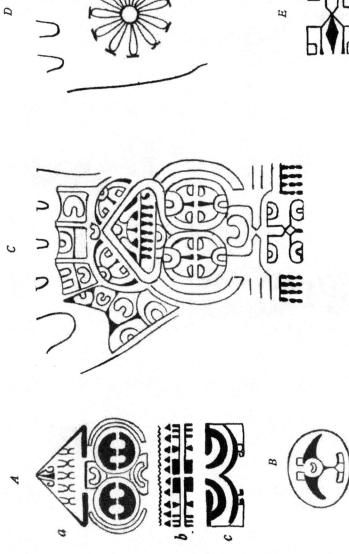

TATTOO DESIGNS IN THE MARQUESAS

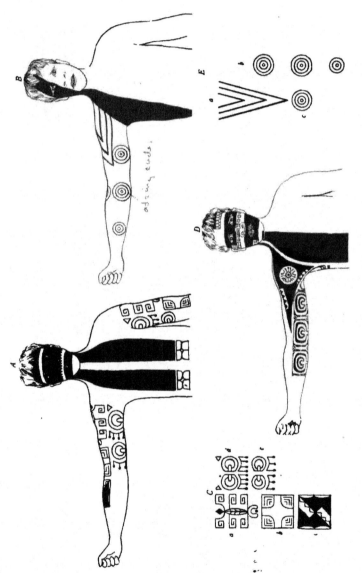

TATTOO DESIGNS IN THE MARQUESAS

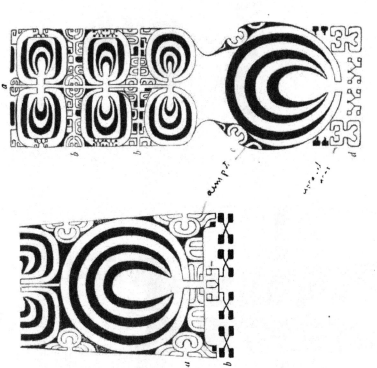

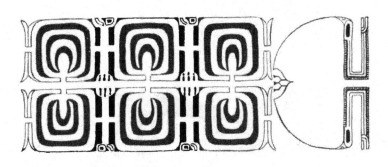

TATTOO DESIGNS IN THE MARQUESAS

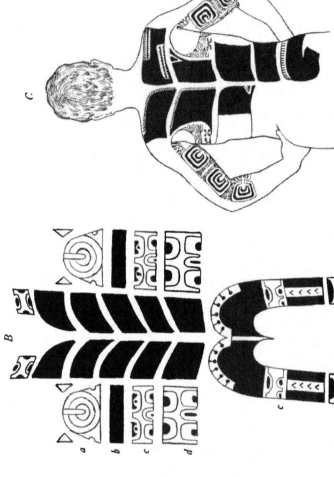

TATTOO DESIGNS IN THE MARQUESAS

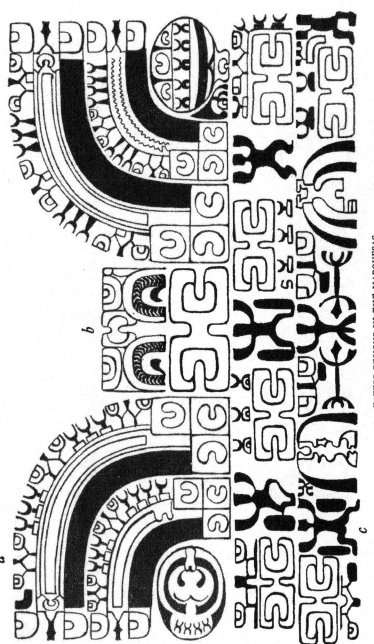

TATTOO DESIGNS IN THE MARQUESAS

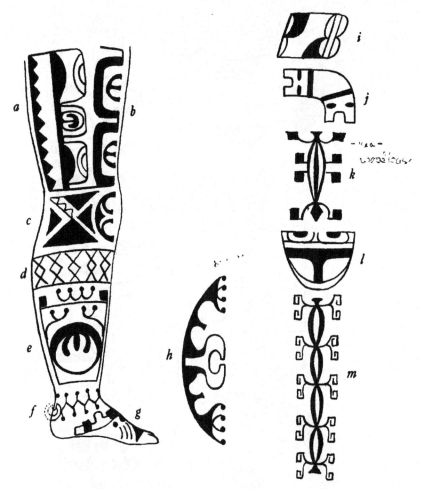

TATTOO DESIGNS IN THE MARQUESAS

B

A

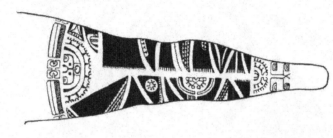

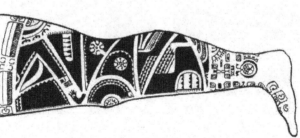

TATTOO DESIGNS IN THE MARQUESAS

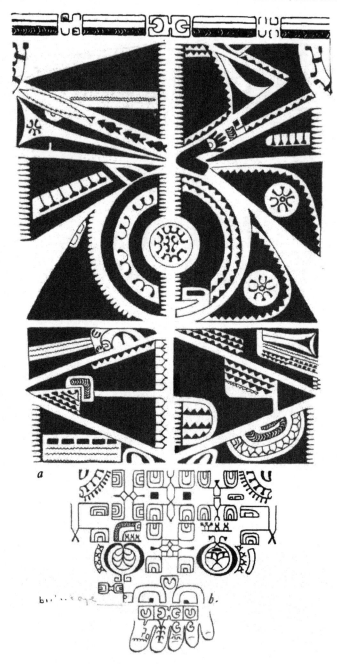

TATTOO DESIGNS IN THE MARQUESAS

BULLETIN 1, PLATE XIX

A

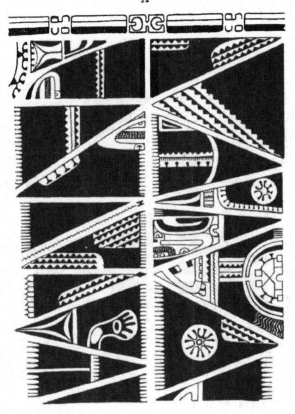

B

C

TATTOO DESIGNS IN THE MARQUESAS

A

B

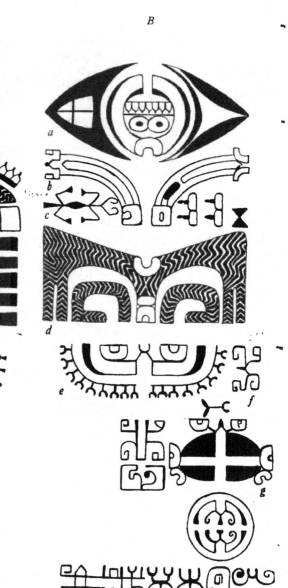

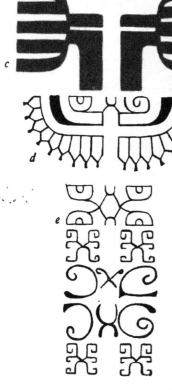

TATTOO DESIGNS IN THE MARQUESAS

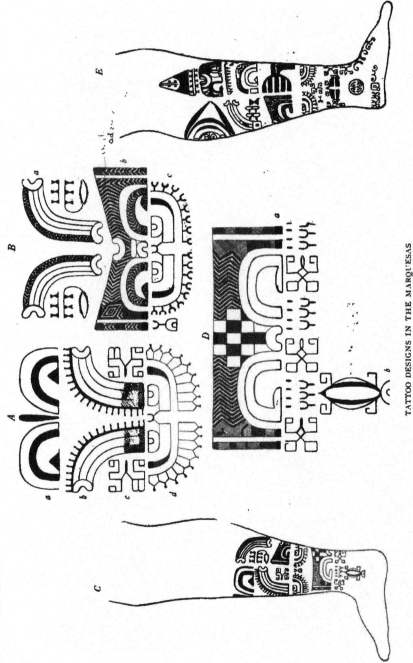

TATTOO DESIGNS IN THE MARQUESAS

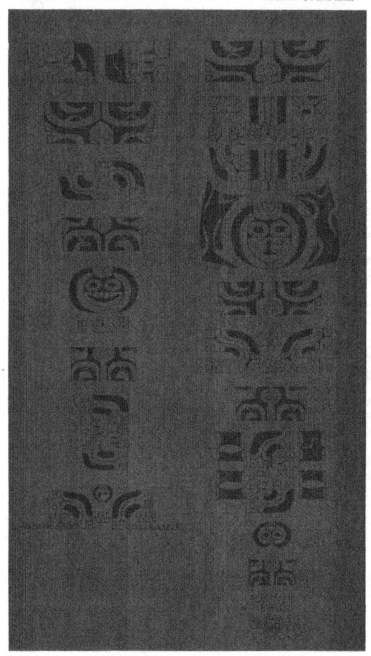

TATTOO DESIGNS IN THE MARQUESAS

A

B

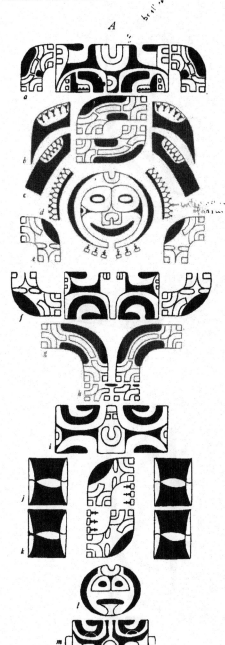

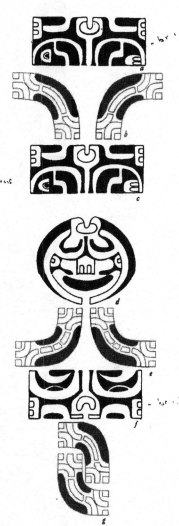

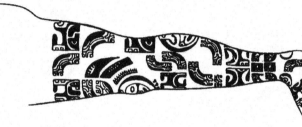

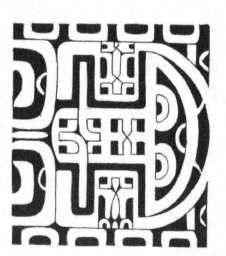

A

B

C

TATTOO DESIGNS IN THE MARQUESAS

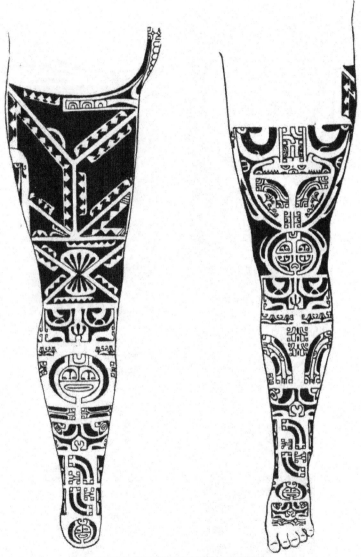

TATTOO DESIGNS IN THE MARQUESAS

A

B

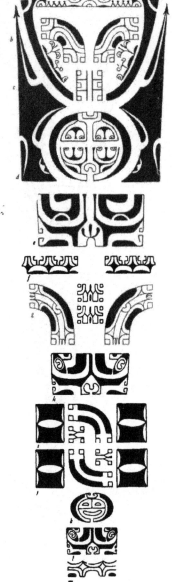

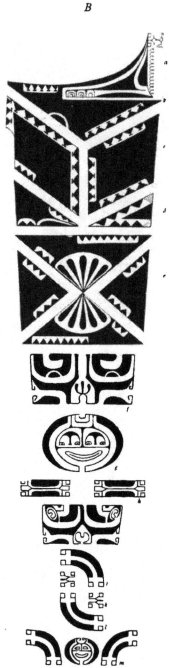

B

A

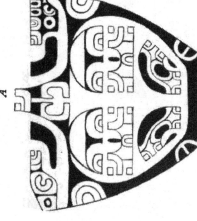

C

E

F.

D

TATTOO DESIGNS IN THE MARQUESAS

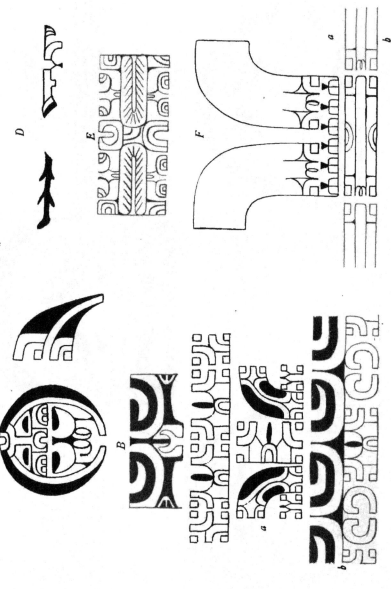

TATTOO DESIGNS IN THE MARQUESAS

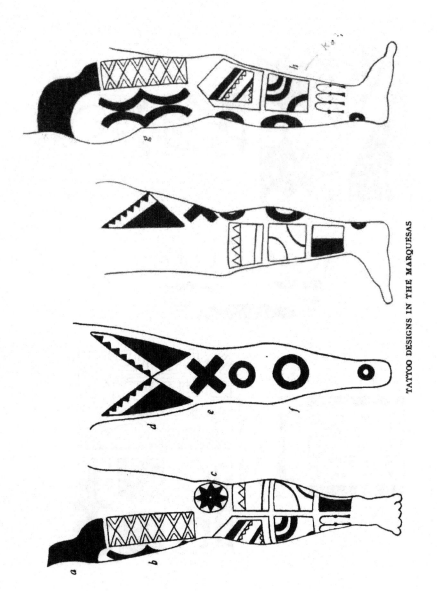

TATTOO DESIGNS IN THE MARQUESAS

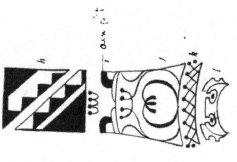

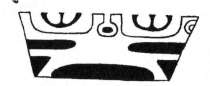

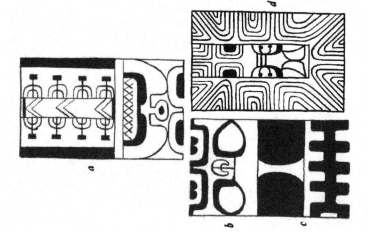

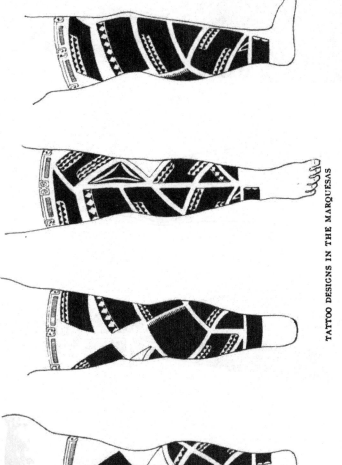

TATTOO DESIGNS IN THE MARQUESAS

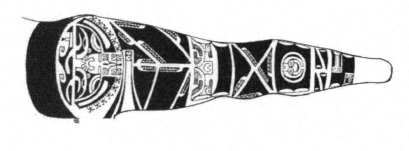

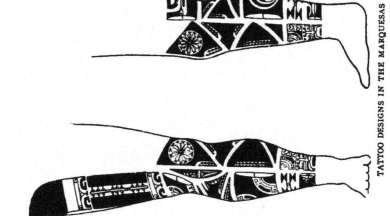

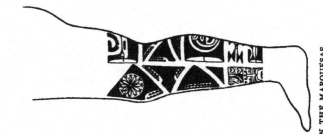

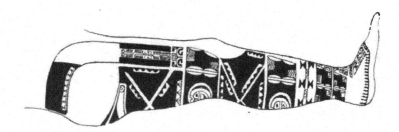

TATTOO DESIGNS IN THE MARQUESAS

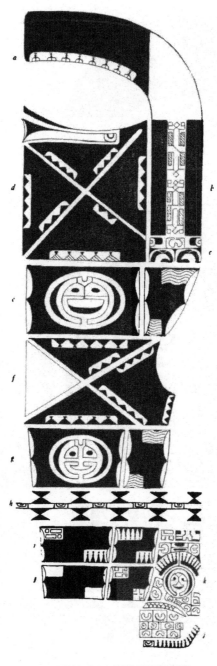

TATTOO DESIGNS IN THE MARQUESAS

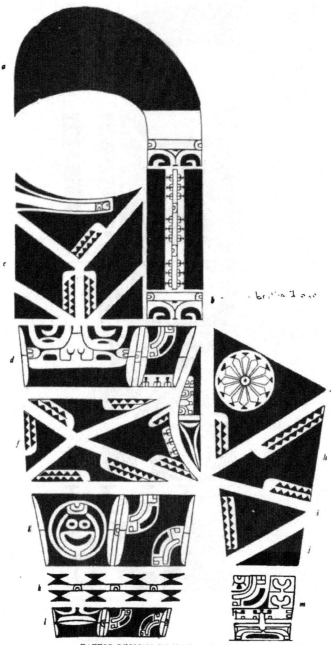

TATTOO DESIGNS IN THE MARQUESAS

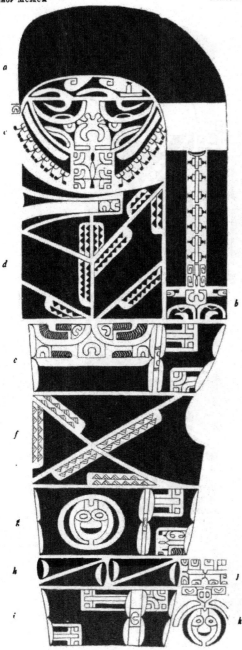

TATTOO DESIGNS IN THE MARQUESAS

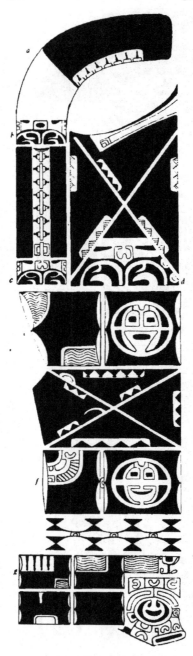

TATTOO DESIGNS IN THE MARQUESAS

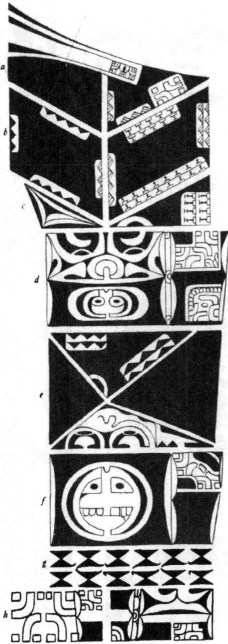

TATTOO DESIGNS IN THE MARQUESAS

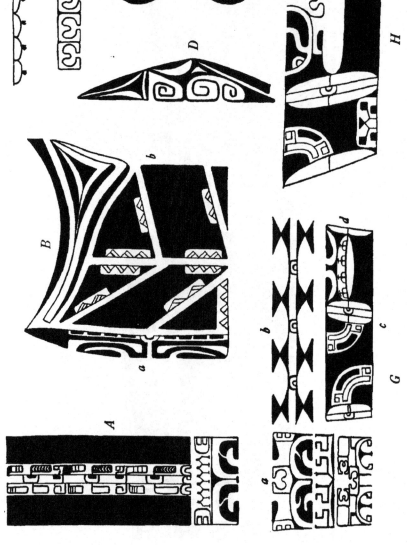

TATTOO DESIGNS IN THE MARQUESAS

LY REFERENCES TO HAWAIIAN ENTOMOLOGY

BY
J. F. ILLINGWORTH

BERNICE P. BISHOP MUSEUM
BULLETIN 2

HONOLULU, HAWAII
PUBLISHED BY THE MUSEUM
1923

Early References To Hawaiian Entomology

By J. F. ILLINGWORTH

INTRODUCTION

While examining the narratives of the early voyages of the Pacific, I came across several entomological references so interesting that I decided to extend the search and present the results in a form more readily available to workers in this field.

As the investigation proceeded, references multiplied so rapidly that I decided to call a halt with the year 1900, as the numerous papers appearing since that time are fairly well known.

In preparing the bibliography an effort has been made to examine all available printed matter dealing directly or indirectly with Hawaii, but it is not unlikely that some references have been overlooked, especially in the earlier writings of the missionaries.

It is a pleasure to acknowledge the assistance received—particularly in regard to the more recent publications—from the published bibliography by D. L. Van Dine (224)[1] and from the card catalogues that have been gradually built up in Hawaiian institutions.

The subject of the distribution of organisms, especially in the Pacific, has a most important bearing upon our life here in the Hawaiian islands. Among insects, practically all of our pests have gradually arrived along the lines of commerce; and even now, with our strict quarantine system, new ones continue to gain an entrance every year.

Hence, such a review of the literature is especially interesting and valuable, because it aids in determining the time of introduction and also the distribution of the various organisms found in Hawaii.

DISCUSSION OF THE LITERATURE

In reviewing the written history of these islands, I naturally began with the account of the voyages of Captain Cook (2), who discovered the Hawaiian islands in 1778. Diligent search failed to locate any reference to insects, although dogs, hogs, rats, and birds are mentioned. However, in a separate narrative, William Ellis, the assistant surgeon of this voyage of 1778, indicates clearly that at least house flies were troublesome. In describing the natives, Ellis says (1, Vol. II, p. 156),

They have also a kind of fly-flap, made of a bunch of feathers fixed to the end of a thin piece of smooth and polished wood; they are generally made of the

[1]The references in parentheses refer to works listed in the bibliography on pages 19 to 50.

tail feathers of the cock but the better sort of people have them of the tropick birds' feathers, or those belonging to a black and yellow bird called Mo-ho. The handle is very frequently made of the bones of the arm or leg of those whom they have killed in battle, curiously inlaid with tortoise-shell; these they deem very valuable and will not part with them under great price. This ornament is common to superiors of both sexes.

Later, Captain Nathaniel Portlock referred to these brushes (4, p. 88) when describing the supplies purchased from the natives:

Curiosities, too, found their way to market and I purchased two very curious fly-flaps, the upper part composed of very beautiful variegated feathers; the handles were human bone, inlaid with tortoise-shell in the neatest manner which gave them the appearance of fineered (veneered) work.

Captain George Dixon, who was associated with Portlock refers to these objects (3, p. 272) as follows:

Fans and fly-flaps are used by both sexes . . . The fly-flaps are very curious; the handles are decorated with alternate pieces of wood and bone which at a distance has the appearance of fineered work; the upper part or flap is the feathers of the man-of-war bird.

Vancouver, also, mentions fly-flaps (6, Vol. III, p. 42) for the dispersal of offending insects; but makes no further references to entomology.

Apparently, the first entomological work in Hawaii was done by Doctor Johann Friedrich Eschscholtz, who at the age of 22, in the capacity of physician and naturalist, accompanied the Russian explorer Otto von Kotzebue on his first voyage. This brilliant student, upon his return to his native country was appointed professor of anatomy and afterwards director of the zoological museum of the university at the University of Dorpat, his native city. Kotzebue himself, though only an intelligent sailor, makes several interesting allusions (7, Vol. I, p. 306) to the fauna of the group:

"The chief employment of the royal ladies consists in smoking tobacco, combing their hair, driving away the flies with a fan and eating." Speaking of the king's daughter (7, Vol. I, p. 307), he says: "Behind her stood a little negro boy, holding a silk umbrella over her head to protect her from the rays of the sun; two other boys with tufts of red feathers, drove away the flies from her." And in describing how the sailors were entertained at dinner ashore, Kotzebue (7, Vol. I, p. 311) relates: "Each of them had, like us, a kanaka standing behind him with a tuft of red feathers to drive away the flies." Finally he speaks more directly of the fauna (7, Vol. III, p. 237), "The only original wild quadrupeds of the Sandwich Islands are a small bat and the rat. To these is added our common mouse, besides the flea, some species of Blatta and other noxious parasites."

In the appendix of the third volume of the narrative of Kotzebue's voyage (7, p. 376) is the description by Eschscholtz of our native Hawaiian butterfly, *Vanessa tameamea* and descriptions of all the new butterflies collected in the various countries visited. The other orders of in-

sects, taken during the voyage, were described later in separate papers, of which the most important are his "Entomographien" (8).

A missionary, James Montgomery, states that the boat used by his party swarmed with cockroaches at the time of its arrival in Hawaii (1822) (15, Vol. I, p. 365). In describing a gathering at a mission service, he says (15, Vol. I, p. 417), " . . . members of the royal family had servants in attendance with fly-flaps and fans of peacock's feathers to cool their faces and drive away the troublesome insects." He says also (15, Vol. I, p. 434):

There are no mosquitoes here; neither are there any bugs. When the latter are brought on shore in bedding or packages from shipboard, they presently die; the climate of the Society Islands is equally fatal to them. Flies are very numerous and annoying, . . . The few spiders, moths and dragon flies which we have seen, much resemble those of the South Sea Islands.

In referring to the table manners of the natives, Montgomery (Vol. I, p. 472) writes:

When a common fly was found drowned in their messes, they seemed at once to grow sick and turn away their faces with no equivocal expression of utter loathing. Flies, indeed, may be said to be an abomination with these savages—probably from some superstitious prejudice, for vermin far more disgusting are greedily picked by them from their own bodies—nay, from the very dogs—and devoured.

Gilbert F. Mathison, an English traveler, also remarked upon the troublesome house flies. In speaking of the chiefs in their home life (9, p. 365), he says he found "some asleep, some fanning away the flies . . . " He further states that the queen at the mission service "was attended by several female servants, carrying fly-fans" (9, p. 378). When dining with the natives, he notes (9, p. 401), "One brushed away the flies . . ."

C. S. Stewart, a London missionary who spent several years in the islands, also made reference (11, p. 153) to these annoying insects, describing the natives as "eating *poe* surrounded by swarms of flies . . ." Further, in referring to the unsanitary conditions and skin diseases of the people, he remarked the prevalence of head-lice, saying:

Dozens may, at any time, be seen sporting among the decorated locks of ignoble heads; while, not infrequently, a privileged few wend their way through the garlands of princes of the blood, or triumphantly mount the coronets of majesty itself.
As to the servants of the chiefs and the common people, we think ourselves fortunate indeed, if, after a call of a few minutes, we do not find living testimonies of their visit, on our mats and floors, and even on our clothes and persons! The bare relation of the fact, without the experience of it, is sufficiently shocking. But the half is not told; and, I scarce dare let the truth, here, run to its climax. The lower classes not only suffer their heads and tapas to harbour these vermin; but they openly and unblushingly *eat them!* Yet so fastidious are they in point of cleanliness, than an emetic could scarce be more efficaciously administered than to cause them to eat from a dish in which a fly had been drowned! So much for the force of custom, and the power of habit!

In 1824, Kotzebue made a second voyage to the Hawaiian islands and was accompanied, as before, by the naturalist, Professor Eschscholtz. Again this navigator remarked on the house flies, which were evidently abundant. He states, "Two young girls lightly dressed, sat cross-legged by the side of the queen, flapping away the flies with bunches of feathers," and that the queen ate, "Whilst two boys flapped away the flies with large bunches of feathers" (13, Vol. II, p. 207).

In the appendix of this second volume, Eschscholtz (13, Vol. II, p. 357) alludes to the entomological material collected in the Hawaiian islands:

The number of insects is small, as is indeed the case with all land animals; it is therefore creditable to our industry, that we were able to muster twenty sorts of beetles. A small *Platynus* is the only Carabide; in the water, two *Colymbetes* and a *Hydrophilus* were found. The only *Elater* belongs to a species *(Agrypnus N)* in which we reckon various specimens found only in the old world, such as *Elater tormentosus, fuscipes, senegalensis,* etc.; beetles which have two deep furrows in the lower part of the neck-shield, to receive the feelers, and which go in search of their food at night. They resemble many of the European springing beetles covered with scales and included by Megerle under the name Lepidotus; such are *fasciatus, murimus, varius.* Two Aphodii were found; one of the size of the *Psammodius porcalus,* but very flat, lives under the bark of a decayed tree, the wood of which has become soft. Another has the almost prickly shoulders of the *Aphodius stercorator* and *asper;* of these we form the species *stenocnemis* and include therein four new varieties found in Brazil and Luzon. It may be here observed that *Psammodius sabuleti* and *cylindricus* N, must be classed with *Aegialia* which, on account of the horny nature of the jaws, and the projection of the upper lip, enter into the same class with the *Trox;* the remaining kinds of *Psammodius,* however, do not at all agree with the character given them by Gyllenhal, and ought in their turn to be classed with Aphodius. Among the remaining beetles, all of which dwell under the bark of trees, a *Parandra* was the largest.

A few remarks on the various beetles mentioned by Eschscholtz will not be out of place here. The carabid, *platynus,* is probably one of the numerous small native Hawaiian species of Anchomenus. The two Colymbetes are undoubtedly our *Coplatus parvulus* (Esch.) and *Rhantus pacificus* (Esch.); possibly both introduced very early. The hydrophylid was later described by Eschschlotz as *Hydrophilus semicylindricus,* though it is now placed in the genus Hydrobius. Blackburn considered it an immigrant. The elatrid, *Agrypnus N.,* is undoubtedly the *Agrypnus modestus,* MacL., which is now placed in the genus Adelocera. This species is said to be widely distributed in Polynesia and elsewhere. I have had more difficulty in trying to place the two Aphodii mentioned. It is hard to say what the flattened species is; but the one with the "almost prickly shoulders" is probably *Ataenius stercorator* Fab. This widely distributed species, Blackburn states, is not rare in the neighborhood of Honolulu, yet no specimens of it are in the Hawaiian collections.

Finally, the cerambycid, Parandra, is undoubtedly *Parandra puncticeps* Sharp, which Blackburn and Sharp (120) state is closely allied to a species occurring in the Philippine Islands.

Lord Byron, though on a mission of mercy to the Hawaiian Government, spent some time during 1825 in exploration. In his narrative there are a few interesting references to the fauna and flora of the Hawaiian group. Andrew Bloxam, an enthusiastic student just out of Oxford, was naturalist on the voyage and though a botanist by preference, he collected many zoological specimens during the eighteen months spent in Hawaii. This material was deposited in the British Museum. Probably based on information supplied by Bloxam, Lord Byron (10, p. 252) states:

We met with only one Papilio, which Kotzebue has described under the name *Vanessa tamehameha* (tameamea). We caught one sphinx moth; brown, with a purple stripe on each side of its body, which glitters in the sun. There are several minute moths, several varieties of Libellula (dragon-flies), one species of Cicada, a black earwig, a wood spider and innumerable fleas.

It would be interesting to know what the cicada mentioned is, also the sphinx; no moth answering that description is in the Hawaiian collections.

Captain F. W. Beechey (14), an English explorer, who visited Hawaii in 1826 and 1827, apparently made no reference to the insect fauna, though his remarks (14, Vol. II, pp. 100 and 112) on the first export of a cargo of sugar to California are of interest, considering the prominence which the sugar industry has now attained.

In the Reminiscences of Rev. Sereno Edward Bishop I found two interesting references. Describing the customs of the chief, Bishop says: (16, p. 30):

Objects much in evidence among the natives, when visiting or at meetings as well as in their homes were their fans, and their fly brushes or kahilis. The fans were made from the ends of young coconut leaves. The broad end being elastic, threw the air far more efficiently than the stiff fans now commonly braided. Get an old-fashioned native fan for comfortable use. Small fly-brushes were used by all the people. They were about four feet long, the upper half of the stick having the tail feathers of fowls tied on. The kahilis of the chiefs were larger and more elaborate. The long handles were often beautifully encased with tubes and rings of human bone and whale-tooth, also turtle shell, all finely polished. A high-chief always had two or more attendants armed with such fly-brushes.

In discussing (p. 37) the destruction of the trees of the islands, Bishop remarks;

About 1860, a minute insect called "red spider" came to infest the under-side of the leaves to such an extent as in the course of a year to destroy every kou tree, not only in Lahaina, but throughout the group. The timber of the dead trees was cut and used for furniture, much being sent to Germany. The chief's great calabash bowls of kou are now rare and choice. Young trees of the species exist here and there. The trees have always succumbed to the insect pest before attaining any considerable size.

"Moolele Hawaii," written about 1832 by David Malo, a native, has interesting references (17, p. 65). Malo says:

The following are the flying things (birds, *manu*) that are not eatable: The *o-pea pea* or bat, the *pinao* or dragon-fly, the *okai*, (a butterfly), the *lepe-lepe-ahina* (a moth or butterfly), the *pu-lele hua* (a butterfly), the *nalo*, or common house-fly,

the *nalopaka* or wasp. None of these creatures are fit to be eaten. The *uhini* or grasshopper, however, is used as food.

The following are wild creeping things; the mouse or rat, (*iole*), the *makaula* (a species of dark lizard), the *elelu*, or cockroach, the *poki-poki* (sow-bug), the *koe* (earthworm), the *lo* (a species of long black bug with sharp claws) the *aha* or ear-wig, the *puna-wele-wele* or spider, the *lalana* (a species of spider), the *nuhe* or caterpillar, the *poko* (a species of worm or caterpillar), the *nao-nao* or ant, the *mu* (a brown-black bug or beetle that bores into wood), the *kua-paa* (a worm that eats vegetables), the *uku-poo* or head-louse, the *uku-kapa* or body louse.

Whence comes these little creatures? From the soil no doubt, but who knows?

Speaking of the animals imported from foreign lands during the time of Kamehameha I and as late as the time of Kamehameha III, Malo (17, p. 66), after enumerating those valuable for food continues:

There are also some flying things that are not good for food: such as the mosquito (*makika*), the small roach (*elelu liilii*), the large flat cockroach (*elelu-papa*), the flea (*ukulele*, jumping louse). The following are things that crawl: the rabbit, or *iole-lapaki*, which makes excellent food, the rat or *iole- nui*, the mouse or *iole-liilii*, the centipede (*kanapi*) the *moo-niho-awa* (probably the scorpion for there are no serpents in Hawaii). These things are late importations; the number of such things will doubtless increase in the future.

This prophecy has been abundantly fulfilled, for even now with our efficient quarantine, new organisms frequently gain entrance.

F. D. Bennet, an English naturalist, who came to the Pacific primarily to investigate the anatomy and habits of the whales of the Southern Pacific and to collect natural history material, discusses the insect fauna of Hawaii (24, p. 252) as follows:

Insects are not more numerous here than at the Society Islands; they present, also, nearly the same genera, and are equally remarkable for the apparent addition of many exotic kinds to those few which were found on the soil by our navigators when this archipelago was first discovered. Together with some smaller butter-flies, we find at Oahu a *Venessa*, closely resembling the *V. atalanta* of Europe; as well as a second species, differing in no appreciable respect from *V. cardui;* and as the habitat of the latter insect is the thistle in the northern parts of the globe, so here the analogous species resorts to the prickly foliage of the *Argemone Mexi-cana*. A hawk-moth, (*Sphinx pungens*) similar to that inhabiting the Society Islands, is very common on the pastures in the vicinity of the coast. Its larva is large, of a green colour with longitudinal and oblique lilac bands on the sides, and has the characteristic horn on the back. The habits of the perfect insect are similar to those of the humming bird, hawk-moth, *Sphinx macroglossum*. It flies by day, and appears to seek the warmth and brightness of the noontide sun; and flitting from flower to flower, on which it seldom alights, it drains the nectar from the blossoms with its proboscis as it floats in the air with a rapid, vibratory motion of the wings. On one occasion, when I was endeavouring to capture this coqueting insect, a native came to my assistance and undertook the task in his own way: gathering two of the elegant blue convolvulus flowers around which the moth had been fluttering, and holding one in each hand in an inviting position, he cautiously approached or followed the insect to tempt it within his reach. The active but stealthy movements of the young and scantily-clad islander, as he pursued his shy game over the plains; the seducing attitudes he assumed, and the insinuating manner in which he presented the flowers to the moth when opportunities offered, afforded a very ludicrous scene. Although the exertions of my entomological friend were at this time fruitless, I have often seen the plan he adopted successfully employed by other natives; the hawk-moth, approaching the proffered blossoms, protrudes its long proboscis, which is seized with the fingers and the creature secured.

The insects we noticed here, though not at any of the other Polynesian Islands we visited, were large tarantula spiders, (*Lycosa Sp.*) the millipede or wood-louse, (*Oniscus asellus*) and centipedes, eight or ten inches long, their colour brown-yellow, the sides and abdomen blue. The luminous centipede (*Scolopendra electrica*) is also found in the houses at Honoruru, emitting its characteristic phosphorescent light, and leaving behind it a trail of luminous matter.

In a footnote Bennet gives this additional information:

Ships are, doubtless, the active, though involuntary agents in disseminating insects over remote regions of the globe. After we had been at sea for several weeks, or even months, it was not uncommon to find on board the Tuscan many kinds of land-insects in a living state, from the hardy beetle to the delicate and more ephemeral butterfly, whose germs had probably been received on board together with supplies of fruit and vegetables.

The statement quoted from Bennet is one of the earliest definite references that I have been able to find bearing upon the introduction of the cosmopolitan butterfly, *Vanessa cardui Linn.*, other than the unverified report of four specimens sent to the British Museum, two collected by Captain Byron in 1825 and two by Captain Beechey in 1827. (See Bibliography Nos. 27 and 65.)

Dr. Alonzo Chapin, a resident missionary, in writing on the diseases of the Hawaiian islands in 1838, remarks (22, p. 253) upon the absence of malaria as follows:

Before going out to the Sandwich Islands, I spent several years in our southern states, much of the time in the low country of South Carolina; and was, during the hot seasons of the year, accustomed to recoil at every standing body of water, on account of the poisonous exhaltions which they there emit, endangering the lives of every individual exposed to their influence. On my arrival at the islands, I more than once made the inquiry, "why the numerous kalo (taro) ponds are not productive of sickness." Thousands of acres are entirely converted into ponds of standing water in which the natives cultivate their kalo, while their houses are built on the narrow spaces between. These are never dry, and are often so numerous as to exhaust entire rivers in keeping them filled. I could not at once reconcile my mind to the belief of their innoxious tendency, notwithstanding circumstances are such as to make the fact very obvious. Though the ponds are subject to the perpetual influence of a torrid sun, they cannot become putrid by reason of the continual supply of fresh water, and multitudes of fish live and thrive in them, such is their freshness and purity.

The streams originate from springs and rain on the summits of the mountains, pour down their sides with great impetuosity and after a few meanderings are turned aside from their courses to irrigate the lands and replenish the ponds, or are discharged directly into the sea; and I know of no body of water emitting sufficient miasma to create sickness along its borders. I have occasionally met with stagnant ponds, which emit a foul and offensive odour, and could in no way satisfy myself of the reason for the exemption of the inhabitants along their borders from fevers, but by supposing the effluvia to be diluted and rendered inert by the continual currents of winds.

Small marshes abound but are fed by springs, and the pure mountain streams, and are thus prevented becoming noxious. They speedily dry up during a few weeks absence of rain; and the rivers also disappear unless kept alive by frequent showers, and the small pools, which remain at such times and which abound after every rainy season, do not become sufficiently putrid to exhale a *fever-generating* miasm.

If any one variety of *soil* has a specific power to produce malaria it does not appear to exist at those islands. The upland soil is there formed of decomposed lava, the lowland plains along the sea are constituted of a mixture of alluvion washed from the mountains, and decomposed coral. Its immunity from noxious exhalations is the same, whether parched with drought, or merely moist, as when the evaporation is most abundant, after the rains.

The habitations of the natives are for the most part considerably scattered, but are in a few instances crowded together in such numbers as to exhibit the dense appearance of our large towns and villages. There is, however, throughout, an entire exemption from those pestiferous exhalations which, so extensively, poison the atmosphere of populous places in hot climates. All animal and vegetable substances thrown away by the people, or cast up by the sea, are quickly devoured by the multitudes of starving dogs and swine, so that no detriment is experienced from their putrefaction.

With so entire an exemption from the existence of miasmata, there is also an entire exemption from those affections induced by it. Malignant bilious fevers do not occur, and as I shall, hereafter, have occasion more particularly to state, derangements of the liver and biliary organs do not prevail, neither is the stomach and intestinal canal, and other organs of the abdominal viscera subject to the numerous and complicated affections so common in every miasmatic region.

It should be borne in mind, however, that Chapin wrote before the relation of mosquitoes to malaria was known, and that probably these insects had not become generally distributed in Hawaii at that date.

Jarves' notes (23, p. 70) on the beginning of the silk industry in Hawaii are also of interest:

In 1836 Messrs. Ladd & Co. leased a portion of their land to Messrs. Peck and Titcomb, for the purpose of cultivating the mulberry and raising silk. They have now upwards of forty thousand trees, which at nine months growth, are as thrifty and forward as those of several years, in New England. As yet they have been disappointed in obtaining the silk worm, but are daily expecting a supply of eggs from China.

The following (23, p. 75) gives some indications of the proportions of the new industry:

At Mouna Silika, the mulberry-plantation, 85,200 of the black mulberry (*Morus multicaulis*) have been planted, and the ground and slips prepared for many more. Many thousands of the white mulberry (*Morus alba*) have also been set out. The average age of 42,000 of the former is six months, and it is computed that they will afford thirty and a half tons of leaves, sufficient to feed 1,200,000 worms. The leaves of one tree of eight months growth, weighed three and a half pounds, and a leaf of three months growth measured seven inches in length. The trees that were plucked, leaved out again in six weeks so fully, that they could not be distinguished from those in the same row which were left unplucked. They are planted in hedge rows, ten feet apart, and two feet separate in the row. The silkworm of the white species, which produces the finest silk, has been received from China, but the proprietors do not intend to raise them in numbers until the plantation is thoroughly stocked with trees, and the necessary arrangements for buildings, machinery, reeling, etc., be made in the United States, which one of the proprietors, Mr. Peck, is upon the point of visiting, for that purpose. If the natives can be taught the art of reeling silk, this branch of industry will be of infinite benefit to them, as the raising of cocoons is attended with so little expense and trouble. Women and children are particularly adapted to it, as well as old and infirm persons. Thus it will afford occupation to many who are incapacitated from entering into any laborious trade. The amount of land in the plantation is between three and four hundred acres, undulating partly wooded, and well watered.

These citations by James J. Jarves, who came here from Boston in search of health in 1837, are only a prelude to his later writing on Hawaii. In his history (25, p. 10) discussing the fauna, Jarves writes:

Insects are few, though mostly of a destructive or troublesome character. A species of caterpillar at certain seasons destroys vegetation to a great extent, eating even the grass to its very roots. A slug deposits its eggs in the cotton blossoms, which, when ripe, are pierced through by the young insects, and the staple entirely destroyed. Large spiders are very numerous and mischievous weaving strong webs upon shrubs and young trees, in such quantities as to check their growth, and even impede the passage through an orchard. A species of woodlouse fastens upon the limbs, entirely covering them, and which speedily exhausts the juices; and their growth is for the time effectually checked. A black rust, firm, hard, and stiff, like strong paper, resembling soot in its appearance, attacks many varieties of trees and plants, covering the bark, and even the leaves, giving them the singular appearance of being clothed in mourning. This causes no permanent damage, and while it disfigures fruit, does not appear seriously to injure it. Rats damage the sugar-cane to a considerable extent, annually. Though the Hawaiian agriculturist escapes many of the evils incidental to other tropical climes, enough exist here to make his labours no sinecure. The noxious vermin, such as mosquitoes, fleas, cockroaches, scorpions, and centipedes, are a modern importation, and have extensively increased. The bite of the two latter causes no permanent injury, and is not more injurious than the sting of a common wasp. They are very abundant about the seaports. No serpents, frogs, or toads, have as yet reached the islands. A small lizard is common.

Later, in his Scenes and Scenery in the Hawaiian Islands, Jarves refers to the extensive silk industry and the many difficulties that beset it. (See 28, pp. 105-112 and 164-9.)

The United States Exploring Expedition being principally a marine investigation, hardly touched upon the land fauna of Hawaii, yet I found two valuable references in the Races of Man by the naturalist, Charles Pickering. Discussing animals and plants of aboriginal introduction (26, p. 314) he says:

There are, however, uninvited attendants on human migrations; such as, a small species of rat, whose presence throughout Tropical Polynesia, seems nearly universal. On some of the more remote coral islets, the presence of this animal, proved to be the only remaining evidence of the visits of man.

On the other hand, the house fly, which so abounds at certain coral islands, was uniformly absent from the uninhabited ones. Various other insects, have doubtless been transferred from island to island by human means.

This, too, was probably the case with the lizards (Scincidae); for the agency of drift-wood, seems insufficient to account for their universal presence.

In referring to animals and plants of European introduction, Pickering (26, p. 333) writes:

We were informed at the Hawaiian Islands, that the centipede, was "introduced five years previously from Mazatlan." It has greatly multiplied at Honolulu; and during our visit, it made its first appearance on Maui.

The house scorpion, likewise abounds at Honolulu; and its introduction was equally attributed to vessels from Mazatlan. The other Polynesian groups, remain free from the above two pests.

The natives of the Hawaiian Islands, attributed the introduction of the mosquito to the same quarter; and we obtained evidence of the possibility of such an occurence, in the larva continuing on shipboard for many days after we left Honolulu. One or more native species of mosquito, were observed at the other Polynesian groups.

It will be noted that these observations coincide with those of all the earlier navigators, that flies were evidently a native introduction previous to the appearance of European ships. That the house fly, *Musca domestica* Linn., will travel long distances by small boats is now a matter of common observation. Moreover, on this point there is the conclusive evidence by S. C. Ball (225), who recently investigated the migration of insects over sea, along the coast of Florida.

Since the natives in their wanderings in the Pacific previous to the appearance of white men, evidently took along their hogs and dogs, together with coconuts and other plants, it is only natural to conclude that flies also traveled from place to place with them.

That flies very early made their appearance in the Hawaiian islands, is further indicated by the great development of the kahilis or fly flaps. Dr. Brigham amplifies this point in his comprehensive review of Hawaiian feather work (193, p. 14), in which he says:

It is probable that a bunch of feathers used as a fly-flap was the primal form of feather work. Flies (*nalo*) were here though not in such abundance as found by early explorers on other islands of the Pacific; but even for this useful purpose the bunch of feathers was no doubt preceded by a bunch of leaves, and the prototype of the kahili seems to have been a stem of that most useful plant the *ki* (*Cordyline terminalis* Kunth). On many of the islands of the Pacific, a branch of *ki* was the symbol of peace and on the Hawaiian islands it shared in early times with a coconut leaf the representation of high rank
Very early the hand plumes became symbols of rank and on all public occasions kahili bearers attended a chief, or while he ate or slept a *kaakui* brushed away with small ones all troublesome insects. In public they were tokens; in private fly-flaps.

Indeed, it is hardly necessary to draw upon the imagination to understand the gradual development of the immense, symbolic kahilis with shafts of twenty feet or more in length, used at funerals of royalty; especially when it is known that small fly-flaps of similar construction have always been waved over the body at funerals in Hawaii to keep away these obnoxious insects.

In describing the Hawaiian fauna in 1850, Henry T. Cheever (33, pp. 105-6) says:

Not a noxious beast, reptile, or insect existed on the islands when first made known to Europeans. Now they have mosquitoes, fleas, centipedes, and scorpions.
The snake, toad, bee, and all stinging insects of the latter sort are still unknown. One would think the flea certainly indigenous, where now it is found so much at home both with man and beast; but the natives have an amusing story of the first time they got ashore from a ship, through the trick of a sailor, which is better to be imagined than told.
Whether that be true or not, the name by which they call the flea is pretty convincing evidence that it has not been known as long as some other things. It is called *uku lele,* or the jumping louse, the *uku* being an old settler from time immemorial, and nothing else they knew so much like the imported flea. So they named the stranger the jumping *uku*: it is one of the first aboriginals

a traveler becomes acquainted with in going about among Hawaiians and sleep-
ing in native houses, and it is the last he is so glad to bid good-by to when he
comes away, though it is ten chances to one if they do not insist upon keeping
him company and making themselves familiar half the voyage home.

The Royal Hawaiian Agricultural Society organized in 1850 did splen-
did work for several years. In the Transactions of this society I found a
number of references to entomology. William Duncan (36) suggested
good cultivation and clean culture for the eradication of insects and urged
that land adjoining sugar plantations be either kept fallow or burned to
keep away caterpillars.

Dr. Wesley Newcomb also contributed to the Transactions (37) an
interesting paper in which (p. 95) he states that *Vanessa cardui* was intro-
duced presumably at the same time as *Argemone mexicana* (poppy or
thistle) though he does not suggest the date. Among other insects, he
mentions three species of Sphynx, one of them, *S. pugnans,* being common
at Honolulu. Of the small moths he recognized seven species as enemies
of agriculture and gives the larval characters of the principal cut-worms.
The corn leaf-hopper, or corn-fly, he records as a serious pest at that time.
He mentions also the red spider as destructive to the leaves of many plants
and a microscopic white fly (from his description difficult to determine)
destructive to the leaves of melons. Mention, too, is made of a small
caterpillar that bores into the stalks of tobacco—undoubtedly the tobacco
split worm, *Phthorimaea operculella* Z. a rather serious pest in more recent
years. The description of a wormlike borer of the sweet potato suggests
the larva of our common pest, the sweet potato weevil, *Cylas formicarius*
Fab. Newcomb states that he was not able to detect any true aphids, but
he recognizes that the numerous ants filling the soil play an important
part in the destruction of the larvae of pestiferous moths and of other
insects.

At meetings of the Society in 1851, the introduction of the common
honey bee was considered, and the next year it was reported (38) that
three hives were coming from New Zealand by the first vessel direct to
Honolulu. I could find no statement indicating that these ever arrived,
but the record (42) shows that two years later an attempt to import two
hives of bees from Boston proved unsuccessful because of the ravages of
the bee moth on the way. In 1855, a report was presented to the Society
upon the economic relation of insects to crops with suggestions for the
importation of natural enemies of these from abroad (45). The report
states that though wasps are abundant, bees have not yet been success-
fully introduced.

At a meeting in 1856 a very valuable paper was presented by the well-
known botanist, Dr. William Hillebrand (46). This paper written by
Valdemar Knudsen, deals primarily with the control of cutworms which

were evidently very numerous at that time. Descriptions (46, p. 96) are given of five kinds as follows:

 1st. Brown, with a white stripe on the back and white belly. It grows to the largest size, fully 2½ inches long and one-quarter inch thick. It is very voracious, and a single worm will strip a large plant, leaving nothing but the ribs.
 2nd. Gray, with a brown back of a bright, shining appearance; it does not grow as large as No. 1. It is the regular cutworm that seems to enjoy nothing but the juice of the stems, which it will often cut off when quite large and hard.
 3d. It is destructive as the former, and also like it in color and size, only not bright or shining on its back.
 4th. Is bluish-gray, with head and tail white—rather rare.
 5th. Mud-colored; is the one that appears every year, and seems able to do with less wet soil. It is not quite as voracious, nor does it attain the size of the former ones, but still is very destructive.

It is interesting to note that the cutworms were excessively abundant on land that had been flooded for a few days. This observation agrees with my experiences in North Queensland. The only explanation that I am able to suggest is that flooding in some way interferes with the natural enemies of these pests.

A great impulse was given to the investigation of the Pacific fauna by the coming of the Swedish Frigate "Eugenie" with a staff of trained investigators. These scientists arrived in Hawaii in August, 1852 and though their stay in the islands was short, they evidently improved the opportunity, for among the insects collected were about twenty new species, belonging to several orders. Unfortunately no record was made of their catches except of the new species. These records were worked up several years later—the Coleoptera by C. H. Boheman, the Orthoptera and Hemiptera by Carl Stal, the Lepidoptera by D. J. Wallengren, the Hymenoptera by A. E. Holmgren, and the Diptera by C. G. Thomson (49).

The coming of the energetic student, Rev. Thomas Blackburn, in 1877 marked a new epoch in the history of systematic entomology in Hawaii. Though his special hobby was Coleoptera, Blackburn collected all orders of insects and published papers on most of them (67). The extent of his scientific work during the six years of his stay is marvelous especially considering that it was all done at odd moments whenever his strenuous duties to the Church would permit. Indeed, so abundant were his catches that he kept almost a dozen specialists (principally in the British Museum) busy describing his material, in addition to all the descriptions that he himself prepared for the press. A glance at the bibliography (pp.) will give a suggestion of the extent of these labors. The following specialists assisted him in publishing his material: Bormans (105) handled the Orthoptera; McLachlan (110, 111, 138) helped with the Neuroptera including the Odonata; White (71, 81, 88, 100) did part of the Hemiptera; Butler (74, 90, 96, 106, 108), Meyrick (112, 122, 131) and Tuely (79, 80) all worked on the Lepidoptera; Sharp (75, 76, 77, 78, 85, 93, 99, 119,

120, 124) and Waterhouse (87), part of the Coleoptera; while Smith (86) and Cameron (97, 109, 125, 127) helped with the Hymenoptera.

In 1882 J. E. Chamberlin published an interesting paper dealing with the devastating hordes of cutworms, or army worms, on Oahu (104). The outbreak of this pest is said to have extended from the sandy beach to the mountains. The land over which the worms had fed appeared bare, as if scorched; cattle starved to death. Blackburn identified the species as *Prodenia ingloria* Walker, a cutworm known in Australia; yet all evidence goes to show that this pest was an old resident in Hawaii. I was particularly interested in the following statement by Chamberlin: "Whenever a tract is burned, a great flight of moths appeared immediately; and an army of worms shortly followed, entirely destroying the tender grass." This was exactly my experience with a similar species in North Queensland. Whenever an accidental fire ran through the growing cane, a scurge of cutworms soon followed to wipe out the crop just as it was beginning to recover from the burn. The only explanation that I was able to offer was that those abnormal conditions in some way upset the natural controlling factors so that the development of the pest, for a time, was not hindered by them.

The investigations of the Challenger Expedition were primarily marine. Small attention apparently was given to land fauna and few references to insects appear in the published works. Kirby, in describing the Hymenoptera collected, mentioned only three from Hawaii. (This is the only reference that I have been able to find.) But among the pelagic insects belonging to the genus Halobates, monographed by White (114), are several species found in Hawaiian waters. These were described and figured in colored plates, making their determination easy.

As a young graduate just out of the University of Oxford, the indefatiguable worker, R. C. L. Perkins, came to the islands in 1892 (?). The results of his work of more than twenty years stand as a monument to the hardships that he endured and the efforts that he put forth. During these years numerous papers were published, but the general results from the study of the tremendous amount of material he collected appear in the three large volumes of the Fauna Hawaiiensis. Of this work the following parts were published previous to the year 1900: Macrolepidoptera by E. Meyrick; Hymenoptera Aculeata by R. C. L. Perkins; Formcidae by August Forel; Orthoptera, Neuroptera and Coleoptera Rhynchophora, Proterhinidae, Heteromera and Ciodae by R. C. L. Perkins; and the Coleoptera Phytophaga by David Sharp. Since the Fauna Hawaiiensis is available in the principal libraries, I have not taken space to list the numerous species described.

IMPORTANT IMMIGRANT INSECTS

Among the introductions by European commerce was the night mosquito (*Culex quinquetasciatus* Say), a pest of first importance especially as a carrier of disease. Though it has been generally understood that these insects came to us from the coast of Mexico, it is interesting to read the following account by Osten Sacken (118):

> About 1828-30 an old ship from Mazatlan, Mexico, was abandoned on the coast of one of the Sandwich Islands. Larvae of Culex were probably imported in the water-tanks upon it. The natives soon became aware of the appearance round the spot of a—to them unknown—blood sucking insect; it so far excited their curiosity that they used to congregate in the evening in order to enjoy the novelty. Since then the species spread in different localities, and in some cases became a nuisance.
>
> This was related to me by Mr. T. R. Peale, the well known American entomologist and artist, who visited the Sandwich Islands a few years later with the United States Exploring Expedition under command of Captain C. Wilkes (1838-40). A distinguished American, who spent many years on the islands and whose acquaintance I made in Washington, confirmed the story to me, and told me that he remembered positively that there were no mosquitoes on the islands about 1823.
>
> This version is at any rate more probable than another which I read in the German periodical, "Die Natur," that gnats were intentionally imported into those islands by a mischiveous sea-captain, in vengeance against the inhabitants.

Another pest of importance in Hawaii is the sugar-cane borer, *Rhabdocnemis obscurus* Boisd., which was evidently introduced from some of the Pacific islands; Boisduval (20) in 1835 described the species from New Ireland and Fairmaire (32) later recorded it from Tahiti. This borer began to make inroads upon the sugar industry of Hawaii apparently during the early eighties (107, 113), rapidly spreading until brought under control by the introduced tachinid parasite (*Ceromasia sphenophori* Vill.). The species was recorded by Blackburn and Sharp (120) with a few brief systematic notes. The first careful study of the life history and economic relations was that by C. V. Riley (132), the specimens being sent to this celebrated entomologist at the request of his Majesty, King Kalakaua.

Another cosmopolitan insect found in Hawaii during recent years, though of little economic importance compared with the cane borer, is the milkweed butterfly, *Danaida archippus* Fab. This insect was not mentioned by any of the early voyagers and in fact the first reference to its presence in the islands is from Blackburn's material in 1878 (74). The geographical distribution of this species was reviewed in 1886 by Walker (126), who stated that these butterflies were abundant and well established in Hawaii at that date.

In the early nineties exotic scale insects began to command attention (134) and during the following decade fully fifty species had been re-

corded in Hawaii. *Icerya purchasi* Mask. is thought to have made its appearance in the islands during the spring of 1889. By 1890 it had become widely distributed in the gardens of Honolulu. During the following year, C. V. Riley (137) reported that it had been successfully controlled by the Vedalia beetle introduced from California. Nevertheless, other coccids began to make themselves felt, even attacking the coffee, which was so seriously affected that Mr. Albert Koebele, who had been so successful with the California State Board of Horticulture, was engaged in 1893 by the Hawaiian Government to search Australia for its natural enemies (143, 145). His work proved eminently successful and by 1895 there was a marked decrease in many of the scale insects owing to the natural enemies introduced (154). Chief among these friendly insects were lady bird beetles (Coccinellidae), fully three dozen species being in the list (153). As new scales continued to make their appearance in the islands, coming in on frequent plant and fruit importations, Koebele's valuable services were retained. By 1897 he had brought in fully 200 species of ladybird beetles besides many other natural enemies of various harmful insects (175).

The numerous scale insects were fairly well under control and Koebele began to turn his attention more seriously to other pests. In 1899 Koebele (202) wrote:

About the middle of April my attention was called to a troublesome fly upon cattle and on the 26th of the same month, the first specimens were brought to me . . . and during the summer it spread over all the islands.

This pest later proved to be the European horn-fly, *Haematobia irritans* Linn. which had reached the mainland of the United States about ten years earlier. Koebele further relates: "The first flies were noticed on the island of Oahu during February 1898, by Mr. J. P. Mendonca of the Kaneohe ranch." During 1900, pests of various crops were studied and the introduction of natural enemies was continued (215). It was at this time that a tineid larva of cotton balls was first reported, which eventually was found to be the pink boll-worm, *Geleckia gossypiella* Sndrs.

The Japanese Beetle (*Adoretus sinicus* Burm.) is reported to have come into the islands about 1891, probably in soil from Japan (142). Four years later it had already become such a pest that serious consideration was given to the introduction of such natural enemies as moles, bats, and toads (153). In 1897, 600 bats were introduced from California but apparently they never became established (175). Better results were secured by the introduction of toads from California and frogs from Japan. These reproduced freely in the streams here. But the spread of the beetle was rapid and by 1897 it was also reported from Maui and Kauai. Koebele

introduced a fungus that proved destructive to the beetle under wet surroundings (175), but unfortunately it appeared immune to this disease in the drier portions of the islands. During 1900 the Japanese beetles were reported (215) from the island of Hawaii, thus extending their range throughout the group, injuring the foliage of a large variety of cultivated trees and other plants.

It is reported that previous to 1898, all forms of melons, cucumbers and squashes could be grown in Hawaii with comparative ease. About this time a new pest that has come to be known as the melon fly (*Dacus cucurbitae* Coq.) began to make itself felt. Mr. Byron O. Clark who was the first to observe the flies said that they made their appearance during the summer of 1897 and that by 1898 and 1899 the melon industry was practically destroyed. The first published reference to the subject is in the form of correspondence printed in a weekly newspaper in Honolulu. The original is now almost unobtainable and so it is fortunate that the complete account has been reproduced in at least two scientific papers dealing with this serious pest. (See 184.)

DEVELOPMENT OF QUARANTINE SYSTEM

The entrance of so many noxious pests naturally stimulated a desire to shut out further introductions of these undesirable immigrants. During the reign of King Kalakua we find the beginning of this system in an Act dated July 16, 1890, relating to the suppression of plant diseases, blights, and insect pests (134). Again, in 1892, similar regulations were adopted in an Act to establish a Bureau of Agriculture and Forestry (139).

No one recognized the need of such regulations better than Professor A. Koebele who had devoted many years to a study of these organisms in various parts of the world. As official entomologist of the Hawaiian islands, in a letter (191) to Dr. Maxwell, who was special agent of the United States here at the time, he said,

Strict attention should be paid towards guarding against the introduction of melolontids, elaterid beetles, etc., destructive to living roots of plants, as well as to any fungoid diseases destructive to vegetation that are liable to reach the islands with soil or plants imported.

From these beginnings has grown up the efficient quarantine system that we find in the islands today.

BIBLIOGRAPHY

The following list is arranged chronologically and the names of authors are in alphabetical order under each year. For the convenience of workers resident in Hawaii the Honolulu libraries in which the publications cited may be found are indicated by the following abbreviations: AF, Board of Agriculture and Forestry; BM, Bishop Museum; DPI, Division of Plant Inspection, Board of Agriculture and Forestry; HS, Historical Society; HSPA, Hawaiian Sugar Planters' Experiment Station; PL, Library of Hawaii; UH, University of Hawaii; US, Hawaii Agricultural Experiment Station. References to publications indicated by an asterisk (*) have not been verified.

1. ELLIS, W(ILLIAM), An authentic narrative of a voyage performed by Captain Cook and Captain Clerke; . . . in search of a northwest passage between the continents of Asia and America. Including a faithful account of all their discoveries, and the unfortunate death of Captain Cook 2 vols., London, 1782. (BM)

2. COOK, JAMES, A voyage to the Pacific Ocean, undertaken by the command of His Majesty, for making discoveries in the Northern Hemisphere. Performed under the direction of Captains Cook, Clerke, and Gore, in His Majesty's ships "Resolution" and "Discovery"; in the years 1776, 1777, 1778, 1779, and 1780. 3 vols.; vols. 1 and 2 written by Captain James Cook, F.R.S., vol. 3 by Captain James King, LL.D. and F.R.S.; 2d ed., London, 1785. (BM)

3. DIXON, GEORGE, A voyage round the world but more particularly to to the northwest coast of America, performed in 1785, 1786, 1787, and 1788, in the "King George" and "Queen Charlotte," Captains Portlock and Dixon London, 1789. (BM)
 The expedition visited Hawaii in 1786.

4. PORTLOCK, NATHAN, A voyage round the world but more particularly to the northwest coast of America, performed in 1785, 1786, 1787, and 1788, in the "King George" and "Queen Charlotte," Captains Portlock and Dixon London, 1789. (BM)
 The members of the expedition were in Hawaii from May 26 to June 13, 1786.

5. *FABRICIUS, J. C., Entomologica systematica Hafniae (Copenhagen). 4 vols., 1792-4.
 References to Hawaiian species in vol. 2, p. 269 (*Odynerus radula* Fab.), and in vol. 3, p. 463.

6. VANCOUVER, GEORGE, A voyage of discovery to the North Pacific Ocean, and round the world; . . . performed in the years 1790, 1791, 1792, 1793, 1794, and 1795, in the "Discovery," sloop of war, and armed tender "Chatham." . . . 3 vols. London, 1798. (BM)
 Vancouver arrived in Hawaii March 2, 1792.

7. KOTZEBUE, OTTO VON, A voyage of discovery into the South Sea and Beering's Straits, for the purpose of exploring a northeast passage, undertaken in the years 1815-1818, . . . in the

ship "Rurick" translated edition by H. E. Lloyd. 3 vols., London, 1821. (BM)

Original, published in German at Weimar, 1821, contains colored plates of butterflies described by Eschscholtz. English translation by H. E. Lloyd. 3 vols. London, 1821. (BM)

The expedition arrived in Hawaii November 22, 1816.

8. *ESCHSCHOLTZ, JOHANN FRIEDRICH, Entomographien, 1 Lieferung, 128, iii p., 11 col. pl., 23 1/2 cm., Berlin, G. Reimer, 1822.

The Hawaiian species described are: *Hydrophilus semiclindricus* (p. 42), and *Blata punctata* (p. 86), which is a synonym of *Pycnoscelus surinamensis* (Linn.).

9. MATHISON, G. F., Narrative of a visit to Brazil, Chile, Peru, and the Sandwich Islands, during the years 1821 and 1822. . . . London, 1825. (BM)

Mathison arrived in Hawaii June 24, 1822.

10. BYRON, LORD, Voyage of H.M.S. "Blonde" to the Sandwich Islands, in the years 1824-5. London, 1826. (BM)

11. STEWART, C. S., Journal of a residence in the Sandwich Islands, during the years 1823, 1824, and 1825, London, 1828. (BM)

12. ESCHSCHOLTZ, FRIEDRICH, Zoologischer Atlas. Kotzebue's second voyage, 1823-6, Berlin, 1829. (HS)

No Hawaiian insects appear to be discussed, but beetles and other animal forms from other Pacific islands are described and illustrated by colored plates.

13. KOTZEBUE, OTTO VON, A new voyage round the world, in the years 1823, 1824, 1825, 1826. 2 vols., London, 1830. (BM)

14. BEECHEY, CAPTAIN F. W., Narrative of a voyage to the Pacific . . . 1825-8. 2 vols. London, 1831. (BM)

The first export of sugar to California discussed (vol. 2, pp. 100 and 112); no Hawaiian insects mentioned.

15. MONTGOMERY, JAMES, Journal of voyages and travels by the Rev. Daniel Tyerman and George Bennet, Esq. . . . London Missionary Society, . . . in the South Sea islands, China, India, etc., between the years 1821 and 1829. . . . 2 vols. London, 1831. (BM)

Tyerman and Bennet reached Hawaii in April, 1822.

16. BISHOP, SERENO E., Reminiscences of old Hawaii. Originally published in the Friend (BM) and in the Honolulu Advertiser 1901-1902. Reprinted in book form, Honolulu, 1916. (BM)

The Reminiscences relate chiefly to the period 1830-1860.

17. MALO, DAVID, Hawaiian antiquities, (Moolelo Hawaii), translated from the original Hawaiian by Dr. N. B. Emerson: B. P. Bishop Mus. Special Publ. 2, Honolulu, 1903. (BM)

Most of Moolelo Hawaii was written 1835-36. Parts of it were printed in 1838, 1839, and 1858.

8. BURMEISTER, HERMANN, Rhyngota seu Hemiptera. Beiträge zur Zoologie gesammelt auf einer Reise um die Erde, von Dr. F. J. F. Meyen, pp. 285-306. Nova Acta Acad. Caes. Leop., Breslau und Bonn, 1834. (BM)

 Burmeister describes *Asopus griseus* Burm. (p. 293).

9. ERICKSON, H. W., Coleoptera and Lepidoptera. Beiträge zur Zoologie gesammelt auf einer Reise um die Erde, von Dr. F. J. F. Meyen, pp. 219-284. Nova Acta Acad. Caes, Leop. . . . Breslau und Bonn, 1834. (BM)

 Erickson describes *Anchomenus corruscus* Erichs. (p. 223).

0. BOISDUVAL, J. A., Voyage de l'Astrolabe, pendant les annees 1826-29, faune entomologique de l'ocean Pacifique, Coleoptères, Paris, 1835, (BM) (AF)

 Colymbetes pacificus Esch. and *Colymbetes parvulus* Esch. (p. 50) are described.

1. *DEJEAN, P. F. M. A., Catalogue des coleoptères de la collection de M. le Compte Dejean. . . , 3d ed., p. 503, Paris, 1837.

 References to Hawaiian species are *Colymbetes pacificus* Esch. p. 55, and *C. parvulus* Esch., p. 56.

2. CHAPIN, ALONZO (M.D.), Remarks on the Sandwich Islands; their situation, climate, diseases. . .: Hawaiian Spectator, vol. 1, No. 3, pp. 248-267, Honolulu, 1838. (BM) (HS)

3. JARVES, J. J., Sketches of Kauai: Hawaiian Spectator, vol. 1, No. 1, pp. 66-86, Honolulu, 1838. (BM) (HS)

4. BENNET, F. D., Narrative of a whaling voyage round the globe from the years 1833 to 1836, London, 1840. (BM)

 Bennet arrived in Hawaii April 16, 1834.

5. JARVES, JAMES J., History of the Hawaiian or Sandwich Islands. . . , Boston, 1843. (BM)

6. PICKERING, CHARLES, The races of men and their geographical distribution: U. S. Exploring expedition . . . IX, Philadelphia, 1848. (BM) (HS)

 This expedition made a brief call at Hawaii in September, 1840.

7. *DOUBLEDAY, EDWARD, First list of British Museum butterflies, London, 1844(?)

 Describes four specimens of *Vanessa cardui* (p. 79) from Hawaii, two brought by Captain Byron in 1825 and two by Captain Beechey in 1827.

8. JARVES, JAMES J., Scenes and Scenery in the Sandwich Islands . . . Boston, 1844. (BM)

 Describes the attempt to establish a silk industry at Koloa in 1837-1841, rendered unsuccessful by the ravages of aphid, or wood louse, which destroyed the mulberry trees and consequently starved the silk worms (pp. 105-111). The "silk plantation" at Hanalei is also discussed (pp. 164-169).

29. MOTSCHULSKY, VICTOR DE, Observations sur le Musée Entomologique de l'université impériale de Moscou: Soc. Imper. Nat. Moscou Bull., vol. 18, pp. 332-388, pls. 5-7, 1845. (AF)

This paper discusses the beetles collected by Eschscholtz during his two voyages around the world, Plagithmysus n. g. for *Stenopterus pulverulentus* Esch. (pp. 369-70), Pl. 6, 5 figs. In error described from California.

30. MOTSCHULSKY, VICTOR DE, Remarques sur la collection de coleoptères russes da Victor Motschulsky: Soc. Imper. Nat. Moscou Bull. vol 28, pp. 1-85, pls. 1-3, 1845. (AF)

Stenopterus pulverulentus Esch. is erroneously recorded from California, p. 250.

31. *DOUBLEDAY, EDWARD, The genera of diurnal Lepidoptera, comprising their generic characters, a notice of their habits and transformations, and a catalog of the species of each genus. 2 vols., 86 pls. (85 col.), London, 1846.

Reference to *Vanessa cardui* from Hawaii is found on page 205.

32. FAIRMAIRE, M. LEON, Essai des Coleoptères de la Polynesie: Rev. et Mag. de Zool., June, 1849. (HSPA) (AF) (US)

Hydrobius semicylindricus Esch. was collected in a taro plantation on Oahu (p. 30 of sep. = 434 of original). *Heterophaga mauritanica* Fabr. is recorded (p. 42); also *Calandra obscura* Boisd. from Tahiti (p. 70). This species of Calandra, originally described from New Ireland, is the well-known cane-borer in Hawaii; now placed in the genus Rhabdocnemis.

33. CHEEVER, HENRY T., The island world of the Pacific, New York, 1851. (BM)

34. *FAIRMAIRE, M. L., Rev. et Mag. de Zool., p. 51, 1850.

35. DALLAS, W. S., List of specimens of Hemiptera in the British Museum, pt. 1, London, 1851; pt. 2, 1852. (AF)

The species *Eysarcoris insularis*, pt. 1, p. 228 and *Rhyparochromus nigriceps*, pt. 2, p. 577, are described.

36. DUNCAN, WILLIAM, On the prevention and eradication of worms: Roy. Haw. Agric. Soc. Trans., vol. 1, No. 3, pp. 71-86, Honolulu, 1852. (BM)

This paper, excellent for that period, deals only with the economic phases of the subject.

37. NEWCOMB, WESLEY (M. D.), Report of the committee on worms and other injurious vermin: Roy. Haw. Agric. Soc. Trans., vol. 1, No. 3, pp. 94-97, Honolulu, 1852. (BM)

This is a valuable paper dealing rather specifically with the insect pests of agriculture.

38. THIERRY, BARON DE, Report *on bees*: Roy. Haw. Agric. Soc. Trans., vol. 1, No. 3, p. 116, Honolulu, 1852. (BM)

Records the first attempt to introduce bees direct from New Zealand.

*WALKER, F. A., Catalog of the specimens of neuropterous insects in the collection of the British Museum, London, 1852.

Myrmelon perjurus n. sp., p. 340; *M. violentus* n. sp., p. 348, are described.

MOTSCHULSKY, VICTOR DE, Etudes entomologiques, 1852: Soc. Lit. Finnoise, 1853. (AF)

Under synonymies (p. 76), the author states: *"Plagithmysus pulverulentus* Esch. décrit et figuré dans le même ouvrage, appartient au genre Oenemona Newman."

SMITH, FREDERICK, Catalogue of hymenopterous insects in the collection of the British Museum, London, 1853. (HSPA)

Prosopis anthracina n.sp. and *P. flavipes* n.sp., from the Hawaiian islands, are described (pt. 1, p. 23).

CHAMBERLAIN, WARREN, Report of the committee on the honey bee: Roy. Haw. Agric. Soc. Trans., vol. 2, No. 1, pp. 53-57, also letter from C. R. Bishop, pp. 57-60, Honolulu, 1854. (BM)

This paper discusses the difficulties encountered in an attempt to introduce honey bees.

SIGNORET, DOCTEUR V., Revue iconographique des Tettigonides: Soc. Ent. France Ann., p. 15, pl. 1 (colored), fig. 15, 1854. (HSPA)

Describes *Tettigonia varicolor* n.sp., Honolulu, coll. Boheman et Signoret.

*STAL, CARL, Nya Hemiptera: Ofv. af K. Vet.-Ak. Forh., vol. 9, 1854.

Includes a reference to *Delphax pulchra* Stal.

MARSH, J. W., Report on birds, bees, insects, and worms: Roy. Agric. Soc. Trans., vol. 2, No. 2, pp. 47-50, Honolulu, 1855. (BM)

This is a purely economic paper dealing with pests and suggesting the introduction of natural enemies, various sorts being enumerated.

KNUDSEN, VALDEMAR, Report on worms: Roy. Haw. Agric. Sec. Trans., vol. 2, No. 3, pp. 94-97, Honolulu, 1856. (BM)

Contains interesting suggestions for the control of cutworms by protecting natural enemies and importing others, such as the black ant of North America.

SMITH, FREDERICK, Catalogue of hymenoterous insects in the collections of the British Museum, London, 1856. (HSPA)

Crabro unicolor (pt. 4, p. 421), *C. distinctus* (p. 422), and *Mimesa antennata* (p. 431), described from the "Sandwich Islands."

BOHEMAN, C. H., Coleoptera: Voyage de "l'Eugenie," Insecta, pp. 1-112, pl. 1, Stockholm, 1858. (BM)

The following species are described from Honolulu: *Calleida insularis*, p. 4, also found in Tahiti; *Calleida amoenula*, p. 4; *Lebia insularis*, p. 6, also found in Tahiti; *Selenophorus insularis*, p. 10; *Selenophorus picinus*, p. 11; *Trechus fasciatus*, p. 17; *Canthon balteatus*, p. 41; *Onthophagus muticus*, p. 48; *Ammophorus insularis*, p. 89.

49. VIRGIN, C. A., Voyage autour du monde sur la frègate Suédoise
 "l'Eugènie," 1851-53, sous le commandement de C. A.
 Virgin. . . . Zoologie I. Insecta, 617 pp., 9 Pls. Stockholm,
 1858-68.
 The following groups of insects are discussed: Coleoptera, by C. H.
 Boheman, pp. 1-218, 1858; Hemiptera, by C. Stal, pp. 219-298, 1859; Orth-
 optera, by C. Stal, pp. 299-350, 1860; Lepidoptera, by H. D. J. Wallengren,
 pp. 351-390, 1861; Hymenoptera, by A. E. Holmgren, pp. 391-442, 1868;
 Diptera, by C. G. Thomson, pp. 443-614, 1868.

50. BOHEMAN, C. H., Coleoptera: Voyage de "l'Eugènie," Insecta, pp.
 113-218, Pl. 2, Stockholm, 1859. (BM)
 The following genera and species described from Honolulu: *Oodemas*
 n. gen. (p. 138) created for *Oodemas aenescens*, p. 138; *Rhyncolus longulus*,
 p. 149; *Rhyncolus gracilis*, p. 150; *Megascelis subtilis*, p. 152; *Luperus in-
 sularis*, p. 182; *Graptodera verticalis*, also found in California and Tahiti, p.
 187; *Crepidodera puberula*, also found in California and Tahiti, p. 196;
 Hyperaspis annularis, also found in California, p. 205; *Scymnus kinbergi*,
 p. 209.

51. STAL, C(ARL), Hempitera: Voyage de "l'Eugènie," Insecta, pp.
 219-298, pls. 3 and 4, Stockholm, 1859. (BM)
 The following species described from Honolulu: *Arma patruelis*, p.
 220; *Arma pacifica*, p. 221; *Nysius coenosulus*, p. 243; *Capsus pellucidus*, p.
 255; *Delphax pulchra*, p. 275; *Bythoscopus viduus*, p. 291.

52. STAL, C(ARL), Orthoptera: Voyage de "l'Eugènie," Insecta, pp. 299-
 350, Pl. 5, Stockholm, 1860. (BM)
 Gomphocerus (Hyalopteryx) plebejus is described from Honolulu, p. 339.

53. OSTEN-SACKEN, Baron, Einfuhrung von Mucken (Culex) auf den
 Sandwich-Inseln: Stett. Ent. Zeit., vol. 22, pp. 51, 52, 1861.
 (HSPA)
 Describes the introduction of mosquitoes (Culex), about 1828-30, in an
 old ship from Mazatlan, Mexico.

54. WALLENGREN, H. D. J., Lepidoptera, Voyage de "l'Engènie," In-
 secta, pp. 351-390, pls. 6 and 7, Stockholm, 1861. (BM)
 The following species are described from Honolulu: *Colias ponteni*,
 p. 351; *Heliothis inflata*, p. 376; *Salbia continuatalis*, p. 381.

55. *HAGEN, H. A., Notizen beim Studium von Brauers Novara-Neu-
 ropteren: Verb. Zool. bot. Ges. Wien., vol. 17, p. 34, 1867.
 From Oahu are recorded: *Anax strenuus* n.sp. and *Anax junius* n.sp.
 Specimens of 3 *junius* in Berlin Museum are labeled *A. ocellatus, A. severus*,
 and *Alschua prasina*.

56. HOLMGREN, A. E., Hymenoptera, Voyage de "l'Eugènie," Insecta,
 pp. 391-442, pl. 8, Stockholm, 1868. (BM)
 The following species are described from Honolulu: *Echthromorpha
 maculipennis*, p. 406, and *Rhygchium nigripenne*, p. 441.

57. SCUDDER, S. H., A century of Orthoptera, Decade 1, Gryllides: Bos-
 ton Soc. Nat. Hist. Proc., vol. 12, pp. 139-143, Boston, 1868.
 (BM)
 Trigonidium pacificum is described from the Hawaiian Islands, p. 139.

58. THOMSON, C. G., Diptera. Voyage de "l'Eugènie," Insecta, pp. 443-614, pl. 9, Stockholm, 1868. (BM)

 The following species are described from Honolulu: *Sarcophaga barbata*, p. 533; *Sarcophaga dux*, p. 534; *Sacrophaga pallinervis*, p. 535; *Catapicephala limbipennis*, p. 541; *Musca flavinervis*, var.? p. 547; *Lispe metatarsalis*, p. 562; *Trypeta crassipes*, p. 583.

59. *STAL, CARL, Ennumeratio Hemipterorum I: K. Svenska Vet.-Ak. Handl., vol. 9, pp. 1-121, 1870.

 Dysdercus peruvianus Guer. is recorded from Hawaii.

60. WATERHOUSE, C. O., On a new genus and species of Coleoptera belonging to the family Lucanidae, from the Sandwich Islands: Ent. Soc. London Trans., p. 315, 1871.

 Mr. Harper Pease sent two specimens of a new beetle from Honolulu, for which Waterhouse created the genus Apterocyclus, naming the new species *A. honoluluensis*. These specimens were from the mountains of Kauai.

61. BUTLER, A. G., List of the diurnal Lepidoptera of the South-Sea Islands: Zool. Soc. London Proc., pp. 274-291, pl. 44 (colored), May 5, 1874. (BM)

 The following species from the Hawaiian islands are included: *Pyrameis tammeamea* Eschscholtz, p. 284; *Colais ponteni* Wallengren, p. 287; *Papilio sarpedon* Linnaeus, recorded from the Hawaiian islands by Beechey, p. 290. No mention is made of *Vanessa cardui* Linn, which was undoubtedly in the islands. (See 24, 27 and 37.)

62. McLACHLAN, ROBERT, Note on some Odonata (dragon-flies) from the Hawaiian Islands . . . Ent. Month. Mag., vol. 11, p. 92, 1874. (A) (HSPA)

 Anax junius Drury, *Pantala flavescens* Fab., and *Tremea lacerata* Hagen are noted as abundant, and said to prey on the produce of what the Hawaiians call the army worm, a species of Hadena, which occurs in multitudes.

63. *STAL, CARL, Ennumeratio Hemipterorum IV: Svensk. Vet. Ak. Handl., vol. 12, pp. 121 and 152, 1874.

 Includes notes on *Nysius caenosulus* and *Pamera nigriceps* from Hawaii.

64. THRUM, THOMAS, Notes on the history of coffee culture in Hawaiian Islands: Haw. Ann. for 1876, pp. 46-52, 1875. (BM)

 Refers to the coffee blight with a discussion of control measures, p. 49.

65. SCUDDER, S. H., A cosmopolitan butterfly, its birthplace and natural history: Amer. Nat., July, 1876. (AF)

 Refers to the single citation of *Vanessa cardui* Linn. from the Hawaiian islands, which appeared in the first list of the British Museum Butterflies, where (p. 79) Mr. Doubleday credits four specimens to those islands, two brought by Captain Byron and two by Captain Beechey. Scudder states:

 "I am informed by Mr. Butler that there is now only one specimen in the museum from the Sandwich Islands, and the reference upon the ticket is to the oldest manuscript register, not now to be found. Byron and Beechey were at the islands in 1825-27. Mr. W. T. Brigham informs me that *V. cardui* was not found by Mr. Mann and himself during a twelve month's residence at the islands ten years ago, and I can find no authority for its present existence. Dr. Pickering writes that it was unknown when the Wilkes expedition visited the islands 1840-41. The 'Vincennes,' to which Dr. Pickering was at-

tached, was at the islands from the end of September to the beginning of April. Byron and Beechey's visits were between the latter part of January and the middle of July. Mr. Butler does not consider the specimen in the British Museum, nor the record of Doubleday, sufficient authority to include this insect in his list of South Sea butterflies. Upon the whole, we cannot fairly accept the present authority for the presence of this insect in the Pacific Islands." (See also 24, 27, and 37.)

66. WALLACE, A. R., Geographical distribution of animals, 2 vols., London, 1876.

Contains a brief note on Apterocyclus (vol. 1, p. 446).

67. BLACKBURN, THOMAS, Insect-notes from the Sandwich Isles: Ent. Month. Mag., vol. 13, pp. 227-228, London, 1877. (AF)

In discussing his first impressions of the insect fauna of the islands, Blackburn states:

"Coleoptera are distinctly not common; Orthoptera, chiefly earwigs and cockroaches, in considerable variety; a fair number of Hymenoptera; too many Diptera of the mosquito type; a few Hemiptera; and many Lepidoptera, but only two butterflies, a large Papilio and *Vanessa kammeamea.*"

68. BLACKBURN, THOMAS, Characters of a new genus and descriptions of two new species of Cossonidae from the Sandwich Islands: Ent. Month. Mag., vol. 14, pp. 4-5, London, 1827. (AF)

Anotheorus n.gen., *A. montanus* n.sp., *Oodemas halticoides*, n.sp. are described.

69. BLACKBURN, THOMAS, Characters of a new genus, and descriptions of new species, of Geodephaga from the Sandwich Islands, I: Ent. Month. Mag., vol. 14, pp. 142-148, London, 1877. (AF)

The following insects are described: Saronychium n.gen., *S. inconspicuum*, n.sp., *Anchomenus muscicola* n.sp., *A. epicurus* n.sp., *A. protervus* n.sp., *A scrupulosus* n.sp., *A. fraternus* n.sp., *A. meticulosus* n.sp., *A. cuneipennis* n.sp., *A. fossipennis* n.sp., *A oceanicus* n.sp., *A. bardus* n.sp., *A. fugitivus* n.sp., *A. mysticus* n.sp., *Dyscolus tantalus* n.sp., *D. palmae* n.sp., *D. mutabilis* n.sp., *D. caliginosus* n.sp.

70. BUTLER, A. G., List of heterocerous Lepidoptera recently collected by the Rev. T. Blackburn in the Hawaiian Islands: Ent. Month. Mag., vol. 14, pp. 47-50, London, 1877. (AF)

The forms described are: *Deilephila livornica* Esper., *Protoparce cingulata* Fab., *Leucania dislocata* Walker, *Prodenia ingloria* Walker, *Plusia verticillata* Guénée, *Hypena obsoleta* n.sp., *H. insignis* n.sp., *Herminia caeneusalis* Walker, *Botys blackburni* n.sp., *B. accepta* n.sp., *Pyralis achatina* n.sp., *Rhodaria despecta* n.sp., *Hymenia recurvalis* Fab., *Ephestia elutella* Hub., *Argyresthia* sp., *Laverna* sp.

71. WHITE, F. B., Descriptions of new species of heteropterous Hemiptera collected in Hawaiian Islands by Blackburn, No. 1: Annals and Mag. Nat. Hist., 4th ser., vol. 20, pp. 110-114, 1877. (HSPA)

The species described are Cydnidae: *Geotomus subtristis* n.sp., *G. jucundus* n.sp.—Anthrocoridae: *Tripleps persequens* n.sp., *Cardiasthethus mundulus* n.sp.—Nabidae: *Nabis innotatus* n.sp., *N. subrufus* n.sp., *N. lusciosus* n.sp.—Emesidae: *Luteva insolida* n.sp.—Hebridae: Merragata n.gen., *M. hebroides* n.sp.—Corixidae: *Corixa blackburni* n.sp.

. BLACKBURN, THOMAS, Some observations on the genus Oodemas of the family Cossonidae with descriptions of new species: Soc. Ent. Belgique Ann., pp. 73-76, 1878. (AF)

The following species are described: *Oodemas nivicola* n.sp., *O. aenescens* Boh., *O. sculpturatum* n.sp., *O. insulare* n.sp., *O. robustum* n.sp., *O. obscurum* n.sp., *O. angustum* n.sp., *O. mauiense* n.sp., *O. borrei* n.sp., *O. halticoides* Blackb.

. BLACKBURN, THOMAS, Characters of new genera and descriptions of new species of Geodephaga from the Hawaiian islands, II: Ent. Month. Mag., vol. 15, pp. 119-123 and 156-158, London, 1878. (AF)

The following are described: Atrachycnemis, n.gen., *A. sharpi n.sp.*, Disenochus n.gen., *D. anomalus,* n.sp., *Anchomenus insociabilis* n.sp., *A. erro* n.sp., *A. sharpi* n.sp., *A rupicola* n.sp., *Cyclothorax montivagus* n.sp., *C. micans* n.sp., *C. multipunctatus* n.sp., *C. brevis* Sharp, *C. oahuensis* n.sp., *C. simiolus* n.sp., *C. obscuricolor* n.sp.

. BUTLER, A. G., On Lepidoptera from the Hawaiian islands: Ent. Month. Mag., vol. 14, p. 185, London, 1878. (AF)

Descriptions are given of the following species: *Danais archippus* Fab., *Leucania dislocata* Walk., *Plusia verticillata* Guénée, *Botys blackburni* Butler, *B. accepta* Butler.

. SHARP, DAVID, Descriptions of some new species and a new genus of rhyncophorous Coleoptera from Hawaiian Islands: Ent. Soc. London, Trans., for 1878, pp. 15-26, 1878. (AF)

The following insects were collected by Thomas Blackburn: *Proterhinus vestitus* n.sp., *P. blackburni* n.sp., *P. simplex* n.sp., *P. obscurus* n.sp., *P. oscillans* n.sp., *P. debilis* n.sp, *Dryophthorus squalidus* n.sp., *D. gravidus* n.sp., *D. crassus* n.sp., *D. declivia* n.sp., *D modestus* nsp., *D. pusillus* n.sp., *D. insignis* n.sp., *Pentarthrum prolixum* n.sp., *P. obscurum* n.sp., *P. blackburni* n.sp.

. SHARP, DAVID, On some Nitidulidae from the Hawaiian Islands: Ent. Soc. London, Trans. for 1878, pp. 127-140, 1878. (AF)

Descriptions are given of the following beetles collected by Blackburn: *Gonioryctus latus* n.sp., *G. blackburni* n.sp., *G. monticola* n.sp., *Brachypeplus discendens* n.sp., *B. puncticeps* n.sp., *B. robustus* n.sp., *B. reitteri* n.sp., *B. infirmus* n.sp., *B. impressus* n.sp. *B. inaequalis* n.sp., *B. omalioides* n.sp., *B. brevis* n.sp., *B. asper* n.sp., *Carpophilus hemipterus* Linn., *C. dimidiatus* Er., *C. maculatus* Murray, *Haptoncus tetragonus* Murray, and *H. mundus* n.sp.

. SHARP, DAVID, On some longicorn Coleoptera from the Hawaiian islands: Ent. Soc. London, Trans. for 1878, pp. 201, 210, 1878. (AF)

Descriptions are given of the following beetles collected by Blackburn: *Parandra puncticeps* n.sp., *Stenocorus simplex* Gyll., Astrimus n.gen., *A. obscurus* n.sp., Sotenus n.gen., *S. setiger* n.sp., Clytarlus n.gen., *C. robustus* n.sp., *C. cristatus* n.sp., *Micracantha nutans* n.sp., *Oopsis nutator* Fab., and *Lagochirus araneiformis* Linn.

. SHARP, DAVID, Description of new species probably indicating a new genus of Anchomenidae from the Sandwich Islands: Ent. Month. Mag., vol. 14, pp. 179-180, 1878. (AF)

Describes *Blackburnia insignis* n.sp.

TUELY, N. C., Description of new species of butterfly from Sandwich Islands: Ent. Month. Mag., vol. 15, pp. 9-10, 1878. (AF)

Describes *Holochila blackburni* n.sp.

TUELY, N. C., Description of the larvae of *Pyrameis hunteri*: Ent. Month. Mag., vol. 15, pp. 16-17, 1878. (AF)

WHITE, F. B., Descriptions of new species of heteropterous Hemiptera collected in the Hawaiian islands by the Rev. T. Blackburn, No. 2: Ann. and Mag. Nat. Hist., 5th ser., vol. 1, pp. 365-374, 1878. (HSPA)

The Hemiptera described are Asopidae: *Oechalia patruelis* Stal.—Lygaeidae: *Nysius dallasi* n.sp., *N. delectus* n.sp., *N. arboricola* n.sp., *N. coenosulus* Stal, *Pamera nigriceps* Dall, *Clerada apicicornis* Sign., Reclada n.gen., *R. moesta* n.sp., Metrarga n. gen., *M. nuda* n.sp., *M. villosa* n.sp. Capsidae: *Capsus pellucidus* Stal.—Anthocordidae: *Cardiastethus sodalis* n.sp. Acanthiidae: *Acanthia lectularia* Linn.—Saldidae: *Salda exulans* n.sp. —Nabidae: *Nabis blackburni* n.sp.—Veliidae: *Microvelia vagans* n.sp.

BLACKBURN, THOMAS, Characters of new genera and descriptions of new species of Geodephaga from the Hawaiian islands, III: Ent. Month. Mag., vol. 16, pp. 104-109, London, 1879. (AF)

· Blackburn describes Anchomenidae: *Anchomenus lucipetens* n.sp., *A. incendiarius* n.sp., *Cyclothorax pele* n.sp., *C. bembidioides* n.sp., *C. paradoxus* n.sp., *C. deverilli* n.sp., *C. vulcanus* n.sp.—Bembidiidae: *Bembidium (Lopha) ignicola* n.sp.

BLACKBURN, THOMAS, *Vanessa cardui* in Hawaii: Ent. Month. Mag., vol. 16, p. 161, London, 1879. (AF)

From the paper by Blackburn the following is quoted:
Referring to the paper headed "The Recent Abundance of *Vanessa cardui*," in the August number of this magazine, it may be of interest to note that I have observed the species in considerable abundance (but not in compact swarms) at various points on the Hawaiian Archipelago, between February and July this year (1879),—though I have not previously noticed it during the three years I have been living on the islands. Its near ally, *V. hunteri*, has occurred in about the usual numbers. The season has been here, probably, as much cloudier and more showery than usual as in Great Britain. *V. cardui* has been recorded, I believe, as occurring on the Hawaiian Islands, but I cannot at this moment lay my hands on the authority. (See 24, 27, 37, and 65.)

BUTLER, A. G., On heterocerous Lepidoptera collected in the Hawaiian islands by the Rev. T. Blackburn: Ent. Month. Mag., vol. 15, pp. 269-273, London, 1879. (AF)

The species described are Leucaniidae: *Leucania photophila* n.sp.—Noctuidae: *Agrotis suffusa* W.V., *A. arenivolans* n.sp.—Hydrocampidae: *Oligostigma curta* n.sp.—Botydidae: *Botys accepta* Butl., *B. continuatalis (Salbia continuatalis* Wllgr.), *B. demaratalis* Walk., *Mecyna exigua* n.sp.—Larentiidae: *Larentia insularis* n.sp., *Pseudocoremia paludicola* n.sp., *Scotosia rara* n.sp. —Phycidae: *Plodia interpunctalis* Hüb.—Tineidae: *Scardia lignivora* n.sp.

SHARP, DAVID, On some Coleoptera from the Hawaiian islands: Ent. Soc. Trans., pp. 77-105, London, 1879. (AF)

Descriptions are given of the beetles collected by Blackburn. They represent Hydrophilidae: Omicrus n.gen., *O. brevipes* n.sp., *Hydrophilus semicylin-*

dricus Esch., *Cyclonotum subquadratum* Fairm., *Sphaeridium abdominale* Fab.
—Nitidulidae: *Brachypeplus tinctus* n.sp., *B. explanatus* n.sp., *B. protinoides*
n.sp.—Cucujidae: Monanus n.gen., *M. crenatus* n.sp.—Colydiidae: Antilissus
n.gen., *A. asper* n.sp.—Mycetophagidae: *Litargus vestitus* n.sp., Propalticus
n.gen., *P. oculatus* n.sp.—Scarabaeidae: *Aphodius pacificus* n.sp.—Cioidae:
Cis alienus n.sp., *C. pacificus* n.sp. *C. procatus* n.sp., *C. signatus* n.sp. *C. bi-
color* n.sp. *C. tabidus* n.sp., *C. diminutivus* n.sp., *C. laeticulus* n.sp., *C. evanes-
cens* n.sp.—Aglycyderidae: *Proterhinus nigricans* n.sp. *P. collaris* n.sp. *P. hu-
meralis* n.sp. *P. pusillus* n.sp., *P. longulus* n.sp., *P. basalis* n.sp., *P. sternalis*
n.sp., *P. lecontei* n.sp., *P. paradoxus* n.sp.—Scolytidae: *Hypothenemus macu-
licollis* n.sp.—Cerambycidae: *Clytarlus microgaster* n.sp., and *C. modestus*
n.sp.

86. SMITH, FREDERICK, Descriptions of new species of aculeate Hy-
menoptera collected by the Rev. Thos. Blackburn in the Sand-
wich islands: Linn. Soc. London Journ., vol. 14, pp. 674-685,
1879. (BM)

The species described are as follows: Formicidae: *Camponotus sex-
guttatus* Fab., *Phenolepis clandestina* Mayr.— Poneridae: *Ponera contracta*
Latr.—Myrmicidae *Tetramorium guineense* Fab., *Pheidole pusilla* Heer.,
Solenopsis gemmata Mayr. and Roger.— Sphegidae: *Pelopoeus flavipes*
Fab.— Larridae: *Pison iridipennis* n.sp., *P. hospes* n.sp.—Crabronidae:
Crabro affinis n.sp., *C. mandibularis* n.sp., *C. denticornis* n.sp., *C. unicolor*
Smith.—Eumenidae: *Odynerus localis* n.sp., *O. maurus* n.sp., *O. rubritinctus*
n.sp., *O. montanus* n.sp., *O. congruus* n.sp., *O. dubiosus* n.sp., *O. agilis* n.sp.—
Vespidae: *Polistes aurifer* Sauss.—Andrenidae: *Prosopis blackburni* n.sp.,
P. fuscipennis n.sp., *P. facilis* n.sp., *P. hilaris* n.sp., *P. volatilis* n.sp.—Apidae:
Megachile diligens n.sp., *Xylocopa aeneipennis* De Geer, and *Apis mellifica*
Linn.

87. WATERHOUSE, C. O., Description of a new genus and species of
heteromerous Coleoptera of the family Cistelidae from Hono-
lulu: Ent. Month. Mag., vol. 15, pp. 267-268, London, 1879.

The genus and species described are: Labetis n.gen., *L. tibialis* n.sp.

88. WHITE, F. B., Descriptions of new Anthocoridae: Ent. Month.
Mag., vol. 16, pp. 142-148, London, 1879.

The following are described from Hawaii: *Dilasia denigrata* n.sp.,
Hawaii, 3,000 feet; *D. decolor* n.sp., Honolulu; Lilia n.gen.; *L. dilecta* n.sp.,
Maui, 5,000 feet.

89. BLACKBURN, THOMAS, and KIRBY, W. F., Notes on species of acu-
leate Hymenoptera occurring in the Hawaiian islands: Ent.
Month. Mag., vol. 17, pp. 85-89, London, 1880. (AF)

The following species are discussed: *Prosopis blackburni* Sm., *P. fusci-
pennis* Sm., *P. facilis* Sm., *P. hilaris* Sm., *P. volitalis* Sm., *P. flavifrons* n.sp.,
Xylocopa aeneipennis De G., *Apis melifica* Linn., *Pelopaeus flavipes* Fab.,
Odynerus localis Sm., *O. maurus* Sm., *O. rubritinctus* Sm., *O. blackburni*
n.sp., *O. montanus* Sm., *O. congruus* Sm., *O. dubiosus* Sm., *O. agilis* Sm.,
Crabro afinis Sm., *C. mandibularis* Sm., *C. denticornis* Sm., *C. unicolor* Sm.,
C. stigius n.sp., *Pison irridipennis* Sm., *P. hospes* Sm., *Polistes aurifer* Sauss.,
Camponotus sexguttatus Mayr., *Prenolepsis clandestina* Mayr., *Ponera con-
tracta* Latr., *Leptogenys insularis* Sm., *Tetramorium guineense* Fab., *Phei-
dole pusilla* Heer., *Solenopsis geminata* Fab., *Evania laevigata* Latr.

90. BUTLER, ARTHUR G., On two small consignments of Lepidoptera
 from the Hawaiian Islands: Ent. Month. Mag., vol. 17, pp. 6-9,
 London, 1880.

The following species collected by Blackburn are described: *Danais
archippus* Fab., *Protoparce blackburni* n.sp., *Deilephila livornica* Esper.,
Leucania dislocata Walk., *L. extranea* Guen., *Prodenia ingloria* Walk., *Car-
adina venosa* n.sp., *Agrotis suffusa* Gmel., *Spaelotis lucicolens* n.sp., *S. cre-
mata n.sp.*, *Heliothis conferta* Walk., *Plusia verticillata* Guen., *Toxocampa
noctivolans* n.sp., *Scotosia rara* Butl., *Hypena obsoleta* Butl., *H. insignis* Butl.,
H. fascialis Cram., *Scopula exigua* n.sp., *S. altivolans* n.sp.

91. HAROLD, E. VON, Einige neue Coleopteren: Münchener Ent. Ver.
 Mitth., vol. 4, pp. 148-181, 1880. (AF)

Von Harold describes *Clytarlus finschi* n.sp. von den Sandwich-Inseln
(Finsch!) (p. 166). This species is now in the genus Plagithmysus. [J.F.I.]

92. RILEY, C. V., Note: Amer. Ent., vol. 3, p. 150, 1880. (HSPA)

Riley states: Mr. T. Blackburn of Honolulu communicated that *Vanes-
sa cardui* appeared quite frequently in the year 1879, on the island of Hawaii,
during the month of February till July. He never before observed the
species on the island mentioned above.

93. SHARP, DAVID, On some Coleoptera from the Hawaiian Islands: Ent.
 Soc. London Trans., pp. 37-54, 1880. (AF)

Th following species are described: *Falagria currax* n.sp., *Tachyusa
pumila* n.sp. *Diestota plana* n.sp., *D. parva* n.sp., *D. latifrons* n.sp., *D. pal-
palis* n.sp., *D. puncticeps* n.sp., *D. carinata* n.sp., *D. rufescens* n.sp., *Phlaeo-
pora cingulata* n.sp., *P. diluta* n.sp., *Oligota clavicornis* n.sp., *O. polita* n.sp.,
O. glabra n.sp., *O. mutanda* n.sp., *Liophaena gracilipes* n.sp., *L. flaviceps* n.sp.,
Myllaena vicina n.sp., *M. familiaris* n.sp., *M. curtipes* n.sp., *M. discidens* n.sp.,
Pachycorynus discedens n.sp., *Oxytelus advena* n.sp., *Trogophlaeus senilis*
n.sp., *T. frontinalis* n.sp., *T. abdominalis* n.sp., *Glyptoma blackburni* n.sp.,
G. brevipenne n.sp., *Lispinodes explicandus* n.sp.

94. BLACKBURN, THOMAS, Description of four new species of Cossoni-
 dae from the Hawaiian Islands: Ent. Month. Mag., vol. 17,
 pp. 199-201, London, 1881. (AF)

The four species are: *Oodemas olindae* n.sp., *O. substrictum* n.sp., *O.
infernum* n.sp., *O. ignavus* n.sp.

95. BLACKBURN, THOMAS, Characters of new genera and descriptions of
 new species of Geodephaga from the Hawaiian Islands, IV:
 Ent. Month. Mag., vol. 17, pp. 226-229, London, 1881. (AF)

The following are described: Anchomenidae: *Disenochus terebratus*
n.sp., *Anchomenus putealis* n.sp., *Cyclothorax unctus* n.sp., *C. laetus* n.sp.,
C. robustus n.sp.—Bembidiidae: *Bembidium (Notaphus) spurcum* n.sp., *B.
teres* n.sp.

96. BUTLER, A. G., On a collection of nocturnal Lepidoptera from the
 Hawaiian Islands: Annals and Mag. Nat. Hist., 5th ser., vol.
 7, pp. 317-333, 1881. (AF) (HSPA)

Descriptions are given of the following species collected by Blackburn:
Sphingidae: *Deilephila calida* n.sp.—Larentiidae: *Scotosia corticea* n.sp.,
Eupithecia monticolens n.sp.—Noctuidae: *Spoelotis crinigera* n.sp., *Apa-
meidae chersotoides* n.sp., *A. cinctipennis* n.sp.—Heliothidae: *Heliothis ar-*

migera Hub.—Hypenidae: *Hypena obsoleta* Butl., *H. altivolans* Butl., var. *simplex.*—Hercynidae: *Boreophila minuscula* n.sp., *Aporodes micacea* n.sp.— Margarodidae: *Margaronia glauculalis* Guenee.—Botididae: *Anemosa aurora* n.sp., *Mecyna ennychioides* n.sp., *M. nigrescens* n.sp., *M. exigua* Butl., *M. virescens* n.sp.—Scopariidae: *Scoparia hawaiensis* n.sp., *S. jucunda* n.sp., var. *formosa, S. frigida* n.sp., *S. coarctata* Zeller, *S. venosa* n.sp.—Phycidae: *Ephestia humeralis* n.sp., *E. albosparsa* n.sp.

97. CAMERON, PETER, Notes on Hymenoptera, with descriptions of new species: Ent. Soc. London Trans., pp. 555-563, 1881. (AF)

The following species, collected by Blackburn, are described from Honolulu: *Sierola* n.gen., *S. testaceipes* n.sp.—Braconidae: *Chelonus carinatus* n.sp., *Monolexis palliatus* n.sp.—Chalcidae: *Chalcis polynesialis* n.sp., and Crabronidae: *Crabo polynesialis* n.sp.

98. KARSCH, F., Zur Käferfauna der Sandwich-Marshall-und Gilberts-Inseln: Berlin Ent. Zeit., vol. 25, pp. 1-14, pl. 1, 1881. (AF) (US)

The following species are recorded from Hawaii: *Acupalpus biseriatus* n.sp., *Platynus planus* n.sp., *Calpodes octoocellatus* n.sp., *Anisodactylus cuneatus* n.sp., *Promecoderus fossulatus* n.sp., *Corymbites coruscus* n.sp., *Elater humeralis* n.sp., *Trypopitys capucinus* n.sp., *Epitragus diremptus* n.sp., *Rhyncolus opacus* n.sp., *Aegosoma reflexum* n.sp., *Stasilea curvicornis* n.sp., *Clytarlus finschi* Har., *C. pulvillatus* n.sp.

99. SHARP, DAVID, On some new Coleoptera from the Hawaiian Islands: Ent. Soc. London Trans., pp. 507-534, 1881. (AF)

Descriptions are given of the following beetles collected by Blackburn: Nitidulidae: *Brachypeplus inauratus* n.sp., *B. affinis* n.sp., *B. bidens* n.sp., *B. vestitus* n.sp., *B. metallescens* n.sp., *B. varius* n.sp., *B. guttatus* n.sp., *B. sordidus* n.sp., *B striatus* n.sp, *B. obsoletus* n.sp., *B. blackburni* n.sp.— Anobiidae: Xyletobius n.gen., *X. marmoratus* n.sp., *X. nigrinus* n.sp., *X. osculatus* n.sp., Holcobius n.gen., *H. granulatus* n.sp., *H. glabricollis* n.sp., *H. major* n.sp., Mirosternus n.gen., *M. punctatus* n.sp., *M. obscurus* n.sp., *M. muticus* n.sp., *M. carinatus* n.sp., *M. glabripennis* n.sp., *M. debilis* n.sp., *M. bicolor* n.sp.—Aglycyderidae: *Proterhinus hystrix* n.sp., *P. dispar* n.sp., *P. gracilis* n.sp., *P. angularis* n.sp., *P. punctipennis* n.sp., *P. validus* n.sp.— Cerambycidae: *Clytarlus pennatus* n.sp., and *C. fragilis* n.sp.

100. WHITE, F. B., Descriptions of new species of heteropterous Hemiptera collected in the Hawaiian Islands by the Rev. T. Blackburn, No. 3: Annals and Mag. Nat. Hist., 5th ser., vol. 7, pp. 52-59, 1881. (HSPA)

The species described are: Scutelleridae: *Coleolichus blackburniae* n.sp. —Lygaeidae: *Nysius blackburni* n.sp., *N. nitidus* n.sp., *N. nemorivagus* n.sp., *N. rubescens* n.sp., *N. pteridicola* n.sp., *N. vulcan* n.sp., *Cymus calvus* n.sp., *C. criniger* n.sp.—Anthrocoridae: *Dilasia denigrata* White, *D. decolor* White, *Lilia dilecta* White.—Emesidae: Ploiariodes n.gen., *P. whitei* (Blk.M.S.)n.sp.

101. BLACKBURN, THOMAS, Descriptions of the larvae of Hawaiian Lepidoptera: Ent. Month. Mag., vol. 19, pp. 55-56, 1882. (AF)

The species discussed are: *Vanessa tammaemea* Eschscholtz, *Holochila blackburni* Tuely, *Agrotis cremata* Butler and *Rhodaria despecta* Butler.

102. BLACKBURN, THOMAS, Characters of new genera and descriptions of
 new species of Geodephaga from the Hawaiian Islands, V:
 Ent. Month. Mag., vol. 19, pp. 62-64, London, 1882. Continued
 from vol. 17, p. 229.

 The following species are described Anchomenidae: *Cyclothorax
 harschii* n.sp., *Acupalpus biseriatus* Karsch, *Platynus planus* Karsch, *Colpodes
 octocellatus* Karsch, *Anisodactylus cuneatus* Karsch.

103. BLACKBURN, THOMAS, Hawaiian entomology: Haw. Ann. for
 1882, pp. 58-61, Honolulu, 1881. (BM)

 Blackburn says that Hawaii is a comparatively unexplored field of nat-
 ural history. His statements may be summarized as follows: The Orth-
 optera are represented by few species; no true grasshoppers and no Man-
 tidae are known; about 500 species of Coleoptera have been collected, 80
 per cent of them apparently native; the Neuroptera (including Odonata)
 have been little studied; the order Hymenotera is richer than other orders;
 ants are numerous, the Madeira house ants, *Pheidole pusilla* Heer, being the
 most abundant; the Lepidoptera are little known, but about 100 species have
 been described—not a quarter of those that might be collected; Hemiptera
 and Homoptera are represented in collections by about 100 species; there
 are probably hundreds of species of Diptera, but scarcely 50 are represented
 in collections; mosquitoes, (house) flies, and fleas are pests. Blackburn's
 paper includes a bibliography of Hawaiian entomology.

104. CHAMBERLAIN, J. E., The *peelua* or army worm of the Hawaiian
 Islands: Haw. Ann. for 1883, pp. 44-50, Honolulu, 1882. (BM)

 A valuable historical paper upon the activities of *Prodenia ingloria*
 Walk. as a pest of grasses.

105. BORMANS, AUG. DE, Faune orthopterologique des Iles Hawai ou
 Sandwich: Genoa Mus. Civ. di St. Nat. Ann., vol. 18, 11
 Luglio, pp. 338-348, 1882. (AF) (US)

 The following species collected by Blackburn are discussed: Forficularia:
 Anisolabis littorea White, *A. maritima* Bonelli, *Labia pygidiata* Dub., *Che-
 lisoches morio* Fab., *Forficula hawaiensis* n.sp.—Blattaria: *Blatta hiero-
 glyphica* Brunn., *Periplaneta decorata* Brunn., *P. ligata* Brunn., *P. americana*
 Linn., *Eleutheroda dytiscoides* Serv., *Panchlora surinamensis* Linn., *Onis-
 cosoma pallida* Brunn., *Euthyrrapha pacifica* Coquebert.—Locustodea: *Eli-
 maea appendiculata* Brunn., *Conocephalus blackburni* n.sp. Gryllodea: *Gryl-
 lus innotabilis* Walk., *Trigonidium pacificum* Scud.

106. BUTLER, A. G., On a small collection of Lepidoptera from the Ha-
 waiian Islands: Ent. Soc. London Trans., pp. 31-45, 1882.
 (AF)

 Descriptions are given of the following Lepidoptera collected by Black-
 burn: Lycaenidae: *Polyommatus boeticus* Linn.—Leucaniidae: *Leucania
 extranea* Guenee.—Gonopteridae: *Gonitis hawaiiensis* n.sp.—Hypocalidae:
 Hypocala velans Walk.—Pyralidae: *Locastra monticolens* n.sp.—Steniidae:
 Metasia abnormis n.sp., *Scotomera hydrophila* n.sp.—Botididae: Mestalobes
 n.gen., *M. aenone* n.sp., *M. simaethina* n.sp., *M. semiochrea* n.sp., *Scopula
 constricta* n.sp.—Scopariidae: *Scoparia coarctata* Zell.—Crambidae: *Eromene
 bella* Hubn.—Tortricidae: *Teras illepida* n.sp., *Proteopteryx walsinghamii*
 n.sp.—Tineidae: *Tinea simulans* n.sp.—Elachistidae: *Laverna parda* Butler,
 var. *montivolans,* L. *aspersa* n.sp.—Pterophoridae: *Platyptilus littoralis* n.sp.

WHITNEY, H. M., The cane borer: Haw. Planters' Monthly, vol. I, pp. 145-146, Honolulu, 1882. (BM) (HSPA)

A popular economic article—recommends burning.

BUTLER, A. G., On a small series of Lepidoptera from the Hawaiian Islands: Ent. Month. Mag., vol. 19, pp. 176-180, London, 1883. (AF)

The following species are described: Scotorythra n.gen., *S. arboricolens* n.sp.,—Pyrales: *Scopula litorea* n.sp., Orthomecyna n.gen., *O. albicaudata* n.sp., *O. exigua*, var. *cupreipennis*, Melanomecyna n.gen., *M. stellata* n.sp., *Gesneria floricolens* n.sp.,—Tineina: Depressaria sp., *Azinis hilarella* Walk.

CAMERON, PETER, Descriptions of new genera and species of Hymenoptera: Ent. Soc. London Trans., pp. 187-193, 1883. (AF)

Descriptions are given of the following Hymenoptera collected by Blackburn: Chalcididae: *Epitranus lacteipennis* n.sp., Moranila n.gen., *M. testaceiceps* n.sp., Solindena n.gen., *S. picticornis* n.sp., *Eupelmus flavipes* n.sp. —Evaniidae: *Evania sericea* n.sp.—Ichneumonidae: *Limneria polynesialis* n.sp., *L. blackburni* n.sp., *Ophion lineatus* n.sp., *O. nigricans* n.sp.

McLACHLAN, ROBERT, Neuroptera of the Hawaiian Islands: Annals and Mag. Nat. Hist., 5th ser., vol. 12, pp. 226-240, 1883. (HSPA)

Descriptions are given of the following neuropteroid insects collected by Blackburn: Termitidae: *Calotermes castaneus* Burm., *C. marginipennis* Latr.—Embidae: *Oligotoma insularis* n.sp.—Psocidae: Psocus sp., *Elipsocus vinosus* n.sp., Odonata, *Pantala flavescens* Fab., *Tramea lacerata* Hagen, *Lepthemis blackburni* n.sp., *Anax junius* Drury, *A. strenuus* Hagen, *Agrion xanthomelas* Selys., *A. hawaiiensis* n.sp., *A. pacificum* n.sp., *A. deceptor* n.sp., *A. calliphya* n.sp., Megalagrion n.gen., *M. blackburni* n.sp., *M. oceanicum* n.sp.

McLACHLAN, ROBERT, Neuroptera of the Hawaiian Islands, Part II, Planipennia, with general summary: Annals and Mag. Nat. Hist., 5th ser., vol. 12, pp. 298-303, 1883. (HSPA)

This paper includes descriptions of neuropteroid insects collected by Blackburn: Hemerobiidae: Megalomus sp.—Chrysopidae: Anomalochrysa n.gen., *A. hepatica* n.sp., *A. rufescens* n.sp., *Chrysopa microphya* n.sp., *C. oceanica* Walk.—Myrmeleontidae: *Formicaleo perjurus* Walk.

MEYRICK, EDWARD, Notes on Hawaiian Microlepidoptera: Ent. Month. Mag., vol. 20, pp. 31-36, 1883. (AF)

Descriptions are given of the following moths collected by Blackburn: Conchylidae: *Heterocossa achroana* n.sp.—Gelechidae: *Depressaria indecora* Butl., Thyrocopa n.gen., *T. (Depressaria) usitata* Butl., Synomotis n.gen., *S. epicapna* n.sp., Automola n.gen., *A. pelodes* n.sp., *Parasia sedata* Butl., Diplosara n.gen., *D. (Sardia) lignivora* Butl.—Tineidae: *Blabophanes longella* Walk.

SMITH, W. O., Cane borer: Planters' Monthly, vol. 2, pp. 56-57, Honolulu, 1883. (HSPA)

This is a popular article, which includes suggestive discussion of control measures.

114. WHITE, F. B., Report on the pelagic Hemiptera procured during the voyage of H.M.S. "Challenger," in the years 1873-76: Rept. Voyage H.M.S. "Challenger," Zoology, vol. 7, 82 pp., 3 pls. (2 col.), London, 1883. (BM)

 Describes *Holobates sericeus* Esch., the principal species occurring in the waters about Hawaii. (See pp. 47-48, Pl. 1, fig. 7.)

115. BLACKBURN, THOMAS, Notes on some Hawaiian Carabidae: Ent. Month. Mag., vol. 21, pp. 25-26, London, 1884. (AF)

 Discusses Atrachynemis, *Anchomenus muscicola* Blackb., and Mauna n.gen. created for the insect hitherto called *Blackburni frigida* Blackb.

116. BLACHBURN, THOMAS, Notes on Hawaiian Neuroptera with descriptions of new species: Annals and Mag. Nat. Hist. 5th ser., vol. 14, pp. 412-421, 1884. (HSPA)

 The species described are: Odonata: *Agrion satelles* n.sp., *A. oahuense* n.sp., *A. nigro-hamatum* n.sp., *A. koelense* n.sp., *A. pacificum* Macl.—Hemerobiidae: Megalomus spp.—Chrysopidae: *Anomalochrysa maclachlani* n.sp., *A. montana* n.sp., *A. ornatipennis* n.sp.

117. KIRBY, W. F., On the Hymenoptera collected during the recent expedition of H.M.S. "Challenger": Annals and Mag. Nat. Hist., 5th ser., vol. 13, p. 402, 1884. (HSPA)

 This paper includes the following references to Hawaiian insects: Evaniidae *Evania laevigata* Latr. (p. 403).—Vespidae· *Polistes aurifer* Sauss. (p. 410), *P. carnifex* Fab. (p. 411).

118. OSTEN-SACKEN, C. R., Facts concerning the importation or non-importation of Diptera into distant countries: Ent. Soc. London Trans., pp. 489-496, 1884. (AF)

 These interesting historical notes relate to the introduction of the night mosquito, *Culex quinquefasiatus* Say.

119. SHARP, DAVID, On some genera of the subfamily Anchomenini (Platynini Horn.) from the Hawaiian Islands: Ent. Month. Mag., vol. 20, pp. 217-219, London, 1884. (AF)

 The following genera are discussed: Metromenus n.gen., Colpodiscus n. gen., Barypristus n.gen., Blackburni, Disenochus, Atrachycnemis and Cyclothorax.

120. BLACKBURN, THOMAS, and SHARP, DAVID, Memoirs on the Coleoptera of the Hawaiian Islands: Roy. Dublin Soc. Trans., 2d ser., vol. 3, pp. 119-290, pls. 4 and 5, 1885. (BM) ('AF) (HSPA)

 This resumé of knowledge of the Coleoptera of Hawaii includes descriptions of the following new genera and species: Dytiscidae: *Coplatus mauiensis* n.sp.—Staphylinidae: *Bolitochara impacta* n.sp., *Diestota montana* n.sp., *D. incognita* n.sp., *Myllaena pacifica* n.sp., *M. oahuensis* n.sp., *Oligota kauaiensis* n.sp., *O. longipennis* n.sp., *O simulans* n.sp., *O. variegata* n.sp., *O. prolixa* n.sp., *Lithocharis incompta* n.sp., *Oxytelus bledioides* n.sp., *Lispinodes quadratus* n.sp., *L. pallescens* n.sp.—Corylophidae: *Corylophus rotundus* n.sp., *C. suturalis* n.sp., *Sericoderus basalis* n.sp., *S. pubipennis* n.sp., *Orthoperus aequalis* n.sp.—Histeridae: *Bacanius atomarius* n.sp., *B. confusus* n.sp., *Acritus insularis* n.sp., *Aeletes longipes* n.sp., *A. concentricus* n.sp., *A.*

monticola n.sp., *A. facilis* n.sp.—Nitidulidae: *Gonioryctus fugitivus* n.sp., *G. similis* n.sp., *Brachypeplus olinda* n.sp., *B. torvus*, n.sp., *B. koelensis* n.sp., *B. floricola* n.sp., *B. celatus* n.sp., *B. apertus* n.sp., *B. quadracallis* n.sp., *B. parallelus* n.sp., *B. expers* n.sp., *B. spretus* n.sp., *B. bicolor*, n.sp., *B. discedens* Sh.var., *kauaiensis* n.var., and *B. blackburni* Sh.var. *lanaiensis* n.var.— Colydiidae: *Eulachus hispidus* n.sp.,—Cucujidae: *Brontolaemus* n.gen., *B. elegans* n.sp., *Laemorphloeus aeneus* n.sp., *Monanus brevicornis* n.sp., *Telephanus insularis* n.sp., *T. pallidipennis* n.sp.—Crytophagidae: *Telmatophilus debilis* n.sp.—Erotylidae: *Euxestus minor* n.sp., Eidoreus n.gen., *E. minutus* n.sp.—Coccinellidae: *Scymnus vividus* n.sp., *S. ocellatus* n.sp., *S. discendens* n.sp.—Dermestidae: *Attagenus plebeius* n.sp., Labrocerus n.gen., *L. jaynei* n.sp., *L. concolor* n.sp., *L. obscurus* n.sp., *Cryptorhopalum brevicorne* n.sp., *C. terminale* n.sp.—Eucnemidae: *Fornax bonvouloiri* n.sp., *F. sculpturatus* n.sp., *F. parallelus* n.sp., *F. longicornis* n.sp., *F. obtusus* *n.sp.*—Elateridae: Eopenthes n.gen., *E. basalis* n.sp., *E. obscurus* n.sp., *E. debilis* n.sp., *E. konae* n.sp., *E. ambiguus* n.sp., *E. satelles* n.sp., Itodacnus n.gen., *I. gracilis* n.sp.— Malacodermidae: *Helcogaster pectinatus* n.sp.,Caccodes n.gen., *C. debilis* n.sp.—Ptinidae: *Xyletobius insignis* n.sp., *X. affinis* n.sp., *X. serricornis* n.sp., *X. lineatus* n.sp., *Catorama pusilla* n.sp., *Mirosternus acutus* n.sp.—Bostrichidae: *Bostrichus migrator* n.sp.—Cioidae: *Cis bimaculatus* n.sp., *C. nigrofasciatus* n.sp., *C. longipennis*, n.sp., *C. apicalis* n.sp., *C. setarius* n.sp., *C. concolor* n.sp., *C. chloroticus* n.sp., *C. calidus* n.sp., *C. insularis* n.sp., *C. roridus* n.sp., *C. attenuatus* n.sp., *C. ephistemoides* n.sp., *C. vagepunctatus* n.sp.—Tenebrionidae: *Platydema obscurum* n.sp., Sciophagus n.gen. for *Heterophaga pandanicola* Esch., *Labetes tibialis* Wat., *Cistela crassicornis* n.sp., *Anthicus mundulus* n.sp., *Ananca collaris* n.sp.—Aglyceleridae: *Proterhinus linearis* n.sp., *P. scutatus* n.sp., *P. similis* n.sp., *P. laticollis* n.sp., *P. tarsalis* n.sp., *P robustus* n.sp., *P. ineptus* n.sp., *P. integer* n.sp., *P. detritus* n.sp., *P. longicornis* n.sp., *P. insignis* n.sp.—Curculonidae: Rhyncogonus n. gen., *R. blackburni* n.sp., *R. vestitus* n.sp., *Acalles lateralis* n.sp., *A. duplex* n.sp., *A. angusticollis* n.sp., *A. mauiensis* n.sp., *A. ignotus* n.sp., *A. decoratus* n.sp., Chaenosternum n.gen., *C. konanum* n.sp., Hyperomorpha n.gen., *H. squamosa* n.sp., *Calandra remota* n.sp., *Oodemas tardum* n.sp., *O. aequale* n.sp., *O. crassicorne* n.sp., *Heteramphus* n.gen., *H. wollastoni* n.sp., *H. foveatus* n.sp., *H. hirtellus* n.sp., *H. cylindricus* n.sp., *Pseudolus* n.gen., for *Rhyncolus longillus* Boh., Dolichotelus n.gen., *D. apicalis* n.sp.—Scolytidae: *Xyleborus obliquus* n.sp., *X. truncatus* n.sp., *X. rugatus* n.sp., *X. insularis* n.sp., *X. immaturus* n.sp., *X. frigidus* n.sp., *Hypothenemus griseus* n.sp.—Anthribidae: Mauia n.gen., *M. satelles* n.sp.—Cerambycidae: *Clytarlus blackburni* n.sp., *C. filipes* n.sp.

HAGEN, H. A., Monograph of the Embidina: Can. Ent., vol. 17, pp. 141-155, 1885. (HSPA) (AF) (UH)

Records *Ologotoma insularis* McLachl., in alcohol, from Honolulu, taken in a private garden greenhouse. (See p. 143.)

MEYRICK, EDWARD, Descriptions of New Zealand Micro-lepidoptera VII, Tortricina: N. Zeal. Inst. Trans., vol. 17, pp. 141-149 (1885). (BM)

Chiloides straminea Butl., originally described from Hawaii, is here recorded also in New Zealand (p. 142).

*REUTER, O. M., Monographia anthocoridarum orbis terrestis: Acta Soc. Sci. Fenn., vol. 14, pp. 555-758, 1885.

SHARP, DAVID, Note on the genus Plagithmysus Motsch.: Soc. Ent. Belg. Bull. for 1885, pp. LXXIV-LXXV (Compt. rend.), 1885.

This paper clears up the synonomy of this genus.

125. BLACKBURN, THOMAS, and CAMERON, PETER, On the Hymenoptera
of the Hawaiian Islands: Manchester Lit. Soc. Mem., ser. 3,
vol. 10, pp. 194-244, 1886. (BM)

This excellent paper includes the following descriptions: Anthophila:
Andrenidae: *Prosopis fuscipennis* Smith, *P. satellus* n.sp., *P. blackburni*
Smith, *P. facilis* Smith, *P. flavifrons* Kirby, *P. kona* n.sp., *P. coniceps* n.sp.,
P. rugiventris n.sp., *P. hilaris* Smith, *P. volatilis* Smith, *P. anthracina* Smith,
P. flavipes Smith.—Apidae: *Megachile diligens* Smith, *Xylocopa aeneipennis*
De Geer.—Fossores: Vespidae: *Polistes aurifer* Sauss., *P. hebraeus* Fab.,
Odynerus radula Fab., *O. extraneus* Kirby, *O. nigripennis* Holmgren, *O.*
dromedarius n.sp., *O. vulcanus* n.sp., *O. hawaiiensis* n.sp., *O. haleakalae* n.sp.,
O. congruus Smith, *O. dubiosus* Smith *O. rubritinctus* Smith, *O. blackburni*
Kirby, *O. montanus* Smith, *O. cardinalis* n.sp., *O. pacificus* n.sp., *O. rubro-*
pustulatus n.sp., *O. obscure-punctatus* n.sp., *O. diversus* n.sp., *O. agilis* Smith,
O. insulicola n.sp.—Crabronidae: Crabro *affinis* Smith, *C. mauiensis* n.sp.,
C. distinctus Smith, *C. mandibularis* Smith, *C. polynesialis* Cameron, *C. ab-*
normis, n.sp., *C. unicolor* Smith, *C. stygius* Kirby, *C. adspectans* n.sp., *C.*
rubro-caudatus n.sp.—Larridae: *Pison iridipennis* Smith, *P. hospes* Smith.—
Sphegidae: *Pelopaeus caementarius* Drury, *Mimesa antennata* Smith.—
Heterogena: Formicidae: *Camponotus sexguttatus* Fab., *Tapinoma melano-*
cephala Fab., *Prenolepis longicornis* Latr., *P. obscura* Mayr.—Poneridae:
Ponera contracta Latr., *Leptogenys insularis* Smith.—Myrmicidae: *Mono-*
morium specularis Mayr, *Tetramorium guineense* Fab., *Pheidole megacephala*
Fab., *Solenopsis geminata* Fab.—Oxyura: *Scleroderma polynesialis* Saunders,
Sierola testaceipes Cameron, *S. monticola* n.sp., *S. leuconeura* n.sp.—Tere-
brantia: Ichneumonidae: Pimplides, *Echthromorpha maculipennis* Holmgren,
E. flavo-orbitalis n.sp., *Pimpla hawaiiensis* n.sp.—Tryphonides: *Metacoelus*
femoratus Grav.—Ophionides: *Ophion lineatus* Cameron, *O. nigricans* Cam-
eron, *Limneria polynesialis* Cameron, *L. blackburni* Cameron, *L. hawaiiensis*
n.sp.—Braconidae: *Chelonus blackburni* Cameron, *Monolexis? palliatus* Cam-
eron.—Evaniidae: *Evania sericea* Cameron, *E. laevigata* Latr.—Chalcididae:
Epitranus lacteipennis Cameron, *Chalcis polynesialis* Cameron, *Spalangia*
hirta Haliday, *Moranila testaceipes* Cameron, *Solindenia picticornis* Cameron,
Eupelmus flavipes Cameron, *Encyrtus insularis* n.sp.

126. WALKER, J. J., Anosia plexippus Linn. (*Danais archippus* Fabr.):
A study in geographical distribution: Ent. Month. Mag., vol.
22, pp. 217-224, London, 1886. (AF)

Walker states that *Anosia plexippus,* "unobserved by the early voy-
agers to the Sandwich Islands, it is now abundant and firmly established
there." (p. 219).

127. CAMERON, PETER, Note on the Hymenoptera of the Hawaiian Islands:
Ent. Month. Mag., vol. 23, p. 195, London, 1887. (AF)

The species discussed are: *Odynerus nautarum=O. insulicola* Sm.,
Odynerus sandwichensis=O. rubritinctus Sm.

128. BAILEY, EDWARD, The flora and fauna of the Hawaiian Islands:
Haw. Ann. for 1888, pp. 49-54, Honolulu, 1887.

Contains a brief interesting account of the insects of the islands.

129 *BIGOT, J. M. F., Diptères nouveaux ou peu connus, 3ᵉ partie, XLI,
Tachinidae: Soc. Ent. France Ann., ser. 6, vol. 8, pp. 77-101,
1888.

Chaetogaedia monticola is described.

BLACKBURN, THOMAS, Notes on the Hemiptera of the Hawaiian Islands: Linn. Soc. N. S. W. Proc., 2d ser., vol. 3, pp. 343-354, 1888. (BM) (HSPA) (AF)

The following species are included: Scutatina: Aechalia sp., Coleotichus sp., *Geotomus subtristis* White, and *G. jucundus* White.—Lygaeina: *Nysius longicollis* n.sp., *N. mauiensis* n.sp., *N. whitei* n.sp., *Metrarga contracta* n.sp., *M. obscura* n.sp., *Capsina* sp.—Anthrocorina: *Acanthia lectularia* L., Cardiastethis sp., Lilia sp., Dilasia sp.—Emesidae: *Ploiariodes rubromaculata* n.sp., *P. pulchra* n.sp.—Nabina: *Nabis rubritinctus* n.sp., *N. oscillans*, n.sp., *N. innotatus* White, *N. koelensis* n.sp., *N. subrufus* White, *N. curtipennis* n.sp.—Saldina: *Salda oahuensis* n.sp.

MEYRICK, EDWARD, On Pyralidina of the Hawaiian Islands: Ent. Soc. London Trans., pp. 209-246, 1888. (AF) (US)

The material for this extensive list of moths was collected by Blackburn during his six-years' residence in the islands, 1877-1883. Some interesting notes on origin and distribution are included. The list follows: Pyralididae: *Asopia gerontialis* Walk.—Hydrocampidae: *Paraponyx linaelis* Gn.—Botydidae: *Margarodes exaula* n.sp., *Omiodes blackburni* Butl., *O. (Botys) accepta* Butl., *O. (Salbia) continuatalis* Wallgr., *O. (Botys) demaratalis* Walk., *O. monogona* n.sp., *O. liodyta* n.sp., *O. (Botys) localis* Butl., *Zinckenia recurvalis* F., *Scopula eucrena* n.sp., *S. (Locastra) monticolans* Butl., *S. (Aporodes) micacea* Butl., *S. (Mecyna) nigrescens* Butl., *S. (Mecyna) ennychioides* Butl., *S. (Melanomecyna) stellata* Butl., *S. argoscelis* n.sp., *S. (Rhodaria) despecta* Butl., Protocolletis n.gen., *P. (Scopula) constricta* Butl., *Mecyna (Anemosa) aurora* Butl., *M. virescens* Butl., *Orthomecyna albicaudata* Butl., *O. (Mecyna) exigua* Butl., *O. aphanopis* n.sp., *Mestolobes (Metasia) abnormis* Butl., *M. semiochrea* Butl., *M. minuscula* Butl., *Eurycreon litorea* Butl.—Scopariadae: *Scoparia frigida* Butl., *Xerocopa venosa* Butl., *X. melanopis* n.sp., *X. ambrodes* n.sp., *X. demodes* n.sp., *X. ischnias* n.sp., *X. hawaiensis* Butl., *X. pachysema* n.sp., *X. mesoleuca* n.sp., *X. (Scoparia) formosa* Butl., *X. (Scoparia) jacunda* Butl.—Pterophoridae: *Trichoptilus (Aciptilia) hawaiensis* Butl., *Platyptilia rhynchophora* n.sp., *P. cosmodactyla* Hb., *P. brachymorpha* nsp., *P. (Platyptilus) littoralis* Butl.— Crambidae: *Eromene ocellea* Hw., *Hednota (Gesneria) floricolens* (rect. *floricolans*) Butl., *H. (Scotomera) hydrophila* Butl., *H. oxyptera* n.sp.— Phycitidae: *Ephestia (Plodia) interpunctella* Hb., *E. desuetella* Walk., *E. eulella* Hb., *Homoeosoma (Ephestia) humeralis* Butl., *Genophantis* n.gen., *G. iodora* n.sp.—Galleriadae: *Achroea grisella* F.

RILEY, C. V., A Sandwich Island sugar-cane borer, *Sphenophorus obscurus* Boisd.: Insect Life, vol. 1, pp. 185-189, illus., 1888. (HSPA) (UH) (BM)

This paper gives a description of the several stages of development with references to the literature.

DALLA TORRE, K. W. v., Hymenopterolgische Notizen: Wien. Ent. Zeit., vol. 8, p. 124, 1889. (HSPA)

Contains the following note: *"Odynerus cardinalis* Blackb. u. Cam. 1886) non Mor. (1885)=*O. rudolphi M."*

KALAKAUA REX, An act relating to the suppression of plant diseases, blight, and insect pests: Laws of the Hawaiian Islands, chap. 2, 1890.

Section 2 relates to the prevention of introduction of any plant disease, blight, or insect pests injurious to vegetation, and extermination of such as

were already established. Section 3 deals specifically with the landing of plants or soil by the masters of vessels entering Hawaiian ports and makes provision for inspection. Section 4 provides for destruction of imported plants or other material found to be infested. Section 5 requires every person to immediately report infestation of vegetation wherever discovered. Section 6 provides for the enactment of further regulations preventing the introduction and spread of plant diseases, blight, and insect pests.

135. COQUILLETT, D. W., Icerya in Honolulu: Insect Life, vol. 3, p. 329, 1891.

Icerya is said to have made its appearance in the Hawaiian islands during the spring of 1889, but widely distributed in 1890—in about 50 gardens in Honolulu. The pest is thought to have come in on fruit from California. The predaceous Vedalia beetle was introduced from California, and by November, 1890, Icerya was rare.

136. RILEY, C. V., Rept. of the Ent., Rept. U. S. Dept. Agric. to Sec. Agric., p. 234, 1891.

Mr. Koebele left specimens of *Chilocorus bivulnerus* at Honolulu, while on his way from California to Sydney.

137. RILEY, C. V., and HOWARD, L. O., Introduction of Icerya into Honolulu: Insect Life, vol. 3, p. 307, 1891. (HSPA)

Refers to the introduction of Icerya from California and its successful control by introducing the Vedalia.

138. McLACHLAN, ROBERT, Supplementary note on the Neuroptera of the Hawaiian Islands: Annals and Mag. Nat. Hist., 6th ser., vol. 10, pp. 176-178, 1892. (HSPA)

McLachlan suggests that *Deielia fasciata* Kirby is probably a mistaken locality—since this dragon fly does not occur in Hawaii (p. 177). A new Myrmeleonidae, *Formicaleo wilsoni n.sp.*, from Lanai, is described.

139. KALAKAUA REX, An act to establish a bureau of agriculture and forestry: Laws of the Hawaiian Islands, Chapter 81, Sec. 4, 1892.

The act provides for guarding against the introduction of plant diseases or insect pests and the suppression of those already affecting agricultural products and live stock.

140. WARREN, W., Description of new genera and species of Pyralidae: Annals and Mag. Nat. Hist. Ann., ser. 6, vol. 9, pp. 429-442, 1892.

A new genus, Loxocreon, is created for Meyrick's Omiodes of the Hawaiian islands. Type *L. continuatalis* Wllngrn. (Salbia).

140a. KOEBELE, ALBERT, Studies of parasitic and predaceous insects in New Zealand, Australia, and adjacent islands: U. S. Dept. Agric., [Report No. 51] Washington, 1893. (BM)

Work in Honolulu is referred to on page 5 and again on page 11, where the following pests are discussed: Dactylopius spp., *Pulvinaria psidii* Mask., *Lecanium acuminatum* Sign., *L. depressum* Sign., and *L. longulum* Dougl. The introduction of *Cryptolaemus montrousieri* Muls. and Rhizobius spp. is recommended. Koebele further states that a number of *Chilocorus bivulenerus* Muls. were turned loose in good condition. He also found internal parasites preying upon the various species of Lecanidae in

Honolulu, and one of these he took to California in considerable numbers, liberating them in an orange orchard infested with *Lecanium oleae* Burm. and *L. hesperidum* Linn. A few species of Scymnids and *Coccinella abdominalis* Say. were also found. These insects are discussed also on page 23, where it is stated that the *Coccinella abdominales* was sent to California and liberated on *Lecanium hesperidum* Linn.; and that three small Scymnids were found among the insects sent from Honolulu.

MASKELL, W. M., Further coccid notes: with descriptions of new species from Australia, India, Sandwich Islands, Demerara, and South Pacific: N. Zeal. Inst. Trans., vol. 25, pp. 201-252, pls. 11-18, 1893.

The following Hawaiian species are described: *Lecanium acuminatum* Sign., *L. longulum* Dougl., *Pulvinaria psidii* n.sp., *Sphaerococcus bambusae* n.sp.

RILEY, C. V., and HOWARD, L. O., An injurious Hawaiian beetle (*Adoretus umbrosus*): Insect Life, vol. 6, p. 43, 1893. (HSPA) (UH)

This species was first noticed in Hawaii about 1891 and in 1893 it had already become a serious pest, riddling the leaves of many trees and plants.

THRUM, THOMAS, Bureau of Agriculture and Forestry: Haw. Ann. for 1894, pp. 92-94, Honolulu, 1893. (BM) (PL) (UH)

Refers to the engagement of Prof. A. Koebele to study the blight and insect enemies of vegetation and to discover remedies for them. Mentions consignments of coccinellids and toads from California.

DYAR, H. G., Preparatory stages of *Lephygama flavimaculata* Harv., and other notes: Can. Ent., vol. 26, pp. 65-69, 1894. (HSPA) (AF) (UH)

Includes description of all stages.

COOPER, ELWOOD, Address of the president: Calif. Sta. Bd. Hort, 4th Bien. Rept. 1893-4, pp. 240-250, Sacramento, 1894. (HSPA) (AF)

Refers to the engagement of Koebele by the Hawaiian Government to search for parasites in Australia (p. 246).

CRAW, ALEXANDER, Entomology and quarantine: Calif. Sta. Bd. Hort., 4th Bien. Rept. 1893-4, pp. 79-109, Sacramento, 1894, (US) (HSPA) (AF)

Records oleanders from Honolulu infested with scale, Aspidiotus sp. (pp. 79-80).

THRUM, THOMAS, Coffee outlook in Hawaii: Haw. Ann. for 1895, pp. 65-68, Honolulu, 1894, (BM)

A brief discussion of coffee blight and its control by introduced insects.

BRUNNER, v. WATTENWYL, On the Orthoptera of the Sandwich Islands: Zool. Soc. London Proc., pp. 891-897, 1895. (BM) (AF) (US)

The following species are included: Dermaptera: *Anisolabis littorea* White, *A. maritima* Bon., *A. pacifica* Erichs., *A. annulipes* Luc., *Labia pygidiata* Dubr., *Chelisoches morio* Fab., *Forficula hawaiensis* Borm.— Blattodea: *Phyllodromia heiroglyphica* Brun., *P. obtusata,* n.sp., *Stylopyga decorata* Brun., *Methana ligata* Brun., *Periplaneta americana* L., *Eleutheroda dytiscoides* Serv., *Leucophaea surinamensis* Fab., *Oniscosoma pallida* Brun., *Euthyrrapha pacifica* Conqueb.—*Acridiodea:* *Oxya velox* Fab.—Locustodea: *Elimaea appendiculata* Brun., *Brachymetopa discolor* Redtenb., *B. blackburni* Borm., *B. deplanata* n.sp., *B. nitida* n.sp., *Xiphidium fuscum* Fab.—Gryllodea: *Gryllus innotabilis* Walk., *G. poeyi* Sauss., *Paratrigonidium pacificum* (Scudd.), *P. atroferrugineum* n.sp., Prognathogryllus n.gen. ex tribu Prodoscirtium, *P. alatus* n.sp., *P. forficularis* n.sp.; the last two figured.

149. COCKERELL, T. D. A., Notes on the geographical distribution of scale insects: U. S. Nat. Mus. Proc., vol. 17, pp. 615-625, 1895. (BM) (UH)

The following are included from Hawaii (p. 621): *Dactylopius citri, Lecanium hesperidum, L. depressum, L. oleae, L. acuminatum, Asterolecanium pustulans, Pulvinaria psidii,* and *Sphaerococcus bambusae.* Only the last two were originally described from Hawaiian specimens.

150. COCKERELL, T. D. A., Miscellaneous notes on Coccidae: Can. Ent., vol. 27, pp. 253-261, 1895. (HSPA) (US)

Mentions *Asterolecanium pustulans* (Ckll.) on oleander from Honolulu (p. 259).

151. DYAR, H. G., Preparatory stages of *Phlegethontius cingulata* (*Sphinx convolvuli*): Ent. News, vol. 6, p. 95, 1895. (AF) (UH) (HSPA)

Includes descriptions of all stages.

152. KOEBELE, ALBERT, Report of the entomologist: Republic of Hawaii, Min. of Interior, Rept. for 1894, pp. 98-104, Honolulu, 1894. (US)

The report discusses injurious insects in Hawaii. Koebele says that though these are numerous they may be controlled by introducing natural enemies. He mentions some of the principal scale pests and reviews the numerous species of ladybird beetles sent from California to prey upon them.

153. MARSDEN, JOSEPH, Blights and insect pests: Republic of Hawaii, Min. Int. Rept. for the nine months ending Dec. 31, 1894, pp. 31-38, Honolulu, 1895.

This paper lists about three dozen species of Coccinellidae which were successfully sent from Australia and liberated in Hawaii to prey upon plant lice, scale insects, and red spiders. Control measures are discussed for the Japanese beetle (Adoretus) with suggestions for the introduction of moles, bats, and toads. Notes a suggestion from University of California that the caneborer (*Rhabdocnemis obscurus* Boisd.) is a native of New Ireland, and that this island is the place to search for parasites. Discusses the damage done by this pest in Fiji.

154. MARSDEN, JOSEPH, Blights and insect pests: Report to commissioners of Agriculture and Forestry: Rept. Min. Int. Repub. Haw., for 1895, pp. 118-120, 1896.

Records a marked decrease in scale pests, due to the introduction of natural enemies. This is particularly true in regard to the coffee scale, which

is said to be a thing of the past. The Japanese beetle is reported troublesome, also the red spider (*Tetranychus telarius*) on coffee, and cutworms on the canaigre plant.

MASKELL, W. M., Synoptical list of Coccidae reported from Australasia and the Pacific Islands up to December, 1894: N. Zeal. Inst. Trans., vol. 27, pp. 1-35, 1895. (BM)

The following are mentioned from Hawaii: *Aspidiotus aurantii* Mask., *A. longispina* Morg., *A. nerii* Bouché, *Diaspis boisduvalii* Sign., *D. rosae* Sandb., *Mytilaspis flava* Targioni-Tozzetti, var. *hawaiiensis* Mask., *M. pallida* Green, var. (?) Mask., *M. pomorum* Bouché, *Chionaspis* (?) *biclavis* Comst., var. *detecta* Mask., *C. prunicola* Mask., *Lecanium acuminatum* Sign., *L. longulum* Dougl., *L. nigrum* Niet., var. *depressum* Targioni-Tozzetti, *L. oleae* Bern., *Pulvinaria mammeae* Mask., *P. psidii* Mask., *Dactylopius vastator* Mask., *Sphaerococcus bambusae* Mask., *Icerya purchasi* Mask.

MASKELL, W. M., Further coccid notes with description of new species from New Zealand, Australia, Sandwich Islands, and elsewhere, and remarks upon species already reported: N. Zeal. Inst. Trans., vol. 27, pp. 36-75, pls. 1-7, 1895. (BM)

The following species concern Hawaii: *Aspidiotus longispina* Morg., *Diaspis boisduvalii* Sign., *Mytilaspis pallida* Green, *M. flava* Targioni-Tozzetti, *Chionaspis prunicola* n. sp., *C. biclavis* Comst., var. *detecta* n. var., *Pulvinaria mammeae* n. sp., *Dactylopius vastator* n. sp.

SHARP, DAVID, Cambridge Natural History, vol. 5, Insects, part 1, pp. 83-584, and vol. 6, Insects part 2, pp. 1-625, London, 1895. (BM) (UH)

In part 1, reference is made to *Oligotoma insularis* (p. 354) and to the numerous chrysopides in Hawaii (p. 471). The pecularities of Hawaiian Odonata are discussed (pp. 425-426). In part 2, the Hawaiian bees (Prosopis, pp. 21-22) and the peculiarities of Hawaiian wasps (Odynerus, pp. 76-77) are discussed.

TRYON, HENRY, New cane varieties and new diseases: The Plantters' Monthly, vol. 14, pp. 449-459, Honolulu, 1895.

Discusses the distribution of the beetle-borer (*Rhabdocnemis obscurus* Boisd.). This New Guinea borer is said to occur also in New Ireland, Tahiti, Fiji, and Hawaii.

ALFKEN, J. D., Zur Insectenfauna der Hawaiischen und Neuseelandischen Inseln. Ergebnisse einer Reise nach dem Pacific (Schauinsland 1896-7): Zool. Jahrb., 19 Band, Heft 5 (1903). (BM) (HSPA)

Includes notes on the various insects collected on the Hawaiian islands, including Laysan.

ALFKEN, J. D., Neue Orthopteren von Neuseeland und der Hawaiischen Inseln, nebst kritischen Bemerkungen zu einigen bekannten Arten. Ergebnisse einer Reise nach dem Pacific (Schauinsland 1896-7): Abh. nat. Ver. Bremen, vol. 17, pp. 141-152 (1901). (BM)

Paranemobius n.gen. and *P. schauinslandi* n.sp. are described (p. 145).

161. COCKERELL, T. D. A., A check-list of the Coccidae: Ill. Sta. Lab.
 Nat. Hist. Bull. 4, pp. 318-339, 1896. (HSPA)

 Lists the following from Sandwich Islands: *Dactylopius vastator* Mask.
 (p. 326), *Sphaerococcus bambusae* Mask. (p. 329), *Pulvinaria mammeae* Mask.
 (p. 330), *Mytilaspis flava*, var. *hawaiiensis* Mask. (p.336).

162. CRAW, ALEXANDER, A list of scale insects found upon plants enter-
 ing the port of San Francisco: U. S. Dept. Agric. Div. Ent.
 Bull. 4, Tech. ser., pp. 40-41, 1896. (AF) (UH)

 The following are listed from Honolululu: *Aspidiotus nerii* Bouché, on
 palms; *Asterolecanium pustulans* Ckll., on oleander; *Ceroplastes rubens* Mask.,
 on Asplenium fern; *Diaspis patellaeformis* Sasak., on shrub; *Dactylopius al-
 bizziae* Mask., on orange; *Icerya purchasi* Mask., on rose; *Lecanium hes-
 peridum* Linn., on orange; *Lecanium longulum* Dougl., on *Carica papaya; Le-
 canium perforatum* Newst., on palms; *Lecanium tessellatum* Sign., on ferns;
 Lecanium oleae Bern., on deciduous magnolia; *Pulvinaria psidii* Mask., on
 ferns, orange, coffee, pomegranate and avocado.

163. CRAW, ALEXANDER, Injurious insect-pests found on trees and plants
 from foreign countries: Calif. Sta. Bd. Hort., 5th Bien. Rept.
 for 1895-6, pp. 33-55, pls. 6-8, Sacramento, 1896. (US)

 The following references to Hawaii: *Chionaspis delecta* Mask. (p. 37),
 Diaspis patelliformis? Sasak. (p. 39), *Planchonia (Asterolecanium) pustulans*
 Cock. (p. 43), *Ceroplastes rubens* Mask. (p. 44), *Lecanium nigrum* Niet., *L.
 perforatum* News, and *L. tesselatum* Sign. (p. 46), *Pulvinaria psidii* Mask.,
 and *Adoretus umbrosus* Z. (p. 47).

164. CRAW, ALEXANDER, Entomology and quarantine: Calif. State Bd.
 Hort., 5th Bien. Rept. for 1895-6, pp. 127-135, Sacramento,
 1896. (US)

 Includes the following references to Hawaii: *Lecanium longulum* Doug.,
 taken on papaws (*Carica papaya*), and *Ceroplastes rubens* Mask. on ferns
 (pp. 127-8), and the mongoose (p. 135).

165. HOWARD, L. O., and MARLATT, C. L., The San Jose scale: U. S.
 Dept. Agric., Div. Ent. Bull. 3, n. ser., pp. 1-80, 1896. (HSPA)

 Mr. Koebele found this scale on the island of Kauai upon prune and
 peach trees imported from California, some trees having been utterly de-
 stroyed by the scale and others badly infested.

166. KORBELE, ALBERT, Report on insect pests: Haw. Planters' Monthly,
 vol. 15, pp. 590-598, Honolulu, 1896. (HSPA) (US)

 The following pests are discussed and suggestions given for their con-
 trol: the cane borer, *Sphenophorus obscurus* Boisd.; the coffee borer, *Aego-
 soma reflexum* Karsch.; the coconut pyralid, *Botys* sp.; the cut-worm, *La-
 phygma frugiperda* Hub.; the mole cricket, *Gryllotalpa* sp., the sugarcane
 mealy bug, *Dactylopius calceolaria* Mask.; and plant lice, *Aphis* sp.

167. MARLATT, C. L., Insect control in California: U. S. Dept. Agric.
 Yearbk., pp. 217-236, 1896. (BM)

 Includes a reference to the introduction of *Cryptolaemus montrousieri*
 Muls., which had been very successful in Hawaii in ridding coffee plantations
 of *Pulvinaria psidii* (p. 226).

168. PERKINS, R. C. L., A collecting trip on Haleakala, Maui, Sandwich Islands: Ent. Month. Mag., 2d ser., vol. 7, pp. 190-195, 1896. (BM) (AF)

169. SHARP, DAVID, On Plagithmysus, a Hawaiian genus of longicorn Coleoptera: Ent. Month. Mag., vol. 32, pp. 237-240, 241-245, 271-274, London, 1896.

The following species are described: *Plagithmysus vitticollis* n. sp., *P. newelli* n. sp., *P. concolor* n. sp., *P. solitarius* n. sp., *P. cuneatus* n. sp., *P. (Clytarlus) finschi* Har., *P. pulverulentus* Motsch., *P. bishopi* n. sp., *P. vicinus* n. sp., *P. bilineatus* n. sp., *P. lanaiensis* n. sp., *P. perkinsi* n. sp., *P. varians* n.sp., *P. darwinianus* n.sp., *P. (Clytarlus) blackburni* Sharp, *P. sulphurescenes* n. sp., *P. speculifer* n. sp., *P. aestivus* n. sp., *P. funebris* n. sp., *P. aequalis* n. sp., *P. arachnipes* n. sp., *P. (Clytarlus) cristalus* Sharp.

170. TOWNSEND, C. H. T., Some Mexican and Japanese injurious insects liable to be introduced into the United States: U. S. Dept. Agric. Div. Ent. Bull. 4, Tech. ser., pp. 9-25, 1896.

Includes several brief references to species occurring in the Sandwich Islands.

171. COCKERELL, T. D. A., San Jose scale and its nearest allies: U. S. Dept. Agric., Bur. Ent. Bull. 6, Tech. ser., 1897. (UH)

Morganella n. subg. is proposed for *maskelli* n. sp. (p. 22).

172. COCKERELL, T. D. A., Food plants of scale insects: U. S. Nat. Mus. Proc., vol. 19, pp. 725-785, 1897. (BM)

Most of the Hawaiian species are included in this extensive list.

173. COQUILLETT, D. W., Revision of the Tachinidae of America north of Mexico: U. S. Dept. Agric., Bur. Ent. Bull. 7, Tech. ser., 1897. (UH)

Chaetogaedia monticola Bigot is recorded from Hawaii, pp. 11 and 137.

173a. GUPPY, H. B., On the summit of Mauna Loa: Nature, vol. 57, p. 21, London, Nov. 4, 1897.

174. HAMPSON, G. F., On the classification of two subfamilies of moths of the family Pyralidae: the Hydrocampinae and Scoparianae: Ent. Soc. London, Trans., pp. 127-240, 1897. (HSPA)

The following references are given to Hawaiian species: on p. 227—*Xeroscopa melanopis* Meyr., *X. ombrodes* Meyr., *X. ichnias* Meyr., *X. demodes* Meyr., *X. pachysema* Meyr., *X. mesoleuca* Meyr., *X. venosa* Butl., *X. hawaiensis* Butl., *X. jucunda* Butl.; on p. 229—*Mestolobes abnormis* Butl., *M. minuscula* Butl., *M. semiochrea* Butl.; on p. 233—*Scoparia frigida* Butl., and *S. montana* Butl.

175. KOEBELE, ALBERT, Report of the entomologist of the Hawaiian Government: Haw. Planters' Month., vol. 16, pp. 65-85, Honolulu, 1897. (BM) (US) (HSPA)

This valuable paper deals with the work of Koebele from the time of appointment to December 31, 1896. Report is made upon the success of the introduced Australian ladybird beetle, *Crytolaemus montrouzieri* Muls., in controlling the following scale insects: *Dactylopius vastator* Mask., *D. ceri-*

ferus News., *D. chalceolariae* Mask., *D. adonidum Linn.*, and *Pulvinaria psidii*
Mask. Other scale insects mentioned are: *Aspidiotus aurantii* Mask., *A.
longispina* Morg., *A. duplex* Cock., *A. camelliae* Sign., *A. nerii* Bouché, and
several species of this genus; *Parlatoria sizyphi* News., *P. pergandei* Comst.,
Mytilaspis citricola Pack., *M. gloverii* Pack., *M. pallida* Green, *M. flava* Targ.-
Toz., *M. pomorum* Bouché, *Diaspis rosae* Sandb., *D. boisduvalii* Sign., *Chion-
aspis biclavis* Comst., *C. eugeniae* Mask., *C. prunicola* Mask., *Diaspis patelli-
formis* Sasaki, *D. amygdali* Tryon, *Fiorinia camelliae* Comst., *Ceroplastes
rubens* Mask., *C. ceriferus* Ander., *C. floridensis* Comst., *Lecanium acumi-
natum* Sign., *L. filicum* Boisd., *L. hemisphaericum* Targ.-Toz., *L. coffea* Niet.,
L. hesperidum Linn., *L. longulum* Doug., *L. mori* Sign., *L. nigrum* Niet., *L.
oleae* Bern., *L. tessellatum* Sign., *Pulvinaria mameae* Mask, *Eryococcus arau-
cariae* Mask., and *Icerya purchasi* Mask., also other undetermined coccids
present in the islands. About 200 species of ladybirds had been introduced
to prey upon the scale insects, also two species of fungi destructive to all the
Lecanidae. Remarking upon the introduced Coccinellidae, Koebele says that
only 3 species were present in Blackburn's time: *Coccinella abdominalis* Say,
Scymnus ocellatus Sharp, and *S. vividus* Sharp, and that these were evidently
introduced very early. Extensive notes are given upon the habits of the
various other exotic species introduced by the author. Of the other in-
troduced predators and parasites Koebele mentions syrphids and chrysopid
flies as established, and says *Chalcis obscurata* Walk. is active against various
pyralid and tortricid larvae. Mention is also made of the introduction of
bats from California—600 of which reached Hawaii alive but were apparently
not established. Toads from California and frogs from Japan reproduced
freely. Among cutworms the *Agrotis ypsilon* Rott., *A. saucia* Hbn., *Lecania
unipuncta* Haw., *Plusia verticillata* Guen., *Laphygma frugiperda* Hbn., are
mentioned; these have few parasites. Coffee trees are reported badly infested
by a white fly, Aleurodes sp.; natural enemies of these were introduced. *Ado-
retus umbrosus* F., probably introduced from Japan in soil, was reported from
Oahu, Maui, and Kauai. These insects will be controlled by the fungus in
the wet districts. Notes are given on life history, food plants, and natural
enemies, with full discussion of the experiments with fungus. The small
green tineid larvae destructive to the leaves of sweet potatoes (native "po-
nallo") and the somewhat allied *Plutella cruciferarum* Z. are mentioned
briefly.

176. MASKELL, W. M., Further coccid notes with new species and dis-
cussion of points of interest: N. Zeal. Inst. Trans., vol. 29,
pp. 293-331, pls. 18-22, 1897. (BM)

The species described which concern Hawaii are: *Chionaspis eugeniae*
Mask and *Ceroplastes rubens* Mask.

177. MASKELL, W. M., On a collection of Coccidae, principally from
China and Japan: Ent. Month. Mag., vol. 33, pp. 239-244,
London, 1897. (AF) (HSPA)

The following species are recorded from Hawaii: *Aspidiotus cydoniae*
Comst., on casuarina; same, var. *tecta*, n. var., on ohia trees; *Aspidiotus
longispina* Morg., on kukui trees; *Lecanium hesperidum* Linn., on papaya and
on ohia trees.

178. PERKINS, R. C. L., The introduction of beneficial insects in the Ha-
waiian Islands: Nature, vol. 55, pp. 499-500, 1897. (BM)

This article deals principally with scale insects and the reasons for the
success of their introduced natural enemies. Perkins says: "Few countries
have been more plagued by the importation of insect pests than the Hawai-

ian Islands; in none have such extraordinary results followed the introduction of beneficial species to destroy them."

179. PERKINS, R. C. L., Notes on *Oligotoma insularis* McLach. (Embiidae) and its immature conditions: Ent. Month. Mag., 2d ser., vol. 8, pp. 56-58, London, 1897. (BM) (AF)

Discusses development and habits.

180. *PERKINS, R. C. L., Notes on some Hawaiian insects: Phil. Soc. Cambridge Proc., vol. 9, pp. 373-380, 1897.

181. SHARP, DAVID, On Plagithmysus, a Hawaiian genus of longicorn Coleoptera: Ent. Month. Mag., vol. 33, suppl. p. 12, London, 1897. (AF) (HSPA)

Description given of *Plagithmysus albertisi* n. sp., collected in West Honolulu by Signor d'Albertis in 1874.

182. WALSINGHAM, LORD, Western equitorial African Microlepidoptera: Ent. Soc. London Trans., pp. 33-67, pls. 2, 3, 1897.

Describes *Monopis* Hb. (*Blabophanes Z.*) *longella* Wlk. recorded from the Hawaiian islands (Honolulu).

183. ALFKEN, J. D., *Megachile schauinslandi* n.sp. Eine neu Megachileart aus Honolulu: Ent. Nachr., vol. 24, pp. 340-341, 1898. (HSPA)

184. CLARK, B. O., Official bulletin of the Bureau of Agriculture: The Hawaiian, vol. 1, p. 6, Honolulu, Aug. 13, 1898.

The Hawaiian was a weekly newspaper which started February 12, 1898, its object being to advertise the islands. Mr. Clark, then secretary and commissioner of the Hawaiian Bureau of Agriculture, edited a page dealing with agricultural subjects. The only complete file, so far as known is owned by Mrs. B. J. Mesick, 2029 Beckley Street, Honolulu, widow of the editor, L. H. Mesick. This, the first reference dealing with the melon fly (*Dacus cucurbitae* Coq.) in Hawaii or elsewhere, consists of correspondence. A letter dated August 8, 1898, from L. C. Swain, Laupahoehoe, Hawaii, described this new pest, which he had observed affecting pumpkins, squashes, beans, tomatoes, and watermelons. Mr. Clark, in his reply gave the life history of the flies, which he had observed carefully the previous year near Honolulu; he also suggested measures of control.

A complete copy of this correspondence appears in Haw. Agric. Exp. Sta. Rept. for 1907, pp. 30-31, also in U. S. Dept. Agric. Bull. 491, pp. 57-58, 1917.

185. COCKERELL, T. D. A., The Coccidae of the Sandwich Islands: Ent., vol. 31, pp. 239-240, London, 1898.

The species described are: *Icerya purchasi* Mask., *Sphaerococcus bambusae* Mask., *Asterolecanium pustulans* Ckll., *Dactylopius citri* Risso., *D. albizziae* Mask., *D. vastator* Mask., *D. virgatus* Mask. (syn. *ceriferus* Newst.), *Ceroplastes rubens* Mask., *Lecanium nigrum* Nietn., *L. nigrum*, var. *depressum* Targ., *L. hesperidum* L., *L. oleae* Bern., *L. acuminatum* Sign., *L. longulum* Dougl., *Pulvinaria mammeae* Mask., *P. psidii* Mask., *Aspidiotus aurantii* Mask., *A. longispina* Morg., *A. hederae Vall.*, var. *nerii* Bouché, *A. cydoniae* Comst., *A. maskelli* Ckll., *A. persearum* n. sp. *A. perniciosus* Comst., *Mytilaspis gloverii* Pack., *M. hawaiiensis* Mask., (as var. of *flava*), *M. pomorum* Bouché, *M. pallida* Green, var. *maskelli* Ckll., *Howardia biclavis* Comst., var.

detecta Mask., *Chionaspis prunicola* Mask. (syn. of *Diaspis amygdali* Tryon), *C. eugeniae* Mask., *Fiorinia fioriniae* Targ., *Aulascaspis boisduvalii* Sign., *A. rosae* Bouché.

186. HAMPSON, G. F., A revision of the moths of the superfamily Pyraustinae and family Pyralidae: Zool. Soc. London Proc., pp. 590-761, 1898.

The following Hawaiian species are included: *Nacoleia blackburni* Butl., *N. accepta* Butl., *N. continentalis* Wllgrn., *N. demaratalis* Wlk., and *N. localis* Butl. (p. 699).

187 HOWARD, L. O., On some new parasitic insects of the subfamily Encyrtinae: U. S. Nat. Mus. Proc., vol. 21, pp. 231-248, 1898. (BM)

Blepyrus marsdeni n. sp. is described from Honolulu (p. 234).

188. KIRBY, W. F., Description of a new genus of Odonata: Annals and Mag. Nat. Hist., 7th ser., vol. 2, pp. 346-348, 1898. (HSPA)

Describes Nesogonia n.gen., *N. blackburni* McL. Also published in Haw. Planters' Mo. vol. 17. pp. 208-219 and 258-269, Honolulu, 1898. (BM) (US) (HSPA).

189. KOEBELE, ALBERT, Report of Prof. Albert Koebele, Entomologist of the Hawaiian Government: Rept. Min. Int. Repub. Haw. for 1897, pp. 105-137, Honolulu, 1898. (BM) (US) (HSPA)

Most of this report is a repetition of the valuable report presented by this author the previous year (see No. 175). New matter, starting on page 130, deals with natural enemies of pests observed in California, Arizona, and Mexico.

190. MASKELL, W. M., Further coccid notes with descriptions of new species and discussion of points of interest: N. Zeal. Inst. Trans., vol. 30, pp. 219-252, 1898. (BM)

Includes a discussion of *Aspidiotus cydomae* Comstock, var, *tecta* n. var., from Hawaii (p. 224).

191. MAXWELL, WALTER, The Hawaiian Islands: U. S. Dept. Agric. Yearbook for 1898, pp. 563-582, 1899.

Includes a brief note on quarantine against insect pests and plant diseases and a letter from Mr. Koebele (p. 574).

192. ALFKEN, J. D., Die Xylocopa-art der Hawaiian Islands: Ent. Nachr., vol. 25, pp. 317-318, 1899. (HSPA)

The introduced bee, commonly known in Hawaii as *Xylocopa aeneipennis* Deg., is here considered to be the Asiatic species, *X. chloroptera* Lep.

193. BRIGHAM, W. T., Hawaiian feather work: B. P. Bishop Mus. Mem., vol. 1, No. 1, Honolulu, 1899.

Contains interesting references to the development of kahilis and their relation to house flies.

194. COCKERELL, T. D. A., The Coccidae of the Sandwich Islands: Ent., vol. 32, pp. 93, 164, 1899. (AF)

Discussed the distribution of what were considered endemic Hawaiian species, namely: *Kermicus* (formerly *Sphaerococcus*) *bambusae*, which also

occurs in Ceylon, Mauritius, and Brazil; *Dactylopius vastator*, also found in Mauritius; and *Mytilaspis hawaiiensis*, which has been found at Amoy, China. The following are to be added to the Hawaiian list: *Aspidiotus (Evaspidiotus) transparens* Green, *A. (Hemiberlesia) greeni* Ckll., and a young Icerya, indeterminable. Cockerell adds the following species from Koebele's report to his list of Hawaiian coccids: *Dactylopius calceolariae* Mask., *D. adonidum* Linn. (but probably *citri*), *Eriococcus araucariae* Mask., *Ceroplastes ceriferus* Anders., *C. floridensis* Comst. (these two often introduced but not established), *Lecanium hemisphaericum* Targ., *L. mori* Sign., *L. tessellatum* Sign., *Parlatoria zizyphis* Luc., *P. proteus*, var. *pergandei* Comst., *Mytilaspis beckii* E. Newman (*M. citricola* Pack.), *Aspidiolus rapax* Comst., *A. duplex* Ckll. (p. 164). There are also mentioned two unidentified species of Pulvinaria.

*COCKERELL, T. D. A., A check-list of the Coccidae. First supplement: Ill. Sta. Lab. Nat. Hist. Bull. 5, pp. 389-398, 1899.

COQUILLETT, D. W., A new trypetid from Hawaii: Ent. News, vol. 10, pp. 129-130, 1899.

Describes *Dacus cucurbitae* n.sp.: two males and two females bred by George Compere from larvae in green cucumbers.

EMERY, CARLOS, Ergebnisse einer Reise nach dem Pacific (Schauinsland 1896-97), Formiciden: Zool. Jahrb., vol. 12, Syst., pp. 438-440, 1899. (HSPA)

Describes four species of ants collected from Laysan: *Monomorium gracillimum* F.Sm., *Tetramorium guineense* Fabr., *Tapinoma melano-cephalum* Fabr., *Ponera punctatissima* Rog., *schauninslandi* n.subsp.

FOREL, AUGUST, Heterogyna (Formicidae): Fauna Haw., vol. 1, pp. 116-122, 1899.

HAUGHS, DAVID, Insect pests and diseases: Report Commissioner of Agriculture: Rept. Min. Int. Repub. Haw. for bien. period ending 1899, pp. 120-123, Honolulu, 1900. (US) (AF)

Consists of a report by Professor Koebele of a trip to Australia in search of parasites, primarily for the cane-borer. The Mediterranean fruit fly is noted as a bad pest in Australia, a condition which led to a quarantine of Australian fruit. Other exotic fruit flies are also discussed.

*HOWARD, L. O., Economic status of insects as a class: Sci., n.s., vol. 9, p. 241, 1899.

KIRKALDY, G. W., Eine neue hawaiische Fulgoriden-Gattung und Art: Ent. Nachr., vol. 25, p. 359, 1899. (HSPA)

Phalainesthes n.gen., *P. schauinslandi* n.sp., are described from Hilo.

KOEBELE, ALBERT, Report of the entomologist: Republic of Hawaii, Min. of Int., Rept. for 1898, pp. 84-87, Honolulu, 1899. (US) (AF)

Records the introduction of the hornfly, *Haematobia irritans* Linn.

*KONINGSBERGER, J. C., Erste overzicht der schadelijke en nuttige Icesten van Java: Mededeelingen uit 's lands plantentuin, vol. 22, pp. 1-53, 1899.

204. MEYRICK, EDWARD, Macrolepidoptera: Fauna Hawaiiensis, vol. 1, pp. 123-275, pls. 3-7, 1899.

This is the most extensive work on this group; it includes descriptions of many new species.

205. PERKINS, R. C. L., Hymenoptera aculeata: Fauna Hawaiiensis, vol. 1, pp. 1-122, pls. 1, 2, 1899.

This is the most extensive work on this group; it contains descriptions of many new species.

206. PERKINS, R. C. L., Orthoptera: Fauna Hawaiiensis, vol. 2, pp. 1-30, pls. 1, 2, 1899.

This is the most extensive work on Orthoptera; it contains descriptions of many new species.

207. PERKINS, R. C. L., Neuroptera: Fauna Hawaiiensis, vol. 2, pp. 31-89, pls. 3-5, 1899.

This is the most extensive work on Neuroptera; it contains descriptions of many new species.

208. SCHAUINSLAND, H., Drei Monate auf einer Korallen-Insel (Laysan), Bremen, 1899. (HSPA)

The insects listed are Lepidoptera: Noctuidae: *Apamea chersotoides* Butl., *Spaelotis crinigera* Butl.—Pyralidae: *Zinckenia recurvalis* F., also an undetermined tineid.—Hemiptera: Nabis sp.—Hymenoptera: *Chelonus cameroni* D.T. (=*carinatus* Cam.).—Coleoptera: *Dermestes domesticus* Garm., *Clytus crinicornis* Chevr., *Silvanus surinamensis* Linn., *Tribolium ferrugineum* Fab., also an abundance of roaches, Periplaneta (pp. 102-103). The flies and ants are not included in this paper.

209. ASHMEAD, W. H., Notes on some New Zealand and Australian parasitic Hymenoptera: Linn, Soc. N.S.W. Proc., vol. 25, pp. 327-360, 1900.

Describes the Pteromalid, *Tomocera californica*, parasite for *Lecanium oleae*, p. 345.

210. DYAR, H. G., Larvae from Hawaii—a correction: Can. Ent., vol. 32, pp. 156-158. (HSPA) (AF) (UH)

Spodoptera mauritia Boisd. is described as *Laphygma flavimaculata* Harv. in Can. Ent., vol. 26, p. 65, 1894. Other caterpillars described are: *Lycaena boetica* Linn., *Plusia chalcites* Esp., and *Omiodes blackburni* Butl. It is also noted that *Sphinx convolvuli* is the insect described as *Phlegethontius cingulata* in Ent. News, vol. 6, p. 95.

211. *FRANK, A. B., and KRUEGER, F., Schildlausbuch . . . Berlin, p. 120, 1900.

Records *Aspidiotus pernicosus* from Hawaii, p. 70.

212. HOWARD, L. O., A dipterous enemy of cucurbits in the Hawaiain Islands: U. S. Dept. Agric., Div. Ent. Bull. 22, n.ser., pp. 93-94, 1900.

Specimens were received March 13, 1899, from George Compere, Honolulu, of what is locally known as the melon fly. This was pronounced by Coquillett to be a new species, to which he gave the name, *Dacus cucurbitae*.

213. KOEBELE, ALBERT, Report: Haw. Sugar Planters' Exp. Sta. Rept., pp. 40-42, 1900. (US)

Records an examination of the dying roots of sugarcane: no organic disease could be found, though the epidermis of roots had been broken, probably by wind.

214. KOEBELE, ALBERT, Diseases of the cane: The Planters' Monthly, vol. 19, pp. 519-524, 1900.

Discusses the distribution, food plants, habits, and control measures of the sugar cane beetle borer, *Rhabdocnemis obscurus*; also includes brief notes on the pyralid moth *Omiodes accepta* Butl.

215. KOEBELE, ALBERT, Report of Prof. Albert Koebele, entomologist: Rept. Comr. Agric. and Forestry for 1900, pp. 36-49, 1901. (US)

Koebele reports the introduction of parasites from California for *Pieris rapae*, *Plutella cruciferarum*, and various cutworms. Salamanders were also brought over. Notes Lecanidae kept in check now by many ladybirds; other predators and parasites sent from Fiji and Australia. A brief review of exotic fruit flies is included, with remedies. Fuller's rose beetle, *Aramigus fulleri* Horn, is found to be the same as the so-called Olinda bug. A tineid larva of cotton bolls (*Geleckia gossypiella* Sndrs.) is reported; a tortricid, also bred from cotton bolls, and a common beetle, *Araeocerus fasciculatus* De.G. Japanese beetles are reported from all parts of the islands. Suggestions on various phases of the production of silk as an industry for the islands terminates this paper.

216. KOEBELE, ALBERT, Destruction of forest trees: Rept. Comr. Agric. and Forestry Hawaii, for 1900, pp. 50-60, 1901. (US)

Discusses the depredation of insects on forest trees of Hawaii. *Icerya purchasi* Mask. is under control, the ladybird beetle, *Vedalia cardinalis*, being abundant. Other scale insects mentioned are *Lecanium nigrum* Neit., *L. longulum* Doug., and *Pulvinaria psidii* Mask. which are also well checked by introduced natural enemies. The same is said in regard to the mealy bugs, *Dactylopius ceriferus* News., on *Erythrina monosperma*. Notes on the span worm, *Scotorythra idolias*, a tortricid, and on a Bruchus destructive to the seed of the koa tree. The list of Cerambycid beetles noted includes: *Plagithmysus varians* Shp., *P. pulverulentus* Motsch., *P. cristatus* Shp., *P. aequalis* Shp., *P. arachnipes* Shp., *P. darwinianus* Shp., *P. blackburni* Shp., *P. funebris* Shp., *P. bilineatus* Shp., *P. bishopi* Shp. *P. vicinus* Shp., *P. collaris* Shp., *P. diana* Shp., *P. finschi* Har., *P. pulvillatus* Karsch, *P. lanaiensis* Shp., *P. aestivus* Shp., *P. concolor* Shp., *P. permundus* Shp., *P. perkinsi* Shp., *P. lamarckianus* Shp., *Clytarlus filipes* Shp., *C. mediocris* Shp., *C. debilis* Shp., *C. claviger* Shp., *C. nodifer* Shp., *C. modestus* Shp., *C. laticollis* Shp., *C. pennatus* Shp., *C. fragilis* Shp., *C. longipes* Shp., *C. annectens* Shp., and *Callithmysus microgaster* Shp. Koebele considers the worst pest of the native forest to be cattle (pp. 57-59).

217. KOEBELE, ALBERT, Notes on insects affecting the koa trees: Rept. Bd. Comr. Agric. and Forestry, Hawaii, 1900, pp. 61-66, 1901, (US)

The insects noted are: *Parandra puncticeps* Sharp, *Aegosoma reflexum* Karsch in the dead wood of the decaying forest. The living trees affected by the "Olinda bug," *Pandamorus olindae* Perk., by tortricid and geometrid larvae, and by a fungoid disease.

218. KOEBELE, ALBERT, Hawaii's forest foes: Haw. Ann. for 1901, pp. 90-97, Honolulu, 1900.

Discusses causes' of the disappearing forests of the islands, describing the various species of insects that attack trees, with their natural enemies.

219. MEYRICK, EDWARD, New Hawaiian Lepidoptera: Ent. Month. Mag., vol. 36, pp. 257-258, 1900. (HSPA) (AF)

The specimens described were collected by Professor Schauinsland. *Agrotis eremioides* n.sp. and *A. procellaris* n.sp., were obtained at Laysan, and *Scotorythra diceraunia* n.sp., *S. triscia* Meyr., *Phlyctaenia synastra* Meyr. came from Molokai.

220. *PERKINS, R. C. L., Introduction of beneficial insects into the Hawaiian Islands: Berlin Ent. Zeit., pp. 45-46, 1900.

This is a resumé of an article that appeared in Nature, vol. 55, pp. 499-500, 1897.

221. PERKINS, R. C. L., Coleoptera, Rhynchophora, Proterhinidae, Heteromera, and Cioidae: Fauna Hawaiiensis, vol. 2, pp. 117-270, pls. 7-10, 1900.

The most extensive work dealing with these groups; it contains descriptions of many new species.

222. SHARP, DAVID, Coleoptera Phytophaga: Fauna Hawaiiensis, vol. 2, pp. 91-116, pl. 6, 1900.

The most extensive work on this group; it contains descriptions of many new species.

223. THOMAS, W. B., Farming in Hawaii: Haw. Ann. for 1901, pp. 124-128, 1900. (BM)

Includes a brief reference to insect pests which are said to make it almost impossible to grow certain vegetables (p. 127).

224. VAN DINE, D. L., A partial bibliography of Hawaiian entomology: U. S. Dept. Agric., Office Exp. Stations Bull. 170, pp. 52-59, 1906.

225. BALL, S. C., Migration of insects to Rebecca Shoal Light-Station and the Tortugas Islands, with special references to mosquitoes and flies: Carnegie Inst. Wash., Pub. No. 252, pp. 193-212. 1918.

Contains an interesting note on the observation of house flies migrating long distances in a small boat (p. 208).

HAWAIIAN LEGENDS

BY
WILLIAM HYDE RICE

Bernice P. Bishop Museum
Bulletin 3

Honolulu, Hawaii
Published by the Museum
1923

Wm Hyde Rice

CONTENTS

PREFACE

The collection of Hawaiian legends of which a translation is given in the following pages represents the work of many years by William Hyde Rice of Kauai. However, it is only within the last few years that Mr. Rice has translated the legends from his Hawaiian manuscripts. He has tried to make his version as literal as possible, preserving at the same time the spirit of the original Hawaiian, its flavor, rhythm, and phrasing. He has avoided adding modern embroidery of fancy, as well as figures of speech foreign to the Hawaiian language and to its mode of thought and expression.

For the furtherance of this aim, Mr. Rice has spent much of the past year in a complete review of his translation, adding and rejecting, and in every way attempting to approximate the spirit and letter of the Hawaiian.

Mr. Rice has been exceptionally well prepared for this work, as he has been familiar with the Hawaiian language from his earliest childhood. In fact until he was twenty, he never *thought* in English but always in Hawaiian, translating mentally into his mother tongue. In 1870 when he became a member of the House of Representatives, during the reign of Kamehameha V, Governor Paul Kanoa and S. M. Kamakau, the historian, both well-known Hawaiian scholars, gave Mr. Rice much help with his Hawaiian, especially teaching him the proper use of various complicated grammatical constructions, and explaining obscure variations in pronunciation and meaning.

The sources of the legends in this collection are varied. A number of the stories Mr. Rice remembers having heard as a child, and other rarer ones were gathered in later years. Many are from more than one source, but have corresponded even in details, and almost word for word. The legend of Kamapuaa, for instance, is one of the first which Mr. Rice remembers hearing. When a boy, the places mentioned in this story were pointed out to him: the spot where the demi-god landed, where he found the hidden spring, and where he rooted up the natives' sugar-cane and sweet potatoes. The story of "The Small Wise Boy and the Little Fool" he has also been familiar with since childhood. The places mentioned in this tale can likewise be pointed out.

Most of the legends are from Kauai sources, but a number have been gathered from the other islands of the group. Whenever Mr. Rice heard of an old Hawaiian who knew any legends, he went to him, sometimes going to several to trace a special story, as for instance, the "Jonah and the Whale" story, "Makuakaumana", which after a long search he finally procured from Mr. Westervelt. This curious story seems to be more modern than the others of the collection. While hunting for a reliable

version of this story, Mr. Rice incidentally heard the story of "Manuwahi" at Heeia from an old Hawaiian.

"The Bird Man", "Holuamanu", "The Destruction of Niihau's Akua", and "The Girl and the Mo-o", were obtained mainly from Mr. Francis Gay, who is one of the best living scholars of the Hawaiian language. The Niihau legend was heard from several other sources as well. Mr. Gay also gave the legends of the "Rainbow Princess" and the "Shrimp's Eyes"; the ti plants mentioned in the latter legend can still be pointed out, growing at the mouth of a little valley near Holuamanu. The Hawaiian manuscript of part of the Menehune story was obtained from J. A. Akina, while the story of the "Rain Heiau" was told to him in 1912 by a man named Naialau, who has since died at Kalaupapa. "How Lizards Came to Molokai" and "Paakaa and Ku-a-paakaa" were told Mr. Rice by a man from Hawaii named Wiu, while the Rev. S. K. Kaulili, who is still living at Koloa, Kauai, gave him the most complete version of the "Rolling Island".

During Mr. George Carter's term as Governor, a reception was given in his honor, at Hanalei, where Mr. Rice was much interested in the very fine *oli* (chanting) of an old Hawaiian, named Kaululua. From him he obtained a number of legends, including that of "Ulukaa" and corresponding versions of others already in his collection. Other legends have been lost forever on account of ill-timed ridiculing by some chance companion, for Mr. Rice has found that the old people who know the legends are very sensitive, and when they find an unsympathetic auditor, refuse to continue their stories.

Mr. Rice's theory as to the origin of these legends is based on the fact that in the old days, before the discovery of the islands by Captain Cook, there were bards and story-tellers, either itinerant or attached to the courts of the chiefs, similar to the minstrels and tale-tellers of medieval Europe. These men formed a distinct class, and lived only at the courts of the high chiefs. Accordingly, their stories were heard by none except those people attached to the service of the chiefs. This accounts for the loss of many legends, in later years, as they were not commonly known. These bards or story-tellers sometimes used historical incidents or natural phenomena for the foundation of their stories, which were handed down from generation to generation. Other legends were simply fabrications of the imagination, in which the greatest "teller of tales" was awarded the highest place in the chief's favor. All these elements, fiction combined with fact, and shrouded in the mists of antiquity, came, by repetition, to be more or less believed as true.

This class of men were skillful in the art of the *apo*, that is, "catching" literally, or memorizing instantly at the first hearing. One man

would recite or chant for two or three hours at a stretch, and when he had finished, his auditor would start at the beginning of the chant and go through the whole of the *mele* or story without missing or changing a word. These trained men received through their ears as we receive through our eyes, and in that way the ancient Hawaiians had a spoken literature, much as we have a written one. Mr. Rice has several times seen performances similar to the one described, where the two men were complete strangers to each other.

To the readers of this collection of Hawaiian legends the following biographical information will be of interest:

William Hyde Rice, the only son of William Harrison and Mary Hyde Rice, was born at Punahou, Honolulu, Hawaii, on July 23, 1846. At that time his parents, who had come to the islands as missionaries in 1840, were teachers at the school which had been established at Punahou in 1842 for the children of missionaries.

In 1854 the family moved to Lihue, Kauai, where the greater part of Mr. Rice's life has been spent. Besides his sisters his only young companions were Hawaiian boys, from whom as well as from his nurse, he readily learned the language. After a few years of teaching at home the boy was sent to Koloa, Kauai, to attend the boarding school of the Rev. Daniel Dole, whose son, Sanford Ballard Dole, was one of the boy's closest companions. Later, Mr. Rice attended Oahu College, Punahou, and Braton's College in Oakland, California.

Mr. Rice served in the House of Representatives from 1870 to 1872 (the year of his marriage to Miss Mary Waterhouse in Honolulu), 1873, 1882, 1887, 1889, and 1890, and as a member of the Senate from 1895 to 1898. He was one of the thirteen committeemen who waited upon King Kalakaua, giving him twenty-four hours to sign the constitution, and was Governor of Kauai under Queen Liliuokalani until after the revolution in 1893.

In the present translation Mr. Rice has received much able and sympathetic assistance from Miss Katherine McIntyre in a secretarial capacity, extending over a period of several years. Miss Ethel Damon has been of inestimable value in her sound judgments and encouragement, and it has been my privilege to assist my grandfather during the past year. No one who has only read these legends can fully appreciate the charm of them as told by Mr. Rice in person. Many of them he still recites word for word in Hawaiian. One of the most vivid memories of my childhood will always be that of hearing my grandfather tell these legends, as he pointed out to us the places mentioned in the stories.

Lihue, January, 1923. Edith J. K. Rice.

HAWAIIAN LEGENDS

By William Hyde Rice

THE GODDESS PELE

Pele was the daughter of Moemo and Haumea, both well-known names in the oldest Hawaiian legends. Many other children were born to this couple, seven illustrious sons and six distinguished daughters. The youngest sister of Pele, Hiiaka-ika-poli-o-Pele, was born into the world as an egg. Pele concealed this egg under her arm until the child was hatched, and ever afterwards showed great affection for her.

When Pele had grown to womanhood, she begged her parents' consent to travel. This was granted, and wrapping Hiiaka in her pa-u, or tapa skirt, the adventurous Pele set forth.

She traveled first to the kingdom of her brother, Kamohoalii, Champion of the King. When he inquired where she was going Pele replied, "I shall first find Pola-pola. From there I shall go to the land of Kauihelani, where Kane hides the islands. I shall then find the far-reaching lands, the kingdom of Kaoahi, the Fire-Thrower—Niihau."

To help his sister in this long journey Kamohoalii gave her the canoe of their brother, the Whirlwind, Pu-ahiuhiu, and his paddlers, the Tide, Keaulawe, and the Currents, Keau-ka. Stepping into this canoe Pele was snatched away at once by the wind. Kamohoalii looked after her and called, "Go your way. I shall soon follow with your relations."

In a short time Pele, borne by the magic canoe, reached Niihau. She ordered the canoe to return to her brother as she hoped the queen would give her another one. Then, crossing the salt marshes, she came at evening to the dwelling of the queen, Kaoahi, whose guards cried out that a beautiful stranger was coming. When Pele was brought before Kaoahi her beauty astonished the queen, who had never before seen a woman whose back was as straight as a *pali* and whose breasts were rounded like the moon.

Great aloha grew in the heart of the queen for her guest, and before eating together they took the oath of friendship. Then they retired to the beds made of fine Niihau mats where they slept until the cocks crowed.

Early in the morning the queen sent forth her messengers to summon the *konohiki*, the overseers of the land, who were ordered to instruct all

the people of the island to bring presents for Kaoahi's great friend. Each person brought his gift to Pele without a word of complaining.

Every day for ten days Pele entered into the games, the hula dancing, the surf-board riding, and the other pleasures of the people. Everyone was eager to talk with the beautiful stranger, and Pele saw all that was in their minds.

One day the beautiful guest disappeared. The queen thought she had gone to visit one of the chiefs. No amount of search could reveal her hiding place. The *kahuna* were called together to divine where the woman had gone. At last they said to Kaoahi, "O Queen! the Night tells us that Pele is not a human being like you. She is an *akua*. She has many bodies."

These words aroused great wonder on Niihau as to how Pele had come and where she had gone.

After her sudden disappearance Pele went to Point Papaa from where she looked across to Kauai. Taking on her spirit body, she quickly passed through Mana and the mountains back of Waimea and came to Haena.

As darkness fell she heard the hula drums beating. Following the call of the music Pele came to a rude enclosure where the people were gathered for sports. In the crowd she saw a very handsome man, Lohiau, the king of Kauai, whom she suddenly resolved to seek for her husband.

The assembly was startled by hearing a beautiful voice chanting a *mele* of the hills, and by seeing at the door a woman of wondrous beauty and charm.

Lohiau ordered the people to stand aside so that the stranger could enter. The chiefs of Kauai crowded around Pele, wondering who she was. Lohiau was surprised when his unknown guest asked him to become her husband. He did not consent until he heard that she was Pele, the mortal.

Then Lohiau bade his servants prepare the tables for a feast, and he invited Pele to sit with him and partake of the food. After the meal was eaten Pele told Lohiau that she could not live with him until she had found a suitable home for them. The king of Kauai was rather ashamed to have his wife prepare the home, but he consented.

Kaleiapaoa, Lohiau's best and truest friend, was summoned to see Pele. But before he looked upon her he hurried to the king's sister, the celebrated tapa maker of Kalalau, and asked for a pa-u. She gave him one she had just made by beating with *lauae*, the fragrant cabbage fern, from the cliffs of Honopu. Pele was very much pleased with this pa-u because it was so sweet scented. When she had finished admiring it, she said to Lohiau, "Now I shall go to prepare our house."

At once she began to dig a cave, but striking water she left it. She tried again and, meeting with the same results, left Haena and came to

the *kukui* grove near Pilaa. Pleased with this spot she turned to the mountains where she dug as before, but met with unsatisfactory results.

Taking the form of an old woman, Pele hurried to Koloa. There she again struck water. Repeated efforts to dig a dry cave having failed, she decided to leave Kauai and to find on Oahu a suitable place for her home.

Pele landed at Kaena on Oahu. Near the hill Kapolei she again began to search for a home. As before she soon struck water. Discouragement filled her heart and looking toward Kauai she wept for her loved one there.

Walking through the wiliwili trees Pele reached Kuwalaka-i where she took her egg-like sister, Hiiaka, from her pa-u and placing her safely on the ground hurried to the sea for *limu*, or sea-weed, from which she squeezed the juice for drinking water.

Pele decided to spend the night in this place. She called the flowers which grew there "the pa-u of Hiiaka" and she crowned her fair head with a lei of them. As she slept, her lover appeared before her. This vision brought courage to Pele and early in the morning she hurried on her way.

On the heights of Moanalua, near Honolulu, Pele tried again to dig a dry cave. Striking salt water, she called the place Alia-paakai, the Salt-Marsh. When she came to Makapuu she saw the chiefess Malei, the Wreath, stringing flowers for a lei, while her subjects were cleaning the fish they had just brought from the sea.

At the little harbor of Hanauma a canoe was being prepared for a trip to Molokai. There Pele shook off her spirit body and as a beautiful woman greeted the men. At the sight of her great beauty they all fainted. When they had recovered, Pele asked them to take her to Molokai with them. They readily consented.

When Pele jumped ashore on Molokai, she became invisible and disappeared. The captain of the crew told the king about the beautiful woman who had come with him from Oahu. The whole island was searched, but Pele could not be found.

In the meantime Pele had dug a cave between Kalaupapa and Kalawao. Finding water, she left Molokai and hurried to Maui. She traveled over Maui from end to end hunting for a suitable place for her home. Finding none, she was greatly grieved and filled the whole island with Pele's smoke, and then hastened on to Hawaii.

Pele landed at Puna on Hawaii. She decided to call first on the god of the island, Ailaau, the Wood-Eater, who had his dwelling at Kilauea. When Ailaau saw Pele coming towards his home, he disappeared because he was afraid of her.

Pele began to dig. At last success crowned her efforts. Digging day and night, she came to fire and knew that this spot would be suitable for the long-sought home. She decided to make a home large enough for all her many brothers and sisters.

After the fiery pit was dug, Pele changed her egg-like sister, Hiiaka, into human form and the two lived happily in her new home.

One day Hiiaka went down to the forest of Panaewa near Hilo. There she saw a girl so skilled in making leis of lehua blossoms that she longed to make of her a personal friend. Hiiaka learned that her name was Hopoe, and she spoke to her in these words, "Now that we are friends you must go wherever I go. Wherever I sleep you shall sleep. We shall never be parted."

Hopoe was very happy and answered, "I spend my time making leis. I have planted two groves of trees, one white and one red. These I give to you."

So Hiiaka returned to Kilauea with her friend who pleased Pele very much by teaching her to make leis of lehua flowers. Soon all Pele's household was busily stringing the flowers.

As Pele worked she heard the voice of her beloved Lohiau calling her, for the wind carried his sad song to her ears. So Pele called her sisters to her and asked each one to go to Kauai to find her husband. All refused. Then Pele commanded Hiiaka, "Go to Kauai and bring my husband to me. Do not dare to kiss him, lest some dire disaster befall you. Be gone no longer than forty days." All agreed that it was wise for Hiiaka to go, as she was the youngest.

Stretching out her right hand to her sister, Pele bestowed upon her all the supernatural powers she possessed, so that the journey could be accomplished in safety.

Hiiaka prepared for the journey and as she worked she sang a *mele* in which she voiced her complaint that she should go alone to Haena for the handsome Lohiau. Pele heard her and cheered her by saying that she would meet someone who would go with her.

So with a sad heart Hiiaka set forth on her sister's errand. Looking back she saw her home in the volcano where her brothers and sisters were sitting like stone images. She called to them to care for her beloved grove of lehua trees.

As she entered the forest above Hilo she met Wahine-omao, the Stead-fast-Woman, who was on her way to carry gifts of pig and sugar cane as a sacrifice to Pele. Thinking that Hiiaka was Pele, Wahine-omao laid her gifts before her. Hiiaka saw that the stranger was mistaken and spoke these words to her: "I am not Pele. She is still in Kilauea. Carry

your presents there. After you have reached Kilauea descend into Halemaumau where you will see many beautiful women bedecked with lehua leis. Sacrifice your gifts to an old woman lying on a pillow made of wiliwili wood and covered with Puna mats, for she is Pele."

Wahine-omao, still believing that Pele stood before her, replied, "Do not deal falsely with me. No doubt you are Pele. I shall give you my gifts and so spare myself the long journey."

Finally Hiiaka made it clear that she was not Pele, and the woman departed with her gifts. With the aid of her supernatural powers Hiiaka put such speed into her feet that she traveled as fast as the whirlwind, and in no time came to Halemaumau and gave her gifts to the old woman. At once old age left Pele and she became the most beautiful of all in the pit.

Then Pele asked the stranger, "Did you meet a woman as you came? Go back and meet her again. Become friendly with her and travel with her."

Wahine-omao did as she was told and soon overtook Hiiaka whom she told what Pele had commanded. Looking back the lonely Hiiaka saw the smoke rising from the home of Pele. She saw her sisters and friend going to the sea. She saw her beloved grove of lehua trees being destroyed by a lava flow. Bitterness filled her heart and she wept over her fate.

Wahine-omao, who could not see what her companion saw, upbraided her with these words, "How do you know these things? We are in the forest and cannot see beyond its limits. Complain no more, for you weary me."

So in silence they walked on until they came to Hilo where the king was having games. In the midst of the people two beautiful women decorated with leis of seafoam were singing. As the eyes of the king fell upon Hiiaka and her companion, he was startled to see how far their beauty surpassed the beauty of the singers.

When Hiiaka saw the beautiful women she said, "These are not women. They are *akua.*"

The king replied, "*Akua* would not come at midday and eat and drink with us. These women refused to sing until we had given them presents."

Hiiaka still contended that they were not what they appeared to be and asked the king, "Allow me to try them. If I look at them and they depart, you will know that they are *akua.* If they stay you will know that they are human."

To this request the king replied, "What wager will you place that they are not human?"

Hiiaka answered, "My companion and I have no property, but we will wager our bodies."

Whereupon a man in the crowd called, "It is not good to wager one's body. Let me back your wager with my property."

To the king's question as to what his property consisted of he replied that he owned a canoe, a fishing net, a patch of sugar cane, several taro patches and a pig. Against all these things the king wagered two store-houses filled with food and tapa and the land on which these buildings stood.

As soon as these wagers had been placed, Hiiaka approached the women. When they saw her, one said, "She is our lord." Whereupon they ran. Hiiaka followed and put them both to death as her supernatural powers were greater than theirs.

As she returned to the king the crowd cheered her for her beauty and bravery. The king paid his wager and Hiiaka gave it to the man who had helped her. Calling Wahine-omao, Hiiaka hurried on to the river Wai-luku, where they saw a man ferrying freight. He agreed to take them across the river, and so the friends left Hilo and entered the forest, where their path was beset by *akua* trying to delay them. Hiiaka killed all who blocked their way and came at last to the plains of Makiki.

By this time the forty days allotted for making the journey to Kauai had expired, but Hiiaka decided to go on anyway. More troubles befell them. A certain king, Maka'ukiu, tried to block their way by causing huge waves to break over the cliffs so that they could not swim around the point. Hiiaka prayed and the sea became calm.

So they traveled on. A bird flew over them carrying a spray of be-gonia in its bill. Hiiaka sang a *mele* in which she expressed a wish for a safe journey on the errand of her powerful sister Pele.

Finally they came upon some men loading a canoe with gifts which they said were to be taken to Olepau, the king of Maui. The women asked to be taken in the canoe. The men consented and the next morning they reached Kahikinui on Maui.

As soon as the canoe grated on the beach, the two young women sprang ashore and called to the canoe-men that they were going to search for a bath. In fact they hurried on to Keala where the plains had been burned off. There the natives were catching plover with baited sticks. Hiiaka startled them with these words, "I am sorry for the king of Maui. He is dead. You are so engrossed in catching plover and grasshoppers that you have no time for your king."

The people could not believe these words, but nevertheless, they re-turned home and found that they were indeed true. Their king was dead. They hurried to the celebrated prophet and told him that two young women had made known to them the king's death. When he had heard

the description of the women, the prophet said that they were Hiiaka and Wahine-omao. He sent messengers as swift as arrows shot from the bow to overtake them.

When Hiiaka saw these messengers following her she changed herself and her companion into feeble old women. Soon the messengers overtook them and asked if they had seen anything of two beautiful young women.

Hiiaka answered that two such women had passed them long before. The messengers hurried on but, overtaking no one, they returned to the prophet and told him their experience.

The prophet knew that the old women were Hiiaka and Wahine-omao in disguise. He said that they must be brought back before the king could come to life. This time he did not trust their capture to messengers, but he himself swam around the point and met them coming from the other direction.

Hiiaka consented to return and restore the king to life. She told the prophet to go ahead and gather all the sweet smelling herbs. This he did in the twinkling of an eye, but Hiiaka and her friend had reached the king and brought him to life before the prophet got there. Then the prophet knew that the women were *akua*.

Inquiring whither they were bound he learned that they were on their way to Haena to find Lohiau. The prophet ordered the king's canoe-men to bring out the canoe and to take the travelers to Koolau on Oahu.

After an uneventful trip of a day and a night the friends were landed at Koolau. The canoe-men asked them where they were going and were told that Ewa was their destination. The men answered that Ewa was *kapu* for them, so they rested near the sea.

Then Hiiaka began her journey to the Nuuanu Pali. The woman in charge of the Pali tried to delay her, but was struck down by the prowess of the stranger.

After this there were no difficulties encountered as they made their way to Kalihi. There they saw a great many people diving for clams. Nearby two men were preparing a canoe for a trip to Kauai. Hiiaka told them that she had heard many times of Kauai but had no way of going there. The men, noticing that the speaker and her friend were young and beautiful, generously offered them a seat in their canoe.

As the sea was rough Hiiaka wanted to help with the paddling, but the men were strong and never became tired. They landed at Wailua and encountered many difficulties in traveling from there to Haena.

First a certain *Kupua,* the demi-god of the locality, guarding the surf, saw them coming and sent messengers to see if they walked over the *ti* leaf without breaking it, which was a sign that they were supernatural

beings—*akua*. Hiiaka deceived them by sending Wahine-omao ahead as she was more human and her feet tore the leaves. The messengers returned and reported that the strangers were human beings.

Next they came upon a *Kupua* swollen to twice his natural size, but he was unable to stop them.

Near Kealia they came upon a man cooking his *luau* or young taro leaves to eat with his poi. Hiiaka by her magic power cooked the *luau* in a few minutes.

Looking into the man's house Hiiaka saw a very sick woman whom all the *kahuna* had been unable to help. Hiiaka uttered a prayer and at once health was given back to the woman.

Having done this act of kindness, Hiiaka went on her way to Hanalei. At the valley of Kiaiakua the *akua* were lying in wait to stop them. As one tried to block their way, Hiiaka gave him a blow like a stroke of lightning and he fell back stunned.

At the mouth of the Hanalei River they again met resistance from an angry *akua*, who was struck to earth as the others had been.

Coming to Kealahula they saw Hoohila combing her hair. She, too, tried to delay their journey by making the sea break over the cliff. Wahine-omao threw sand into the eyes of the *akua*, and this difficulty was overcome.

Near Wainiha they were treated more kindly. The great fisherman of the place killed his favorite dog for them and then gave games in their honor.

So the travelers were nearing their journey's end. As they came to the wet caves dug by Pele in her efforts to find a suitable home for herself and Lohiau, Kilioe, the sister of Lohiau, saw them, covered with lehua leis, and knew that they had come for her brother. Kilioe was the great hula dancer and teacher. No one could hula in public on Kauai unless approved by her and given the *unike*, the sign which served in place of a diploma.

But, alas, the beloved Lohiau was dead and in a *mele* Kilioe made known this sad fact to Hiiaka. Hiiaka was not discouraged, for magic power was in her hands and she set about overcoming this difficulty, apparently the greatest of all.

As luck would have it, she saw the spirit of Lohiau flying over one of the points nearby. He was beckoning to her. Hiiaka gave to Wahine-omao swiftness of flight and together they chased the elusive spirit over many a steep *pali*. When they came to the ladder of Nualolo, the weary Wahine-omao cried, "Indeed you must love this Lohiau greatly."

At last Hiiaka caught the spirit in a flower and hurried back to the *pali* above the wet caves where the body of Lohiau had been laid. Then she began her task of putting the spirit back into the body.

Kaleiapaoa was fishing and grieving over the death of his truest friend. Looking towards the mountains he was startled to see a fire. At first he thought it was only the spirit body of Lohiau, but as it continued to burn he thought that someone must be attempting to steal the body of his chief. Quickly coming ashore he silently climbed up the *pali* and was greatly surprised to see two beautiful women trying to put the spirit back into Lohiau's body. This sight filled him with gladness and he returned to his home, where he told his wife what was being done by the strangers.

In the meantime Hiiaka was patiently accomplishing her task. She put the spirit back into the body through an incision in the great toe, but she found it very difficult to get the spirit past the ankles and the knee joints. However, after she had worked for eight days Lohiau was restored to life. Hiiaka carried him to his home and bathed him in the sea on five successive nights, as was the custom. At the end of that time he was purified, so that he could again mingle with his friends.

Then for the first time in many days Hiiaka and Wahine-omao slept very soundly. Lohiau's sister passed by the house and, seeing the door open, entered. She was surprised to see her brother sleeping soundly. She beat the drum and made known to all the people that Lohiau, their chief, was alive again. Many came, bringing gifts with grateful hearts.

Hiiaka was very anxious to start for Hawaii, as the forty days allotted her had long since expired and she feared that Pele would be angry.

At Kealia the chief entertained the three guests with sports in which Lohiau was very skillful. Reaching Kapaa, they met the king, who gave them a canoe to carry them to Oahu.

After a short stay on this island, where there was much dancing and royal feasting, the travelers left for Hawaii. As they were passing Molokai, Hiiaka saw a chiefess standing near the shore and asked her to give them fish. The chiefess replied, "I have no fish for you, proud slave." These words so angered Hiiaka that she swam ashore and killed her.

After this adventure they went on quietly until they reached Hawaii, where they landed at Puna and then hastened on towards the home of Pele and to a relentless fate.

When they came to the brink of the volcano, Hiiaka sent Wahine-omao ahead to greet Pele while she and Lohiau stayed behind. There in full view of Pele and her other sisters, Hiiaka, suddenly overcome with emotion for the man she had grown to love, threw her arms around him and kissed him.

Pele's anger knew no bounds. She cried, "Why did she not kiss Lohiau while they were on Kauai? She does it before my eyes to laugh at me."

Seeking revenge, Pele sent her sisters to destroy her lover by means of a lava flow. They put on their fire robes and went forth rather unwillingly. When they came near and saw how handsome Lohiau was, pity took hold of them and they cast only a few cinders at his feet and returned to Pele in fear. Hiiaka knew that the falling cinders would be followed by fire and so she told Lohiau to pray.

When Pele saw her people returning from their unaccomplished errand she sent them back, commanding them to put aside their pity for the handsome man. So the five burst forth again and gradually surrounded Lohiau. At last the rocky lava covered his body.

When Hiiaka saw what her sister had done, she was so angry that she dug a tunnel from the volcano to the sea, through which she poured the fire, leaving only a little in the crater. This small amount was kept by one of her brothers under his arm.

Seeing what Hiiaka was doing, Pele became alarmed and sent Wahine-omao to beg her to spare her sisters. Hiiaka did not heed her friend and Pele cried, "This is a punishment sent upon me because I did not care for Hiiaka's friend, and I allowed her lehua trees to be burned."

Wahine-omao again entreated Hiiaka to spare Pele, recalling to her mind the many days of travel they had spent together. At last Hiiaka promised to spare Pele but refused to see her again.

As soon as possible she returned to Kauai and told the faithful Kaleia-paoa what Pele had done. This true friend of Lohiau made a solemn vow to pull out the eyelashes of Pele and to fill her mouth with dirt.

Led by the magic power of Hiiaka, Kaleiapaoa soon reached the outer brink of the crater and began to attack Pele with vile names. Pele answered by urging him to come down and carry out his oath. Attempting many times to descend and punish Pele, he was always forced back. At last Pele allowed him to come before her, but he no longer wished to carry out his threat. Pele had conquered him by her beauty and charm. After he remained in the crater four days, he was persuaded to return to Kauai with Hiiaka as his wife.

Two brothers of Pele who had come from foreign lands, saw Lohiau's body lying as a stone where the lava flow had overtaken him. Pity welled up in their hearts and they brought Lohiau to life again. One of these brothers made his own body into a canoe and carried the unfortunate Lohiau to Kauai, where he was put ashore at Ahukini.

Coming to Hanamaulu, Lohiau found all the houses but one closed. In that one were two old men, one of whom recognized him and asked him to

enter. The men were making tapa which they expected to carry soon to Kapaa, where games were being held in honor of Kaleiapaoa and his bride, Hiiaka.

As soon as the tapa was prepared, the men, joined by Lohiau, started for the sports. At the Wailua River discussion arose. Lohiau wanted to swim across, but the men insisted on carrying him over on the palms of their outstretched hands.

When they reached Waipouli, Lohiau suggested that the men carry the tapa over a stick, so that he could be concealed between its folds. This was done and at last they came close to Hiiaka.

Lohiau told the men to enter the *kilu*[1] game. Lohiau promised to *oli* for them in case they were struck. First the old man was struck, and from his hiding place Lohiau sang a song that he and Hiiaka had sung in their travels. The next night in the game the other old man was struck, and Lohiau sang the song that he and Hiiaka had composed as they neared the volcano.

Hiiaka knew that these were the songs that she and Lohiau had sung together during their days of travel. She lifted up the tapa and saw again Lohiau—the man twice restored to life from death, the lover for whom she had dared the wrath of Pele, the mate whom she now encircled with loving arms.

When Kaleiapaoa saw that his old friend had returned, his shame and sorrow were so great that he hastened to the sea and threw himself into the water to meet his death.

So, at last, Hiiaka and Lohiau were united and lived happily at Haena for many years.

[1]See glossary.

THE RAINBOW PRINCESS

A LEGEND OF KAUAI

A family of Hawaiians were moving into the valley of Nualolo, on the Napali coast. To reach this valley it was necessary to climb up a swinging ladder, which hung over the cliff. One man was carrying a baby girl, and as he swung on to the swaying ladder he dropped the child. The parents, in agony, watched their baby falling but were overjoyed to see the *akua* of the rainbow catch her up before she struck the water, and carry her on the rainbow over the mountains down to Waimea valley. In this valley, they placed her in a small cave beneath a waterfall. There she lived, watched over by the *akua*, who always sent the rainbow to care for her. There she grew, at length, into beautiful womanhood, and every day she sat in the sunshine on the rocks above the cave with a rainbow above her head.

Then it happened that a prince from Waimea fell deeply in love with the beautiful Rainbow princess, as she was called. He would hasten to the rocks above the waterfall and try to woo her. But his efforts were all in vain, for with a merry laugh she would dive into the water and call to him, "When you can call me by name, I will come to you."

At last, growing sick with longing for the princess, he journeyed to Maui and Hawaii to consult the *kahuna* in regard to the girl's name. Alas, none could help him!

In despair he returned to Waimea and called on his old grandmother who inquired the reason for his great sadness. The prince replied, "I love the Rainbow Princess who lives in the waterfall. She only laughs at me and tells me that when I can call her by name she will be my wife. I have consulted all the *kahuna* and none can tell me her name."

With these words the grandmother cheered the heart of the sorrowing prince, "If you had come to me I could have told you her name. Go to the waterfall. When the princess laughs at you, call her U-a, which means rain."

The prince hastened to the waterfall and when he called "U-a" the beautiful maiden went to him. They were married and lived together many happy years.

ULUKAA, THE ROLLING ISLAND

Kaeweaoho, the king of Waipio, Hawaii, was greatly beloved by his people because he give them a beneficent government. After he had reigned a short time he chose two men from his people as his personal fishermen. Fishing was one of his favorite sports. He often asked his fishermen to allow him to go fishing with them, but they always refused to take him because they feared some accident might befall them at sea, and their king would be in danger.

The king showed such favoritism to his fishermen that his head steward became very jealous and in his heart plotted injury to them. One day when the men were away fishing the head steward left no food at their homes. When the fishermen returned from the king's fishing with baskets full of fish they found no food at their homes. Being very hungry they kept a few of the smaller fish from the king's basket.

The next morning they went fishing as usual. They returned at night and again found no food at their homes. This time they believed that the king had given his order that no food be left for them. They could not understand the king's neglect, for they had always served him faithfully and had brought to him their entire catch of fish. Anger against their lord grew in their hearts and they decided to get revenge in this manner: The next time the king asked to go fishing with them, they would take him and would leave him in the deep sea. They prepared their canoe. They placed in it four paddles and two gourd bailers. Under their fishing tackle they concealed two paddles and one gourd.

Early the next morning the young king, Kaeweaoho, came to his fishermen and begged them to take him with them as the sea was very smooth. They answered, "Yes, O King, today you shall go with us for the sea is smooth and we have too often refused your request."

They got into the canoe and paddled out until the sea hid the land. The king often asked, "Where are your fishing grounds?"

To this question the fishermen replied, "See the white caps yonder. There we shall find the best fishing. Where the sea drinks in the point of Hanakaki, there lies Hina's canoe. There we shall drop anchor."

The king thought that fish were to be found nearer land, but they told him that only *poopaa*, the easiest fish to catch, were in the shallow water. In the deep sea all the best fish lived.

When land could no longer be seen, the two fishermen began to carry out their cruel plan. One man dropped his paddle, saying that a wave had knocked it from his hand. Then the gourd and the other paddle were dropped into the sea and were carried away by the waves.

The king, seeing the danger they were in, said, "I am the youngest man here. Let me swim for the paddles, which are still close by. Then we can go safely home."

One of the men replied, "Do not jump into the sea. The big fish will devour you." But the king heeded not and was soon swimming for the paddles. Then the fishermen took out their hidden paddles and turned the canoe towards land.

The bewildered king called to them, "Come and save your king. If I have done wrong I shall right it. You shall have lands. Come and get me or I shall die."

The fishermen paddled away as fast as they could. Then the king looked about him and saw no signs of land. He wept bitterly, fearing that he would never again see his parents. While the unhappy king was weeping in great distress, the rainbow, the fine mist, and the red glow, all signs that he was a high chief, hung over him.

As Kaeweaoho was swimming, Kuwahailo, Kaanaelike's grandfather, looked down from the sky and seeing the high chief signs hovering over a swimmer knew that the man must be a very high chief or a king who would make a suitable husband for his favorite granddaughter, who lived on Ulukaa. So he decided to save the swimmer.

At once a great storm arose on the sea, and Kuwahailo moved the rolling island close to the young king. Kaeweaoho was alarmed when he heard the big waves breaking on the land. He thought it was the big fish coming to devour him. Just as his strength was failing a breaker rolled him upon the soft sand where he lay as one dead.

When life returned to him he was greatly surprised to find himself on land. He tried to rise but was scarcely able to do so, as his limbs were cramped from the many hours he had spent in the water. He fell back on the warm sand and slept for many hours. At last the heat of the sun awakened him. He stood up and saw that the land was very beautiful. As he was looking about hunger whispered to him, "Do not tarry to admire the landscape. Walk on until you find something to eat." The king did as hunger bade him and finding ripe bananas ate of them, and strength returned to him.

After Kaeweaoho had eaten he decided to go on to see if he could find who inhabited this beautiful land. He had not gone far before he came upon a large taro patch, the banks of which were covered with breadfruit, sweet potatoes, sugar-cane, and bananas. The king eagerly partook of food and his beauty returned like the beauty of the young banana leaf.

Kaeweaoho saw no signs of any house. He wondered to whom such a beautiful island belonged. While he was wondering, the queen of the

island, Kaanaelike, was watching him secretly, admiring his beauty and rejoicing over the coming of such a handsome creature. She had never seen a man before. At last her curiosity led her to speak thus to the stranger: "I grieve to see you eating food which is poisonous, food which only birds should eat. We of this land eat only berries." These words carried to Kaeweaoho the knowledge that all these fruits had not been planted by the hand of man.

When the queen asked the stranger whence he had come, he answered, "I have long heard of the beauties of this land. Now I hear the music of your voice. If I speak in the language of my land you will ridicule me. I came from the sea where a cruel wave wrecked my canoe. Give me food, for I am hungry."

Kaanaelike led the way to her house from which she brought out berries for the king to eat. The king told her that he could not eat raw food, and asked her why she did not cook the fruit. The queen replied that cooking was unknown to her and also to her parents, who were in the mountains gathering berries.

Kaeweaoho saw many dead trees nearby so he gathered the dry boughs and after having made an *imu* he rubbed two dry sticks together as he had seen his servants do in his far away island. He found it difficult to get a spark of fire but at last he was successful. He then bent over the tiny flame to strengthen it by blowing in it. Suddenly it blazed up and burnt off his eyebrows. The first fire of the king was not a very successful one, but he made another which proved to be a good one. After the king had placed the food in the *imu* to cook, he went to fish. When he had caught a few fish he came back and lying down beside the *imu*, fell asleep.

The queen found him there and believing him dead, cried, "Why did you labor so hard? You have killed yourself, my beautiful one."

These words awakened the king, who hurriedly uncovered his *imu*. He took out the taro and after peeling it ate the first food he had ever cooked. Busy thoughts filled his mind, thoughts of how changed his life was. As a king he had been born to every luxury. Now he was an outcast working to find food to keep his body alive.

Soon he put aside these sad thoughts and called to Kaanaelike to come and taste the cooked food. She feared it would poison her and that she would never see her parents again, but the king told her it would make her grow more beautiful. At last he persuaded her to try first the taro, then the breadfruit. After a time Kaanaelike tasted the sweet potato, which the king said would give her great strength and beauty. She was surprised to find that no harm came to her.

Kaanaelike asked the Man-from-the-Sea, as she called the king, to go home with her. When he reached her house he found it filled with berries. These the queen threw out, and making a bed of mats gave the stranger a room. Thus they lived for two months. Daily he cooked food and fish in his *imu* and the queen eating thereof grew more beautiful.

At the end of two months Kaanaelike's parents sent messengers from the mountains with packs loaded with berries. As they neared the house they saw their queen eating the cooked food, so dropping their packs they rushed back to the mountains crying, "The queen will be killed! The queen will be killed!"

As soon as the queen's parents heard these words they ordered everyone to follow them to the seashore.

When Kaanaelike saw the messengers running back to the mountains she spoke to Kaeweaoho in this manner: "Man-from-the-Sea, dig a hole under my room. We will line it with mats and there you can hide so that my parents will not kill you when they come." This they did and she hid the king.

When her parents came Kaanaelike ate the cooked food. At once they and their followers began to wail, thinking that she would die. She told her parents that she would not die. She had eaten of this food for two months, and they could see that she was more beautiful and stronger than before. She persuaded them to eat of the cooked food and she gave the remainder to the followers.

Then her parents asked Kaanaelike how she had learned to cook food. She told them that the Man-from-the-Sea, who had been very kind to her, had taught her. Her parents said, "If these things you tell us are true the Man-from-the-Sea must be very good."

No longer fearing for his life, Kaanaelike removed the mats and led forth the king, whom she said she loved and wish to marry. Her parents told her that this could not be without the consent of her grandfather. Kaanaelike asked where her grandfather lived, and learned that his home was in the sky.

In order to visit her grandfather to gain his consent, Kaanaelike was directed to a large calabash which concealed a small coconut tree. This tree she was told to climb. Before she began to climb it her parents gave her the sacred pa-u, or skirt, which she was to hold on her lap and no harm would ever befall her.

No sooner had the queen climbed into the tree than it began to grow. It grew and grew until it reached the deep blue of heaven. In the sky she found an opening which led into the kingdom of her grandfather. She

went in, and as soon as she had left the tree it grew smaller and smaller, until it reached its original size.

After watching the coconut tree disappear Kaanaelike saw a path which she followed until she came to two guards keeping watch over a large stone hollowed out like a huge pot. The guards urged this woman to depart at once before their master came, for he spared neither man, woman, nor child; all shared the same cruel death in the pot.

Kaanaelike did not obey them but asked for her grandfather, Kuwahailo. The guards replied, "You are asking for our lord. He has gone to hunt for more victims to fill his pot. He takes any person he finds, old or young, until his pot is full. He heats a huge stone until it is red hot, then he rolls it into the pot, and so cooks his victims. You see all about you the bones of many victims. Therefore, be advised, you who are young and beautiful. If you wish to live return at once by the path you came."

But Kaanaelike was determined to see her grandfather and asked which way he had gone. The guards said that he had gone to the East looking for victims to hurl into his pot. Then the granddaughter asked where their lord slept and they answered, "It is not known to us. His home is held sacred. It is *kapu* for us, his servants, to go there. We have warned you. Now depart if you wish to live."

Still Kaanaelike questioned them: "When does your mighty lord return?"

To this they answered that she would know, for the land would quake, the trees would be bent over, and the wind would blow. First his tongue would come with victims in its hollow. Then his body would follow.

After Kaanaelike had heard all these things she followed a path which led to a cave. In the cave was a pile of bones of chiefs whom the king had eaten. Nearby was a smooth stone used as a pillow by the king. The queen was becoming very weary and so she rolled up her sacred pa-u, and using it as a pillow, lay down on the mats to rest. Suddenly she felt the earth quake and heard the wind blowing. Then she remembered that these were the signs of the coming of her grandfather.

When Kuwahailo reached his guards he called out in a loud voice, "I smell the blood of a mortal!"

In fear the guards answered, "We have seen no one pass by. Someone may have passed behind us. We saw no one as we were busy guarding the pot."

The angry king said, "If you lie to me I shall eat you both!" Then he looked to the east, and west, and south. He saw no one. As he turned

towards his home, he cried, "The presumptuous mortal has dared to enter my cave. He will answer for this by his death!"

Before entering his home the king unfastened his huge tongue and hung it at the side of the cave. As soon as he stepped into the cave he saw a woman lying on his bed. Violent anger possessed him. He tried to seize her, but when he touched her he received a severe shock, almost like a kick. The sacred pa-u was protecting Kaanaelike. Kuwahailo knew that this was no ordinary mortal. He looked closely at her and saw that she was his own granddaughter. He cried, "Arise, my child. Why did you come to visit me without my knowledge? I have always warned your parents to inform me when to expect visits from you. Had I known you were coming I would have cleaned my cave."

Kaanaelike was angry and without replying she struck the side of the cave with such force that all the hangings and decorations fell from the walls.

The king cried, "What an angry granddaughter I have here. See, you have knocked from the walls the sacred bones of your ancestors."

These words drove away anger from her heart, and Kaanaelike sat on the sacred lap of her grandfather, who inquired what great object had brought her to him. She told him that she had come to gain his permission to marry the man who had come to her island from the sea.

The king was silent for a few minutes before replying, "Neither you nor your parents brought that man to your island. I sent him there. I saw him swimming in the sea. The signs of a high chief were hovering over him and I knew he would be a suitable husband for you. So I rolled Ulukaa up to him. Therefore, go back and take him as your husband. Do not make him work for you, for I shall take your life if you do."

Kaanaelike answered her grandfather thus: "All you say is good. I shall obey all your commands. But I have power as well as you. If I promise to obey you, you must likewise promise to obey me. You must not eat any more people." "That is only fair, my granddaughter," answered the king.

At once he went to his guards and told them to release the victims from the pot, to send them home, and then to go home themselves. Then he returned to his granddaughter, who asked where the path to her island lay. The king took his tongue from the side of the cave and fastened it in his mouth. Taking her sacred pa-u with her, Kaanaelike sat on the crook of the tongue, while the giant slowly lowered her to the Rolling Island. As soon as she was safely home the tongue disappeared.

Kaanaelike hastened to her parents to tell them the outcome of her visit. She told them how her grandfather had rolled her island up to the

man struggling in the sea, and had selected him as a husband for her whom they must all obey.

Her parents said, "Now great happiness dwells with us. If your grandfather had refused to allow you to marry the man from the sea, we would have given him to your younger sister."

The marriage of Kaanaelike and Kaeweaoho was celebrated by a great luau.

During the years that Kaeweaoho had ruled his people on Hawaii his fame had spread to all the islands, for he had cared tenderly for his subjects and had given them a wise and just rule.

At his disappearance his bird sisters had flown over the world hunting for him. At last, after he had been married to Kaanaelike for six months, they found him on Ulukaa. As he lay on the sand they cast him into deep sleep. A dream came to him. He heard a voice saying, "You are living in peace with your beautiful wife while your people far away are going up and down the land mourning for you. Your sacred temple has been desecrated; your bundles of tapa have been used by evil ones; your *awa* has been drunk; your sacred landing has been used; your parents mourn so that they are no longer able to eat, and sleep comes not often to them. O King, beloved by all, sleep now, but when you awake return to your land for which you had such great aloha."

When Kaeweaoho awoke he was surprised to find that he had heard this voice in a dream. Three times the same dream came to him. He became very heavy-hearted. He wanted to return to Hawaii, but he had no canoe. Hourly this dream, like an image, haunted him. As he remembered his aged, grief-stricken parents and his unhappy subjects, tears filled his eyes.

When his wife noticed his sad demeanor, she cried, "O my Man-from-the-Sea, why do your tears flow? Have my parents been unkind to you?"

To these words her husband replied, "Your parents have not been unkind to me. I weep because I pine for my native land. On your island I am called the Man-from-the-Sea. In my land I am a great king. The island of Hawaii is my kingdom."

Kaanaelike went weeping to her parents and told them that her husband was the king of Hawaii, and that grief because of his treatment on their island filled her heart.

Her parents knew that the king of Hawaii was called Kaeweaoho. They told their daughter to ask her husband his name. If he replied "Kaeweaoho," she would know that he was not deceiving her.

As soon as Kaanaelike asked her husband this question he answered, "In your land I am called the Man-from-the-Sea. In my land I am called Kaeweaoho, King of Hawaii."

Then Kaanaelike's parents knew that their daughter was not deceived, for they had heard much of the wise and just rule of this king.

Kaanaelike begged her husband not to return to Hawaii. "Wait until old age dims our eyes before you leave me for your native land," she wept.

Her husband answered, "Hawaii calls me. My people need me. I shall go. If a son is born to us call him Eye-Brows-Burnt-Off, Na-kue-maka-pauikeahi. If a daughter is born to us you may name her as it pleases you. My love for you is great, but I cannot remain here. I must return to my people and my country."

By these words the unhappy Kaanaelike knew that her husband would leave her, and so she prepared to carry out his wishes. She ordered a canoe to be built for him. This canoe was to be built in one day, cut in the early morning, and ready for the sea by sunset. This canoe was to be red, with a red mast, red sails, red ropes, and the sailors were to be dressed in red tapa.

At sunset Kaeweaoho and his sailors got into the canoe. Kaanaelike warned them not to look back lest some dire calamity befall them on their journey. As the canoe glided over the sea, Kaanaelike rolled her island along close to it until she saw the waves breaking on the shores of Hawaii. Then she rolled her island back into the sea. Kaeweaoho looked back and saw only the vast water.

As Kaeweaoho approached his sacred landing he heard the crowd crying, "The *kapu* is broken. Now anyone can use the king's landing." Then he knew that his dream was true.

When the people saw Kaeweaoho they at once recognized their lost king, and with tears of joy they rushed to the sea, and, seizing the canoe, carried it into the palace yard on their shoulders, with the king and all the sailors in it. Before the palace they lowered the canoe. The king gave his great aloha to all. He entered his home, and greeted his parents and all his chiefs, whom he found living in filth and want, mourning his long absence.

Kaeweaoho issued a proclamation saying that all the sacred places which had been desecrated should be returned to their *kapu* or again set apart, and that all lands set aside for the king's use should be reserved for him as before. He then sent his messengers to find and bring before him the two fishermen who had deserted him at sea.

The messengers easily found these men, for they had not heard of the king's return. When they were brought before the king they knew him

to be the one they had left to die in the deep sea. Terror filled their hearts.

The king spoke to them in these words, "Why did you leave me at sea when I swam for the paddles? Were you angry with me? Had I done you any wrong?"

The terrified men answered, "Yes, you had done us a great wrong. Day after day, while we were fishing for you, no food was left at our homes by your orders."

These words greatly troubled the king. He sent for his head steward who allotted each man's food. When the steward came before the king he crawled on his hands and knees. He could not reply to the king's questions, and so he was ordered to be put to death. The king left the punishment of his fishermen to his subjects. They sentenced them to die also. So the three men were executed that day.

After Kaeweaoho had departed from Ulukaa, Kaanaelike was very troubled. She wondered what she would say to her child when it asked for its father. After her husband had been gone three years a son was born to the queen, whom she named Eye-Brows-Burnt-Off. When he was two days old he could walk, and when three days old he could talk. On the sixth day of his life he could play *ke'a pua*[2] with the large boys. That day he said to his mother, "Where is my father?"

Kaanaelike replied, "You have no father."

Her son replied, "Yes, I must have a father. Was I not named Eye-Brows-Burnt-Off because my father burned off his eyebrows making an *imu?*"

Then Kaanaelike knew that her secret had been made known to her son and she told him that his father was the king of Hawaii.

Eye-Brows-Burnt-Off wanted to seek his father at once. His mother told him that he could go when the canoe returned from Hawaii. Kaanaelike read the signs in the heavens and knew that her son would die if he went to Hawaii. This she told him but he only replied, "If I go to seek my father and die, it is well. If I live it is well."

So Kaanaelike prepared the canoe for her son as she had prepared it for her husband. As the boy entered it she cried to him, "Go and find your father. Give him my aloha. I fear you will never see him. You will be killed by his subjects. Do not look back. Let nothing stop you until you reach your father."

Then she followed the canoe with her rolling island until she could see the sacred landing of the king.

[2]This game is described in the legend of the Menehune.

When the people on shore saw a red canoe nearing the beach they cried, "Kill anyone who attempts to land. No man, woman, or child shall desecrate the king's landing place."

As Eye-Brows-Burnt-Off came closer to land he said to his sailors, "Paddle no farther. I shall go ashore alone. If I am killed, return at once to Ulukaa. If I die it is well. If I reach land safely I shall build a fire. If the smoke blows towards the sea I live. If it blows towards land I die."

After he had spoken these words, the boy jumped into the sea and swam ashore. Someone tore off his clothes, but he jumped on the heads of the people standing close together in the crowd, and ran on them until he reached the gate to the palace yard. There, Eye-Brows-Burnt-Off tried to slip past the guards, who had the power of life and death over anyone entering the yard. One kindly guard wanted to let the child pass, but the other guard struck him as he ran by.

Eye-Brows-Burnt-Off breathlessly entered the room where his father was sleeping. Twelve kahili bearers were gently waving their kahili over the sleeping king. As the boy sprang up and sat on his father's lap the priest, who had mystic powers, recognized him as the king's son and warned the attendants to treat him well. When the king awoke he said, "Who is this on my lap?"

The boy answered, "I am Eye-Brows-Burnt-Off. Your wife, Kaanaelike, sent her aloha to you. Behold, I am wounded at the hands of your people."

Kaeweaoho was very angry to think that anyone had laid hands on his son, and quickly ordered any person who had harmed him to be put to death. The unkind guard and many others were executed. At last Eye-Brows-Burnt-Off begged his father not to kill any more.

The king then prepared a great feast for his son from Ulukaa. As they lit the *imu* the smoke rose and was swept to the sea by the breeze from the mountains. Thus the paddlers knew that their master lived.

When the feast was spread and all were seated, Eye-Brows-Burnt-Off said, "I cannot enjoy this luau. My faithful paddlers are still at sea. I had forgotten them."

The king sent at once for these men, who were given places at the feast, where they were treated as honored guests by all the chiefs of Hawaii. After the meal, they were sent to the houses they had occupied on their former visit to Hawaii, when they had brought the king home.

When evening came, Eye-Brows-Burnt-Off told his father that at sunrise on the following day he would return to Ulukaa. The king urged him

to stay with him but the boy answered, "If I remain you will die. My mother has gathered all her sisters together to try you. After I am gone you must build eleven houses for them. They will come here and each one will pretend that she is your wife. You must send each one to the house you have prepared for her. When the youngest sister, Keahiwela, who is the most beautiful, comes, you will think that she is your wife. You must tell her that even her whole body is not as beautiful as your wife's eyes. Kaanaelike will be the last to come ashore. If she sits on your lap and kisses you, you will know that she is your wife, and your life will be spared. If you do not do as I say, death will be your fate."

Early the next morning Eye-Brows-Burnt-Off got into his canoe and started for Ulukaa. As they neared the Rolling Island the boy saw the eleven beautiful women. His mother was looking at them from the top of her house. She was preparing to go to Hawaii to avenge the injuries done her son by her husband's subjects.

As soon as the boy stepped ashore, the beautiful women got into the canoe. Kaanaelike was the last to enter. She moved the Rolling Island close to Hawaii. Just at daybreak her island disappeared, and with her sisters concealed in the canoe, the angry queen paddled toward the shore. When the natives saw the canoe coming to the king's sacred landing they cried, "The canoe comes which took the prince away. A woman is paddling it."

After the canoe had reached the shore one of the beautiful sisters stepped on land. The people cried, "What a beautiful woman. She must be the king's wife. Take her to the palace."

But the king remembering his son's words, said, "She is not my wife. Lead her to her house."

When the sixth sister stepped ashore the people cried, "This is your wife. Admit her to the palace. There are no more beautiful women in the canoe."

She looked so much like Kaanaelike that even the king thought she was his wife, but his *kahuna* warned him, "Take her not. She is not your wife. If you admit her you will die. The sea will cover your land."

She was sent to her house.

When the youngest sister came, the king was certain she was his wife. But as before his *kahuna* warned him to remember his son's words. So she was sent to her house, having first been told that her beauty could not compare with that of Kaanaelike.

At last Kaanaelike came to the palace of her king. Her beauty was as blinding as the sun. The people were unable to look upon her. Then Kaeweaoho knew that she was his wife. His son had spoken truthfully,

and a great aloha for the boy filled the father's heart. Kaanaelike sat
on her husband's lap and kissed him, and he knew that he would live.

Kaanaelike made known her plans. She said that when the sun rose
on the following day, the king should return with her to Ulukaa. The
king agreed to this. At sunrise the king and queen paddled away from
Hawaii, which was left in the hands of Kaeweaoho's father. The father
ruled until all the chiefs of Hawaii had died. At his own death, the king-
dom passed into the hands of twins from Kauai.

After Kaanaelike and her husband had reached Ulukaa, the queen sent
all her sisters home to their own islands except the youngest sister, Kea-
hiwela, Hot-Fire, who lived with her by the sea.

In a short time Kaanaelike saw that her husband was paying too much
attention to her beautiful sister, so she took him to live under the watchful
eye of her parents.

One day the king asked permission to go fishing. His wife prepared
his bait and fishing lines. He went to the sea and caught twelve fish.
Before going home he went to the home of his wife's sister. He wakened
her, but she warned him to go away, or his wife with her supernatural
powers would see him. The king listened to her and departed, leaving her
seven of the fish.

Towards evening the king returned home with the other five fish.
Kaanaelike felt the fish and seeing that they were dry, asked her husband
where he had been. He replied that the sun had been very hot, and he had
walked slowly. Then his wife looked at his fishing lines and saw that
twelve fish had been caught. When Kaanaelike asked where the other fish
were Kaeweaoho answered that his canoe had capsized and he had lost all
but the five which she had.

A few days later the king asked to go to catch birds. His wife pre-
pared the gum for him, and he went through the forest putting gum on the
flowers. Instead of waiting for the birds to come he hurried to the
younger sister's house and stayed all day with her. At sunset he went
home and when his wife asked for the birds he told her that he had had
an unlucky day. She looked at the gum and said, "Plenty of birds have
been caught but no one was there to collect them."

The next day Kaeweaoho went again to the house of the beautiful
sister. This time his wife followed him. When she saw her husband
and sister together, she spat between them, and fire broke out which de-
stroyed the king and spread rapidly over the island, wiping out everything
and everybody. Keahiwela turned herself into a pile of stones, so that the
fire could not destroy her. Kaanaelike put out the fire to save the life of

her son, Eye-Brows-Burnt-Off. When the fire was out, she saw the pile of stones and knew that her sister still lived in it.

Just at this moment the foster parents of Keahiwela, who had become greatly alarmed over her long absence, sent their dog to find her. He was named Kuilio-loa, My-Long-Dog. Everywhere this dog went, the country was polluted. With one bound he landed on Ulukaa and saw that all the people on the island had been destroyed. He returned to his master, telling him that Keahiwela was dead. The master sent him back to Ulukaa with power to kill Kaanaelike. He jumped back to the island with his mouth wide open to bite Kaanaelike. Keahiwela saw him and, shaking off the rocks that covered her, jumped into the dog's mouth. When Kaanaelike saw the dog with bloody teeth she took her sacred pa-u and struck him, cutting off his tail and ears. From that day to this bob-tailed dogs have lived on the islands. This dog took Keahiwela home to her parents, and then he jumped across to Kauai where he lived until his death.

When Eye-Brows-Burnt-Off saw all that had happened on Ulukaa, he said to his mother, "You have brought all this trouble to the land. There are no people left for me to rule over. I shall go to some other land where there are people. You must live here alone to the end of your life."

The old Hawaiians believe that Kaanaelike still lives on the Rolling Island, Ulukaa, which can be seen, a cloud-like vision, with the other eleven islands, on the horizon at sunrise or at sunset. At sunrise the island of Ulukaa has a reddish tinge, which shows that it is still burning. Because they are sacred islands, it is bad luck to point at them.

THE STONES OF KANE

A LEGEND OF KAUAI

In the beginning, a woman and her two brothers, Pohakuloa and Pohaku, in the form of stones, came through the water from distant lands. When they reached the reef off Haena the sister wanted to stay there, but one of the brothers urged her to go on, saying, "If you stay here the *limu* will cover you, the *opihi* will cling to you, and the people coming to fish will climb over you."

To this the sister replied, "If you go into the mountains the birds will light on you and the lizards will crawl over you."

So the sister stayed in the sea where at low tide she is still to be seen. The Hawaiians call the rock O-o-aa, the Fast-Rooted. The brothers swam towards land. When about two hundred yards inland from the shore one became tired and lay down to rest, and there he can be seen to this day lying, covered with moss, among the *puhala* trees. He is called Pohakuloa, Long-Stone. The sand beneath Pohakuloa was used as a burial place for common people. The other brother went on and began to climb up the steep mountain side. The great god, Kane, saw him and, taking pity on him, threw him up on the top of the ridge where he is today known as the Stone of Kane, Pohaku-o-Kane.

THE MENEHUNE

A LEGEND OF KAUAI

The belief of the Hawaiians of ancient times was that there was one great continent, stretching from Hawaii, including Samoa, Lalakoa, and reaching as far as New Zealand, also taking in Fiji. And there were some lowlands in between these higher lands. All this was called by one name, that is Ka-houpo-o-Kane, the Solar-Plexus-of-Kane (the great god), and was also called Moana-nui-kai-oo, the Great-Engulfing-Ocean. This is the same that is mentioned in the prayer used by the *kahuna ana-ana*, who can pray to death, and who can also defend from death, when they pray in these words to ward off the evil that is keeping the sick one down:

To You, Who are the Breath of the Eighth Night:
To You, Kane, the Yellow Edge of Night:
To You Kane, the Thunder that Rumbles at Night:
To You, Kane, Kamohoalii, Brother of Pele, Sea of Forgiveness:
To You, Ku, Kane, and all the other Gods that hold up the Heavens:
And likewise the Ku, the Goddess women that hold up the Night:
To You, Kane, Who is bristling, to Ku, and to Lono:
To You, Lono, Who is awakening as the sun rises:
To All of You in the Night: Stand up!
Let the Night pass, and Daylight come to me, the *Kahuna*.
Look at our sick one: If he be dying from food eaten in the day,
Or from tapa, or from what he has said,
Or from pleasures he has had a part in,
Or from walking on the high-way,
From walking, or from sitting down,
Or from the bait that has been taken,
Or from parts of food that he has left,
Or from his evil thoughts of others,
Or from finding fault, or from evils within,
From all deaths: Deliver and forgive!
Take away all great faults, and all small faults,
Throw them all into Moana-nui-kai-oo, the great ocean!
If Ku is there, or Hina: Hold back death!
Let out the big life, the small life,
Let out the long life, for all time:
That is the life from the Gods.
 This is the ending of my prayer
 It is finished; *Amama ua noa.*

This is what they thought in regard to the land of Ka-houpo-o-Kane, which is related in the most ancient tradition, that has been handed down for countless generations, the tradition known as "Ke Kumulipo", "the Tradition that comes from the Dark Ages."

The great flood came, Kai-a-ka-hina-alii, the Sea-that-Made-the-Chiefs-Fall-Down, (that destroyed the chiefs), submerging all the lower lands, leaving only specks of higher land, now known as islands, above the waters. The lower lands were covered by Moana-nui-kai-oo. Nuu, a powerful *kahuna,* saved a great many people.

After the Deluge there were three peoples: the Menehune, who were dwarfs or pygmies; the Ke-na-mu and the Ke-na-wa. A great part of these other peoples were destroyed by the Menehune. One of the chiefs of the Ke-na-mu had come to Hawaii from Kahiki. The name of this chief was Kualu-nui-kini-akua, Big-Kualu-of-the-Four-Thousand-Gods. He had a son Kualu-nui-pauku-moku-moku, Big-Kualu-of-the-Broken-Rope, the father of Ola, Life. They came from Kapaia-haa, otherwise called Kahiki-moe, the land that is now called New Zealand. They came to the land of Ka-ma-wae-lua-lani nei, that is now called Kauai-a-mano-ka-lani-po. That was the land where the three peoples had their home, the Ke-na-mu, the Ke-na-wa, and the Menehune. They lived there and emigrated thence as the people of more recent times have lived and travelled. At one time the Menehune journeyed until they reached the land of Kahiki-ka-paia-haa (New Zealand). That is why some people believe that they came originally from New Zealand, but that is not so. They were natives of Hawaii.

In the ancient tradition of "Kumulipo" it is told that there were a great many men and women from Ka-houpo-o-kane who went to Kahiki-ka-paia-haa, and in those emigrations, there was one called He-ma, the progenitor of the Maori race. When He-ma went, at about that time, the Menehune people went, too, from Kauai-a-mano-ka-lani-po.

At that time Ma-oli-ku-laiakea or Maori-tu-raiatea, in the New Zealand language, was the king of the Menehune. He went with his people, accompanied by their chief, Aliikilola, and his wife, Lepoa. This was in the time of He-ma. And from the first part of the name of the king of the Menehune, the New Zealanders called themselves Maori. From the last part of the same name a place in New Zealand is called Raiatea. That is what is told in the most ancient of all traditions, called "Ke-Kumulipo."

When the Menehune returned to Kauai, they began to increase. The tribe grew until there were enough grown men to form two rows, reaching all the way from Makaweli to Wailua. They were so many, counting the women and children, that the only fish of which each could have one to himself, was the shrimp.

The Menehune were a small people, but they were broad and muscular and possessed of great strength. Contrary to common belief they were not possessed of any supernatural powers, but it was solely on account of

their tremendous strength and energy and their great numbers that they were able to accomplish the wonderful things they did. These pygmy people were both obedient and industrious, always obeying their leaders. Their average height was only from two feet, six inches, to three feet, but they were intelligent and well organized. They took no food from other lands, but cultivated enough for themselves. As they were hard workers, they always had plenty of food. Their favorite foods were *hau-pia*, a pudding made of arrow-root, sweetened with coconut milk; *pala-ai*, the squash, and *ko-ele-pa-lau*, or sweet potato pudding. They were also very fond of *luau*, the cooked young leaves of the taro, fern-fronds, and other greens. They had elaborately made and carved wooden dishes and utensils for their food.

One curious thing about the Menehune was that they never worked in daylight, as they never wanted to be seen. It was their rule that any enterprise they undertook had to be finished in a single night. If this could not be done they never returned to that piece of work. Being such a strong people, they almost always finished the task in one night. It is not known where their houses were, but it is said that they lived in caves and hollow logs, and as soon as it began to be daylight, they all disappeared. One great thing that they did was to cultivate the wild taro, either on the *pali* or in the swamps, for they planted anywhere they could find room for a single plant.

On the cliffs of Kauai are still seen many paths and roads which were built by them, and which are still called Ke-ala-pii-a-ka-Menehune, the Trails-of-the-Menehune. These trails are still to be seen above Hanapepe, Makaweli, Mana, Napali, Milolii, Nualolo and Hanapu. In the little hollows on the cliffs, they planted wild taro, yams, ferns, and bananas. No cliff was too steep for them to climb.

They also built many heiaus, including those of Elekuna, Polihale, and Kapa-ula, near Mana, Malae at Wailua, on the Lihue side of the river, just above the road, and Poli-ahu on the high land, between the branching of the Wailua river and the Opai-kaa stream. All the stones for these heiaus were brought from Makaweli. The Menehune formed two lines, and passed the stones from man to man. They also built the heiau at Kiha-wahine on Niihau. It is built of coral rock and is oblong in shape, with two corners fenced in as *kapu* places; one for the sacrificial altar, and the other for the *kahuna*, or high priest.

The Menehune hewed out two stone canoes, which were called by the Hawaiians, Waa-o-kau-meli-eli. These canoes, covered with earth, are still to be found at the Mana side of the Waimea Hotel.

At one time the Menehune hollowed out a huge stone, and carried it to Waimea, where the head Menehune fisherman used it as a house. It was called Papa-ena-ena, from his name. He sat in this house, and watched his men fish.

It was their custom to place in the streams big stones on which to pound their food. One of these big stones is to be seen far up the Hanalei River. Another was carried from Mahaulepu across Kipukai to Huleia. Still another was placed near the mountain of Maunahina in a little brook, above Wainiha, where to this day, natives leave offerings of lehua branches to the *Kupua*, or demi-god, of the locality. On this stone, Lahi and his son lived, after Lahi had been defeated in Waimea. His story is told in the legend of "The Bird Man." From his life came the saying, "Tear the bird, the water is rippling." The explanation of this proverb is that if anyone stepped into the brook, the ripples could be seen along its whole course. Therefore, when the water rippled, the boy knew that someone was wading through the stream, and said, "Tear the bird," meaning, "Eat at once," so that they would be prepared, in case it were the enemy approaching.

At one time the Menehune built two canoes of koa in the mountains near Puu-ka-Pele. As they were dragging them down to the lowlands, they were caught by a heavy rain-storm, and were forced to leave the canoes across a little valley. The storm covered the canoes with debris, and later, a road was built across them, over which all the materials to build the village of Waimea were hauled.

While these canoes were being placed in this valley one of the Menehune broke a law, and was condemned to die. He was turned into a stone which is still called Poha'-kina-pua'a, and can be seen on the Waimea Canyon road, not far below Puu-ka-Pele. As the stone was being placed, such a shout was raised that it frightened the ducks on the Kawainui pond near Kailua, on Oahu. At Mahaulepu, on Kauai, another Menehune was turned to stone for stealing watermelons. The Menehune regarded a thief with great contempt, and the penalty for such a crime was death by being turned into stone.

It is believed that this happened before the Menehune left Kauai and journeyed to New Zealand. When a son, Ola, was born to the king of Waimea, the headman, Kualu-nui-pauku-moku-moku, hastened to the far-lying islands of New Zealand, and brought the Menehune back to Kauai.

After their return the Menehune built the wall of the Alakoko fish pond at Niumalu. Standing in two rows they passed the stones from hand to hand all the way from Makaweli to Niumalu. Daylight came before

they had finished the work, and two gaps were left in the wall. These were filled in by Chinamen in late years, and the pond is still in use.

Ola, the king, obtained the promise of the Menehune that they would build a waterlead at Waimea, if all the people stayed in their houses, the dogs muzzled, and the chickens shut in calabashes, so that there would be no sound on the appointed night. This was done, and the Menehune completed the water-course before daybreak. It has stood the storms of many years, and is still called Kiki-a-Ola, Ola's-Water-Lead.

The Menehune also carried large flat stones from Koloa to Kalalau, where they built a big heiau, which stands to this day.

The favorite sport of these small men was to jump off cliffs into the sea. They carried stones from the mountains to their bathing places, where they placed them in piles. Then, throwing a stone into the sea, the skillful swimmer would dive after it. This was repeated until all the stones had disappeared.

One of their bathing places was at Ninini, a little beach, surrounded by cliffs, just inside the point where the larger Nawiliwili lighthouse now stands. While the Menehune were carrying a large rock from Kipukai to Ninini, half of it broke off, and fell into the Huleia River, where it is still used as a bridge called Kipapa-o-ka-Menehune, the Causeway-of-the-Menehune. The other half of the rock is still at Ninini.

From Ninini the swimmers went to Homai-ka-waa, Bring-the-Canoe, the next valley beyond Kealia. While they were bathing there a very large shark almost caught A-a-ka, one of the Menehune. They all swam ashore to a plain still known as A-a-ka, where they discussed plans to get revenge. Soon all the Menehune were ordered to gather morning-glory vine, of which a large basket was made. This, filled with bait, was lowered into the sea, and the shark was caught. Then he was towed around to a reef beyond Anahola. The odor of the shark soon brought so many land and sea birds to feast upon the flesh that the reef was called A-li-o-ma-nu, Where-the-Water-is-made-still-by-the-Oil-from-the-Shark, and is still known by this name.

The Menehune never again bathed at Ho-mai-ka-waa, but they built there the big heiau where Kawelo worshipped his shark god. The story of Kawelo is told in the legend of that name. They also erected a pile of stones at A-li-o-ma-nu in memory of their delivery from the shark. This pile of stones is called Ka-hua-a-li-ko.

At Molowaa, the Dry-Canoe, stones were piled up, and a bathing place called Uluoma was made. While the men were bathing there, the *luna*, or head man, saw that one Menehune, named Maliu, was missing. He quickly sent out a searching party. In the meantime the missing one, who

had been visiting at some Hawaiian home, saw the searchers, and began digging at the spot where a spring came out from a coral rock. There he was found, and he explained that he had discovered this spring, where they could all drink good water. So his life was spared. The spring was called Ka-wai-a-Maliu, the Water-of-Maliu, and is still to be seen.

Traveling on, the Menehune moved a big stone to Kahili, below Kilauea, which they used to dive from. At Mokuaeae, the island off the present Kilauea lighthouse, they began to fill in the channel between the island and the mainland. They were just able to touch the bottom with a paddle when morning dawned, and their task was left unfinished.

Near Kalihiwai a cave was dug, called Wa-ka-ulua. This became a well-known spot for catching ulua. At Hanalei, a large narrow stone, called Lani-ho-eho, Brushed-off-the-Heavens, was placed near the point of Pooku by one of the little men, none of his companions being willing to help him. At the point of Kealahula, at Lumahai, these wonderful men made a small hill on the seashore, by cutting off part of the point. You can still see the bare place on the ridge, where the earth was sliced off. At the base of this small hill, the Menehune placed a large stone, which they used as a jumping-off place. The hill is called Ma-ka-ihu-waa, the Landing-Place-of-the-Canoes.

On the plain above the Lumahai River the Menehune made their homes for a time. There one of the small men began to build a heiau which he called Ka-i-li-o-o-pa-ia. As he was working, the big owl of Kane came and sat on the stones. This bird was large enough to carry off a man, and, naturally, it frightened away the little workman. He returned next day, only to see the huge bird flying over the spot, croaking. He also saw the great monster dog, Kuilio-loa, My-Long-Dog, running about the heiau. These evil omens caused the Menehune to believe that the heiau was polluted, so he gave up his work.

One day, as the Menehune were bathing at Lumahai, one of them caught a large *ulua*. The fish tried to escape, but the little man struggled bravely, and finally killed it. The man was so badly wounded, however, that his blood flowed over the spot, and turned the earth and stones red. This place is still called Ka-a-le-le, from the name of the wounded man.

Weli, a bow-legged, deep-voiced Menehune *konohiki*, king's sheriff or executor, is remembered as an agriculturist. On the plain of Lumahai he planted breadfruit trees, which are there to this day. They were called Na-ulu-a-Weli, after the Menehune.

The small explorers soon found their way to the head of the Lumahai Valley, whence they crossed over to Wainiha. There they found an immense rock, one side of which was gray, and the other black. This they

hewed out into the shape of a poi board, and placed it near the falls of the Lumahai River. To this day, the *wi*, or fresh water shell-fish, come out on the gray side in the day-time, and on the black side at night. Even now no woman can successfully fish there unless she wears a certain lei of shredded *ti* leaves or breaks off two lehua branches, crying to the *Kupua*, as she throws one to the *mauka* side or towards the mountains, and one to the *makai* side or toward the sea, "Pa-na-a-na-a, give us luck!" If a man fishes there, he first throws two small stones into the water, asking for success.

The next nocturnal enterprise of these little men was to span the river with a bridge of flat stones, but freshets have since removed all traces of this work.

During their stay at Lumahai one of the Menehune who was skilled in stone carving, tried to escape by climbing up the cliffs towards Waialeale. The *konohiki* sent his men to capture him. They overtook him at about the middle of the cliff, and the usual punishment was meted out to him—his body was turned into stone and placed on the spot where he was captured. It is there today, a huge stone in the form of a man with a gray body and a white head. The path the pursuers followed zigzags up the steep *pali* to the stone, which is called Ma-i-na-ke-ha-u, the Man-Out-of-Breath.

The Menehune then went on to Wainiha, where they placed a stone in the middle of the ridge, leaving such a narrow space to pass that in after years the Hawaiians had to hold on to the stone, and make themselves as small as possible in order to edge around it. So the stone became known as the "Hungry Stone." In the Wainiha River a flat stone was placed which reaches from bank to bank, and part of which is always above water.

Hurrying on to the top of Kilohana, the Menehune built on the plain there a little hill about ten feet high called Po-po-pii. There they amused themselves by rolling down its slopes. They made so much noise at this sport that the birds at Kahuku, on Oahu, were frightened.

Ka-u-ki-u-ki, the Angry-one, a Menehune, declared that he could go to the top of this hill and catch the legs of the moon. This boast was ridiculed, and when he was unable to carry it out, he was turned into stone. This stone was often covered with maile and lehua branches by the natives, so that the rain and fog would not prevent their carrying out their plans.

In the valley of Lanihuli the Menehune lived for some time, planting it with different varieties of plants which are still there. Several times

Hawaiians tried to steal their food, and were always turned into stone on the spot where they were overtaken.

After they had been living in this valley for some time the king found that many of his men were marrying Hawaiian women. This worried him greatly as he was anxious to keep his race pure. At last he decided to leave the islands. Summoning his counselors, his astrologers, and his leading men, he told them his plans. They agreed with their king, and a proclamation was issued calling all the Menehune together on the night of the full moon.

On the appointed night such a crowd gathered on the plain of Ma-hi-e that the vegetation there was trampled down, and the place, to this day, is barren.

There, in the moonlight, the king saw all the Menehune and their first-born sons, and he addressed them with these words, "My people, you whom I love, I have called you together to explain my plans for leaving this island. I desire that we keep our race distinct from others, and in order to do this we must go to other lands. You must leave behind you, your wives chosen from the Hawaiian race. You may take with you only your older sons. The food we have planted in this valley is ripe. It shall be left for your wives."

As soon as the king had finished speaking, a man called Mo-hi-ki-a said, "We have heard your words, O King. I have married a Hawaiian woman and we have a son grown to manhood. I have taught him all the skill I possess in making stone and koa canoes. He can polish them as well as hew them out. I beg you to take him in my place. He holds in his right hand the stone adz for making stone canoes, and in his left hand the adz for koa canoes. I have had mighty strength. No stone was too large for me to move. No tree was too tall for me to cut down, and make into a canoe. My son has strength, as I have had. Take him in my place. If at any time you need me, send a messenger for me. My son can be that messenger. He has been taught to run."

Having heard this request, Kii-la-mi-ki, the speaker of the Menehune, rose and answered in this manner: "You who beg to be left behind to live with your Hawaiian wife, listen! That woman has only lately come into your life. The king has always been in your life. We see your first-born there, but none of us have seen him work, and we do not know what he can do. You say that you have taught him all you know in canoe building, but we have never seen him work. We do not know that he can take your place. We all feel that you must go with us."

These words were echoed by a great chorus from the crowd: "He shall not stay! He shall go!"

When at last the Menehune were quieted they heard the voice of the high sheriff saying, "One word from the king, and we shall obey in every-thing. It is only by listening to his words, and by obeying him that our race shall be kept together. Otherwise rebellion will come. All must be done as he says."

Then a great stillness fell upon the assembled people. The herald of the king rose, and cried out, "Let no word be spoken! Words are *kapu*. *Meha meha*, be absolutely still! The heavens speak through the voice of your king. Lie down on your faces before him!"

After seeing these signs of his people's obedience the king rose and said, "Listen, my people, to these words which shall come from my mouth. I deny the request of Mo-ho-ki-a. I ask you not to leave him behind. We shall start on our way tomorrow night. Take only what food you need for a few days. Leave all the growing crops for the Hawaiian women you have taken as wives, lest criticism fall upon us. Before we depart I wish a monument to be erected to show that we have lived here."

As soon as the people had heard these words they began to build a pile of stones on the top of the mountain. When they had finished their work they placed a grooved stone on top, as a monument to the Menehune king and his leaders. Not far from it was dug a square hole, with caves in its sides. This was the monument to the Menehune of common birth.

When these last works of their hands were completed, the little men raised such a great shout that the fish in the pond of Nomilu, across the island, jumped in fright, and the *moi*, the wary fish, left the beaches.

The rest of the night was used by the *konohiki*, who separated the men into twenty divisions of sixteen thousand each. The women were divided into eight divisions of twenty thousand each. Besides these, there were ten thousand half-grown boys, and of girls up to the age of seventeen there were ten thousand six hundred. Each division was placed under a leader. The work of the first division was to clear the road of logs, and similar obstructions. That of the second was to lower the hills. The third was to sweep the path. Another division had to carry the sleds and sleep-ing mats, for the king. One division had charge of the food and another of the planting. One division was composed of *kahuna*, soothsayers, and astrologers. Still another was made up of story-tellers, fun-makers, minstrels, and musicians, who furnished amusement for the king. Some of the musicians played the nose-flute, which was one and a half spans long, and half an inch in diameter, and made of bamboo. One end was closed, and about two inches below, was the hole into which they breathed, and blew out the music. About the middle of the flute was another hole which they fingered, to make the different notes. Others blew the ti-leaf trumpets,

which were made by ripping a ti leaf part away along the middle ridge, and rolling over the torn piece. Through this they blew, varying the sound by fingering. Others played crude stringed instruments of pliable black hau wood with strings of tough *olo-na* fiber. These, called *ukeke*, they held in their mouths, and twanged the strings, with their fingers. Still others beat drums of shark skin, stretched taut over the ends of hollow tree trunks.

When all was arranged, orders were given for starting the following night.

At the appointed time the Menehune set forth. Many obstructions were found but each division did its work of cutting, clearing, and sweeping the path. They also planted wild taro, yams, and other food-producing plants all along the way. After they had climbed to the top of the mountain, they encamped at a place called Kanaloa-huluhulu, the Hairy-Devil, and sent men back to fish.

It happened that while they were resting there one of the chiefesses, Hanakapiai, gave birth to a child. When the child was a week old the mother died. Her body was turned into stone, and a valley was named after her. A few days later another chiefess, Hanakeao, stepped on a stone, which rolled down into the next valley, hurling her to death. That valley bears the name of the unfortunate one. As these women had been dearly loved, the king ordered a period of mourning which was to last sixty days. During that time no sports were to be indulged in.

All the fishermen were sent back to Haena to fish. There they found a great many small fish, so many in fact, that they could not carry all. So they took part of the catch, and left them on the plain, near the *pali*. When they returned with the remainder of the fish, they saw that the *akua* had stolen all the first half, and had disappeared through a hole in the mountain. The fishermen divided into two groups, one following the thieves into the hole, and the other began digging a cave near the supposed outlet of the hole. In a short time a huge cave was dug, and then they came upon the offending *akua* who were promptly put to death. This dry cave is still to be seen at Haena, and the natives call it Maniniholo, after the head fisherman of the Menehune, or Kahauna, from the smell of the dead bodies of the *akua*.

When at last the sixty days of mourning were ended, the king ordered the *ilamoku*, the marshal, to proclaim a big feast to be followed by sports of many kinds.

Some of these were: spinning tops, or *olo-hu*, made of small gourds or kukui nuts, or sometimes carved of wiliwili wood, boxing, wrestling, and similar games such as *uma*, or *kulakulai*. This was played by the two

opponents stretching at full length, face down, on the ground, with their heads together, and their bodies in opposite directions. Each leaned on his right elbow, and grasped the other's right hand, firmly. Then each tried to twist the other's arm back, until the back of his opponent's hand touched the ground, meantime keeping his own body flat on the ground. This game could be played with the left hand, as well as with the right.

They also played *maika*, a game resembling discus throwing, played with evenly-rounded, perfectly balanced stones, from two to eight inches across, and thicker in the middle than on the edge. On Kauai the *maika* were made of black stone, but on the other islands they were generally of sand-stone. They were always highly polished. The *maika* were thrown to see how far they would go, but sometimes the men would race with the *maika*.

Another game they played was *ke'a-pua*, in which they took the straight shafts of the sugar-cane tassels, and shot them like arrows from a whip-like contrivance. This was made of a stick about three feet long, with a string five or six feet long, attached. The end of this string, doubled over, was folded around the shaft, and the remainder wound around smoothly and evenly, so as not to catch. The shaft was laid on the ground, with the point a little raised, and then whipped off. If it was well-balanced, it flew several hundred feet. The person whose *ke'a-pua* shot furthest, won, and he kept his arrow, which was called Hia-pai-ole, the Arrow-which-could-not-be-Beaten.

The queen's favorite game was *puhenehene*. This was played by placing five piles of tapa on the ground. A little flat stone, called the *noa*, was hidden in one of the piles, while the opponent watched the nimble fingers and movements of the arm muscles of his rival. Then he had to guess under which pile it was hidden, and point his stick at it. The queen usually won from the king, laughing at him, thus giving the game its name, which means "jeering."

Another sport was the tug-of-war. When one side was about to be beaten, others jumped in, and helped them. On the ninth and tenth nights of their celebration the Menehune had foot-races. In these, two Menehune raced at a time. The two last to race were Pakia and Luhau. These were known to be so swift that they could run around Kauai six times in one day. Pakia won the race, beating Luhau by three fathoms. The people stood up and cheered when the decision was given, and picked up the champion, and carried him on their shoulders.

The next night they were to have sled races. They were to race down the steep hill-side of a little valley that leads into Hanakapiai. If the course for the races was not slippery enough, they covered it with very fine rushes

to make the sleds slide easily and swiftly. The first to race were Pahuku and Pohaha. The sled of Pahuku tipped, and he was thrown off, so Pohaha reached the goal first, and won the race. The next race was between two women, who were noted for their skill, Kapa'i, and Mukea. Kapa'i won this race, and Mukea joined in cheering her opponent. Next came a race between Mohihi, the queen, and Manu, a chief. Mohihi won, by only half a length, and Manu joined in the applause. The king and all the chiefs were very much pleased that the queen had won the race. It was a great thing for her to beat Manu, for he was supposed to be the champion of all the Menehune people. That was the last of the races.

Then the father of Manu came to the king, and suggested that they make a big pile of stones at this spot, as a monument. Then all the Menehunes clapped their hands, and agreed to do so. There was great rejoicing among them, and so they built up a huge pile of stones, which they finished just at daybreak. Then the Menehune left that place, and traveled on their way.

THE STORY OF OLA

As we have already been told, the king of the Ke-na-mu on Kauai-a-mano-ka-lani-po, was K u a l u-n u i-p a u k u-moku-moku, Big-Kualu-of-the-Broken-Rope. While he was living in Waimea, he met and fell in love with a beautiful princess, Kuhapuola, who had come from Peapea, above Hanapepe, on the Waimea side. At length, after having spent many happy days with her, the king decided to return to his kingly duties at Kekaha. He called the lovely girl to his side, and gave her his *malo* and *lei palaoa,* a necklace of many braided strands of human hair, fastened by a hooked ivory ornament. This could be worn only by high chiefs, and was one of the signs of royalty. He told her that if a boy were born to her, she should name him after the king's family, but if a girl were born, she might select the name herself.

After a time the princess gave birth to a boy, whom she called Kualunui, as she had been told. As the child grew older he became very mischievous and head-strong. He refused to regard the *kapu* of the *kahuna* and was always in trouble.

At one time the people had gathered to make a *kahe* or fish-trap in the Makaweli River to catch the fish which the freshet would carry down.

An order was issued that no one was to touch the *kahe* until the *kahuna* had removed the *kapu.* But the boy disregarded this order and ate of the fish that had been caught. In great anger the *kahuna* caught him, and took him to Kekaha where he was tried the following day before the king.

Hearing that her son was in trouble, the princess hurried to her *kahuna*, asking what she should do to save her boy. The *kahuna* answered, "Take the *malo* and the *lei palaoa* of the king and six *kukui* nuts. You must walk to Kekaha, and as you go you must be ever tossing the six nuts into the air and catching them. If you drop one, your child will die. If you catch all, his life will be spared." The princess at once set out for Kekaha. Her journey was successful, for not once did she let fall a nut.

When she came into the presence of the king, who was sitting in the heiau of Hauola, she saw her son bound, ready to be offered as a sacrifice, for his crime of breaking the sacred *kapu*. Going before the king, she showed him his *malo* and *lei palaoa*. He at once recognized the princess and spared the life of his son whom he called Ola, or Life, and named him as his successor.

Upon the death of the king, Ola succeeded to the kingdom. His first thought was for his people whose troubles he well knew. They had had a great deal of difficulty in bringing the water from the Waimea River down to their taro patches in the Waimea flats, as none of their flumes had lasted.

Wishing to remove this trouble Ola consulted his *kahuna*, Pi, who gave him this advice: "Establish a *kapu* so that no one can go out of his house at night. Then I shall summon the Menehune to build a stone water-lead around the point of the Waimea River so that your people will always have an abundant water supply."

Ola established the *kapu*. No man, woman, or child was to go out of his house at night. Then Pi summoned the Menehune to come from foreign lands and make the water-lead in one night.

Beforehand Pi had arranged the stones in a cliff, every one of the same size and shape. From this cliff each Menehune took one stone which he called Haawe-a-Pi, the Pack-of-Pi, and placed it in the lead. This water course is still called Kiki-a-Ola, and it has stood the floods of many years.

When this task was finished a great feast was given at the *heiau* of Hauola. The Menehune made such a great noise that the ducks in the pond of Kawainui, at Kailua, Oahu, were frightened.

Ola next ordered the Menehune to build a large canoe house in the mountains. When it was finished they hewed out canoes, which they took to the king as he asked for them. One night as two canoes were being dragged from the mountains, they broke into two pieces and filled up the mouth of the valley of Kawaa-haki. Debris collected around the broken canoes until a road was made.

Later, Ola sent the Menehune to build a heiau at the mouth of the Wailua River, which was to be called Hauola, after the famous city of refuge of his father at Kekaha.

The Menehune encamped above Haena on the flats which they called Kanaloa-hulu-hulu. At Ola's request they planted taro on the cliffs of Kalalau, where it is still growing. Between Kalalau and Waimea they built a big *imu,* called Kapuahi-a-Ola, and the Fire-Sacred-to-Ola.

Ola was ever thinking of improvements for his people, and his faithful laborers, the Menehune, carried them out. Many roads were built by them. One was a road of short sticks through the swamps of Alakai from Waimea to the heights above Wainiha. This road is still the only path across the otherwise impassable swamp.

THE BIRD MAN

A LEGEND OF KAUAI

Lahi, or Lauhaka, as he is sometimes called, lived in Wainiha valley. From childhood he had refused to eat any food but the meat of birds. As he grew older the meat of small birds would not satisfy him, and so his uncle, Kanealohi, the Slow-Man, took him to the top of Kilohana, where the *uwa'u* nested. These *uwa'u* were about the size of chickens. They were gray-feathered, with white breasts, with beaks like those of sea-gulls. Daylight blinded them, and though they were great fishers, they always returned to their nests in the mountains before dawn. Their name comes from the sound of their call or croak, "Uwa'u." While they were in the mountains, the uncle and boy made birds' nests, so that the *uwa'u* would be well cared for.

While they were living there, a giant came who tore the nests and tried to kill the men. The boy planned to get rid of their tormentor, and explained his plan to his uncle in these words, "I shall dig a long hole in the mountain. You crawl into it, dragging with you, by its tail, a bird. When the giant reaches for the bird, you draw it a little further in. When the giant is thus caught in the hole I shall kill him." The plan was carried out, and the giant was put to death.

But, in the meantime, the king had heard that the boy and his uncle were destroying the nests of the *uwa'u*. So there was more trouble in store for them, for he had gathered together four hundred soldiers to do battle with the two bird-catchers on Kilohana.

Now Lahi and his uncle had moved to the head of a very narrow valley through which flowed a small stream. If anyone stepped into this stream at any place in its course, the water at the source would ripple. In this way a warning of the coming of friend or foe was always given, and if they were eating birds, the boy would call, "Tear the bird, Kanealohi, the water is rippling."

One day, as they were roasting birds, the boy saw the water rippling, and called out his warning. The uncle at first replied that no one was coming, but looking again, he saw the dark shadows in the water. Then, in a few minutes, they saw the king and his four hundred men advancing. In despair, Kanealohi cast himself over the cliff, but, as he was falling, the boy caught him and put him behind him out of sight.

The pass was so narrow that only one man could ascend at a time. And so the boy killed the soldiers, one by one, as they attempted to come up, until the four hundred were thrown over the cliff. The last one to

come up was the king. He recognized the boy as his own son and begged, "Give me life in the name of your mother!"

Lahi therefore spared his life. The king thanked him with these words, "I will return to Waimea and there build a house for you. When it is finished, I shall send for you to come to me."

Returning to Waimea, the king ordered his men to dig a very deep hole. Over it, he had them erect an oblong-shaped house with only one entrance. Then he stretched a mat over the hole, and seated his subjects all around the edges to hold it taut. This done, he sent for his son, whose death he was seeking.

As the boy drew near the entrance, his father, from within the house, called to him to enter. Suspicious, Lahi thrust his spear through the mat and discovered the treachery. So, quickly closing the door, he set fire to the house, and destroyed his treacherous father and all his faithless subjects. Then Lahi became king.

THE SMALL WISE BOY AND THE LITTLE FOOL

A LEGEND OF KAUAI

There were two brothers who lived on the flats at Nukole, between Hanamaulu and the Wailoa stream. Their names were Waa-waa-iki-naau-ao, The-Wise-One, and Waa-waa-iki-na-aopo, The-Stupid-One.

One day they decided to go to Waialeale, to exploit their bird preserves. In those days, each person had his special bird grounds as well as fishing grounds. No one could trespass on their rights. As they were starting out, The-Wise-One said to The-Stupid-One, "When we catch the birds, every bird that has two holes in its beak belongs to me. That is my mark. Those that have only one hole belong to you."

So every bird that The-Stupid-One caught, he gave to his brother, for they all had two holes in their beaks. He would say, "This is yours, it has your mark." So, when they started home, The-Wise-One had all the birds, and The-Stupid-One had none.

Then The-Stupid-One went crying to his mother, saying, "All the birds we caught today belong to my brother. They had his mark. I had none to bring home."

After he had explained to his mother about the marks, she comforted him in these words, "That is all right. We will fix it so that you get all the birds next time."

Then she got a lot of bread-fruit gum, and told The-Stupid-One to take it with him. When he caught a bird, he must pull all the feathers off before he gave it to his brother. Then when they were ready to start home, he would have a big pile of feathers. He must let The-Wise-One go first, with the pack of birds. Then The-Stupid-One must smear the gum all over himself, and roll in the feathers. They would stick to him, and he would be completed covered. Then he must follow his brother very quietly, until they got to the path that crosses the top of the hill, Ka-ili-hina-lea. When he reached this spot, The-Stupid-One must rush up behind his brother, crying in a loud voice, "*Apau!* The *akua* of the mountain is after you! He will grab you!"

The mother continued in these words, "Then your brother will look back and see you, and be frightened. He will drop the birds, and run. Then you can pick up the birds and bring them home. You will have them all, and you will have only a little way to carry them."

The-Stupid-One carried out his mother's instructions. All happened as she had said. So that time The-Stupid-One had the best of it in the end.

Another time the two boys went fishing. The-Wise-One told The-Stupid-One that all the fish with two eyes belonged to him. All the fish with one eye, The-Stupid-One could have. The-Stupid-One gave all the fish he caught to his brother, as they had his mark. So The-Wise-One had a big pile of fish. But at last The-Stupid-One caught a fish from the deep sea that had only one eye. So he had something to take home.

KAMAPUAA

A LEGEND OF KAUAI

Kamapuaa came to Kipukai, on the southeast coast of Kauai, in the form of a large fish called by the Hawaiians *humuhumu-a-puaa*. This is a black fish, with a long snout like that of a hog. As soon as Kamapuaa had landed at Point Kipu-ike he changed himself into a hog, and rooted in the sand to get a drink of water. At low tide fresh water is still to be found at Point Kipu-ike.

After Kamapuaa had rested a while, he tried to climb a small, steep cliff nearby, but was unable to do so. When darkness hid him, he ate all the sweet potatoes and sugar-cane belonging to the natives. Then he crossed over to a big rock on the side of the hill to the west, and lay down to sleep.

When the natives wakened in the morning, they found their sugar-cane and potatoes gone. Seeing in the fields the tracks of a large hog, they followed them with their dogs until they came upon the hog, fast asleep. They quickly tied his feet together with strong ropes. He was so large that twenty men had to carry him to the village, where they prepared an *imu* in which to cook him.

When the *imu* was red hot, the men brought a rope to strangle their victim. Then the hog stretched himself, breaking the ropes, and walked away as a man. The men were so astonished that they did not dare to follow. Even in the form of a man, Kamapuaa retained something of the hog. Although his face was very handsome, he still had stiff black bristles down his back. However, he always wore a cape to cover the bristles.

Kamapuaa went on until he came to the hidden spring of Kemamo, over which two *kupua* kept watch. Being thirsty, the stranger asked for water. When the *kupua* refused to give him any, he turned himself into a hog again, and rooted in the earth until he found a spring. Then he seized the *kupua* and threw them across the valley, where they were turned into two large rocks, which can be seen to this day. The water of this spring was very famous for its sparkle, and in the old days, it was taken in gourds to the other islands for special occasions.

Later, Kamapuaa found another spring, in which he lay down and went to sleep. The water of this spring is still so bitter that no animal will drink it, and it is still called Wai-a-ka-puaa, the Water-of-the-Pig. While Kamapuaa was sleeping, the giant Limaloa, Long-Arm, from Kekaha, saw the huge creature lying in the mud, and so he put his back to a large boulder to roll it down on the hog and crush him. As the stone

came near, Kamapuaa awoke and threw a small stone under it, which wedged the great boulder on the hillside, so that it did not fall on him. These stones can still be pointed out on the Kipukai trail.

Then Limaloa saw that the object he was trying to kill was a man. He made friends with Kamapuaa, and told him that on the other side of the ridge, there were two beautiful women, whom he had been courting. They had rejected his suit, but since Kamapuaa was so much more handsome, he might be successful should he attempt his fortune.

The two men crossed from Kipukai, over the gap of Kemamo. As they were coming down the hill on the Lihue side, Kamapuaa slid on a big rock; the groove that his hoof made, can still be seen. The friends saw the two beautiful sisters washing their faces and combing their hair at the two clear pools, like basins, called Ka-wai-o-ka-pakilokilo, the Waters-where-the-Image-is-Reflected. The pools were in a large rock on the hillside and can still be seen at the left of where the paved trail begins. Kamapuaa slid down the slope, and, standing where his reflection could be seen, began to sing.

The sisters were greatly impressed by the beautiful reflection in the water. They looked up, and seeing the handsome stranger, they fell in love with him at first sight, and invited him to go home with them. Kamapuaa said that he would go with them, if his *akua* could accompany him. To this the sisters gladly consented. But when they saw the rejected Limaloa, they cried, "That man is no *akua*. He is the one who has been annoying us by his attentions and presents. We do not care for him."

However, Kamapuaa would not go without his new found friend. So, in order to have the handsome stranger, the sisters allowed Limaloa to follow to the home of their brother, who was king of the Puna side of Kauai. This stretched from Kipukai to Anahola. The king soon gave his sisters to Kamapuaa in marriage.

At this time the Puna side was engaged in a battle with the Kona side, which included all the country from Koloa to Mana. Kamapuaa would wait in the house until all the men had gone to the battlefield. Then, after having made all his body invisible, except his hands, which held a club, he would follow the Puna men to battle, and strike the Kona chiefs on the head. From the dead chiefs he would take their feather capes and helmets. Then he would return home as a hog, and dirty the floormats. When the two beautiful sisters had gone down to the stream to wash the mats the hog had befouled, Kamapuaa would hide the capes and helmets under the *punei*, or beds, which were made with frameworks of *lauhala* logs, covered with many finely-woven mats. Gradually the *punei*

grew higher and higher, for he continued stealing and hiding the capes and helmets for days, until he had collected a huge store of them.

The king began to miss these things, which were always his perquisites from the booty taken. But he was unable to find who was stealing them, or where they were hidden. Finally he called his *kahuna* to help him find the guilty person. The *kahuna* told the king to build a platform, and then to summon all his people, for it was known that the hand which had killed so many chiefs had one day been wounded on the thumb by a spear. The king would stand on the platform, and order everyone to raise his hands. Then he could easily see the wounded hand, and so find the thief.

The king followed out the instructions of his *kahuna*. At a given signal all hands were raised. There was no wounded hand to be seen. Then the king was told that his brother-in-law, Kamapuaa, was not there. So his house was searched, and he was found. Behold, his hand was wounded!

Upon further search, the feather capes and helmets were found. The king was very angry. He gave Kamapuaa his choice of either leaving his home, or being put to death. Kamapuaa wisely chose the former punishment. He next went to Oahu, then to Maui, and Hawaii, where he had many adventures, but he never returned to Kauai. Limaloa returned to Kekaha, where, it is said, that, to this day, at dawn at certain times of the year, he can be seen at Kaunalewa, near Waiawa. Dressed in a yellow feather cloak and helmet he comes out of the phantom houses, which can be dimly seen near the coconut trees, and strides along with his spear.

KAWELO OF KAUAI

Kawelo, the Waving-of-the-Flag, the great opponent of Kauahoa, the giant of Hanalei, was the son of Maihuna and Malaiakalani. He was born in Hanamaulu, Kauai. He had two older brothers, one older sister, and one younger brother, Kamalama. Kawelo was such a good son that he was known as Kawelo-Lei-Makua, Kawelo-Who-Cherished-His-Parents.

The maternal grandparents of Kawelo were celebrated for their skill in phrenology. So when still a small boy Kawelo was taken by his parents to them, and they foretold that he would be a good soldier, a strong man, a conqueror, a son who would bring life to their bones.

Wishing to care tenderly for such a grandson, his grandparents took him to live with them at Wailua where lived Aikanaka, the young prince and Kauahoa, boys of the same age as Kawelo, with whom he played.

Kawelo developed a great appetite. He would eat the contents of an *imu*, or oven, of food at one time. His grandparents grew weary of trying to satisfy this huge appetite, and so they tried to divert the boy's mind. They gave him a canoe to paddle up and down the Wailua River.

As soon as Kauahoa saw Kawelo enjoying his canoe, he made a kite and flew it. At once Kawelo asked his grandparents to make him a kite. So the two boys flew their kites together until one day Kawelo's caught in the string of his friend's and broke it, freeing the kite, which flew off and lit at a place above Koloa, still called Hooleinapea, the Fall-of-the-Kite. The ridge still shows the dent where the kite struck it.

Kawelo feared that Kauahoa would be angry and punish him, as Kauahoa was the larger of the two, but Kauahoa said nothing about the kite, and Kawelo decided that the young giant was afraid of him.

Aikanaka, Man-Eater,[1] the prince, ruled over his two friends even as boys. Whatever he asked them to do they did. So they grew to manhood.

In the meantime the older brothers of Kawelo went to Oahu where Kakuhihewa was ruling. This king had among his retainers a very strong man, the strongest wrestler in the islands. The boys very often went surf-board-riding, and when this exercise was over, they would wrestle with the great champion.

After these boys had been away some years, their grandparents had a great desire to see them, so taking Kawelo with them the old people paddled to Oahu and landed at Waikiki.

On Oahu Kawelo met and soon married Kanewahineikiaoha and in order to provide food for himself and his wife he worked every day in the taro patch.

[1] *Aikanaka* is used figuratively. The Hawaiians were not cannibals.

One day as he was at work he heard great shouting down by the sea. His grandparents told him that his brothers were wrestling with the king's strong man. When one of them was thrown down the people shouted.

At once Kawelo longed to see the sport, but his grandparents forbade his going. So he waited until they were away and then he hurried to the sea, where he saw his brothers surfing. He borrowed a surf-board and joined his brothers and later followed them to the wrestling place. When he stood up to wrestle with the strong man, his brothers tried to prevent him by saying that he was too young, that he was not strong enough. Kawelo did not listen to them and to everyone's surprise he threw the king's great wrestler. This angered the brothers, who were ashamed of their lack of strength, and so they hurried to their grandparents, and told them that Kawelo had been throwing stones at them. Receiving little sympathy they decided to return to Kauai.

Then Kawelo began to desire other accomplishments. First he longed to be able to hula, which meant a training in an art far more diversified than mere dancing. After long schooling the pupils had to pass a strict examination before they could appear in public. But this graceful and difficult art Kawelo could not master, so he turned his mind to other things. His father-in-law taught him, and his wife as well, all manner of spear throwing. Next he wanted to learn to fish well. Makuakeke, the celebrated fisherman, became his teacher.

At dawn Kawelo awakened his teacher with these words, "Makuakeke, awake! The sun is high. Bring the fish-hooks and the nets. Let us fish."

So the fisherman prepared everything. They got into a canoe and paddled out to deep water. As they were going, the older man called out, "Kawelo, the lei of his parents, my king fisherman of Kauai, we will fish here."

But Kawelo answered, "Not here. We shall go on until we reach the point of Kaena. Hold on to the canoe."

Then with one mighty stroke of the paddle the canoe lay off Honolulu harbor, with two strokes it neared Puuloa, and with three it reached Waianae. There Kawelo chewed some *kukui* nuts and blew the oil over the sea so that the water became calm and they could see the bottom. The canoe drifted from the shallow water into the deep as the men fished for ulua.

As it grew late Makuakeke urged Kawelo to return home, for he knew that it was time for Uhumakaikai, the fish god, to appear and he greatly feared this fish.

So the tired fishermen went home. After Kawelo had bathed, he ordered his steward to bring him his evening meal. Forty calabashes of poi, and forty *laulau,* or bundles, of pig, wrapped in *ti* leaves and cooked in an underground *imu,* or oven, were set before him, but this was not enough to satisfy his huge appetite. The same amount was set before him the second time, and having eaten it he lay down to sleep.

As the sun was setting, Kawelo awoke and ordered the mats to be spread, and the pillows and bed tapas to be prepared. Before retiring he read the signs of the heavens and learned that Haupu and Kalanipuu, two mountain peaks near Nawiliwili Bay, were being burned up. "Alas!" he cried, "My love for my parents is coming to me. They may be in trouble. I fear that they are being killed."

His wife, who did not know that her husband was able to read heavens, asked, "How are you able to go to Kauai and back so soon?"

Kawelo answered, "If your parents were in trouble you would weep. Your tears would flow. You care not for my beloved ones."

Early the next morning Kawelo called the fisherman and paddled out to their fishing waters. Soon Makuakeke saw the storm clouds gathering in the sky and knew that the fish god was coming. As the huge fish swam towards them Kawelo threw his net and caught him. Then the fish, pulling the canoe with him, swam out to sea until the men could no longer see their homes or the surf beating on the shore. They went so rapidly that they soon came to Kauai, where the fish turned and swam back with them to Waikiki. There at last the men were able to kill him.

As Kawelo jumped ashore, he saw two messengers from Kauai standing near his six soldiers, who were very skilled in throwing the spear. Kawelo noticed that these soldiers were drawing their spears, and he heard one of the messengers cry, "They are trying to spear Kawelo before he is ready. If they do, our journey to Oahu will have been in vain."

Kamalama, Kawelo's younger brother, answered, "Watch. You will see that the spears thrown at him will be like water."

First two of the soldiers threw their spears in vain at Kawelo. When they were weary, two others, more skilled, took their turns, and so on until all had tried. But this was only a game to Kawelo.

Then Kamalama was told by his brother to bring the sharp spears with which they could do battle. Taking the celebrated spears he cried, "Kawelo, keep your eyes wide open. If you wink your eyes once I will spear you."

Bracing himself, he threw the spear at Kawelo with all his might. Kawelo dodged it, and it flew on until it came to the surf at Waikiki, so great had been the force which sent it. Then Kamalama was told to

throw the second spear directly at the stomach of his brother. Again Kawelo dodged it and this time it flew beyond the surf.

When the messengers from Kauai had seen Kawelo's skill in dodging spears, they marvelled at his strength and declared that he would be the conqueror of the islands. After so much exercise Kawelo hurried to his bath and then sat down to eat his forty calabashes of poi and forty *laulau* of pig. As before, his hunger was not satisfied until he had been served the same amount again. Then, calling the messengers to him, he inquired what had brought them from Kauai.

They answered, "Kawelo, we have come to take you home to your parents, who are in sore need. They have been driven from their homes and have nothing to eat. You must return to fight with Ai-kanaka, the cruel prince."

Without replying to them, Kawelo ordered his wife to secure from her father spears, bows and arrows used for shooting rats, and the ax that he used for hewing out canoes. All these things he would need on Kauai.

After his wife had crossed the stream and walked beyond the coconut trees, Kawelo told Kamalama to follow her, concealed, and to listen to the words of her father.

When Kanewahine came to her father's house she found that he had gone to prepare *awa* for the gods. Now the building where he was working was *kapu* for women, so the mother approached as near as she dared and then wailed loudly to attract his attention. Ceasing his prayers to the gods, the father hurried to his daughter, and asked, "What great thing has brought you here? Are you not afraid of the *akua* which hover about?"

Kanewahine answered, "I came to get the spears, the bows and arrows, and the ax for my husband who must go to Kauai to do battle."

Her father began to berate his son-in-law in these words: "Your husband is a plover with small feet. He is a bird that runs along the beach and is overthrown by the beating surf. He is like a banana tree without strength; he is like a *puhala* tree growing with its roots out of the ground. He is not strong like me, your father, large from head to feet, whom neither the Kona storms nor the wind from the mountains can harm."

"Be careful how you speak of my husband," warned Kanewahine. "He will know whatever you say."

"What wonderful ears he must have!" jeered the angry father. "He is on the Kona side and we are at Koolau."

His daughter replied, "My husband's powerful god, Kalanikilo, has heard your words and he will tell. My husband knows everything. Nothing is hidden from him."

"If that is the case," said her father, "someone must be listening who will carry my words to him. Come, my sons, and we will find the guilty one."

And so they searched everywhere but no one was to be found for as soon as Kamalama had seen them coming he had hurried to tell Kawelo all he had heard. When he began his story his brother stopped him, saying that he knew all. This made Kamalama very angry and he cried, "If you have such good ears why did you send me to that place where I have no friends? I wish to eat."

The head steward carried out forty sweet potatoes and forty *laulau* of pig. While they were eating, the father-in-law with his sons arrived and Kawelo told him all he had said.

"See! It is as I said," cried Kanewahine, "his god is very powerful."

"Yes," answered the father, "I see that your husband can hear in Kona what has been said in Koolau."

Then Kawelo, anxious to punish his father-in-law, said that they must try spear-throwing. His father-in-law told one of his sons to try first, but Kawelo would not hear of this. "The teacher must first try with the scholar," he said. "Then it will be seen which one is stronger."

So the man and his sons were on one side against Kawelo. His father-in-law threw the first spear which was warded off, and flying back, hit the thrower, knocking his down. As his father-in-law rolled over in the sand, Kawelo cried, "My spear, Kuikaa, is stronger than yours. It has hit your jaw. You are being punished for what you said of me. A rooster fed in the sun is stronger than one fed in the shade. One kick from the rooster fed in the sun will knock you down."

Seeing her father lying on the sand, Kanewahine ran to him and, pouring water on his head, restored him to consciousness.

After this trial of spears, Kawelo sent his brother and his wife with two soldiers to Puuloa to beg a canoe from Kakuhihewa, the king of Oahu. When they came before the king, Kanewahine stated their mission. The king gladly gave them a large double canoe because he feared Kawelo and was glad to hear that he was leaving for Kauai to do battle with Aikanaka.

So they returned to Waikiki in the canoe and Kawelo began his preparations for leaving. As soon as all was ready they set sail and went ashore at Waianae where they built a heiau to Kawelo's gods. After Kawelo had placed his gods in this heiau he asked advice from them, for he was uncertain in his mind about this journey. The feathers on one god, Kane-i-ka-pualena, the Yellow-Feathered-God, stood straight up, showing that he was not afraid of the task before them. The other god, Kalanihehu, the

Scatterer-of-the-Heavens, gave no sign. But Kawelo believed he had seen a propitious omen and at evening he left Oahu.

Before morning Kawelo saw Keaolewa, the clouds on the top of Haupu, floating towards them like a great white bird. Soon Kalanipuu came into sight.

These sights were not visible to the other passengers of the canoe and Kawelo's uncle exclaimed, "You must be telling us falsely. We have often been on this voyage with your parents, but always one night and half a day passed before we could see Keaolewa flying towards us like a bird. You say you see it before dawn."

But at daybreak all were able to see that Kawelo was speaking truthfully and in a short time the canoe lay off Hanamaulu, where the messengers urged Kawelo to land so that he could see his parents and friends before going to battle with Aikanaka. Kawelo refused to do this and ordered Kamalama to turn the canoe towards Wailua.

As the canoe anchored at Wailua, Kawelo told his brother to feed all the men so that they would be strong for the work before them.

The people on Nounou saw the canoe, and Aikanaka sent his messengers to find out what sort of canoe it might be, friendly or warlike. If friendly, the passengers were to be given food, tapas, and shelter. If warlike, the two great generals of Aaikanaka were to give battle at once.

In the meantime Kawelo, wrapped in mats, had been placed on the *pola,* the platform joining the double canoes, where he was covered with coconut leaves. When Kamalama saw the messengers swimming out to them, he called to Kawelo, "A man from our king is coming. He is swimming towards us."

As the messenger climbed aboard he asked, "Why have these canoes come?"

"To give battle," answered Kamalama, boldly.

"Who is the general?" inquired the man.

"I," said Kamalama.

"Where is Kawelo?"

"He is on Oahu."

"What is that bundle on the *pola?*"

"That is our food and clothing for this trip."

The messenger, a little suspicious, stepped on the bundle, but, as it did not move, he was deceived.

Then Kamalama asked how the king wished to give battle. He was told to go ashore where, after they had rested, eaten, and put on their war *malo,* they could begin the battle.

"But," warned the messenger, "you cannot win. We feared only Kawelo. Since he is not here you cannot hope for victory. You would do well to return to Oahu. This is not a canoe fit for doing battle with Kauai. Such a canoe must needs be a big canoe, a long canoe, and a wide canoe."

During this conversation crowds of people had gathered on the beach with the two head warriors. Each warrior had four hundred soldiers—not to mention the women and children—all clamoring to begin the fight at once.

But the messenger, mindful of his promise to Kamalama, ordered them back while some of his men carried the enemy's canoe up on the dry sand.

While this was going on Kawelo had secretly told his brother to loosen the rope that bound his feet. This done, he stood up with his mighty spear, Kuikaa, the Whizzing-Point, in his hand. Seeing him, his followers cried out, "Kawelo is on the canoe!"

The word Kawelo aroused such great fear in the hearts of the men who were carrying the canoe that they dropped it, killing several. At once the soldiers of Aikanaka surrounded the canoe.

Kawelo thrust his spear on the right side of the canoe and killed a great number. Then he turned to the left and killed many more. As soon as the Kauai soldiers saw how great the slaughter was, they retreated to the hill of Nounou. There they met great numbers of men hurrying to reenforce their friends by the sea.

After the retreat Kawelo ordered his brother to push the canoe back into the sea where he could watch the battle. Then Kamalama arranged the soldiers skillfully as he had been directed. Kawelo's adopted child, Kauluiki, Little-Rolling-Stone, led the right wing, and another adopted child, Kalaumeki, Meki-Leaf, led the left.

Seeing that Kawelo was not on land, the soldiers of Kauai came forward again, and engaged in furious strife. Kamalama was in the thickest of the battle, fighting with great courage. Kauluiki retreated to the shore but Kalaumeki kept on fighting, killing many.

When Kawelo saw how things were going, he called out in a loud voice, "When we conquer the island, Kamalama shall have all the Kona side of Kauai and Kalaumeki shall have all the Koolau side."

Hearing these words, Kauluiki grieved deeply because he had retreated. "It would have been better to have stayed on Oahu," he mourned. "There I at least had taro to eat. Here I have nothing."

When the messenger saw that the generals and best soldiers of his king had been killed he hurried to carry this news to Aikanaka. Kawelo asked Kamalama to follow the messenger and when he overtook him to scratch him with his spear, to mark him, but to let him go on his errand.

Kamalama overtook the messenger before he was half way up the hill. Tearing off his clothes, he beat him and then let him go. As the poor man ran to his king he cried, "We have no men left. All are killed. When I swam out to the canoe, Kamalama was the leader. Kawelo was nowhere to be seen. When the canoe came ashore, Kawelo appeared."

This news was a great surprise to Aikanaka because when he had heard that messengers had been sent to Oahu for Kawelo he had called together his bravest and most valiant warriors. Kauahoa had also been ordered to join them on the hill of Nounou, which had been well fortified. There provisions had been stored. The hill teemed with the celebrated soldiers of Kauai,

As the king was listening to the report of his messenger, two of his head soldiers, Kaiupepe, Flat-Nose, and Mano, Shark, asked if they could go down to the sea with eight hundred soldiers and engage in battle with the invaders. They asked only for the king's messenger as guide. The king granted this request and they advanced to join in battle.

The fresh troops met Kamalama's men and were slaughtered. Only the messenger escaped. He hurried to carry the news of this disaster to his king. "That is not a battle yonder," he cried, "it is a fire. Kamalama can throw his spear through ten men."

Great anger filled the heart of Aikanaka. Two other generals boasted of their strength and begged to be allowed to fight with their four hundred soldiers. As they advanced, Kamalama met them. In the battle which followed the men from Oahu showed their wonderful skill in spear throwing. They could spear an ant or a fly. Easily they killed all but the two generals. Then the hand of one of these men was speared.

But this battle had been so furious that Kamalama and Kalaumeki were beginning to be weary, and they were being hard pressed by the enemy. Kawelo saw this and called to them to retreat. While they were retreating, Kawelo ordered his paddlers to paddle the canoe to the shore. There he learned that most of the Kauai soldiers had been killed. The rest were about to retreat.

Kawelo then angered his brother by granting more land to his step-son. Kamalama left the battlefield, but was brought back by these flattering words, "Why do you depart, my young brother? You are the greatest soldier of all. You are hungry now; so your strength is waning."

Just then reinforcements came from Nounou and the Oahu soldiers retreated to the spot where Kawelo was standing. Seeing Walaheeikio, one of Kauai's most celebrated soldiers, advancing, Kawelo thus addressed him, "If you will join my forces, I will give you my sister as your wife."

This promise made the warrior think that Kawelo feared him. So he replied, "It is not for you to give me a wife. I shall kill you, and Aikanaka will offer your body as a sacrifice to his gods. I and my men will eat cooked taro on Kauai."

This vain boasting amused Kawelo, who warned, "Break the point off your spear before you thrust it at Kawelo."

"I will not have to break my spear to strike you," laughed the soldier. "You are as large as the end of a house. I must be an awkward animal if I miss you."

"You cannot hit a flying flag," ridiculed Kawelo. "You might hit my waving *malo*. Your shameful boasting will make you weep."

The two warriors raised their spears at the same time and threw them. Kawelo dodged the spear which just touched his *malo* and passed on into the ground. With shame, Walaheeikio turned to hasten back to Nounou but Kawelo threw his spear at his back and killed him.

So only Maomaoikio was left. Pity for the lone warrior filled Kawelo's heart and he offered him a wife if he would desert Aikanaka. But this soldier answered as his companion had answered, and threw his spear at Kawelo. Kawelo dodged it and threw his mighty spear at the king's faithful soldier. Then his canoe was left to drift without its paddler.

The messenger ran to Nounou and reported to Aikanaka, the boasting of his generals and their death at the hands of Kawelo. Then the king cried, "Now a cold chill numbs my bones. The house that gave us shelter is broken."

A soldier, Kahakaloa, skilled in throwing and dodging spears cheered the broken king with these words, "When did Kawelo learn to fight? We all lived here together and he was no more skilled than others. He has not been on Oahu very long. How can he be so skilled even though his father-in-law has been teaching him? I have fought with his father-in-law and neither could win from the other. How then can Kawelo defeat me? So, O King, give me five forties of men and I shall join battle with Kawelo and his younger brother."

Permission was gladly given by the king and Kahakaloa advanced to the foot of Nounou where he met Kamalama. In the battle which ensued, his strength and valor were shown, for he pressed his rival back to the spot where Kawelo was standing. There Kawelo angered him by calling him names, "*Lai-paa!* branded, son of a slave! *Ai-opala*, eater of rubbish! Dog! *Ai-hemu*, eater of leavings!" This was a great insult to a high chief of Kauai.

At length the two warriors stood ready for the encounter. Their spears were thrown at the same time. Kawelo was struck and stunned and his body rolled in the dust. Kahakaloa lost one ear and a little finger.

The king's messenger urged the soldier to strike the fallen Kawelo again, as his eyes were still open, but Kahakaloa answered, "He is killed by one blow from a young man. I shall not strike him again or he will go down to Milu and boast that I had to strike him twice. Now let us go home to eat. After that we shall return and finish our enemy."

Kamalama ran to his brother, for he believed that he had been killed. But in a short time Kawelo sat up. His dizziness left him. He asked where his antagonist had gone. Then he strengthened himself with food.

Kahakaloa, in the meantime, had hurried to his king, where he boasted that he had killed the mighty Kawelo, and that he would soon go back to the sea to put out his light forever. Hearing that his great rival was no more, Aikanaka ordered his steward to place the choicest food before the valiant soldier and the faithful messenger.

While this was being prepared, the king noticed that Kahakaloa had lost a finger and he inquired how the accident had happened.

"That was a branch on the outside which was easily struck," answered the soldier.

"And how about your ear?"

"Oh, that was a branch on top also easily cut off," replied the wounded man.

After Kahakaloa had eaten the food from the calabash he placed the empty vessel on his head as a helmet and went forth to destroy his rival.

Seeing someone coming, Kamalama called to his brother, "A bald-headed man is advancing. I can see the sun shining on his forehead."

But Kawelo was not deceived. He recognized his former antagonist and planned revenge. As Kahakaloa came before him, Kawelo struck the calabash on his head. Being broken, it fell over his eyes so that he could not see, and he was easily killed.

Again the messenger had to carry news of defeat to his king, whose only comment was, "How could he live, so wounded? He was only Kawelo's pig."

There still remained on Nounou, Kauahoa, the strongest of all the king's soldiers. He was known all over the islands for his size. He it was whom Kawelo feared most of all. However, Kawelo remembered their boyhood days when he had broken his friend's kite and had escaped unpunished. If Kauahoa feared him as a boy, possibly he still did. This thought cheered him and he planned how he could gain a victory over his old-time opponent.

Now when Kauahoa heard that Kahakaloa had fallen in the dust, he vowed to seek revenge with his spear, a whole koa tree from Kahihikolo, above Kilauea, so large that the birds sang in its branches while it was being carried. The giant stripped some of the branches from this tree, and they are growing at Kahihikolo now.

As this giant with his huge spear came down from Nounou he was so large that he hid the sun. A cold chill numbed the bones of Kawelo. Fear filled his brave heart. But he prepared for battle.

On his right he placed his wife with her *pikoi*.[4] On his left he stationed Kamalama. Behind him he ordered his foster sons to wait. Thus Kawelo stood with his mighty spear, ten fathoms long.

Kawelo knew that by skill only could he hope for victory. He decided not to wait long. Then he called out:

> I remember the days when we were young.
> Swelled now is the *limu* of Hanalei.
> Swelled above the eyes is the cloud of morning.
> In vain is the battle at the hands of children.
> The great battle will follow,
> As the deep sea follows the shallow water.
> In vain are the clouds dispersed.
> O Kauahoa, the strong one of Hanalei!
> Awake, O Kamalama, the strong one of Kualoa!
> Awake, Kawelo, the strong one of Waikiki!
> Awake, Kaelehapuna, the strong one of Ewa!
> Awake, Kalaumeki, the strong one of Waimea!
> We will all gather together at noonday.
> Postpone the battle, my brother. Leave me.
> This is not the day for us to give an exhibition of battle,
> Friend of my boyhood days, with whom I made lehua leis
> At Waikaee for our lord and older brothers.
> Awake, O Hanalei, the land of chill and rain,
> The land where the clouds hover!
> Awake O Kauahoa, the handsome one of Hanalei!

To these words the giant of Hanalei answered, "To-day we will give battle. To-day either my spear will seek your death or your spear will seek mine. To-day on one of us must fall the heavy sickness."

This answer alarmed Kawelo, but he fanned his flickering courage with the remembrance of the kite incident and replied:

> Hanalei, the land of cold and wet,
> Hanalei, the land where the clouds hover!
> The Ukiukiu, the northerly storm, of Hanakoa,
> The cliffs of Kalehuaweki are in vain.
> The *lama* and *wiliwili* are in flower.
> The rain that flies beyond Mamalahoa
> Is like Kauahoa, the man that Kamalama will defeat.

[4] See Glossary.

Having spoken thus, Kawelo said to his wife, "Throw your *pikoi* high as the ridge pole of Kauai is high. If we kill this giant, Kauai is ours. We shall cover ourselves with the fine mats of Niihau, and shall eat of the birds of Kaula."

Placing his brother and his foster children behind him, Kawelo at last was ready. Then, as Kauahoa threw his spear, Kawelo's wife caught it and drew it to one side with her *pikoi*, enabling her husband to dodge it. As the giant stooped down to pick up his spear, Kawelo cut him in two. So died the last of the strong men of Aikanaka.

That night Kawelo said to his wife, "I and my brother will go up to the hill of Nounou. If you see a fire burning you will know that we have conquered Kauai."

Ascending Nounou, Kawelo called out, "Aikanaka, let us be friends. Let us sleep together on the mats of Niihau."

The king did not reply. His men told him that Kawelo was tired and would soon be asleep. But they heard Kawelo asking if there were no men left on Kauai.

Aikanaka answered that only twelve soldiers were left. Then he begged his *kahuna* to let him go and meet Kawelo. They replied that a king could not fight with a servant whose duty, it was to count cockroaches.

Kawelo heard these words, which filled him with such shame that he started to roll down the hill. His wife threw her *pikoi* and kept him back, saying, "Why should you be ashamed? If you are really a slave, kill yourself. If you had been a slave, you would have been killed during this battle. The roosters are kings because they sleep on the top of the house. They waken you in the morning."

The *kahuna* told Aikanaka to answer that roosters were slaves.

"Oh, no," replied Kawelo, "you use the feathers of roosters to make kahili to wave over your kings."

Suddenly, a stillness fell on Nounou. Aikanaka and his men had fled to Hanapepe. Then Kawelo built a big fire on the hill. Seeing this, his brother and sons knew that Kauai belonged to him and so they hurried to the hill. There Kawelo divided the island, giving Koolau to Kalaumeki, Puna to Kaeleha, and Kona to Kamalama. The whole island was under the supervision of Kawelo, who lived in peace with his parents at Hanamaulu.

Aikanaka was living at Hanapepe with no honor, no food, no tapa. With his own hands he had to cultivate the taro patches. After he had been living in this manner for some time, Kaeleha left Kapaa and came to Hanapepe. There he met Aikanaka, who gave him food. A friendship grew between them and the former king gave his daughter in marriage to his conqueror's foster son.

As time went on Kaeleha grieved because he had nothing to give in return for so much kindness. At last his shame was so great that he decided to lessen it by telling Aikanaka that he could conquer Kawelo by throwing stones at him. This secret brought gladness to the king's heart and he cried, "My bones shall live again!" So Aikanaka and Kaeleha counseled together. The king sent his men to pile up stones near Wahiawa.

In the meantime these plans had been carried to Kawelo, who sent to find out from Kamalama if they were true. Kamalama hurried to Wahiawa, where he saw a great many people on the plains gathering and piling up stones. While he watched, a man approached him and said that these stones were being gathered to give battle to Kawelo, the usurper.

Kamalama sent this report to Kawelo, who was filled with anger. He hastened to Wahiawa, where he discovered Kaeleha's war canoes concealed behind the great pile of stones. There, too, he saw many men armed with stones, ready to give battle. Kawelo had only his spear and his wife's *pikoi*. He and his wife had to fight with all of Aikanaka's men. It was impossible for the valiant Kawelo to dodge all the stones which were flying at him from all directions. They piled up over his head. Several times he shook them off. At last he became weak and the stones were as a grave to him. His wife, wailing loudly, fled.

Believing that he was dead, the men removed the stones and beat his bruised body with sticks until they could feel no more pulse. Then messengers were sent to proclaim Aikanaka king of Kauai again.

Men carried the body of Kawelo to Koloa, where Aikanaka had built a heiau. There they laid the body and covered it with banana leaves, planning to return in the morning to offer the sacrifice.

The heat created by the banana leaves brought warmth to the cold body, and at midnight Kawelo returned to life. He got slowly to his feet and walked about the enclosure waiting for daylight.

The guard heard the footsteps in the heiau and fear took hold of him, for he believed that Kawelo's ghost had returned to seek vengeance. Creeping up to the wall he saw Kawelo standing and so he called, "Is that in truth you, Kawelo? Has death departed from you?"

A voice answered, "Where is Aikanaka with his men? Where am I?" When he heard these words, the guard knew that Kawelo was not dead.

"They are far distant," replied the guard. "They are sleeping. At sunrise they return to place your body on the altar and to offer you as a sacrifice to Aikanaka's god. It is wonderful that you live. I will help you in any way I can, even if in so doing, death come to my bones."

These words cheered Kawelo and he asked for his mighty spear. Then he directed the guard in these words, "Towards morning I shall lie down.

You cover me again with the banana leaves. When Aikanaka and his friends enter the heiau whisper to me."

So Kawelo lay concealed under the banana leaves. Aikanaka did not come until noon and the hidden man was greatly annoyed as he was very uncomfortable.

At last he heard the guard whisper, "Kawelo, Kawelo, awake! Aikanaka, your treacherous son, and all their soldiers are in the heiau!" Then pulling off the banana leaves the guard called aloud as Kawelo stood up, "Behold! Kawelo has come to life!" Utter astonishment seized the men. They could not believe that this was he whom they had left as dead.

Stepping towards Kaeleha, Kawelo cried, "My son whom I fed and cared for, why did you turn against me? Today you shall pay the cost. And you, Aikanaka, shall die today, too."

Then Kawelo hurled his faithful spear and killed all but the guard. To him he gave Koloa, where he should reign as high chief.

Kawelo returned to Hanamaulu and there lived in peace until the day of his death.

THE DESTRUCTION OF THE AKUA ON NIIHAU

The people of the islands of Kauai and Niihau were accustomed to going to one end of Niihau to fish. But it often happened that while they were sleeping on the sand after a hard day's fishing, the *akua* would come and devour many of the men.

At last one brave man declared that he would destroy the *akua* and rid the island of this danger. So he built a long house, similar to a canoe house, leaving only one entrance. Then he made many *kii*, or wooden images of people, placing in the heads mottled gray and black eyes of *opihi*, or mussel, shell. These images he put in the house, concealing himself outside.

At night the *akua* began to come for their usual meal. Looking into the house they saw the *kii* with their shining eyes. At first this surprised them, but as the images lay very still, the *akua* decided that the Kauai men slept with their eyes open, and so they entered and tried to eat the images, with dire results. Their teeth were caught in the wood, and while they were struggling to free them, the crafty Kauai man quickly shut the door and set fire to the house, and all the cruel *akua* were burned to death.

Thereafter Niihau became safe for fishermen, and this part of the island still bears the name Kii.

PAAKAA AND HIS SON KU-A-PAAKAA

Kua-anuanu, Cold-Back, was the head steward of Keawe-nui-a-umi, the Great-One-in-Umi's-Presence, son of Umi, king of Hawaii, and god of all the winds, which he kept in a huge calabash. The king loved his steward greatly and placed great confidence in everything he did.

One day the desire to visit the other islands of the group came to Kua-anuanu, and so as he waited on his king he said to him, "My Lord the King, if you have any love in your heart for me you will allow me to visit the other islands. You will not miss me, for you have many servants. If you need me at any time send a messenger and I shall gladly return."

When the king had heard these words he was very sad at heart for his steward was very skilled in serving him. Nevertheless, he gave his permission and bade his servant farewell, with these words, "Aloha. May the spirits of our ancestors keep you until we meet again."

Kua-anuanu prepared his tapa and *malo* for the journey. Then getting into his canoe, he paddled well and soon came to Lahaina, where he went ashore under the breadfruit trees. Being a chief, he was entertained by the chiefs in a manner befitting his station. He entered into all the sports of the Maui chiefs.

One day when the sea was smooth, Kua-anuanu went surfing with the other chiefs at Uo, the celebrated surfing place. There he showed his wonderful skill. He could gracefully ride the surf board, standing or kneeling, and come to land without the spray even touching his body. Naturally his fame spread to all the islands.

After having spent two months on Maui, Kua-anuanu went to Oahu and landed at Waikiki, where the high chiefs lived. When it was known that the head servant of the king of Hawaii had come, the king of Oahu entertained him in royal fashion. He also ordered his people to bring clothing, mats, and food for the distinguished guest.

When Kua-anuanu had visited here for several weeks and had partaken of the kindness of the king, he decided to travel on to Kauai, where he landed at Kapaa.

Near the sea he built himself a home and there men, women, and children flocked to see the stranger. In the midst of the crowd Kua-anuanu saw a very beautiful woman, who was called Laamaomao, and whom he at once longed to make his wife. Laamaomao consented and after twenty days they were married.

This marriage angered the parents of Laamaomao greatly, for, though they held a high social position through their relationship to the *kahuna*, nevertheless, they were very poor, and had hoped to marry their beautiful

daughter to one of the wealthy princes of the island with whom they could live and spend their old age. Now, their daughter had married a tramp, a stranger with nothing, and they themselves were without food.

The princes of Kauai were also angry, as they had wished to win Laamaomao's hand, and so the stranger from Hawaii was hated by all.

Soon, however, Kua-anuanu had planted taro, potatoes, sugar cane, and bananas to provide food for his wife and her family. When they had lived thus for two months, a messenger from the king of Hawaii came to Kua-anuanu and said, "By the order of the king I come to take you home. The servants whom you left in your place are not skilled in providing for the king. Your lord says that you have traveled long enough."

Hearing these words, Kua-anuanu wept bitterly because his king was in trouble. At last he answered, "I will return with you. On this island I have married. I have planted food for my wife and her parents. It is not ripe yet. If I go my wife will be in great need. She will be forced to crawl to others' doors and beg for food. But my love for my king calls me. These bones are his. He has the power to take my head if he so chooses. I cannot disobey any of his commands."

That evening Kua-anuanu told Laamaomao that he must return to his king but she must stay on Kauai. He explained to her that he was not a common tramp as her parents believed, but a chief and the backbone of a king. To be known as the backbone of the king was the highest honor a chief could attain. He talked over the probable birth of a child to them, telling her to name a girl after her friends, but to name a boy Paakaa, which means the skin of his king cracked with drinking *awa*.

All these things made the beautiful Laamaomao weep bitterly, but she sumbitted to her cruel fate and the next day bade her husband aloha as he departed with the messenger.

After a time a boy was born to Laamaomao and she called him Paakaa, as she had been commanded by the father. The happy mother thought that now the anger of her parents would be appeased, but they refused to receive her and called the baby the child of a servant. They could not forget the plans they had made for their daughter to marry a chief of Kauai.

And so Laamaomao lived on alone where the *pali* rises from the sea at Kapaa, and there she brought up her boy.

When Mailou, Laamaomao's brother, who loved her dearly, saw how his sister was being treated, he stayed with her and helped her care for her boy. Mailou was very skillful in catching birds, as his name signifies, and in this way he made a living for them all.

At one time when they were in great trouble Laamaomao sent Mailou to her brothers and sisters begging for help. They provided for their outcast sister without letting their parents know.

As Paakaa grew older he began to wonder where his father was, and so one day, he asked his mother about him. The mother, not wishing to explain to the boy the father's going, told him that Mailou was his father. This the child would not believe, saying, "He cannot be my father. He is very small and I am very large."

After many such questions Laamaomao was forced to tell Paakaa the truth. She said to him, "Look where the sun rises. There your father lives. We feel the wind which is sent from there by the king, the keeper of all the winds."

So the boy believed his mother and resolved that when he become older he would seek his father.

Meanwhile he tried to increase his skill in all things which add to manhood. He became very skillful in farming, fishing, surfing, and hewing out canoes, but he decided to become a fisherman.

When the king's fishermen were driving the flying fish, Paakaa would follow the fishermen and they always gave him a few fish. He complained to his mother that he was given only a few fish while all the others received many. She told him that this was because the fishermen considered Mailou very lazy and did not want to help him.

Then Paakaa began to beg his mother to allow him to join the fishermen. She feared that he was too small and could not swim well enough. But the boy assured his mother that he could swim as well as any of the men. At last she promised to get her brother's canoe for the boy.

As Paakaa watched the fishermen he noticed how difficult it was to paddle the canoes out to the deep sea, so he tried to find a way to lessen the labor. Day and night he dreamed. At last a thought came to him. He found and cut two slender, straight sticks nine feet in length. Then he took a roll of *lauhala* and wove a small square mat. This finished, he tied its ends to the sticks, thus making a sail as he had dreamed of doing, so that his shoulders would not ache from paddling his canoe. Then the boy went home to await his uncle's return. Thus was the first sail made.

After Mailou had brought birds from the mountains the little family partook of the evening meal. Then Laamaomao told her brother that on the morning he must help lift Paakaa in his canoe into the sea. Mailou complained, saying that he was able to supply enough birds and that they did not need fish. Laamaomao, too, beginning again to fear for her child's safety, urged him to stay at home. But the boy, having the same determination which had led his mother to marry without her parent's consent,

could not be dissuaded from his plan, and his elders reluctantly consented.

Early the next morning Mailou lifted the canoe into the water. Seeing the strange-looking *lauhala* mat, he asked the boy what it was. But Paakaa told him to wait and see. His uncle answered by saying that the fishermen would laugh at him if he went fishing with such a strange object. So the boy explained what it was, and setting up the mast, pushed out the boom. The early morning breeze from the mountains filled the sail and carried the canoe along. Paakaa steered the canoe and it glided gracefully through the water as if it were a living thing.

Mailou was astonished. When he saw what the boy had done he called out to him that history would remember him as the first person to sail a canoe.

As Paakaa neared the fishermen, he concealed his sail. They were surprised to see the boy and wondered why his uncle had not come with him.

The drive of the flying fish began. Paakaa's canoe was in the middle of the fleet. He soon saw that the men on the outside got the first fish caught in the nets, so he paddled to the outside. The older men called to him that his place was not there, but he went on lifting up the net and getting many fish. When they started home the boy had eighty fish in his canoe.

Paakaa urged the men to race to land, placing all the fish as the wager. After much wrangling, a large canoe paddled by eight men accepted the boy's challenge, first placing all their fish in his canoe, for he insisted that they might take advantage of his size and keep the fish, even though they lost the race.

The signal to start was given and in no time the eight paddlers left Paakaa far behind. When they saw the boy turning the bow of his boat to the wind and arranging a mat they jeered at him and asked where his boasted strength was.

As soon as Paakaa had hoisted his sail, he turned his canoe toward land. The wind filled the sail and the canoe began to skim over the deep sea. When he neared the large boat, the men began to paddle with all their strength but the little canoe sailed quickly by them, and they heard the boy calling, "Use more strength so that sooner you may drink the water of Wailua. Paakaa, the first born, will eat the flying fish."

Paakaa reached the dry sand long before the others and so the one hundred and sixty fish in the canoe were his. He shared them with the people who crowded around to see the strange sail, and who wondered at his cleverness. Then rolling up the sail, and putting the fish in a bag, Paakaa hurried home to tell his mother and uncle of his good fortune.

Laamaomao's happiness was very great and she said to her son, "I am rewarded for my care of you. You will bring life to my bones." Mailou was no less happy and it was a very cheerful family which that night enjoyed an evening meal of fish. Laamaomao did not forget her neighbors in her good fortune and they all were given some of the boy's first fish.

At this time Paiea was king of Kauai. One day the desire to visit all the islands came to him, so he sent for his *kahuna* and soothsayers to learn from them the propitious time for starting on such a journey.

These wise men informed him that the time for such an undertaking was at hand, but they advised him first to travel around his own island, Kauai. This advice the king accepted.

Upon hearing of the king's intended journey, his retainers at Kapaa prepared to accompany him to Oahu, Maui and Hawaii. Paakaa's interest in these preparations was intense, and he begged to be allowed to go with them. He won their consent and at last his mother's also, though she feared that the king might abuse her son.

When it became known that Paiea would visit his people, food and fish in abundance were prepared for the entertainment not only of the king but of his retainers and followers as well.

Six months were spent in traveling around Kauai. Paakaa followed the king and his retainers, doing errands cheerfully and humbly. When the division of food was made he was never given any, but so much was wasted by others that he always had enough to eat. He was determined to be so useful that the retainers would take him to the other islands.

As the time for leaving Kauai came near, Paakaa explained to his mother how eager he was to reach Hawaii where his father lived. And the mother wisely advised her son to go in meekness and not in pride, willing to serve others. Thus would he come to the valley of Waipio, on Hawaii, where his father dwelt with the king.

There, she said, "You will see two aged, white-haired men, the king wearing a feather cloak and lei, and your father, holding a kahili. Without fear, sit on your father's lap, tell him that you are Paakaa, and then he will receive you and grant you all the blessings of life, property, and honor. At last, my child, you will come into your own as the son of the chief of Hawaii and the backbone of the king."

Having spoken these words Laamaomao gave Paakaa a very finely polished calabash in a *koko*, or net, which she said contained the bones of his grandmother, Loa, and also the winds which blow from Hawaii and the winds which blow from Kaula, Bird Island. Paakaa took the calabash, and in surprise heard his mother say, "In her life your grandmother

controlled the winds. Before her death she put all the winds into this calabash and gave it to me. She told me that after her death her bones were to be concealed in the calabash with the winds. This I was to keep carefully until my son should need it. Now I place it in your keeping. You will find it very useful on your journey. If becalmed, you can summon any wind you wish. If ridiculed, open the calabash and call for a fair wind which will carry you safely to land. This power to control the winds will win you much fame with kings."

Then Laamaomao taught Paakaa the names of all the winds and the prayers and *mele* used with each. Thus was her only son prepared to go in search of the father he had never seen.

In the meantime Paiea had collected a great crowd of high and low chiefs, retainers, and followers. So many canoes were needed to transport this crowd that when they put to sea the water between Kauai and Oahu became calm. The canoes looked like a great mass of clouds.

This fleet of canoes landed at Waikiki where the king was entertained with great pomp. After a few days Paiea went on to Molokai and Maui and came finally to Hawaii where a landing was made at Kohala. Here the people became alarmed upon seeing so many canoes and, believing it to be a battle fleet, prepared to attack the enemy.

However, as soon as they recognized Paiea they sent word to their king, who ordered messengers to conduct him to Waipio. There he was given a great welcome. The people gladly brought presents of food so that the guests from Kauai had more than they could eat. That day the smoke from the many *imu* where pigs, chickens, taro, and bananas were cooking, obscured the sun.

This hospitality did not last. The streams which had poured in food began to grow dry. Want came and Paiea's followers had to hunt food for themselves. So it always was. The first days of the stranger's visit were over supplied, the last days were neglected.

As the days went by and the shortage of food came, Paakaa, everybody's slave, was often hungry. Looking at the king and his chief advisor the boy would greatly amuse the crowd by saying, "If I can reach those two old men yonder I can have all I want." For these words he was ridiculed. How could he ever hope to reach men so well guarded? Did he not know that to go into the king's presence meant death?

But Paakaa waited his opportunity. One day he put on a fresh *malo* and tapa and watched for a moment when the soldiers were not looking. In an unguarded second he passed them and ran rapidly to his father and jumped onto his lap.

Among the old Hawaiians it was the law of the land that only his own child could sit on his father's lap. So Kua-anuanu asked the name of this boy who had dared to break the *kapu*. When he heard the name, Paakaa, he knew that this was his son, born to the beloved wife he had left on Kauai and named by her as he had ordered. He pressed the boy to his heart and wept bitterly for the absent mother.

Then he told the king of his marriage on Kauai. The king was delighted with Paakaa and said, "You must teach your son all you know so that if you sleep the long sleep before I do he can care for me." Messengers were sent to order the people to bring gifts for Paakaa, the king's new steward. They came with great rejoicing, carrying many presents of food and clothing.

When Paiea and his followers saw into what a position Paakaa had fallen, they were afraid, for they recalled their unkind treatment of the boy. But Paakaa was forgiving and gladly divided all his gifts among the king and his retainers, according to the social standing of each person.

So the son of Laamaomao had come into his own. As he grew in stature be became very handsome. In cultivation of the land, in navigation, in fishing, in astrology, Paakaa excelled all others. This skill brought him great favor with the king who gave him lands. Many of Paiea's retainers preferred to stay with him when their king returned to Kauai, and so he became next to the highest chief on Hawaii.

In his good fortune Paakaa did not forget his mother and when Paiea went home he sent canoes loaded with gifts to her. Many times afterwards he sent canoe loads of presents to her, so that her days of want were ended. In adversity Laamaomao had had no friends. In prosperity many claimed relationship with her and attached themselves to her household.

When Paakaa had reached his twenty-fifth year his father fell ill. The *kahuna* who were summoned said that nothing could be done for him. Knowing that death was near, the faithful old chief called his son to his side and said, "My days on earth on growing few. I leave my king in your care. Listen to his commands at all times. Care for the food which is not eaten. Dry it and place it in calabashes. Care for the fish and the growing *awa*. Care for the king's subjects, high and low."

After death had claimed Kua-anuanu there was great mourning in the land. The king and all his subjects wept bitterly for him, the most beloved of all on Hawaii. When the days of mourning were over Paakaa took his father's place. He was made head chamberlain, diviner, treasurer and navigator. He became the *iwi-kua-moo*, the backbone of the king.

At this time Kahikuokamoku, the prime minister, divided the government of the island into five sections, each section being placed under a chief. Under this system and Paakaa's guidance, Hawaii was at peace. The high and low loved Paakaa dearly, as he was very just in all his dealings. The king loved him because he had even more ability than his father.

However, as always happens, Paakaa had enemies who tried to undermine him with the king. These were two men, Hookele-i-hilo, Navigator-to-Hilo, and Hookele-i-puna, Navigator-to-Puna, skillful navigators who could sail the seas and who could foretell weather conditions. In fact they knew almost as much about navigation as Paakaa did, but they lacked the calabash of winds. They wished for themselves the power and honor that belonged to the youthful Paakaa. So at every opportunity they complained and lied to the king about Paakaa and boasted of their own ability.

Little by little the king was deceived by these lies and began to turn against his faithful servant, who never dreamed what was going on. At last the time came when the king took away all Paakaa's canoes and all his land except two small lots, giving these possessions into the keeping of the boy's enemies. Paakaa was now only treasurer of the king and caretaker of his houses.

Poor Paakaa was sore at heart, for he knew that he was unjustly treated. Soon the chiefs followed the king's example and gave him no honor and tried to find fault with him. Then Paakaa decided to go away. He placed some of the king's most beautiful *malo* in the calabash with the winds and set forth in his canoe.

When his enemies saw him leaving they tried to capsize his canoe, but he escaped probable death by lashing mats to the canoe. Fortunately a fair wind followed him and he reached Hilo safely where his cousin, Lapakahoe, the Flash-of-the-Paddle, was living, taking charge of Paakaa's lands there. Paakaa explained to Lapakahoe that he had fallen into disfavor and was going away from Hawaii and the enemies he had unwittingly made. So, alone, the discouraged Paakaa paddled his canoe and came in due time to Molokai, where a strange fate lay in wait for him.

On Molokai lived a very beautiful woman, Hikauhi, the daughter of Hoolehua and Ilali. Now it happened that the girl's father had promised her hand to Palaau, the chief of that part of the island. But as soon as she had seen Paakaa, she forgot all about her former lover and demanded that the stranger be given to her. Palaau very generously consented, and so they all lived in peace. Paakaa cultivated the lands well, fished skillfully, and brought great prosperity to his wife and her family.

When a son was born to Hikauhi, Paakaa named him Ku-a-paakaa, Standing-in-the-Place-of-Paakaa, for his father and his grandfather. This child was brought up very carefully. His father taught him all the *mele* he had made for the king of Hawaii, for he believed that in time the king would miss him and would send for him, and he wanted the boy to be prepared. He also taught the boy the names of all the winds of the islands as his mother, Laamaomao had taught him long before.

In the meantime things were not going very smoothly with the king of Hawaii. At first his new servants had taken very good care of him but soon they became careless. After Paakaa had been gone several months, the king realized that these men were working only for themselves and were neglecting him sorely. He was patient as long as he could be, but at last he decided to go in search of his faithful Paakaa. Summoning his soothsayers, his *kahuna*, and his diviners he asked them where to find Paakaa. They communed with the spirits of their ancestors and learned that Paakaa was still living, but his dwelling place was not known to them. They urged the king to delay his departure until a large fleet of canoes had been hewn out.

So the king ordered all his people to join the canoe cutters and to hurry to the mountains. All those who were not able to go must prepare the food supply. The king hoped that these preparations could be easily and quickly made. He was doomed to disappointment.

As soon as the first tree had been cut, two birds flew upon the branches, which was a sign that the tree was hollow. A second tree was cut, and again it was seen to be hollow. The cutters went from tree to tree, always with the same result.

Then the king sent for the skilled sling throwers and the net catchers and the gum catchers but they were all unable to catch the two birds who were, in fact, ancestors of Paakaa, and who were trying to prove the king's aloha for the boy.

At last from Kauai came Pikoi-a-kaalala, the Ambitious-One, the most skilled of all in shooting the bow and arrow. He could shoot off the head of a flower. He never missed a bird on the fly.

The king greeted Pikoi warmly and made known to him the trouble he was having with the birds. Taking his bow and arrow, the skillful hunter hurried to the forest where the trees were being cut down and shot both birds. In vain he looked for the bodies of the troublesome birds. However, with the shooting of them, all difficulty was removed and two beautiful canoes were soon prepared for the king, and others were made ready for his retainers.

In the meantime, on Molokai, Paakaa had heard that the king was about to set forth to find him. This news pleased Paakaa very much and that night he dreamed that the spirit of the king came to him and told him that he was searching for him. In his dream Paakaa told the king that he would find him at Kaula. When he awoke and recalled his dream Paakaa was very sorry that he had directed the king wrongly. He decided that if his former lord passed Molokai, he would urge him to land there, for he knew that his son would be a great help to him. He also plotted in his heart revenge on his two enemies.

Now it happened that Paakaa's house was too small to entertain the king and his retainers, and so Paakaa took his son with him into the mountains where they cut down trees to build larger houses. In a short time they had finished six houses of pili grass, one for each division of the island of Hawaii.

As soon as the houses were finished Paakaa and his son planted six ridges of sweet potatoes and six of sugar-cane so that the king would have enough to eat. The king's delay because of the birds gave Paakaa ample time to finish his plans for the king's entertainment.

On the night before the king was to leave Hawaii he dreamed that Paakaa's spirit came to him and said that he would find him on Kaula. In the morning all the *kahuna,* and paddlers, and steerers were summoned and told the dream. They declared that Paakaa was not on Kaula. The king dreamed again that Paakaa was on Kaula. When his *kahuna* still insisted that the dream was not true, the king decided to land on each island so that he could not miss his beloved servant.

At last the canoes set out, the single canoes leading, the double canoes with supplies following. Next were the canoes with the head soldiers, the women, the common soldiers. Then came the six chiefs, followed last of all by the king and his prime minister. A stately fleet whose going showed how well the king loved Paakaa.

The first landing was made at Lahaina. There it was learned that Paakaa did not live on Maui, so the fleet went on. When Paakaa saw the canoes leaving Maui he called his son to go fishing with him. They got into their canoe, Paakaa sitting in the bow with his head so bowed that the king could not recognize him, the boy paddling. As they neared the fishing grounds they caught the first glimpse of the king's fleet. As the canoes came nearer Paakaa recognized those belonging to the six chiefs who were not real chiefs and whom he ridiculed by calling out, "You are an under-chief. You hid behind the sugar cane and ate sugar cane. And you also are only an eel catcher." So he ridiculed all the chiefs in order to arouse their anger.

Ku-a-paakaa was anxious to know when the king would pass by, and his father told him that when the sun rose the king would come in a double canoe. On the *pola* of the canoe would be seen a large house for the king's god, Kaili, the Snatcher; a small one for himself, and a still smaller one for the women.

At last the king's canoe appeared and Paakaa called out, "As you pass by hold up your paddle, Lapakahoe."

These words were told to the king by his messenger and the pilots received orders to approach Paakaa's canoe. As they neared Paakaa, he told his son to ask them to come ashore as a storm was coming. He also bade the boy ask them whom they were seeking. To this question some one answered, "We seek Paakaa, a servant of the king."

This answer surprised Ku-a-paakaa, who said to his father, "They say that you are a servant. You told me you were a chief."

Paakaa told his son to ask the question again, and this time he received this answer from the king, "He is not a real servant. He is a kahili bearer and my backbone."

This answer made Ku-a-paakaa very happy and he sang a *mele* in which he said that these canoes must be made from the great Hawaii of Kane, where the sun rises from the point of Haehae bringing aloha to the king, a friend in days of want when there is no food on the land.

The prime minister answered the boy's *mele* in these words, "Do you not see, O boy, that these are the canoes of Ku and Lono, of Kane and Kanaloa, and all the multitude of gods? These canoes came from Hilo, the land of heavy rain, which makes the leaves fall from the trees. The land where leis are made from the *hala* blossoms of Hapae."

Now Ku-a-paakaa began to sing *mele* urging the canoes to come ashore as the clouds brought by the winds from Ha-o and Ha-ea were gathering on Kawainui, above Wailau, which foretold a storm.

But the king's pilot answered, "Why should we listen to this boy? If we go ashore the canoes will be cracked and we will take the boy's bones to stop the leaks."

Paakaa told his son to reply in this manner, "No one fills the cracks of canoes with the bones of a boy. Everyone takes a stone adz and cuts down a tree. When the tree is felled he cuts off the branches and then hews out the canoe. The bones of a dog or a pig are used to give polish to the canoe."

The king's companions were surprised to hear the boy answer so wisely. Thinking that he probably knew the weather signs of his own island, the prime minister asked him to tell them.

Ku-a-paakaa replied, "A storm will come. The wind will turn your canoes around and bring you back. So far, the wind from Hawaii has helped you. Soon an adverse wind will roughen the sea."

Then Kua-a-paakaa recited the names of all the winds of Hawaii, and also all the winds of Oahu and Kauai. When asked how he happened to know all the winds he answered that all the boys knew them.

To this one of the paddlers cried out, "That is not true. Only two people know all the winds, my cousin, Paakaa, and I. Do you know where Paakaa is? Is he on this island?"

But the boy would not tell the hiding place of his father, saying that he had heard that it was on Kaula.

When the prime minister asked who was in the bow of his canoe the boy replied, "That is my father who is deaf and does not hear your words."

All this delay was very annoying to the paddlers who were anxious to be off, even though their king urged them to go ashore. They vowed that if they ever reached Oahu safely, they would return and put the impudent boy to death.

The king was very much interested in the boy and asked his name. "Come ashore and you shall hear my name," was the only answer he received.

In spite of all his efforts the boy was unable to persuade the paddlers to land. So he tried something more powerful than words. Opening his calabash of winds he called, "Blow winds from Kauai against them. Blow winds of Oahu and Hawaii from the side. Blow winds of Maui and Molokai behind them."

At once the clouds arose, the heavens became dark, the thunder roared, the lightning flashed, and the sea became very rough.

When the king saw these signs of bad weather he was very angry with his paddlers who had told him that clear weather would prevail. He called out, "The wind is coming, the stones are rolling, a great storm is at hand. I urged you to listen to the boy, but you only ridiculed him. Now the deep sea will engulf us and we shall be lost. Would that we had gone ashore."

No sooner had he spoken than the storm struck the first canoes, capsizing some of them and the strong current carried many of the sailors away. Soon the sea filled all the canoes. As the king's canoes went to the help of the smaller ones death came very near to the great king of Hawaii. The sea washed away the food and fish and clothing. The men and their king clung to the canoes though they were chilled to the bone

by the cold rain. Then the king in anger called for Paakaa, his beloved servant, the only person who could take him safely on a journey.

As soon as Paakaa saw the sad plight of the king he ordered his son to close the calabash of winds. At once the sea became calm. The sun shone brightly. The sailors swam back to their canoes and began to bail out the water.

The king looked about and seeing that Molokai was the only land near them, he ordered the canoes to return to the place where the boy was fishing.

As the canoes approached, Paakaa told his son to say that the entrance to their harbor was very crooked. If they would enter it safely they must follow him.

Reaching the boy the king called out, "It came to pass as you said. The storm rose and our canoes were badly damaged. Now we have come back to you for help."

Remembering his father's warning Ku-a-paakaa replied, "If you had come into the harbor when I warned you there would have been no danger. Now the tide is high and we must go carefully or your canoes will be cast on the rocks and you will have none with which to find Paakaa or to return to Hawaii."

So they followed the boy, and the first canoes safely reached the sandy beach.

No sooner had Paakaa's canoe touched land then he jumped ashore and ran as quickly as possible to the house where he had stored the food, for he hoped to hide himself there. It happened that Lapakahoe saw him running and noticed how much he resembled Paakaa.

By evening of this day all the canoes had returned and were safely landed. The king sat on the *pola*, wet and unhappy, for all his clothing had been lost.

Seeing the king's sad state Ku-a-paakaa hurried to his father and told him. Paakaa sent the king's own clothing, which he had brought with him from Hawaii, to the unhappy king who was surprised to see clothing which so much resembled his own. He gave the boy his wet *malo* which he carried to his father. Paakaa hung it over the door, so that no one would dare to enter the room made *kapu* by the king's clothing.

Paakaa also sent to his king the tapas he had brought from Hawaii, telling his son to say that his mother had made them and scented them with sweet smelling herbs.

As with the *malo* the king thought that the tapa looked familiar and remarked, "Only on Hawaii is this tapa made. Paakaa always took care of my tapas. Can he be on this island?"

But the boy replied that his mother had made them in an inaccessible valley for him, her only son and a high chief.

Ku-a-paakaa directed each of the six chiefs to the houses which had been prepared by his father and where nothing was lacking for his comfort.

The king was waited upon by the boy whose adroitness very much pleased him. As night fell the boy heard him say, "My aloha for Paakaa is great. At this time of evening he was wont to prepare the sweet *awa* that brought happy dreams. Together we drank and then lay down to sleep."

These words Ku-a-paakaa told to his father, who at once sent him to the king with the *awa* strainer, the prepared *awa,* and a large piece of *awa* root. When the king ordered him to chew the *awa* the boy was to pretend to do so, but instead he was to give him the prepared *awa*. This would be done so quickly that the king would be greatly pleased. Then he was to run to the sea and bring live fish for the king.

Ku-a-paakaa did all these things as he was told and the king's admiration was great, for the boy had done his work like a man. Happier than he had been for some time, the king drank the *awa* and lay down to happy dreams. All his followers, wearied by events of the day, followed his example and soon sleep claimed them all.

As they slept, Ku-a-paakaa released some of the winds and a great storm arose which would delay their going.

Then Paaka and his son counseled together how they could destroy the king's two navigators who had so unjustly taken Paakaa's place.

After much thought Paakaa explained his plan to his son thus, "Take this hollow log to your grandfather's house. When the food which we have supplied for each chief is gone we shall give each one a ridge planted with potatoes. Ask them not to throw away any of the small potatoes. These must be cooked and given to your grandfather who will store them carefully away in the hollow log. He will also store away dried fish and will fill the gourds with water. When the day for leaving comes the king will urge you to accompany him. Consent if he allows you to take your bundle with you. Besides the log you must take a large stone fastened to a coil of rope. After you have passed through the channel between Oahu and Kauai and have neared Waimea, release some stormy winds from the calabash. Then cast the stone into the sea and anchor the canoes. When the cold winds have chilled the men, give all but my two enemies a palm leaf to shield themselves from the rain. Also give them dried fish, potatoes, and water. Keep doing this until the two navigators are chilled almost to death. Then cover the calabash of winds and take the king back to Hawaii."

The boy listened carefully to his father's words and prepared to do as he was told.

When the stormy month of February had passed one of the chiefs reported to the king that their food was all gone. The king then summoned Ku-a-paakaa and asked for food. The boy told the king that he had six hills of potatoes and six hills of sugar-cane on the uplands ready for him.

"How can six hills of potatoes and six hills of sugar-cane supply my many people?" asked the king.

The boy answered that when the potatoes and cane saw the number of people, they would bear abundantly, and so all the people must go up into the highlands. He told this tale so that the lazy ones would work.

The king sent only half the men to do the work. They were surprised when they saw the fields of potatoes and sugar-cane stretching away farther than the eye could reach. Messengers were sent for the rest of the men and they were all soon busy digging. Ku-a-paakaa told them to take all, big and small, for he wanted the small ones dried. "You will have eaten all my growing food during the stormy months and I must have dried food until I can plant some more," he explained, wishing to keep his father's plan secret.

At last when all preparations were made the calabash was closed and the sea became calm. Ku-a-paakaa ordered the chiefs to lash the canoes together and to float them in the bay, ready to sail them when the morning star appeared. They lay down to sleep until the king's crier should awaken them.

Very early Ku-a-paakaa called them saying, "Awake! Awake! It is half way between night and day. Your weariness is gone. The morning star is rising."

When they realized that it was only the boy calling them, they were very angry and refused to get up. But he kept calling them until at last he aroused them, and the six chiefs left without their king. They had had so little sleep that when they lay off Leahi, Diamond Head, they fell asleep. Then the winds were sent which turned their canoes around and drove them back to the coast of Hawaii. There they met their families and there was great rejoicing for they had been given up as lost.

Meantime on Molokai the king and his followers slept until day dawned. Then the king sent for Ku-a-paakaa and asked him to go with them. At first the boy refused, saying that he must stay with his old people. At last he consented to go if he could take his bundles with him. The king sent two messengers for these bundles. The messengers were greatly sur-

prised when they saw a heavy stone and the hollow log as long as the canoe.

"The king would never have consented to take your bundles if he had seen their size. You are indeed a strange boy to call a stone and a log bundles. We have been working for the king from childhood up and we have never seen bundles like these," cried one messenger.

To this complaint Ku-a-paakaa answered, "Did you not bring women with you? Were they not like stones which never work?"

And so the messengers carried the strange bundles to the paddlers, who were very angry and said that the king would refuse to take them. But the king did not interfere, and at last the bundles were loaded on the canoe.

Then Ku-a-paakaa hurried to the hiding place of his father and told him that everything was ready. Paakaa urged his son to remember all that he had made known to him.

"I am only a boy. If I am killed it is well. If I kill your enemies then you will be avenged," was the son's reply to his father.

So he returned to the king and a fair wind drove the canoes gently along. The skill of the paddlers pleased the boy greatly and he asked to hold one of the paddles but was refused.

After they had passed Oahu and lay off Waimea on Kauai, Ku-a-paakaa opened his calabash of winds and released some stormy winds which quickly blew the canoes out to sea. As before, the sea grew angry, and great waves dashed against the canoes, driving them out to the deep water. But the king was not afraid. Peace filled his mind because Ku-a-paakaa was with him. When the king asked what to do, the boy replied, "Anchor the canoe with my big stone which will keep us in one place, so that we shall not be blown out of sight of land. When the storm is over we can reach land."

Then the boy carried out all the plans his father had so carefully made known to him.

He gave food and water to the men. He gave them the palm leaves to protect themselves against the wind. The two enemies of his father were given nothing. The enemies realized that death would probably overtake them, but they patiently suffered and asked for nothing. As Ku-a-paakaa saw them growing colder and colder, he knew that his father would soon be avenged.

At last Hookele-i-hilo fell into the sea. The people cried, "Alas!" but they were too busy saving themselves to grieve. Soon Hookele-i-puna followed his friend and again the people exclaimed, "Alas!" So these two false friends of the king died the death they had plotted for Paakaa.

When Ku-a-paakaa knew that his father's enemies were dead he covered his calabash and at once the sea became calm. The king asked him to take the place of the dead navigators, and so the boy was in command.

The sun shone brightly and, warming up the king and his followers, soon put them all to sleep. Then Ku-a-paakaa turned the canoe toward Molokai and released from the calabash a fair wind which carried them swiftly along.

At dawn the king was surprised to find the canoe lying off Hawaii. Great excitement prevailed in the canoe and on land, for often it had seemed that there would be no returning.

The men in the canoe were anxious to land at once. Ku-a-paakaa knew that in the glad homecoming he would be forgotten and so, indeed, it came to pass. Each man was welcomed by his own. The great crowd was filled with joy to see the king again. As soon as the wailing and the reciting of *mele* was ended all hurried to their homes. No one thought of the boy who was left alone in the canoe. As he saw the smoke rising from the *imu* he realized how hungry he was, and hoped that someone would remember him. But the king thought the people were caring for him and the people thought that he was surely with the king.

Thus it happened that Ku-a-paakaa found himself at evening alone and forgotten. He prepared to spend the night in the canoe and to eat what he could find in the hollow log. Great loneliness filled his heart and he longed for his home.

For several days the boy saw no one. Then he heard the head fisherman ordering all the men to prepare the canoes for a flying-fish drive. He asked to be allowed to accompany them, promising to bail out the water and not to claim any share in the fish caught. So it came about that Ku-a-paakaa, plotting much in his heart, was taken into one of the canoes.

The fish drive was very successful. Each man was given forty fish and started for his own landing. Ku-a-paakaa, paddling with two companions, saw a larger canoe with six paddlers. He at once challenged this canoe to a race, the fish being placed as the wager. His friends were not eager to paddle against so many, so he told them to join the others and he would paddle alone. He took the precaution his father had taken so many years before of insisting that all the fish be placed in his canoe.

Then the race began. At first the eight paddlers quickly out-distanced the one. But Ku-a-paakaa prayed to his grandmother, "Give me a large surf so that I can reach the shore safely. Then we shall eat flying fish together."

Looking back he saw a huge wave which carried him swiftly to shore and landed him safely on the sand. Then he carried all the fish to the king's canoe where he concealed them.

The paddlers in the larger canoe feared to ride such a big surf. They felt sure that the boy would wreck his canoe. So they waited until the quiet water followed the big wave and then they paddled ashore. When they saw that all the fish were gone they were very angry and challenged the boy to another race.

Ku-a-paakaa consented to a second race, but said that he had nothing to wager. They replied that they would wager their bones. The boy said, "I do not want to wager my bones. I am a wanderer here. I have no friends. If you lose the race and are killed your families and friends will wail for you. I'll wager those two double canoes yonder."

"But those canoes belong to the king. How can you wager them?" they asked.

The boy replied, "The king was a passenger with me. I have cared for the canoes for many days."

Still they insisted that only bodies should be wagered and at last Ku-a-paakaa consented, saying that no blame could be placed on him for laying this wager.

They set the day of Kau, Midsummer Day, for the race. Each contestant was to have a canoe six fathoms long. The loser was to pay the penalty by death in an *imu*.

Ku-a-paakaa, knowing that these eight fishermen had received positions at the hands of his father's enemies, saw his father's complete revenge growing nearer.

The story of the coming race spread all over the island. Eight fishermen had been beaten by a small unknown boy! They would again try their luck on the day of Kau! Such was the news which reached the king's ears and great was his astonishment, for strange as it may seem, he never once remembered the wonderful boy who had saved his life.

People gathered from all over Hawaii to see the race. Men, women, and children hurried to the place of interest bringing with them pigs, dogs, feather cloaks, tapas, and other things. A few wanted to wager on the boy; many risked everything on the eight fishermen.

As the sun rose on the day of Kau, it saw the king's fishermen lifting their canoe into the water, preparing the *imu* and collecting the wood to cook their victim. When everything was prepared they called Ku-a-paakaa to begin the race.

But the boy replied, "First we must have ready two surf boards. The ones who reach the shore first must come in on the surf board four times."

The fishermen were so eager to be off that they consented. In their excitement the length of the course was not determined upon. So they paddled out until they could just see the tops of the houses. Ku-a-paakaa had asked to stop before this, but they would not listen to him.

As they turned their canoes around the boy said to them, "If you had chosen a shorter course you might have beaten me. Now I shall win. Already I feel pity for your families."

The command to start was given. In their excitement the king's fishermen did not paddle together as skilled paddlers. Seeing their confusion, Ku-a-paakaa knew that he would win. He followed in the swell of their canoe, having only to steer his canoe. When the fishermen saw him close behind them they paddled with might and main.

"Paddle! Paddle for your lives!" called out Ku-a-paakaa.

As the canoes neared the shore the crowd saw the king's fishermen ahead and a shout of joy went up from their friends. But the fishermen were very weary. Some had dropped their paddles; some had no strength left to lift the paddles which hung from their hands. Then the boy shot ahead and the cry, "The boy is ahead! He is winning!" aroused anger in the hearts of those who were supporting the king's fishermen.

After Ku-a-paakaa had touched land, he ran for a surf board and rode the breakers four times as had been arranged.

When the eight fishermen had brought their canoe ashore, they threw themselves on the sand and bitterly regretted having wagered their bones. They saw the *imu* ready to receive them and knew that death would soon be their fate. A great aloha for their wives, and children, and friends filled their hearts. They wept bitterly as they saw the unknown boy collecting the rich rewards of his victory.

A messenger had hurried to the king with the news of the boy's victory. Then the king remembered the boy who had saved his life and had brought him safely back to Hawaii, and so he sent his servant to conduct the boy to him.

Ku-a-paakaa gladly hurried into the king's presence. At once the king recognized the boy who had saved him from a bitter death at sea and called him to come before him. The boy, remembering the *kapu*, hesitated, but the king removed the *kapu* and Ku-a-paakaa crawled before him. The king embraced him and wept over him, regretting that he had forgotten him in his happy return home.

Then the head steward was called to prepare a meal of the best food from the king's own table. As Ku-a-paakaa ate he told the king how he had lived in the canoe, eating the food left from the voyage.

"*Auwe, auwe!* cried the king. "Unhappy man that I am to have thus rewarded one who saved my bones and brought me home from a strange land. You foretold that you would be left where the canoes were drawn up and so it has come about. It is my fault and not the fault of my men. Is it you who raced with my eight fishermen? Tell me the wager."

Ku-a-paakaa told him that in the first race the wager had been their fish, in the second it had been their bones. He continued, "When I left the shore the *imu* was being prepared. The men are to be thrown in when it is red hot."

The king wept bitterly for his men. The boy told him that this wager was of their own choosing. He had wanted to wager canoes.

The king cried, "O boy, if you have aloha for me, spare the lives of my eight fishermen who supply me with fish. They are very skillful and never go out without bringing in fish."

To this prayer the boy answered, "I do love you, but I must not spare the lives of these men. If you wish to see Paakaa again you cannot spare the lives of these men."

The king replied, "Bring Paakaa to me. When I see him I shall consent to the death of my fishermen."

"Do you recall the first time we met at sea?" asked the boy. "You saw an old man sitting in the bow of my canoe. That was Paakaa. He did not wish to return to Hawaii until his enemies were killed. I am Paakaa's son. My name is Ku-a-paakaa—so named from the cracks in your skin. The tapas which I gave you when you were wet from the sea were those that my father had carried with him from Hawaii."

The king was filled with delight at these words, for he knew that he would see his beloved Paakaa again. He ordered his eight fishermen thrown into the *imu*. He started the boy off for Molokai at once to bring Paakaa to him.

When Ku-a-paakaa had left Molokai with the king, his mother had bitterly reproached his father for allowing their only child to go away from them. She knew that death at sea would overtake her only son. Paakaa told her not to grieve for the boy would return. He urged her to look towards Maui and she would soon see the mat sail of a canoe. The canoe would belong to the boy who had sent death to the two navigators and the eight fishermen. Then they would know that all those who had estranged him from the king were dead.

All these assurances of her son's safety failed to lessen the mother's anxiety. Nevertheless, she spent her days looking for the mat sail of a

canoe. At last she saw it. Father and mother were overcome with joy. As their son stepped ashore his mother pressed him to her heart.

Paakaa heard the story of the boy's adventures from the day he had left Molokai until his return. When he heard the king's command that he return to Hawaii he asked, "What gifts did the king give you?"

"He gave me nothing," replied Ku-a-paakaa. "He will give you bountiful gifts when you return."

"Without promised gifts there is no use in my returning," answered Paakaa. "Better that I stay on Molokai where I have something to call my own."

In vain Ku-a-paakaa urged his father to return with him to care for the king who had lost all his servants. Paakaa said that when the king had restored his position and lands, then only would he return.

Ku-a-paakaa stayed with his parents for three days, resting and preparing to go back to the king. When he had not returned by the evening of the second day, the king sent his prime minister with many canoes to conduct Paakaa and his son back to Hawaii.

When the sun had reached its zenith on the third day, Paakaa saw the canoes nearing the land and he knew that the king had sent for his son.

As Lapakahoe, now the prime minister, saw his cousin, Paakaa, he threw his arms about him and they wailed together. After this greeting the prime minister asked his old friend why he had not made himself known to the king before. Paakaa replied that he had wanted to test the king's aloha for him and to get his revenge on those who had wronged him.

Then he called his wife, the daughter of a chief of Molokai, whom he had married when he had come as a stranger to the island, and introduced her to the king's men.

Paakaa promised to return to Hawaii if the king would restore his lands and position. The prime minister promised all in the name of the king, and with his canoes loaded with gifts set out for home.

When the king saw his men returning without Paakaa he was very sad. But when he had heard Paakaa's promise he ordered his men to prepare a fleet of two hundred canoes to go for his beloved servant. He kept Ku-a-paakaa with him.

As this great fleet neared Molokai, the people there thought that it must be a fleet fishing for flying fish. But they soon realized that it had come for Paakaa, who returned to Hawaii like a king with friends and retainers. His king wept over him and gave him position and lands befitting so faithful a servant. So Paakaa lived in peace and honor for many years.

HOLUA-MANU

A LEGEND OF KAUAI

Manu, Bird, lived with his parents in the mountains above Waimea valley. His greatest delight was to slide down the steep *pali* sides on his sled.

This sport caused his parents a great deal of worry, for they feared that he would meet with some accident. So they placed two immense rocks on the path he used most. But Manu could not be stopped by this. He jumped over the rocks, and struck the path below. However, he did not enjoy the jar, so he climbed back, and rolled one of the rocks down to the river, where it stands today, as large as a house.

Manu's parents prevented his crossing the river by sending a freshet to stop him. The freshet would start at the same moment that Manu started to slide and it would always reach the river first.

At last, discouraged, Manu took his sled, and went to the highest *pali* of the Waimea valley, where he enjoyed his sport, without interruption. This spot is still called Ka-holua-manu, or the Slide-of-Manu.

THE GIRL AND THE MO-O

A LEGEND OF KAUAI

Living at Holuamanu in the mountains above Makaweli, was a family in which there was one child, a girl, who caused her parents much annoyance by her continual crying. In a cave beneath a waterfall nearby lived a mo-o, which looked like a huge lizard or crocodile. One day when the child was crying as usual, her father in anger pushed her out of the house, saying thoughtlessly, "Go to the mo-o and live with him."

The child hurried to the cave and was welcomed by the mo-o who gladly cared for her and carefully brought her up. On warm, sunny days the girl and the monster would come out above the waterfall and sun themselves. If anyone approached, the mo-o would jump over the fall into the cave, and the girl would spring through a hole which led into it.

As the years went by the girl's parents grew more and more anxious to recover their child. Asking advice of the *kahuna*, they were told to cover the hole above the waterfall with a net, to trap her. One day they did as they were told. Soon the mo-o and the girl came out. The parents approached and the mo-o safely jumped over the waterfall, but the girl was caught in the net. Realizing that there was no escape for her, she cried, "In my youth you drove me from you. The mo-o cared for me. Now, why do you want me again?"

She was like a wild animal, struggling to be free. Not daring to keep her so near the cave the parents moved to Waimea, where gradually they tamed the girl, until she grew accustomed to her old life. She had become very beautiful and later she was married to the prince of Waimea.

NAMAKA-O-KA-OPAE

A LEGEND OF KAUAI

There lived at Holuamanu a women whose husband had been enticed away by another. Seeking advice, the unhappy wife went to her grandmother, who was a *kahuna,* living at the mouth of a little valley near Holuamanu. The grandmother told her to bring two *ti* leaves and she would show her how to destroy her rival.

When the girl returned her grandmother noticed that she had two stalks of *ti* instead of two leaves, so she tore off the leaves she wanted and threw the stalks away. One fell to the right of a little waterfall nearby and one to the left where they are growing to this day.

Then the old woman gave these instructions to the girl, "Take these leaves. Make them clean, and glossy and smooth. Place them on the crest of the waterfall. Go below and sit perfectly still on the rocks. Wait there until your rival comes. When she comes she will pick up a stone to throw at you. Not seeing the glossy *ti* leaves, she will slip on them and fall at your feet."

The miserable wife quickly followed out her grandmother's instructions and in a short time her rival was lying at her feet. Snatching a large stone she threw it on to the woman's stomach and killed her. Today in the clear water of the stream is seen a rock in the shape of a woman on whose stomach still lies the rock thrown by the angry wife.

After having killed her rival, the wife tore out the eyes from the dead body and, wrapping them in *ti* leaves, she threw them into the water. Then she followed the stream until she came to a second small waterfall under which she saw her husband sitting. She dropped a rock on his head which crushed in his skull and left his mouth wide open. By this time her rival's eyes had floated down stream. She placed the eyes in her husband's mouth, saying, "Here is your meat."

He was also turned to stone, and this rock, lying in the stream, can still be seen by passersby. From the ledge above, it looks like the crushed-in skull of a man, with open mouth, and bulging eyes that glitter still as if alive. By the Hawaiians, this rock is still called Namaka-o-ka-opae, the Eyes-of-the-Shrimp.

KANA

A LEGEND OF HAWAII

Kana was the grandson of Uli, the supernatural woman who was married to the god Ku. Uli was born in Hilo. One of her brothers, Manua, lived in the underworld. Another brother, Wakea, had his home in the land where all the islands were born. They were all very high chiefs.

To Uli and Ku was born a very beautiful child whom they called Haka-lani-leo, the Listener-to-the-Heavenly-Voice. As Haka-lani-leo grew older, she became the most beautiful woman of her time. Her skin was like the sun as it rises, or like the feathers of the *mamo*.

Haka-lani-leo married Ha'ka, King of Hilo, and to this union twelve sons were born. Eleven of these children possessed supernatural powers. Ten of them were ten feet tall. The eleventh son, Niheu, was much shorter than his brothers, being only five feet in height. Great wisdom was given to him. He could count even the hairs of his head.

These boys liked to test their strength by trying to lift a large ulua, ten fathoms and a yard long, that lived in the pond at Waiakea. Each boy would try to lift this fish to his shoulder. None succeeded but the small Niheu.

The twelfth and youngest son of Haka-lani-leo, Kana, came into the world in the form of a piece of rope and was at once thrown into the pig pen. The spirit of this child went to his grandmother, Uli, and begged her to save him. Uli departed at once for Hilo.

When the people saw her coming they called, "There comes the old woman, Uli. What brings her here? She has never come when her other grandsons were born."

As soon as Uli reached her daughter's home she asked, "Where is the little stranger that has come?"

"No stranger has come. We saw only a piece of rope which we threw into the pig pen," someone answered. "What do you want it for?"

Uli was led to the spot where the rope had been thrown. A pig was just about to devour this strange looking object, but Uli picked it up and placed it in her calabash. When she reached her home she put the piece of rope into a calabash of water, saying, "It will never do if you come forth from the water with a pig's snout."

Uli watched the water closely and when she saw a snout appearing she quickly placed the rope in another calabash of water and soon a child appeared.

The happy grandmother placed the baby on the mats, and made a bower of maile, ieie and lehua branches to shade it from the sun. Then Uli went to work in her garden, which was very dear to her, and in which she was always busy.

About noon the grandmother returned and stopped the child's crying by food. So Uli cared for her youngest grandson for forty days. By that time he was forty fathoms long. As he grew in stature she enlarged the bower over him.

On the celebrated hill, Haupu, on the island of Molokai, lived Keoloewa, the king. With him were Pepee, Crooked-One, his general; Mo-i, High-Chief, his *kahuna;* Moikeha, the High-Chief-who-Objects, his astrologer; and his three plover messengers, Kolea, or Plover; Ulili, or Sand-Piper; and Akekeke, or Snipe.

One day the king decided that he would marry, so he sent his bird messengers to find the most beautiful woman on earth, whose skin should be like the rising sun. The birds flew everywhere, looking for a woman who would answer the king's description. They found none until they had returned to Hilo and there they saw Haka-lani-leo, the most beautiful woman in the world, bathing in the sea by night.

At once the birds flew back to their king and told him that they had seen a woman whose skin was like the *oo* and all the other beautiful birds of Hawaii.

Keoloewa decided that this wonderful woman should be his wife. He ordered a double canoe prepared for the journey. The birds flew ahead to show the way. They came to the harbor of Hilo just at dusk. There they waited patiently until the first cock crowed, and then they heard a sweet voice singing. The canoe was drifting in the water, where this beautiful woman usually rode the surf.

Just as Haka-lani-leo noticed the dark object, a voice called to her, "O beautiful woman, come here and rest before you ride the surf."

The woman swam to the canoe and getting into it was lost in admiration of its decorations which were made of the feathers of beautiful birds. It was not until the canoe was being rapidly paddled for Molokai, that she realized that she was being carried away. Then she began to mourn for her husband and her home at Hilo.

As the days passed and his wife did not return, Ha'ka sent his people to hunt on land and sea for her. She had disappeared completely. No one could find her.

Then the king called his eleven sons together and asked each one what he should do to find their beautiful mother. He came at last to Niheu who, absently stirring up the fire with a long stick, answered in these

words: "The sea divides Hawaii from Molokai, where the wife you are weeping for is held a prisoner in the strong fortress of Haupu."

This answer made the king angry with Niheu whom he taunted because of his size. Niheu showed that even though he was small he was very strong. He jumped to the top of his house and, seizing the rafters, pulled the building down. Then he beat the ground with his stick and formed eight valleys with precipices so high that only the *koae*, the huge white tropic birds, could fly to their summits.

After he had done these things he said to his father, "Now you have seen what strength I have. But, alas, my strength is great only on this island. If my mother were on Hawaii I could get her for you, but she is on Molokai."

One day when Uli and her grandson, Kana, were working in their garden in the mountains they heard a great shouting coming from the seashore. Uli said that Kana's brothers were trying to lift the large ulua.

When Kana heard what his brothers were doing he was very anxious to test his strength with them. So he waited until his grandmother was busy, and then, after having shortened his body, he secretly hurried towards the spot where the boys were trying to lift the fish to their shoulders.

As he neared the pond of Waiakea, Kana asked the children why there was such a great noise. They replied that the chiefs were trying to lift the big fish, but only the smallest chief could do it.

Kana was greatly surprised that his tall brothers could not lift the fish, and said to the children, "Those men must be very weak if they cannot lift that fish."

One of the children told the chiefs that an unknown boy was making fun of their strength. He was led before them and one of the brothers asked, "Did you say that we were weaklings because we could not carry this fish? Try to lift the fish yourself, if such strength belongs to you."

Kana at once jumped into the pond and turned the head of the fish towards the deep water. As the fish swam into the sea Kana held on to its tail and was carried to Keahua and then back to the pond again. There he easily lifted the fish to his shoulder, and walked away with it.

When the astonished crowd saw this demonstration of strength, they cried, "This is the strongest boy of all."

These words angered the older chiefs, who felt that their strength had been ridiculed in the eyes of the people, for strength was possessed by those of high birth only, and to have a boy of unknown parentage surpass them was a great insult.

So Niheu cried that the boy was carrying the fish, belonging to the chiefs, to his heiau, where he would sacrifice it in gratitude for his strength.

In fact Kana's only thought was to carry his prize home to his grandmother. As he passed the heiau of Niheu, Kana was seized and carried into the heiau where he was tied to the main post. Leaving him there, his captors carried the fish back to the pond. It had been out of water so long that it was very weak.

As Uli was working in her fields, the thought came to her that all was not well with her grandson, Kana. So, not finding him at home, she hurried to her other grandchildren.

When Niheu saw her he asked, "Do you know who that boy is, who tried to steal our fish? We have tied him up in the heiau for attempting to carry off the chiefs' fish."

Uli looked at the captive and at once saw that he was Kana. Turning to Niheu she replied, "That boy is no thief. He is your lord. You were born as a child. He was born as a piece of rope. That is the reason you did not know your brother."

Then Uli told Kana to walk. At once all his ropes fell off, and in his anger he began to tear down the heiau. Uli, fearing that the boy would entirely destroy the sacred place, ordered him to return with her to their mountain home.

As soon as the brothers had recovered from their surprise over the knowledge that Kana was living with their grandmother, Niheu told them that he was going into the mountains to build canoes with which to go to Molokai in search of his mother.

In the mountains he looked for timber suitable for his canoe. He soon found two wiliwili trees, seven feet in diameter.

The following day he felled these trees with two mighty strokes of his ax and commenced hewing them out. By evening he had almost finished them, so he decided to return in the morning.

Niheu was unable to sleep that night because he was very anxious about his canoes. As soon as daylight came, he hurried to the place where he was building them and was greatly astonished to find them standing up and growing again. He left them and looked for other trees suitable for canoes.

Having found two koa trees, Niheu cut them down with two strokes and, as on the previous day, almost finished the canoes by evening. Again he went home for the night.

At daylight he returned to the spot where he had left his unfinished canoes. He found these standing up and growing. The boy was very angry and muttered to himself, "This is the work of my grandmother, Uli. She wishes to bring my work to naught. She is a cruel woman to cast this spell upon me. I shall kill her."

For four days Niheu wandered here and there in the woods, hunting for Uli's home. At last Uli came upon him and asked: "Why have you wandered in the forest so long?"

Niheu replied, "You will soon see why I am here. I am going to kill you now."

To these words of her grandson, Uli replied, "Is death the gift you bring to me? I have done you no wrong. Why did you not come to me and tell me that you needed canoes? I would have told you how to build them. It is not I, but your forefathers, the first builders of canoes, who are now in the nether world, who will not allow you to fell the trees for canoes until they have been appeased. Kill me, if you wish, but then you will never be able to build canoes. Spare me, come home with me, and eat and drink. Then you shall go home and find a black pig without any white hairs. While you are gone, I shall prepare the *awa* root, the large calabash, and the grass to strain the *awa*. Thus with my help you can succeed."

These words appeased Niheu and he followed his grandmother into her house. While he was eating, he looked about for his new found brother, Kana, but did not see him. As soon as he was refreshed, he hurried home and, finding the things Uli had mentioned, he brought them back and laid them at her feet. Then Uli told him to search in the forest until he found two lehua trees. After having felled and topped these, he should return to her.

Niheu followed his grandmother's instructions. Then she gave him the *awa* root and the black pig, which he carried to the place where the trees were lying. Having built an *imu* he killed and cooked the pig and prepared the *awa*. When all was ready Niheu called his ancestors to come and eat the food he had prepared for them. Then Niheu concealed himself under the branches of the trees.

Soon he saw his strange looking forefathers gathering around the table. After they had eaten the food one of their number, Kaikupakee by name, tried to put the tops of the trees onto the trees again. Niheu caught him and held him, saying that he was going to kill him. Kaikupakee answered that if he were killed Niheu's canoe would never be finished. So he was released and at once called out, "I will not build your canoes!"

Poor Niheu was very much discouraged, and hurried to his grandmother to tell her his troubles. Uli comforted the boy with these words: "Your canoes will be finished. Take this flag to the place where the trees lie, and with it mark out the size you wish the canoes to be."

Niheu did as Uli said, and then waited until darkness fell. Nothing was done to the trees that night, but the following night he heard voices saying, "Come, let us finish Niheu's canoes."

Then a wonderful thing happened. The canoes were instantly finished and a canoe house was built. After the ancestors had pulled the canoes under shelter they disappeared.

Early in the morning Niheu went to see what had been done and was greatly astonished to see everything finished. Happiness filled his heart. Looking for food, he came upon a house which he entered. There he saw several coils of rope. Niheu was very glad to see this rope for he needed it to pull his canoes to the sea. He also saw two sticks bent suitably for lashing his canoes together.

Just as Niheu was congratulating himself on his good luck the rope began to uncoil and Kana stood before his astonished brother, who was so frightened that he ran and jumped down a high *pali*. Kana stretched out his arms and rescued the falling boy. Bringing him back, he asked why he had jumped over the *pali*.

Niheu replied, "I jumped over that *pali* because I was anxious to see the handsome people who live down below. You caught me before I saw them."

To this falsehood Kana answered, "You are not speaking the truth. You ran because you saw my big eyes looking at you."

Niheu confessed this to be true. Then he hurried back to his grandmother and told her that the canoes had been finished as she had foretold. He asked her where the grandson lived, who had carried the ulua and whom she had called the lord of himself and his brothers, for that grandson must go to Molokai in search of his beautiful mother.

Uli at first did not want Niheu to take Kana away, but at last she consented, on condition that he be well treated.

Niheu found Kana and made known his errand. Kana consented to help his brother and explained the details of his plan. Niheu was to arrange his brothers and their followers in a long line extending from the mountains to the sea, with himself nearest the sea. These men must all be strong as the canoes were to slide down their shoulders to the sea.

When Kana saw that the long line of men was arranged he pushed the canoes with such force that they slid towards the sea like the wind, destroying everything in their way. The men tried to stop the canoes but were knocked down and killed.

As the canoes were sliding by Niheu, he caught hold of the *manu*, the carved prows, and tried to stop them, but was unable to do so until he had been carried out to deep water. After he had anchored the canoes,

he swam ashore and heard the great wailing over the sudden death of his older brothers.

Niheu hurried to Uli and Kana to tell them the sad news. Kana then told his brother to call the astrologer and the crews for the canoes. After everything was prepared, the people carried Kana to the sea.

Mo-i, the famous *kahuna* of Molokai, saw all these preparations to rescue Haka-lani-leo going on, on Hawaii. He called the plover and said, "Go to our lord, the King, and say that I have had a dream. If he wishes to escape harm he must return the woman he has stolen. If he refuses to do this, dire calamity will befall him. The crop of coconuts and taro will fail. A-a, small lava stones, will cover the land."

The plover flew to the entrance of the palace and made known to the king the dream of his *kahuna*. The king answered that no soldier was brave enough to come to Molokai and attempt to conquer her king.

Soon after, Mo-i slept and dreamed again. The plover, seeing his lips move, awakened him and asked why he was muttering in his sleep. Mo-i sent the plover to warn the king to send back the woman before the wards of Uli should come to rescue her, and to bring disaster to Molokai.

The king, in anger, sent his messenger to tell Mo-i to dream no more, or he would be punished.

Keoloewa then called his body guard of plovers, and told them to fly over the world to see if any soldiers were preparing for a trip to Molokai. The plovers flew everywhere and, seeing no soldiers, all but one returned to the king. This one plover remained on Hawaii. He flew into the house of Uli. Then he went to Hilo and ran along the beach until he became thirsty. After he had gone to a stream for a drink, he flew back to the beach where he saw the tracks of a man in the sand. Each track was a fathom long and a yard wide.

With this information the plover returned to Molokai where he found that the king had built a big fire, to put to death the bird messengers because they had brought no news to him. When the king heard the report of the one plover who had stayed behind, he put out the fire and spared the lives of the others. He believed that there was no strong man on Hawaii as the messengers had seen none.

In the meantime Mo-i dreamed again and as before sent the plover to the king with this message: "O King, return the woman within three days, or the war canoes will be seen approaching our island. In my dream I saw a figure flying above the fortress of Haupu. The head was higher than the mountain. The eyes were as bright as the evening star."

The king was very angry and ordered his soldiers to bring Mo-i before him. Then he sent for Moikeha, the sister of Mo-i, who could tell him if there was any truth in the words of her brother.

When Moikeha came before the king, he told her of the frequent warnings he had received from Mo-i. He said that he did not desire to return the beautiful woman he had stolen.

After hearing the king's message, Moikeha began her rites. She took a large calabash full of water and covered it with tapa. While she was doing this she heard the voice of Mo-i muttering: "Look well to what you are doing and you will see the big eyes of a man standing in the sea. He is coming for the woman who is held here without good cause. If he reaches the island, all will be destroyed. He is so tall that his head is higher than the fortress of Haupu."

As soon as Mo-i had ceased talking, his sister began to pray. While she prayed, a violent earthquake shook the land. When Moikeha removed the tapa from the calabash, she and Mo-i saw a pair of eyes as bright as the moon shining in the water. Then Moikeha knew that the dreams of her brother were true and she warned the king to return his captive to Hawaii.

The king would not listen to this advice and answered, "I will not return my prize. I am able to lift up my island until the fortress reaches the clouds. No man is tall enough to overlook it then."

Mo-i answered that the ward of Uli was able to become taller than any fortress. In fear, the people prepared for the day when the war canoes would reach their island. The king still listened not to the earnest entreaties of his generals and soldiers to return Haka-lani-leo, the beautiful woman of Hawaii.

Meanwhile, on Hawaii, Kana was making his preparations for the journey. He told Niheu to leave behind all the soldiers and paddlers, and to take with them only Pohaku, the Stone, a trusted companion. When all was prepared, the people wrapped Kana in mats, using one thousand of them to cover him. Then they placed him on the *pola*, the frame joining the double canoe.

As they put out to sea, the tide and the currents were against them. Many evil *akua* of the sea tried to delay them. The sword-fish tried to destroy the canoe, but Pohaku lowered himself to the side of the canoe and the fish, striking against the stone of his body, was destroyed. This was the last of their troubles.

Soon they lay off Molokai. The people watching for war canoes were surprised to see a canoe with only one man paddling. A messenger was sent to ask if this was a war or a pleasure canoe. When Niheu answered

that it was a war canoe, the king ordered war preparations to be carried out. In a short time the fortress was filled with soldiers ready to fight for their king.

In the meantime the canoe had landed, and Niheu had commenced to climb up the steep cliff by the aid of his long spear. The people believed that this small man was only a boy, but they wondered at the size of his spear.

Haka-lani-leo, safely guarded in the fortress, heard the words of the soldiers and, ordering them to stand aside, saw the man scaling the cliff and recognized her son, Niheu. Bitterly she wailed for the dear husband and strong sons from whom she had been torn.

The king gave his order to kill Niheu should he try to enter the fortress. But when the soldiers refused to allow him to enter, he struck them down with his spear. Then, using his spear as a bridge, he entered the fortress and rescued his mother. Placing her on his back, he crossed again on his spear and walked safely away.

As Mo-i saw the mother and her son going down the cliff, he called to the plover, "Anyone who is brave enough to pull some hairs from the head of Niheu can destroy his strength."

One of the plovers bravely descended the hill, and pulled five hairs from Niheu's head. Niheu stopped to count his hairs and, finding that five were gone, he cried out, "What slave has dared to steal some of my hair?"

In his anger Niheu dropped his mother and at once the soldiers seized her and carried her back to the fortress. Poor Niheu! He had lost both hair and mother! He was most unhappy. He sent his spear to find the person who had stolen his five precious hairs. It soon caught the plover and brought him, pinioned on its sharp point, to earth at Niheu's feet.

Niheu then rolled down the cliff, breaking his arm and injuring his leg. Weeping, he came to the canoe, and accused his brother of having sent him on this errand because he was small.

Kana was very angry, for he knew that now they would have a great deal of trouble in rescuing their mother again. Kana turned over in the mats and having thus broken the ropes, stood up. The king saw that this man was taller than his fortress, just as Mo-i had said. He ordered his turtles to raise the fortress. As Haupu was slowly raised higher and higher, Kana stretched his body, first his human body, then his rope body, next his convolvulus-vine body, his banana body, and last his spider web body.

When Niheu saw his brother in this strange form, he began to cry that he had been killed. He called out, "Kana, come down again to Uli."

Kana heard his brother's words and lowered his head into Hilo while his feet were still on Molokai. Uli knew that her grandchild was in some trouble, and she was very angry with Niheu, who had thought more of a few hairs of his head than of saving his beautiful mother.

Uli brought food to Kana. He ate all the food that was in the calabash. He ate all the food that was in the garden,—taro, potatoes and bananas. As Kana took this nourishment his feet on Molokai began to grow. When Niheu saw the feet growing, he began to chop at them with a stone.

Kana called to his grandmother, "My feet are in pain. What is the trouble?"

Uli explained to him that Niheu was angry because he was hungry. So Kana promised to take him a hill of sweet potatoes.

Uli also explained to Kana that he must return to Molokai and break the backs of the turtles, so that they could not lift Haupu any higher.

Having heard these words Kana raised his head, and when the turtles tried to lift up the fortress he crushed them to death and pressed the mountain down to its original size. Niheu then climbed up and carried his mother down to the canoe.

The terrified people tried to escape but were driven over the *pali* by the big eyes of Kana. Only Mo-i and his sister escaped.

Kana cut Haupu off from the mainland. He gave the kingdom of Molokai to Hookekua, the king of Kekaha. Then he sent Niheu to Hawaii with his mother, and began his travels.

From Molokai Kana crossed to Oahu whence he soon went to Kipukai, on Kauai. There he saw the beautiful sisters of Kaneike. He traveled on until he reached Kalalau, where he frightened Kahuanui, Big-Foundations, who was making tapa, by stretching himself until his head reached the clouds.

Niihau was next visited by the traveler. After seeing the celebrated mat-weaver and the interesting points he stepped back to Kauai at a place called Ke'e, near Kalalau, which is called to this day, Kapuai-a-Kana, The-Imprint-of-Kana's-Foot. Wherever Kana traveled on Kauai and Niihau he killed the *akua* who were destroying the people.

At last Kana returned to Hawaii, where he found all the chiefs living happily. Niheu asked him to go around Hawaii with him. While they were staying in Kona, Niheu heard the people complaining because their king, Kahoalei, the Friend-of-the-Lei, made them cook food and fish for

him. Niheu decided to talk with the king's messenger when he came with orders for the people, and so called to the man, but he ran away. Niheu followed and catching the poor fellow broke his back.

After this little adventure Niheu returned to Hilo. There his grandmother greeted him with these words: "You have been up to mischief. Your actions will bring trouble to us. Bring your brother to me before the calamity befalls us."

In the meantime Kahoalei had waited until midnight of the third night for the return of his messenger. At that hour the messenger crawled before his king, begging mercy and saying that he had been badly treated by the grandson of Uli.

Kahoalei was very angry and cried, "I shall punish Niheu. I shall take from Hawaii the sun, the moon, and the stars. Only where I am, shall there be light."

After Uli had sent Niheu to find Kana, she fastened a rope to the door of her house and then carried the rope to the sea, so that if the threatened darkness befell the land, she could find her way to and from the ocean. The people, seeing this, wondered what Uli was doing.

As soon as Niheu found his brother he started for Hilo with Kana on his back. They had gone only a short distance, when the sun was taken from the heavens and they had to feel their way. Kana then stretched his head about the clouds and so reached Uli's house.

"So you have come," said his grandmother. "I sent for you because I knew you were the only person who could recover the sun. Go now and find it. It is hidden under the earth. Before you go, see if there is any light in the sky. If there is, come and tell me."

Kana stretched his body until he reached the sky, where he found light. When he had reported this to Uli she said, "Take your brother with you and go up as far as your body will take you. The place that you will touch when you bend over will be Kahiki, and there you will find a spring. If anyone asks you your name, say ,'I am yours and Uli's.'"

With these instructions Kana started on his wonderful journey. When they reached the heavens, Niheu was chilled through and through, and so was left behind to die. Kana fell to Kahiki. The two old people there were startled by the noise of his fall, and each tried to make the other find what had fallen near them.

At last the old woman went out and seeing a white object in the spring tried to catch it with a stick. Failing to do this, she asked the object what it was and was surprised to hear it answer, "I am yours and Uli's."

Crying, "Oh my grandson!" the old woman carried Kana to her husband. They fed him until his strength returned and then asked him if he had come for the sun. When he replied that such was his errand, they gave him two guides who led the way. They sent a fire in front to show them the way and a wind behind to help them on.

When they reached the line dividing the kingdom from the land of the keepers of the spring, the guides left Kana, telling him to go wherever the wind directed.

So Kana journeyed on alone until he came to the guard, Manu-a, sitting by the king's door. Manu-a was friendly, and, urging the stranger to sit down by him, told him how he had to sit there, and watch the king and his followers eat and play while the cold rain fell upon him.

Kana was greatly interested. Soon he saw how the king got his food. He lifted a stone that covered a large hole in the sky and lowered his hand which was quickly filled with food by the people below.

While the king and his men were eating, the guard said to Kana, "Wait with me until they have finished. Then they will return the dishes and what remains of the food. Prop up the stone with your foot. They will think the hole is closed and will go back to their game. Then we may eat."

Kana did as he was told, and when they were alone he lowered his hand through the hole. As he did so the people saw a large black hand and they knew it was not the king's hand. Someone said, "This hand must belong to a soldier. No wonder it is fat. He sits and plays games all day while we labor for him. Perhaps even now he is demanding more food."

However, Kana's relatives recognized his hand, and filled it with food. Manu-a told him to drop the food. Then his hand was filled with water. This Kana also dropped. They next tried birds which the guard ordered up. These birds called out, *"Kiawea,"* the call of the long-legged fish-hawk, and the friends of the king thought that day had come. The king told them that there were no birds there.

Kana again lowered his hand, and it was filled with stars, which he threw into the heavens where they gave light. Then the moon was placed in his hand. Kana put it into the blue sky, where it remained giving light. He was next given all kinds of birds and fowl, and for the first time the rooster broke the morning stillness by crowing.

Yet again Kana lowered his hand through the magic hole in the sky. This time he was given the sun, which he placed in the sky, having received its solemn promise never to disappear again. Since that day no magic power has been able to deprive the people on earth of the great sun.

When the sun rose the king hurried out to see who was interfering with his powers. Kana was about to kill him, but was stopped by the king's promise to bring Niheu to life again.

As soon as Niheu was restored to life, Kana, accompanied by the king, stretched his body and returned to the house of Uli.

This was the king's first visit to this part of his kingdom, and so he planned to visit all parts of it. A canoe made of white chicken feathers carried him from place to place. So he traveled over the world for two years, conquering all lands. At the end of that time he returned to Hawaii and was deeply grieved to hear that the mighty Niheu and the artful Kana had died. He established his kingdom on the island of Hawaii, and collecting worthy ministers, ruled for many years.

KAUAI LEGENDS OF KANA

When Kana came from Oahu, wading through the sea, to Kipukai, Kauai, the turtles were raising up the hill of Haupu. Kana was afraid that it would reach too high, so he stretched himself up until his body was no larger than a spider's web. When he was tall enough, he put his foot on top of the mountain and crushed it down. So, now, three ridges run out from Haupu. He found his brother Niheu starving in Kipukai, and so he said he could relieve his brother's hunger. He lay down and stretched his body until his head reached the place where his grandmother was living, on the hills back of Wahiawa. Then he called to his brother to cut his toe, and when Uli fed Kana *poi*, it ran through his body, and reached Kipukai, where Niheu sucked it out. Thus he saved his brother's life.

After Niheu had been fed, Kana found that his grandmother was making tapa, but the sun came up and went down so fast that there was no time for the tapa to dry. So Kana said he could make the days longer. He ordered all the people on the western side of the island to save all the coconut fiber and to braid it into ropes. When plenty of rope had been made, Kana stood on the top of the hill with the ropes coiled near him, and when the sun came up he lassoed it, and broke off some of the spokes. To this day, when the sun comes up, you can see that some of its spokes are shorter than the others, and those are the spokes which Kana broke. The sun then begged him to let it go. Kana said he would if the sun would promise to go slower, so as to make the days longer so that Uli would have time to dry her tapa. The sun agreed, and to this day has kept its promise. So we have to thank Kana for our long days.

KAILI-LAU-O-KEKOA

A LEGEND OF KAUAI

Kaili-lau-o-kekoa, The-Covering-of-the-Koa-Leaf, was the only daughter of Moikeha and Hooipo, two very high chiefs of Kauai. Her parents loved the child greatly, and gave her every care, engaging a nurse, or *kahu*, to be with her always. As Kaili-lau-o-kekoa grew, her beauty increased. After she had ridden the surf at Maka'iwa, near Waipouli, or had played *konane*, a complicated game resembling chess, her cheeks glowed like the rising sun.

One day, when her parents had gone to cultivate taro in Kapahi, Kaili-lau-o-kekoa was alone, playing *konane* with her nurse. Suddenly a strange man stood before the door. He asked the girl if she enjoyed *konane* very much. When she answered that she did, he suggested that she play a game with him. Kaili-lau-o-kekoa won the game by a score of nine to four. She said to the stranger, "You have been defeated by the daughter of Moikeha."

The man asked, "Is Moikeha still living?"

"Yes," answered Kaili-lau-o-kekoa. "He has gone to the taro patches now. Moikeha loves surf-riding and my mother. He will stay on Kauai till he dies."

After the stranger had heard these words, he said, "I believed that he was dead. I regret not being able to take him back to Molokai with me. When he returns, tell him that the high chief of Molokai has been here, and has been defeated by Moikeha's daughter in a game. Give your father and mother the aloha of Heaa-kekoa."

When the chief from Molokai had spoken these words, he got into his canoe, and started for his island.

Now, at Pihanakalani, where all good things abounded,—a legendary spot on Kauai above the Wailua river, that cannot be found nowadays—there lived two very high chiefs: Kaua-kahi-alii, The-Battle-of-the-Lone-Chief, and his sister Ka-hale-lehua, The-House-of-Lehua. In this garden-spot of Pihanakalani was the far-famed fountain of Wai-o-ke-ola, Water-of-Life, which could restore the dead to life, and renew the youth of the aged. Kaua-kahi-alii owned a very loud-sounding flute called Kanika'wi, which could be heard as far away as Kapaa.

One night Kaili-lau-o-kekoa had been playing *konane* with her nurse until midnight. That night, while the girl slept, the nurse heard the flute crying, "Kaili-lau-o-kekoa, do you sleep?"

When the girl awoke in the morning her nurse told her the words she had heard. Kaili-lau-o-kekoa was greatly excited and said, "Today we shall sleep all day so that I may be awake at midnight, for I must hear this voice from the hills when it calls me."

So they slept until evening. Then they played *konane* to keep themselves awake. At midnight they heard the flute voice calling, "Kaili-lau-o-kekoa, do you sleep in Puna? Is not the surf high?"

"I do not sleep. I shall search for you until I find you," answered the breathless Kaili-lau-o-kekoa.

Then she and her nurse started on their search. They climbed up the mountain side and at daylight reached Kuamoo.

When the sister of the flute player saw these two women coming, she sent the heavy mist and the blinding rain to delay their journey. They found shelter in a hollow tree and when the rain had ceased they went on. Kaili-lau-o-kekoa soon saw a house where a bright fire was burning.

As the two women approached the house of Ka-hale-lehua, the sister of the flute-player, she took pity on them, and welcomed them. She took off their wet clothes, and gave them each a dry *pa'u*. Then she prepared a meal for her unbidden guests. She placed before them a platter of *lipoa limu*, choice sea-weed, and little striped *manini* fish, still alive. Kaili-lau-o-kekoa was greatly surprised to see the live fish, and said to her nurse, "We live near the sea yet we never have live fish. This place is far from the sea. How is it that the fish are still alive?"

Her hostess answered her by saying that she and her brother had a fish pond near their house.

After the meal was finished Kaili-lau-o-kekoa went in search of the flute that had called her away from home. She came to the room of Kaua-kahi-alii and found the flute hidden in his breast. At once a great love for this chief filled the heart of the girl, and she forgot her fond parents and stayed with him.

When the parents of Kaili-lau-o-kekoa found that their daughter was gone, they began to search for her. At last they came to the house where she was living with the young chief, and carried them both to Kapaa. There they tied the chief to a post in a house.

The first day he was given nothing to eat. On the second day a boy passed by, and, seeing the prisoner, asked if he had been given any food or water. When he heard that he had received none, he returned to his parents and made known to them the chief's condition. They ordered their son to put water in a coconut shell, and to get another one for food,

so that he could throw them to the prisoner. With these he crawled through the rushes so that no one would see him.

The boy carried out his parents' instructions on that day, and on many following days. The chief began to look well again.

When the father of Kaili-lau-o-kekoa had recovered from his anger he called his daughter to him and asked her to explain how she came to be in the mountains. She told him that she had heard the flute calling to her, and had wanted to make of the man who played it either a husband or a friend.

Her parents decided to allow the *kahuna* to settle the matter. When they were called together, and had heard the story they all agreed that Kaili-lau-o-kekoa should marry the chief if he could give his genealogy. As soon as Kaua-kahi-alii was called before them, he proved that he was a very high chief, and so the beautiful chiefess was given to him in marriage.

The boy who had carried food and water to the chief in prison became his great friend and was made *luna*, or head-man, over all his lands.

THE RAIN HEIAU

A LEGEND OF MOLOKAI

On Molokai there is an interesting heiau,[5] called Ka-imu-kalua-ua. In a little cave opposite lived the woman Pauulea. Nearby her two brothers Kaoliu and Mawe lived in the form of hills.

Pauulea made tapa in the cave and spread it out to dry. As soon as she had spread it in the sun her brothers would send rain to wet the tapa and tease her.

This happened many times and at last Pauulea found a way out of her difficulty. Taking small oblong stones, she built a heiau. As the rain fell she caught the drops in the stones and cooked them. Thus she always had fair weather to dry her tapa.

[5]This heiau is situated on the edge of a little valley, about a mile northwest of the place where Mr. George Cooke now lives. Mr. Cooke has enclosed it with a fence, so that none of the stones will be removed.

PUU KA MO-O

HOW LIZARDS CAME TO MOLOKAI

In one of the valleys of Molokai lived the most beautiful woman of the island. It happened that every night she was visited by a man who always left before daylight so that she was not able to discover who he was. This suspense began to tell on her and she slowly wasted away.

In their anxiety her parents summoned a *kahuna* to see if he could tell the cause of their daughter's ill health. He made known the girl's secret and said that during the day this nightly visitor was a *mo-o*, or monster lizard; only at night could he take a human form.

The *kahuna* arranged this plan to destroy the girl's tormentor. He was to hide in the house where the girl slept. The girl was to keep her visitor awake as long as possible, so that when he slept he would sleep soundly. Then when deep sleep held him the *kahuna* would tie white tapa rags to his back. At daylight the man would be turned into a mo-o, and crawl off, through the bushes, leaving his trail marked by white tapa rags.

This plan was carried out. The *kahuna* and his men followed the trail of the mo-o until they came to a rocky hill still known as Puu ka Mo-o.[6]

There, surrounded by stones, they saw the monster lying in the sun fast asleep. All the people were ordered to collect wood. This was placed around the mo-o and set afire. As the heat of the fire burned the body of the mo-o, it burst open and myriads of small mo-o were thrown out and ran away among the bushes.

Thus was the beautiful girl saved from her nightly visitor, and thus were the little worm-like lizards introduced into the islands. The hill is still known as Puu ka Mo-o, the Hill-of-the-Monster-Lizard.

[6] Puu ka Mo-o is situated about a mile and a quarter northwest of Mr. George Cooke's home, Kauluwai.

MANO-NIHO-KAHI

A LEGEND OF OAHU

Near the water hole in Malae-kahana, between Laie and Kahuku, lived a man called Mano-niho-kahi, who was possessed of the power to turn himself into a shark. Mano-niho-kahi appeared as other men except that he always wore a tapa cloth which concealed the shark's mouth in his back.

Whenever he saw women going to the sea to fish or to get *limu* he would call out, "Are you going into the sea to fish?"

Upon hearing that they were, he would hasten in a roundabout way to reach the sea, where he would come upon them and, biting them with his one shark's tooth, kill them.

This happened many times. Many women were killed by Mano-niho-kahi. At last the chief of the region became alarmed and ordered all the people to gather together on the plain. Standing with his *kahuna,* the chief commanded all the people to disrobe. All obeyed but Mano-niho-kahi, Shark-with-One-Tooth. So his tapa was dragged off and there on his back was seen the shark's mouth. He was put to death at once and there were no more deaths among the women.

LANILOA, THE MO-O

A LEGEND OF OAHU

Laniloa is the name given to a point of land which extends into the ocean from Laie. In ancient times this point was a mo-o, standing upright, ready to kill the passerby.

After Kana and his brother had rescued their mother from Molokai and had taken her back to Hawaii, Kana set out on a journey around the islands to kill all the mo-o. In due time he reached Laie, where the mo-o was killing many people. Kana had no difficulty in destroying this monster. Taking its head, he cut it into five pieces and threw them into the sea, where they can be seen today as the five small islands lying off Malae-kahana: Malualai, Keauakaluapaaa, Pulemoku, Mokuaaniwa and Kihewamoku.

At the spot where Kana severed the head of the mo-o is a deep hole which even to this day has never been fathomed.

MANUWAHI

A LEGEND OF OAHU

At Laie lived Manuwahi, Free Gift, with his son, Ka-haku-loa, The-Lord-of-a-Long-Land; his grandson, Kaiawa, Bitter Sea, and his great-grandson, Kauhale-kua, The-Village-on-the-Ridge. These men were the keepers of the *akua* at Laie. Manuwahi and his children were hairless and were possessed of supernatural powers.

Manuwahi planted black and white *awa* far up in the mountains for the use of the *akua*. Every *awa* root planted was given one of these names, Kaluaka, The-Hole-That-Gives-a-Shadow; Kumumu, Blunt-Edged; Kahiwa, Best-Awa, or Kumilipo, The-Root-of-Unconsciousness. This was done so than Manuwahi, when sending one of his sons for a piece of *awa* could designate the exact one he wished.

When the *awa* was given to him, Manuwahi would prepare it, and then summon the *akua* from the North, South, East, and West, as well as from above and below, to drink of it. They prayed in this wise, before they drank:

> Gods of the Morning,
> Gods of the Night,
> Look at your progeny:
> Grant them health,
> Grant them long life;
> *Amama ua noa*—it is free!

It happened that during this time, Kamehameha I. had come to conquer Oahu. He had succeeded in subduing all the island except Malae-kahana, between Laie and Kahuku. Determined to add this place to his conquests, the king sent one of his body guard, Ka-hala-iu, In-the-Shadow-of-the-Hala-Tree, with many of his bravest soldiers to subdue Malae-kahana.

Ka-hala-iu marched as far as Hanapepe the first day, where he spent the night. Early the next morning he set out and meeting Manuwahi, whom he did not recognize, asked him where the powerful *kahuna* of Malae-kahana lived.

Manuwahi answered, "Pass over the river and you will see a spring and nearby a hut with trees about it. This is his home."

Ka-hala-iu did as he was told and had soon surrounded the hut with his soldiers. When Manuwahi's son came out Ka-hala-iu asked him, "Where is your father?"

"Did you meet a bald-headed man?" asked the boy in turn.

"Yes," replied Ka-hala-iu.

"Well, that was my father. Why did you come here?"

"I came to kill your father by the orders of King Kamehameha," answered the King's man. Deciding it would profit them nothing to kill the son, the soldiers departed for Hanapepe by the *makai* side of the hill, and failed to meet Manuwahi, who had returned to his home by the *mauka* side.

The next morning the King's body-guard again surrounded with his soldiers the home of the *kahuna*. Manuwahi came out and asked, "What are you here for? Did you come for battle?"

"Yes," answered the fearless soldier, "We came to kill you."

Whereupon Manuwahi called to his assistance all the *akua* from the North, South, East and West as well as those from above and below. They came at once and gave battle to the soldiers of the king. The *akua* fought by biting and scratching their assailants and before long they had killed all but Ka-hala-iu.

Ka-hala-iu cried out, "Spare my life, *kahuna* of the gods, and I will stay with you."

"What can you do if you stay with me?" asked Manuwahi.

"I will plant *awa* for you. I came from Hawaii, where I lived by planting *awa*," answered Ka-hala-iu.

But Manuwahi said, "I do not need you. Go back and tell your king that even his bravest soldiers were not able to conquer Malae-kahana. Tell him that all but you were killed by the *akua* there."

When Kamehameha had heard these words he sent Ka-hala-iu back with another body of soldiers with orders that he must conquer Malae-kahana.

In the meantime, Manuwahi had moved with his sons up to the cave of Kaukana-leau, where the natives made their stone adzes. There the King's soldiers met them. As before, Manuwahi called all the *akua* to his aid. Again the soldiers were quickly put to death and only Ka-hala-iu was left. So Malae-kahana was not conquered.

Ka-hala-iu respected and admired Manuwahi so much that he was very anxious to remain with him, and so he asked again to be allowed to remain as an *awa* grower. Manuwahi consented this time and gave him one side of the valley to cultivate in *awa*.

One day as Ka-hala-iu was preparing the side hill for its cultivation, he noticed that on the opposite side of the valley, trees and bushes were falling in every direction, as if a whirlwind were uprooting them. This frightened him very much, as he could not understand the phenomenon, so he ran in great haste to Manuwahi, and asked what it meant. Manuwahi told him that his *akua* were helping in the clearing of the side hill, and

that if he wished them to help him, they would gladly do so. Ka-hala-iu was only too happy to have help, so he called upon the *akua*, and in a short time both sides of the valley were cleared, and were growing luxuriantly with the most beautiful *awa*.

After the battle, between Ka-hala-iu and the *akua* for the possession of Malae-kahana, Manu-ka, Frightener-of-Birds, one of Manuwahi's sons, moved to Kaneohe, where he died some time later. He was buried *makai* of the present road. The natives dug a very large grave, but before they could cover the body, the *akua* brought red dirt from Ewa, in a cloud, which filled the grave, and made a red hill above it, which can be seen to this day. There is no other red dirt in that district.

MAKUAKAUMANA

A LEGEND OF OAHU

The story of a man who was swallowed by the big
fish, and of this man's gods, Kane and Kanaloa.

Makuakaumana was a farmer, planting *awa*, bananas, and sugar cane
for his gods, and taro and sweet potatoes for himself and his friends. He
and his wife lived at Kauluanui in the district of Koolau, on Oahu. They
had one child, a boy, and when this boy was twelve years old his mother
died.

After the death of his wife, Makuakaumana went alone to his farm in
the mountains, leaving his son in charge of his house. Whenever Makua
ate, or slept, or worked, he prayed to his gods, Kane and Kanaloa, but he
did not know exactly how to end his prayers, for he always omitted the
words *"amama ua noa."*[7]

The gods had noticed Makua's strict observance of prayer and so they
had decided to take him to live with them on Ulukoa, the land that was
hidden from the sight of man, and called the Island-Hidden-by-Kane. The
people who lived on this island were the direct descendants of Kane.
They were O-Kane, Kanaloa, Kane-of-the-Water-of-Life, Kane-of-Thun-
der, Kane-that-Breaks-the-Heaven, Kane-of-the-Rocks, Kane-of-the-Roll-
ing-Thunder, Kane-of-the-Rough-Cave, Kane-of-the-White-Cave, Kane-
that-Sleeps-in-the-Road, Kane-that-Sleeps-in-the-Water, Kane-that-Shakes-
the-Earth, Kane-of-the-Light, Kane-in-the-Break-of-Day, Kane-in-the-Twi-
light, Kane-in-the-Whirlwind, Kane-in-the-Sun, Kane-in-the-Prayers, Kane-
the-Skilful, Kane-the-Jumper, Kane-the-Brave-One, Kane-Who-Hid-the-
Island, Kane-the-Watchman, Kane-that-Ran-on-the-Cliff, and Kane-the-
Eyeball-of-the-Sun.

Each of these gods had his own tasks to perform as indicated by his
name. These gods lived in bodies of men on the beautiful land of
Ulukoa. There all food grew without cultivation. There everyone was
happy. There no weeping, no wailing, no pain, no sickness, no death was
known. There the inhabitants lived forever and when they became very
old, their bodies were changed into spirit bodies without tasting of death,
and then they become gods and lived in the clouds. From their home in
the clouds their spirits could come to earth in men's bodies or in spirit
bodies as they preferred.

[7] "Amama ua noa," "The prayer is finished, or freed." This is almost equivalent
to "Amen," but its use antedates any Christian influence.

It happened that a great fish had come ashore in the bay of Kahana, Koolau, near the village. His body was covered with stones on which grew *opihi* shells and many varieties of *limu*. The people were walking on his body.

As Makua was working alone on his farm, two men ran to him and asked, "Why do you keep on working in your garden? Do you not know that a big fish has come ashore at Kahana and that all the people are hurrying to see it?"

Makua noticed that these men were carrying staffs. He inquired whence they had come and how they had heard of the big fish.

They replied that they had come from Kahana.

Then Makua said, "You must be very spry to come so quickly such a great distance. How did you know my name? You are strangers to me. I have never seen you before."

The strangers answered that the people in the village had told them his name, saying that he was the only one to cultivate anything in the mountains and that they were looking for *awa*, bananas and sugar cane, for which things they were longing greatly.

Makua said, "I have plenty of *awa*, bananas and sugar cane, but I have planted all these things for my gods, Kane and Kanaloa."

Hearing these words, the strangers winked at each other and asked, "Have you ever seen your gods?"

"No," replied Makua, "I have never seen them, but I am told that they are very kind-hearted and full of love for anyone that worships them. That is why I have chosen them for my gods and planted these things for them."

"If anyone besides your gods eats these things, what will become of him?" asked the strangers.

"No one will come and take the things I have planted for the gods. It is not the right of anyone," replied Makua.

"But, suppose you will allow anyone to eat of the food you have planted for your gods, how then can trouble be avoided?" continued the strangers.

"By praying to my gods," Makua answered.

"How shall they pray?" inquired the strangers.

"Thus," said Makua:

> O, Kane, O, Kanaloa,
> Here is the taro, the banana,
> Here the sugar-cane, the *awa*,
> See, we are eating it now.

Then the strangers laughed and said, "Such a short prayer will not tire you much. It is only a few words."

"Yes," said Makua, "my prayer is short. No one has taught me how to pray, so that I can make a longer prayer. But I think my gods accept my prayers. If they do not accept them because they are short, that is no excuse for me to cease praying. As long as I live I shall pray to my gods. I am now half way through my life, and I have prayed at all times. Should I stop now, all my prayers would be lost, and I should receive no blessing from my gods."

"What blessing do you expect to receive from your gods for your devotion?" asked the strangers.

"I shall have enough to eat. All things will grow well on my farm without too much hard work. All that I plant will bear abundantly for my gods, and they in turn will grant me long life," said Makua.

"Then why did your wife die, if the gods have power to grant long life?" persisted the strangers.

Hearing this question, Makua hung his head and tears dropped from his eyes as he answered, "Because my wife died, one cannot say that the gods have no power to grant long life. All men must go by the same path, all from the old man to the child that cannot even creep."

When the strangers heard this answer, they said, "You will not be disappointed in the blessing you hope to receive from your gods, for we see that you have great faith. Now prepare banana, *awa* and sugar cane for us. Before we eat, pray to your gods so that we may hear your prayer and commit it to memory, and so learn to worship your gods."

Makua was filled with joy to think that these men wanted to worship his gods. So he quickly prepared the food, and as he placed it before them, he prayed thus:

> O Kane and Kanaloa,
> I am eating with my strangers
> The banana and the sugar cane.

As the men ate, Makua asked them what they thought of his prayer.

They repled, "There is nothing amiss in your prayer, for we know your great faith and your good works. We believe your gods will approve of your prayer as we do. What would be gained by our changing the language of your prayer?"

The strangers said that they must depart. One presented Makua with a staff, saying, "This staff I received from my ancestors. It is a great help in the cultivation of land. Dig a hole with it and place a plant in the hole and it will grow very fast. A potato will grow so large that no one will be able to carry it."

The other stranger said, "Here is my present to you. This staff is an heirloom from my ancestors. Its great property is to carry loads, lessen-

ing their weight. You can carry with it many rows of potatoes without feeling their weight in the least. But I warn you that when you go to the sea to bathe, you should tell your son the uses and values of these staffs, so that when you are absent he will care for them, and then your gods will never lack for food. Your son will never grow tired at work and will never be hungry."

Makua seemed very doubtful about the truth of these wonderful words. He said, "You seem to have the bodies of men. Where have you received the power to endow these staffs with the supernatural powers you say they possess?"

One man replied, "You are right. We have no power. The power came from our ancestors. Now to dispel your doubts about the properties of the staffs, go, and with the digging stick, dig up all the *awa* in the fields in front of you. Into each hole throw a slip of *awa*."

Makua quickly did as he was told. The *awa* came from its hole as though it were thrown from the ground. Makua could feel no resistance as he dug. He kept on digging and planting until half of the field was finished and he felt no weariness.

Then Makua began to wonder how he could carry so many bundles of *awa*, for one bundle was all he had been able to lift. He decided that it would take four hundred people to carry all he had dug with this wonderful staff.

But the stranger urged him to keep on, saying, "How will you know the value of the stick? Keep on until you have dug up the whole field or I shall take the staff from you and you will only have been helped in the planting of the *awa*."

So Makua finished the whole field. Then the strangers pulled off from the fence much *kowali* or convolvulus plant and told Makua to throw it over the *awa*. Makua did as he was told, throwing the vine over the *awa* root and when he had reached the other side of the field he noticed that the vine had grown over the *awa* and had gathered it all into two big piles. Makua was amazed at this and as he stood looking at the piles and thinking that the men had done the work, one called out to him, "Come and get my lifting stick and see if my gift is of any value."

Makua took the staff with grave doubts. He felt it could not lift so great a burden. But he placed the ends of the stick in the piles of *awa*. As he straightened himself to lift the load, he felt only the weight of the staff,—none of the weight of the *awa*. Then he began to walk toward the sea, but his feet hardly touched the earth and he felt almost as if he were flying. So he lost sight of his guests and in a very short time he

found that he was near his home by the sea. As he lowered his bundle to the ground, he saw again his two friends who asked what he thought of their gifts.

Makua replied, "These staffs will be my parents. I came here as a bird flies, feeling no weight and with great speed. Usually darkness falls before I reach my home. Now it is still daylight. I thank you, and have no longer any doubts as to their usefulness."

The man who had given Makua the digging stick said, "You will not see the real value of my gift until tomorrow when you return to your farm. I warn you to care for these sticks most diligently, but do not injure others through their power or take others' property. You must observe the laws of these sticks. If you do wrong with them, they will lose their magic properties and you will return to your life of hard labor. But if you do as I say, these staffs will retain their power and you may bequeath them to your descendants who in turn must care for them and do no injury to them and they too will receive a blessing from them."

Then the strangers said that they must depart, but Makua urged them to tarry until they had eaten. They replied that they would stay longer when they came again, for then he would have the means of entertaining strangers without trouble. So saying, they disappeared behind the house. Makua followed, hoping to see in what direction they went, but they were nowhere to be seen and he wondered about their supernatural disappearance.

Now these strangers were Makua's gods, Kane, who had presented the *o-o*, or digging stick, and Kanaloa, who had presented the *auamo*, or lifting stick. They had come because they had noticed Makua's weariness after his hard work and also because they wanted to try his faith, after the death of his wife.

Calling his son to him, Makua explained the power of the sticks and the care which must be taken of them. He said that on the following day they would go to the farm, and the boy should see how well he could use them. Food enough for forty men to carry would be prepared and the boy should carry it with the magic staff. This pleased the boy, for he thought that men would wonder at his great strength.

So they ate their evening meal and retired to rest, Makua first offering prayers to his gods. At daybreak, they hurried to the farm, where they were astonished to see that in each hole where the *awa* had been planted the previous day three big bunches were growing.

Then Makua realized for the first time that his visitors were not men and he cried out, "The men who came were not strangers. They must have been my gods. No man would have had power to do these things. The strangers are none other than my gods!"

So saying, he thanked his gods for having revealed themselves to him and then quickly set to work. He gave the *o-o* stick to his son, telling him to dig in all the fields for all the food plants. In a short time the food was thrown into bundles and was covered with the *kowali* vine which quickly tied the food into two larger bundles. Taking the *auamo* stick and placing its ends under the bundles, the boy lifted them as easily as his father had done, feeling no weight. Makua laughed with joy and said, "This is the life which my gods have granted to us, in return for my faith in them and care of them."

So father and son turned towards their home. In a short time the boy with his big load was far ahead of his father, who tried to overtake him, but could not, and the boy reached home before Makua was half way.

Reaching home, Makua as usual prepared his meal and also a meal for his gods. Then he saw two very old men approaching and he invited them to eat with him. Makua asked these men if they had any gods and they replied that they had Kane-huli, or Seeking-Kane; Kane-puaa, Hog-Kane; Hina-puku-ai, Hina-Gatherer-of-Food; and Hina-puku-ia, Hina-Gatherer-of-Fish.

This number of gods surprised Makua and he inquired why they had so many gods. The old men promised to explain after they had eaten and then Makua prayed thus, "O Kane, O Kanaloa, hear. My son, my guests, and I will eat bananas and sugar cane, things you like."

"Your prayer is not right," said the old men. "We must first pray correctly and then we shall eat. This food has been prepared for your gods. They must first eat or some dire disaster will befall you and your son. No harm will come to us as we are only strangers here."

These words made Makua very angry because he thought that these old men did not have faith in his gods, so he decided to kill them. They could see what was passing in his mind, and when he tried to lay hold of them, they called out, "Do not touch us, for we are old men without strength who have only a few more days to live. Your gods do not like to have their followers shed blood."

Makua was filled with fear and prayed, "O Kane and Kanaloa, I have sinned in thinking to break your laws. May the old men forgive me and teach me to pray."

The men forgave Makua and taught him this prayer:

O Kane and Kanaloa,
Here is the *awa* for You,
Here is the sugar cane,
Here is the banana.
We shall eat and drink by Your power.

You give life to me.
Do not shorten this life.
Grant me the life which does not wane,
And You shall have the *kapu*.

Then they drank the three cups of *awa* and they ate the food which Makua had prepared and explained that their gods were Kane-huli-honua, the-Giver-of-Great-Lands; Kane-puaa, the God-of-Sacrifices; Hina-puku-ai, who granted sufficient food, and Hina-puku-ia, who supplied the food from the sea.

"You must worship your gods not only by prayer, but also by sacrifices," they said. "When offering food, ask Hina-puku-ai to carry it to your gods, Kane and Kanaloa. If you are offering fish, call upon Hina-puku-ia, for to her belongs the power over the fish."

Makua was very happy to learn from these old men that he should worship his gods by sacrifices, for he had not known this before, and the knowledge gave him new life.

The men told him that there were many more useful things he should add to his worship which they could not teach him, but someone might come in the future who could teach him more.

Then they prepared to depart, and as night was at hand Makua urged them to stay until morning, but they said that they must hurry on to see the strange fish which had come to land. Makua asked if this fish was good to eat and they said they did not know, as they had not seen it and had only heard of it through others.

So these old men departed. They were very high gods, Kane-huli-honua and Kane-puaa, and they had come to teach Makua the proper way to pray and to sacrifice. They also wished to interest Makua in the great fish.

When Makua awoke the next day, he told his son to remain at home while he went to Kahana to see the big fish he had heard of. As he came near the fish, he saw a great crowd about it. They all thought it was dead. A man explained that the stone *pali*, or cliff, extending to the sea was the fish. When it had come ashore, its tail and its back had been seen, but now it was covered with sand and looked like a *pali*.

While Makua was looking at it, he heard a great noise and saw a great crowd of men and women covered with leis coming to see the fish. When they reached it, they climbed upon its back and jumped from it into the water. They had been to see the fish before and had now returned to dive from it, covered with leis as their custom was. They were enjoying it greatly, as the fish gave them their first opportunity to dive, for up to this time there had been no cliffs on their shore.

Seeing the grand time his friends were having, Makua decided to hurry home to prepare himself for diving.

At home he found his son looking very happy because he had been to the farm and had found that everything which had been planted with the *o-o* stick had grown rapidly and was ready to be harvested. The sugar cane had grown so high, it had fallen over and had grown up again.

Makua told his son not to be surprised at such blessings, for they would receive them continually, if they followed the gods' instructions. Then he explained all the gods had told him about the use and care of the sticks. The boy promised to follow these instructions and Makua was very much pleased, saying, "Blessings will follow you, my son. You will not die. nor yet grow old."

Makua was anxious to see for himself how the farm looked, so he forgot for the time being about the fish, and went to the farm. There standing by his door, he saw two very strange and beautiful men. No one in Koolau could equal them. One held a *malo-puakai,* the red-dyed loin-cloth for surfing, the other a *kuina-kapa-papa'u,* the thick bed-covering of many colors. Makua gave them his aloha, yet he was filled with fear, for he thought that they must be great chiefs from the island of Hawaii, for they wore the cloaks of beautiful feathers from Hawaii. Makua feared that he would make mistakes in their presence. The strangers saw all that was passing in his mind.

Makua had thought that he would always be able to recognize his gods, having seen them once, but he did not know them now and took them for chiefs.

The men asked for food. Makua told his son to bring the *awa.* He quickly got it from the pile and prepared three cups of it as he was very skillful. He also prepared three joints of cane and three bananas.

When Makua saw these things being prepared which belonged to his gods, he cried out, "Did you pray to our gods?"

"No, I did not," answered the boy, "because I am very hungry. Not since the day of my birth have I so longed for food."

"As a punishment for this crime I must put you to death, and sacrifice you to my gods, or the penalty will fall on me," sadly replied Makua.

He began to prepare a big fire for the sacrifice. Meanwhile, the strangers were watching and gave the boy power to speak.

He asked, "Will you kill me in that fire?"

"No, I shall kill you first by means of a stone adz, and then when you are dead, I shall throw you into the fire!"

The boy cried out with a loud voice, and the stranger with the *kuina-kapa,* who was Kanaloa, gave power to him to resist his father and he asked, "In whose name will you kill me, and to whom will you sacrifice me?"

Makua replied, "I shall kill you in the name of Hina-puku-ia, and I shall sacrifice you to Kane and Kanaloa."

The boy stood before his father, saying, "Aloha, will you look at my body? What part of it is like a fish, or like food, that you sacrifice me to Hina-puku-ia and Hina-puku-ai? Neither has power over the body of man."

These words troubled Makua, for he knew that his son was right, and that he should not kill him nor throw him into the fire in the name of the Hina. So he decided to do it without calling on them, for he was angry that his son had disobeyed him. He tied the boy with a rope.

The strangers, seeing the boy tied, gave him power to call out, so that his father would have compassion on him, "O Mother! I am to be burned today in the fire, and shall go into your presence with a body burned by fire. Why did not my father kill me while I was yet small? He has allowed me to grow up, and now wishes to slay me. O Mother! Come and rescue me. I am bound up. I shall be killed with an adz, and shall be thrown into the fire. I shall die today."

These words caused Makua to weep. He could no longer conceal his love for his son because the boy's prayers had recalled fond memories. He kissed his son and said, "Alas, my son, I cannot refuse to do what I have promised the gods in return for their wonderful gifts."

So saying, he placed the boy on the ground and taking his stone adz, prayed, "I am fulfilling my promise to you by sacrificing my only son. Receive this sacrifice, and grant me in turn life which shall never cease."

Having finished this prayer, Makua struck at his son with the adz, but he could not strike him. Three times he missed his aim, the adz falling to the ground, each time. Failing to kill the boy, Makua untied him and hurled his body against a great stone. Three times he did this and each time the boy was unharmed, having no mark even upon his body. As the angry father seized him the fourth time, Kane called out, "Makua, stop! Do not touch the boy again. Your gods will pardon your sin. There is a law among your gods that if a man tries three times to keep his promise and fails, the sin will no longer be held against him. But if he tries the fourth time, then the sin will be his own. So we command you to take your child into the house and, before we eat, pray to your gods for a blessing on this food, and thank them for not allowing you to kill your only son."

These words were like a calabash of cool water poured over Makua's head. They cooled all his troubled thoughts and took away the desire to kill his son. He knew that the stranger spoke the truth and, taking his son into the house, he said, "Aloha, my boy, you shall live. I have forgotten my desire to kill you. I know that I am forgiven by my gods."

Then Makua prepared the food and as his guests sat down before it, he prayed as the old men had taught him. Kanaloa teasingly asked who had taught him to pray, and told him that his prayers were good. He said the gods would try his faithfulness to them three times.

Makua asked why he was to be tried three times and Kanaloa replied, "Because there are three worlds where men who worship the gods will live. First, this world that we are living on; second, the world hidden from the eyes of man, belonging to Kane-huna-moku, Hider-of-the-Island; third, the world where Kane lives and where he takes men good enough to become gods."

"Where do bad people go?" asked Makua.

"First, such people go to a world where men have done neither good nor evil and where they wait to be rescued; second, to the world where they see joy and sorrow; third, to the world where they shall weep because of the heat which lasts day and night," explained Kanaloa.

"In what bodies shall men pass to these worlds?" inquired Makua.

"In spirit bodies," answered Kane.

Makua realized that he would be tried three times. We have seen him tried twice—first, on his farm, then in suffering the sacrifice of his son. There is yet one trial for him to endure.

As the strangers left the house, one gave his *malo-pua-kai* to Makua, saying, "This is my gift to you for your entertainment. Its value is that it shall make you invisible to the eyes of man."

The other gave Makua his sleeping tapa, saying, "This is my gift to you. Its value is that it shall take away from your body the heat of the sun."

Makua was very happy to have received these new gifts. He said, "This is the third time that I have entertained strangers. First, my gods. Then, the old men who taught me how to pray and sacrifice to my gods. Now these handsome men with the *kapu* of the chief."

Now Makua lost all interest in going to his farm to work. He did not have to plant as everything grew luxuriantly. He had plenty of taro, sugar cane, and bananas. He told his son that their days of hard labor were over, life would henceforth be easy for them. And so Makua decided to go again to see the big fish. He tied the *malo* around his waist

and placed the tapa over his shoulders. As he kissed his son farewell, the boy began to weep, saying, "I feel that you will not come back. Fear takes hold of me. I fear this trip will separate us. Something is about to befall you."

The father reassured the boy with these words, "Fear not. We are not men without gods. You have seen with your own eyes that our gods have visited us. Have they not given us gifts? Be cheerful and await my return."

The boy dried his tears and put away fear.

Makua hurried to Kahana. There the people were gathered and they were greatly surprised to see him wearing a *malo* and tapa. They asked him if he were cold. He replied that these were gifts from his gods who had come to his house a few days before. So the men all made *malo* and tapas for themselves and from that day began to wear them.

Then they asked Makua why he had come and he said that he might jump off the stone *pali* of the fish into the sea. They thought he would ruin his beautiful gifts in the water, but Makua said that he would swim without them.

Then the people asked him to wait until the next day, so that they could all join him. He consented and rested and feasted that day.

The next day they all climbed along the back of the fish as they supposed it to be dead. Makua saw many *opihi*, or mussels, clinging to the stones on the fish's back. He began to break the *opihi* off with a stone. He forgot about his plan to leap into the water from the fish. He did not notice the others in the water. Suddenly, he heard his friends calling loudly, "Jump off and come here. The stones are falling from the *pali."*

Makua then saw that the fish had moved away from the land several fathoms. Realizing his danger, he jumped into the sea to swim back to the land. Then the people on land saw a strange sight—the fish opened its mouth and swallowed Makua. A great wail arose, "Makua is dead! The great fish has swallowed him!"

The fish swam straight for the open sea, making the foam fly. When he reached deep water, he dived down and was lost to the sight of the anxious watchers. He swam toward the land of Kane-huna-moku, the hidden land of Kane.

All the people believed, of course, that Makua was dead. They carried this news to his son who was crazed with grief. He ran down to the seashore and hunted on each rocky point for his father's body, thinking that the fish might have eaten only a part of it. On one point he saw an object, but when he had reached it, found it to be only a log. He continued to search until the shadows from the mountains warned him that

darkness was near. Then he went home, and falling exhausted by the door, slept until late the following afternoon. At last, a voice awakened him, calling, "Arise, sleeping boy, I can give you good news about your father."

Sitting up, he was very much astonished to see the handsome strangers whom his father had recently entertained. One said, "Arise, fatherless boy. We came to tell you not to grieve. Your father is not dead as the people believe. He has been swallowed by the big fish and has been carried to the beautiful island of deathless people, where he has been thrown up on land, and where he has been received by the inhabitants and where he will be happy."

These words lightened the boy's sadness, but he asked, "When will my father return?"

The stranger replied, "We do not know when, but we have lived in that land and know how fortunate are those who live there. There men never die. So you should rejoice over your father's fate. We cannot say if he will always live there, for we departed before he had had his trials. If he remains steadfast, and does not fail in his trial, and does not violate any of the laws of the land, he shall remain there until the end of the world. But should he fail, you will see him again, for he will be quickly sent away."

The boy asked how far away that wonderful land was, how many days distant from the shore.

The strangers replied, "If the gods permit the land to be moved close to the earth, it takes only an hour to reach it; but if they do not, you may sail the ocean until you are grey-haired, and you will never see it."

When the strangers asked for *awa* and food, the boy prepared it for them and before he placed it before them, he prayed as his father had taught him.

After having finished their meal, the strangers said to the boy, "We are leaving you now, our young friend. Live with hope as you pray to the powerful gods of your father, Kane and Kanaloa. We will care for you so well that you shall not miss your father. No one shall harm you."

Then their bodies began to grow taller and taller until their heads were hidden in the blue sky and their feet slowly disappeared. People passing saw this and thought that the ghosts were returning to frighten the boy, but the boy realized that the strangers were indeed the gods of his father, and he was filled with joy and no longer sorrowed for him.

When Makua had been swallowed by the fish, he had become unconscious. He knew nothing until he was thrown up on land where he was met by two men. Then the gods Kane-huna-moku and Kane-huli-honua

came to Makua, and the men went back to comfort his son. His new friends took him to their home, where Makua saw many kinds of fruits and vegetables, bananas, and sugar cane of great size. The taro grew until it had no eyes. He also saw a beautiful, clear lake in which swam many varieties of fish. But he saw no houses and no people and so he asked where they were. The gods told him that the houses were inland and he was not allowed to see anyone until he had been tried. If he did not fail in his trial, then he would live forever and at last pass to another world.

Makua was eager to hear the laws of the land, but his guides told him that it was not allowed them to explain. They had the power to refuse him entrance, and to hide the land from the heaven above and the earth beneath.

Then Makua asked, "Should I break the law of this land through ignorance, would I be punished?"

"No," the men answered, "that wrong will not cling to you, but to the one who did not explain the laws. As we draw near to the houses, others will take charge of you, and they will have the power to explain the laws."

Soon Makua was surprised to see two beautiful houses before him. Two men who looked exactly like his guides came out and greeted him, saying, "You have been allowed to set your foot on our land. You shall have one of these beautiful houses which you see. Everything is for you. You will not have to fish, to build, to work. Only one thing is forbidden here. You must not weep nor wail, no tears must fall from your eyes, you must make no noise of sorrow."

Makua asked why no sorrow should be there. His guides replied, "You have no labor here and so the gods will be angry if you weep. We remember the prayers you made when you lived in the land of death."

Makua realized that he was speaking to gods and he wanted to kneel before them. But before his knees touched the ground, he was told to rise in these words, "You do not need to pray here. You have finished your prayers on earth. Here is only joy. That is the reward of the man who has been faithful on earth. You must first endure your trials. Then if you do not fail, you will be received into the fellowship of the gods."

Then the guides left Makua in charge of the new men. Their bodies began to grow and grow until they reached the sky and they slowly disappeared and Makua heard a voice from above saying, "We shall rejoice to receive you when you have passed your trials."

Makua cried out, "I am in great doubt. What must I do this day? This voice from above has startled me and made me fearful of the trials I must pass through."

One of the gods answered and said, "This day we will tell you all. You will become a god with us, if you pass the trials. If not, then you will become a messenger and will tell to men the beauties of this land."

These words were like a calabash of cool water thrown over Makua. They soothed his agitated feelings and he cried, "I am no longer afraid of the tests. I know my gods have faith in me. I am ready to endure the trials. I have faith that I shall resist all temptations. When you are ready, I am ready."

These words surprised the men and they smiled, saying, "We have not the power to try you. That is given to others. But it will not harm you to be ready at all times. You will not know when you are being tried."

Then they took Makua into a house where he saw many delicious looking foods which he had never seen before. There on the table was a pig still steaming, as if it had just been taken from the oven. Makua asked for the people of the house and was told that he would see them after he had eaten. Gods of the same rank as Kane had prepared this meal, Kane Nee-nee and Kane-Paina.

When Makua had finished his meal, he was taken to a beautiful seat from where he noticed a woman and a boy enter. He again asked for his trial, but was told as before not to be anxious, he would not know when it would be, he should have faith that he would stand fast during his temptation.

The woman and the boy who had entered were still in the background. The woman was none other than the spirit of Makua's wife. The boy was his son whom he had left at home. He had been put to sleep in his house and his spirit had been brought here by the gods. Both wife and son had been told all that they should do in the presence of Makua, who was about to be tried.

Makua heard the woman asking the boy how he had reached this land hidden from mortals, and heard her warning him that he would be killed, if discovered. He heard the boy's reply that he had swum hither because he was told that his father, who had been eaten by a big fish, had been thrown up there.

Listening eagerly, Makua heard the boy say further, "I cannot swim back. I have just escaped death from the cold water. My body became stiff and if I had not been washed ashore, I should have perished."

The woman replied, "Then we must both swim across the great sea so that you can return to live with your father."

The boy answered, "My father is dead. A big fish swallowed him."

His mother urged him to leave with her before he was killed by the guards and she quickly led him out of the house.

Makua asked his guide if he might follow to see what the woman was doing with the boy. The guard told him he might become lost and when the time came for his trial, his examiners would grow weary looking for him. But Makua promised not to wander far off. So he followed the woman and boy and soon recognized them as his wife, long since dead, and his son, whom he had left safe at home. Love for them surged up in his heart. Tears came to his eyes, but remembering the law of the land, he refrained from weeping. He thought that the gods had brought his wife to life again, but he feared to speak to her, thinking he might weep, and so he followed far behind them until he came to the beach where the big fish had thrown him upon the sand.

There he saw his wife trying to force the boy into the sea to swim across the water to his home. Noticing that his wife did not show affection for the boy, the father was about to interfere, but he feared he would be recognized. So the boy was forced into the sea, and when he reached the deep water, he cried out, "Oh, Mother, the sharks will eat me." Instantly, he was caught by a shark who swallowed all but his head, and swam off with him. His wife followed the boy into the water and soon Makua saw the big surf roll her over and over, and heard her cry out, "Oh, Makua, my beloved husband, you are watching me die. If I die, you will never see me again."

Makua could endure this agony no longer, and as the waves carried the body of his beloved one up on the sand, he lifted it onto dry land and bathed the face. Tears rolled down his cheeks, but he still refrained from loud cries of sorrow, as he did not want his guides to hear him. Wondering what to do with the body, he was surprised to see that there was still life in it. Slowly, his wife grew strong and throwing her arm about his neck, she wept bitterly. Makua then realized that he had failed in his trial and could not live in this land of the gods,—so he led his wife toward the beautiful house.

When they reached the spot where it had been, they were surprised to find that it had vanished. They rested under the branches of a big tree and there fell asleep. Soon a voice calling, "Makua, where are you?" awakened him.

Makua at first could see no one, but he was afraid because he had not been strong enough in the temptation which had come to him. He knew

that he must return to earth, and tell his friends there about the beauties of the hidden land and the power of the gods. As Makua looked, he saw that his wife had disappeared and he also saw eight men all exactly alike coming toward him, and he told them how his great love for his wife had made him weep when he saw her in danger.

One of the men said to him, "Hear now the sentence we shall give you. Because you have broken the laws of this land, you must be sent back to the land where men die. When you are very old, death shall befall you. Your body will be destroyed, but your spirit will come to us, though you cannot become a god. Your son will become a god, and he will rescue you from those who keep you in bondage and will rescue your wife's spirit, too. You and your wife will live again through the good deeds of your son."

Suddenly a very dazzling light shone. The eight men disappeared. Makua saw that the heavens were open and he beheld two bodies clothed in light and accompanied by many spirits arrayed in glorious raiment, but with sorrowful countenances. The spirits spoke, saying, "Dust to dust," and then the doors of the heavens closed.

Makua realized that the people of heaven were very sad because he had not been strong enough to resist his weakness.

He hurried into the beautiful wood, where he met the men whom he had seen when he had been thrown upon the sand. They asked where he was going, and Makua replied that he did not know, as there was no one to guide him. They then told him to follow a road which led to the sea where he would find many men and women bathing.

So Makua walked on and he saw that he was on a point of land running out into the sea where people were bathing. As he stood there, he heard a voice calling, "Do not stand on the big fish of your gods. Do you not see that you are standing on the scales of the fish which brought you here?"

Then Makua feared that he would again be swallowed by the fish. The fish seemed like a canoe leaving the beach where it had been tied. As it sped swiftly from the land, the people called aloha. The fish swam toward Koolau, and Makua, overcome with sleep, lay down and fell into a deep sleep. For three days and three nights the fish carried the sleeping man and then safely landed him on the sand at Koolau and waited near until he was found by a man, who thought him to be a ghost, and who ran quickly to tell his friends that he had seen Makua's ghost.

Others hurried to the spot and heard his deep breathing. As they wakened him, he heard them saying, "This is not Makua's body. It is the body of a spirit. We have seen him swallowed by the big fish."

Makua opened his eyes and saw a great crowd curiously watching him. His friends took him to their home and having given him food, asked him to tell all his experiences, and how he had come back from death.

So Makua told all that had happened to him from the moment he had been swallowed by the fish. His friends considered him very foolish to have broken the laws of the land that is hidden from the eyes of man.

Now we shall see what Kane and Kanaloa had been doing. They had put the boy to sleep and had taken his spirit to the hidden land to meet his mother. The boy slept peacefully until the shark bit his body in two. This wakened him, and remembering his dream, he was very sad. But he recalled the words of the gods, and was comforted by the thought that his father was happy in the land of the blest. So he went to the farm, where he again fell asleep and in his dreams saw his father's return and knew all his story. This great joy awakened him, and he was sad to find it only a dream. So he took his carrying stick and returned home with his burden. There he was greatly astonished to see his father sitting before the door and wailing—he ran to him and heard his story.

Makua was now too old to work. The boy labored for him, getting food and fish. In due time the father died and the boy, wrapping the body in tapa, carried it to a cave near Koolaupoko and there Makua was buried.

GLOSSARY

It is the purpose of this glossary to give the meaning of the Hawaiian words used in the text and to serve as a guide to pronunciation. The vowel sounds in Hawaiian—with a few exceptions—are as follows:

a (ah), as in father, alms.
e (eh), as in obey, prey.
i (ee), as in sheet, meet.
o (oh), as in open, bone.
u (oo), as in loot, too, fool.

Although each vowel is generally pronounced separately, the following combinations are sometimes pronounced together in a single syllable:

ai, as i in quiet, or as y in fly.
au, as ow in cow.
ei, as ay in day.
iau, as yow in yowl.
oi as oy in boy.

A-a (a'-a'): Rough lava stones.

Akua (a-ku'a): The name of any supernatural being, the object of fear or worship—a god, a ghost, a demi-god, a spirit.

Aloha (a-lo'-ha): A word expressing different feelings or emotions such as: love, affection, gratitude, kindness, pity, tenderness, compassion, grief; also the common salutation at parting or meeting for greeting or farewell.

Apau (a-pa'u): Beware.

Auamo (au-a'-mo): A lifting or carrying stick, like a yoke; a staff or pole for carrying a burden; [au: a handle, and amo: to carry].

Awa (a'-wa): 1. Kava (Piper methysticum), a bitter, acrid tasting plant from the root of which an intoxicating drink is made. 2. The liquor expressed from the root of the plant. The drinking of awa causes the skin to crack and flake off.

Day of Kau (Ka-u'): The longest day in the year, Midsummer Day.

Hala (ha'-la): The puhala or screw-pine tree (Pandanus odoratissimis) from the dried leaves of which mats are woven. Puhala really means a group or clump of hala trees. As they usually grow together, puhala is the word generally used.

Halemaumau (Ha'-le-mau-mau): The crater of Kilauea volcano—"the home of enduring fire." [Hale: house, home, habitation, and maumau: constant, enduring.]

Heiau (hei'-a'u): A sacred place or temple for the worship of one or more of the Hawaiian gods. [The three principal gods were Ku, god of the land; Lono, god of the sea; and Kane, the supreme god.] The large public heiaus were usually enclosed with stone walls. One of the six houses of every chief's regular establishment served as a private heiau. A heiau was sometimes called an *unu*.

Hula (hu'-la): 1. To dance; to play an instrument and dance; to sing and dance. 2. The dance itself. To be proficient in the art of the hula meant a long and arduous training in the various dances, as well as a knowledge of *mele* and musical instruments. The novice was subject to a number of strict rules as to diet, habits, etc. For instance, a pupil was not allowed to eat

sugar-cane, as it might spoil the voice, nor to sit on a stone for fear of stiffness. Before being allowed to perform in public, the would-be dancers had to pass a severe examination, after which they received the *uniki*, the secret sign or religious ceremony. Some of the hulas and musical instruments used with them were: the hula-ula-uli, in which the dancers rattled small double gourds, filled with pebbles, and trimmed with feathers; the hula-apuwal, which was accompanied by the beating of hands on double calabashes, which stood from two and a half to three feet high; the hula-ka-la-au, in which a long, resounding stick was struck with other sticks, in time. A large drum made from the hollowed trunk of a coconut tree over which a shark's skin was stretched was frequently used. Another dance was the hula-pulil in which the dancers were seated on the ground, holding in their hands joints of split bamboo, which rattled as the dancers beat with them and passed them from one to another. With all these hulas there was an accompaniment of singing or chanting, called the oli, sometimes sung by the dancers themselves and sometimes by others. In learning the art of the hula, each pupil had also to learn the art of the *apo*, "catching" or committing to memory, which was to repeat exactly, word for word, after hearing it only once, a *mele*, which sometimes took hours to recite.

Iele (i'e-i'-e): Freycinetia arnotti, a climbing shrub which has a rigid stem about an inch in diameter, numerous climbing and aerial roots, stiff rough leaves from one to three feet long, and a large, handsome leaf-like flower, rose and vermillion in color. Ropes and baskets were made of the woven roots.

Imu (i'-mu): A place or oven for baking meats and vegetables underground by means of heated stones.

Iwi-kua-moo (I'-wi-ku'-a-mo'-o): Literally, the backbone of the king; that is, his chief retainer. This title was the highest honor a king could confer on a subject.

Kahili (ka-hi'-li): A brush made of feathers tied to a long stick, used as a symbol of royalty. The smaller kahili were waved over a king or high chief; the large ones were carried in royal processions. They somewhat resembled large feather-dusters.

Kahu (ka'-hu): An attendant on a person of high rank. The relation between the kahu and his chief was very close, and permanent, and extended to the whole family of the kahu. At the death of a chief, a specially favored kahu, called moe-puu, was killed that his spirit might not be alone on his journey to the next world. To be a *moe-puu* was esteemed a great honor.

Kahuna (ka-hu'-na): 1. A priest, one who offers sacrifice, a physician, an astrologer, a sorcerer, a diviner. 2. A term applied to such persons as are masters of their craft, trade, art, or profession. For example—kahuna kalaiwaa, head canoe maker.

Kapu (ka'-pu) or **tapu** (ta'-pu): Eng. tapu, tabu, taboo: 1. A general name of the system of religion that formerly existed in the Hawaiian islands. The system was based on numerous restrictions or prohibitions, keeping the common people in obedience to the chiefs and priests, though many of the kapu included all classes of people. 2. Prohibited, forbidden. 3. To set apart, to prohibit from use, to make sacred or holy, or consecrated.

Kea-pua (ke'-a-pu'a): A game in which an arrow made of the shaft of a sugar-cane blossom was shot or thrown from a whip-like contrivance.

Kii (ki'-i): An image or images.

Kilu (ki'lu): A game, in which a stick, tied to a string, was swung around a circle of people. Whoever was hit had to sing, or oli.

Koa (ko'-a): Acacia koa, a large hard-wood tree growing in the mountains. Canoes and utensils are made from the wood, which takes a high polish and

is sometimes called Hawaiian mahogany. The leaf is silvery green and crescent-shaped.

Keae (ko-ae'): Phaeton rubricauda or lepturus (if white); variously called the tropic, frigate or bo'sun bird. A large white bird with two long, slender red feathers in its tail; in one variety the two feathers are white. It makes its nest in the cliffs.

Koko (ko'-ko): Network of braided strings used for carrying a calabash.

Konane (ko-na'-ne): A game resembling checkers or chess but more complicated than checkers. It was played with pebbles, or sea-beans, on a marked rock.

Konohiki (ko-no-hi'-ki): An overseer of the land under the chiefs—the principal man of a village.

Koali, also **kowali**: The convolvulus vine, the morning glory.

Kuina-kapa (ku-i'-na-ka'-pa), or **kuina kapa papa'u**: A set of sleeping tapas, generally five beaten or fastened together at one edge, answering the purpose of bed-coverings. They were very warm. When a favored guest came to a house, he was given a new set, and he was expected to take it with him when he left.

Kukui (ku-ku'-i): The name of a tree, Aleurites moluccana, and also of its nut. The nut, which was very oily, was used to burn for lights or was strung on bamboo for torches. The tree produces a gum. In ancient times the trunks were sometimes made into canoes, but the wood was not very durable; the bark of the root was used in coloring canoes black. The *kukui* is sometimes called the candlenut tree.

Kupua (ku'pu-a): The demi-god of a locality, beneficent or evil, as the case might be. A localized spirit, often embodied in a rock or a tree or even in a point of land, to be propitiated by specified offerings. A derived meaning signifies a sorcerer.

Lama (la'ma): Mabu sandwicensis, a species of forest tree of very hard wood, used in building houses for the gods. It has a handsome red berry.

Lauae (lau-a'e): The cabbage fern, which grows only on Kauai and has a delightful fragrance. Tapa was beaten with *lauae* leaves to scent it (*maile, mokihana*, and sandalwood were also used for this purpose).

Lauhala (lau-ha'-la): The pandanus or hala tree; more properly the leaf of the hala tree, which, when dried, is used for weaving mats and for other purposes.

Laulau: Bundles of pork wrapped in ti leaves and cooked in an imu.

Lehua (le-hu'-a) or **ohia lehua**: Metrosideros polymorpha, a valuable hardwood tree, growing on the uplands of all the islands. It bears a beautiful blossom, generally scarlet, but some trees bear orange, yellow, or white flowers.

Lei (lei): A wreath or garland; an ornamental headdress or necklace. Leis are made of beads, seeds, nuts, feathers, green leaves, flowers, and other materials.

Leilehua (le'i-le-hu'-a): A wreath of lehua blossoms. (See lei and lehua.)

Lei palaoa (le'i-pa-la'o-a): A necklace, made of many strands of braided human hair, from which depended a carved hooklike ornament of whale or walrus tusk, wood, or human bone, preferably that of an enemy chief. Kuoloa lands of Oahu were always reserved by the king for his own use, because dead whales or walrus were likely to come ashore there.

Limu (li'-mu): 1. An edible sea-weed. 2. A general name for every kind of edible herb that grows in the sea.

Lipoa limu (li-po'-a li'-mu): A choice, scented, edible seaweed. It is rose pink in color, and found only at certain seasons.

Luau (lu'-au): 1. A feast. (*Paina* is the better word for feast, but luau is the modern term. 2. The young leaf of the *kalo* or taro. 3. Boiled taro leaves.

Luna (lu'-na): A person who is over others in office or command. Hence, an overseer, an officer, a director, a herald or a messenger, one sent on business by a chief, an ambassador, an executive officer of any kind.

Maile (ma'-i-le): Alyxia olivaeformis, a vine with fragrant green leaves of which wreaths are made.

Malo (ma'-lo): A strip of tapa or cloth girded about the loins of men. In former times the malo was the only garment worn by men at work.

Malo-pua-kai (ma'-lo-pu'-a-ka'i): Literally, flower of the sea. A red *malo* used for surfing; made waterproof and dyed red by soaking in a mixture of *kamani* oil and crushed *hame* or *haa* berries.

Mamo (ma'-mo): Drepanis pacifica, a species of bird with yellow feathers under each wing, which were much valued for cloaks, helmets, and other feather work.

Manu (ma'-nu): The carved prows of a canoe.

Mele (me'-le): 1. A song; the words or subject of a song, epic in character. 2. To chant or sing.

Menehune (me-ne-hu'-ne): A race of mythical dwarfs from two to three feet in height, who were possessed of great strength; a race of pygmies who were squat, tremendously strong, powerfully built, and very ugly of face. They were credited with the building of many temples, roads, and other structures. Trades among them were well systematized, every Menehune being restricted to his own particular craft in which he was a master. It was believed that they would work only one night on a construction and if unable to complete the work, it was left undone.

Mo-o (mo'-o): A huge mythical lizard or monster worm.

Oli (o'-li): 1. A song, a singing; a chant, a chanting. 2. To sing; to chant.

Oo (o'-o): An instrument made of hard wood anciently used in cultivating the ground. It was long and flattened at one end to form a digger.

O-o (o'-o): Moho nobilis. A species of bird found formerly in great numbers in Hawaii. The yellow feathers were much valued for making cloaks, helmets, and other articles for the chiefs.

Opae (o-pa'e): The shrimp (Macrobachium grandimanus).

Opihi (o-pi'-hi): A limpet (Helcioniscus exaratus), a species of small shell-fish with mottled black, gray and white shell, generally found clinging to moss-grown rocks on the sea-coast.

Pali (pa'-li): A precipice, a high cliff or cliffs, the side of a steep ravine, a steep hill.

Pa-u (pa-u): A skirt of tapa worn by the women, or dancers—the principal garment of Hawaiian women in former times. It generally consisted of a number of pieces of tapa, usually five, wound around the waist, and reaching to about the knee.

Pikoi (pi-koi): A weapon used in warfare and in robbing or plundering. It was made of a piece of hard wood about two feet long, to which was attached a long rope, the other end of which was tied to the wielder's wrist. When the pikoi was thrown, the rope entangled the victim.

Pili grass (pi-li): Andropogon contortus, a long, coarse grass used in thatching houses.

Poi: A paste-like substance, generally made of the gray root of the *kalo* or taro, but is sometimes made of sweet potato or breadfruit. Poi made from taro was the chief food of the Hawaiians.

Poi board: A board on which poi was pounded or prepared.

Pola (po'-la): The high seat or platform between the canoes of a double canoe or a platform built across a single canoe.

Poopaa (po-o-pa'-a): [Literally: hard heads.] An Hawaiian fish, very easy to catch. Sometimes called oopu-kai (Cirrhitus marmoratus).

Puhala (pu-ha'-la): The pandanus; a group of hala trees.

Punei mats (pu-ne'i): The mats of a punei or bed, serving as springs and mattress.

Tapa (ta'-pa) or **kapa**: 1. The cloth beaten from the bark of the wauki, or paper mulberry, and other similar trees. 2. Clothes in general; a cloak or shawl.

Taro (ta-ro) or **kalo**: (Colocasia antiquorum v. esculentum.) A well-known starchy vegetable of the Hawaiian islands, of which there are at least thirty-six varieties. It is a species of arum esculentum, cultivated in artificial water-beds and also on high, mellow, upland soil. It is commonly made into a food by baking and pounding into a hard paste. After fermenting and slightly souring, it is diluted with water, then becoming poi.

Ti or **ki**: (Cordyline terminalis), a plant, growing to twelve feet in height with long, shiny green leaves, often used in cooking and in carrying bundles of food; sometimes also for thatching roofs.

Ukiuki (u'-ki-u'-ki): A shrub or plant, braided into a strong rope, often used to bind the thatching of houses.

Ulua (u-lu'-a): A large Hawaiian fish of the genus Carangus,, very much prized for eating. In the dedication of a new heiau an ulua was the preferred sacrifice. If one could not be caught, the *moo* (executioner) took the first man he met, for the sacrifice. A hook was placed in the victim's mouth, as if he had been a fish.

Uniki (u-ni'-ki): A secret sign; a religious ceremony for initiation.

Uwau (u-wa'u): A water fowl.

Wi (wi): Neritina granosa, a fresh water snail or shell fish.

Wiliwili (wi'-li-wi'-li): Erythrina monosperma, a large tree, the timber of which is, for its buoyancy made into outriggers for canoes. In former times the best surf-boards were also made of wiliwili. The tree has a handsome flower, generally scarlet, but more rarely orange, yellow, or white.

REPORT
OF THE DIRECTOR FOR
1922

BY

HERBERT E. GREGORY

BERNICE P. BISHOP MUSEUM

BULLETIN 4

HONOLULU, HAWAII
PUBLISHED BY THE MUSEUM
1923

Report of the Director for 1922

WORK OF THE STAFF

The Director, Herbert E. Gregory, has given attention to the work of field parties, to editorial supervision, and to plans for organization and development. Brief trips were made to the islands of Lanai and Maui and the Napali coast of Kauai was explored with a view to later study. The month of January was spent on the Atlantic coast and in Canada in conference with government officials and with scientists interested in Pacific problems. Six weeks in August and September were given to geological work in southern Utah; and to fulfill obligations of the co-operative agreement between the Museum and Yale University, the time from September 20th to the end of the year was devoted to classroom work at New Haven.

The Director has continued his work as Chairman of the Committee on Pacific Investigations of the National Research Council, which is actively engaged in perfecting international arrangements for exploration and for conservation of marine life, and in assisting the Australian National Research Council in the organization of a Pan-Pacific Scientific Congress to be held at Melbourne and Sydney, August 13 to September 2, 1923.

In addition to public lectures and papers read before scientific societies, three articles and nine reviews have been prepared for publication and progress has been made on a manuscript which is to form part of a volume on the history of Hawaii.

William T. Brigham, Director Emeritus, reports progress in the preparation of a series of essays on Hawaiian ethnology.

William H. Dall, Consulting Naturalist, has completed his study of collections comprising more than twelve hundred species and varieties of Mollusca and has submitted an extensive manuscript on the marine shell-bearing Mollusca and Brachiopoda of Hawaii.

In connection with the work of the Philippine Bureau of Science, Elmer D. Merrill, Consulting Botanist, has identified large collections of plants from Samoa and Tahiti and has devoted considerable time to the preparation of a bibliography of Polynesian botany and to a card index of references to systematic literature. Dr. Merrill has added to the herbarium about four hundred sheets of Philippine plants and assisted in the identification of the Polynesian collections. He has generously offered to supply the Museum with a duplicate set of his index cards.

In addition to his exacting duties as entomologist of the Hawaiian Sugar Planters' Experimental Station, Otto H. Swezey, Consulting Entomologist, has generously given much time and thought to increasing the

value of the rapidly growing collections of insects. Much progress has been made in working up and arranging material accumulated during the past years. In the identification of species, the friendly assistance of Hawaiian entomologists has been enlisted and arrangements have been made for reports on beetles of the genus Apterocyclus by Prof. E. C. Van Dyke of the University of California; on Dermaptera and Orthoptera by Dr. Morgan Hebard of the Philadelphia Academy of Science (p. 13); on Cixiidae by W. M. Giffard; on Heteroptera by E. P. Van Duzee of the California Academy of Sciences; on Jassidae by Prof. Hebert Osborn of Ohio State University. Special studies have been made by Mr. Swezey on the Hawaiian Lepidoptera.

By correspondence and personal interviews, Clark Wissler, Consulting Anthropologist, has rendered important service as a sympathetic critic of the Museum's administrative plans, personnel, and program of work. His desire to enlarge the usefulness of the Museum has resulted in strengthening the helpful co-operative relations with the American Museum of Natural History, particularly in providing the services of Louis R. Sullivan. (See p. 11).

Robert T. Aitken, Research Associate in Ethnology, returned on August 8 from a two years' field trip in the Austral Islands as a member of the Bayard Dominick Expedition. A few days were spent at Raivavae and brief visits were made to islands in the Society and Paumotu groups. The remainder of the time available for field work was devoted to investigations on the island of Tubuai. At the end of the year his manuscript on the ethnology of Tubuai was near completion. During October Mr. Aitken addressed the Social Science Club and also the Natural Science Club on the "Natives of Tubuai in the Austral Islands."

In addition to his work as Curator of Collections, Stanley C. Ball served as Acting Director from January 1 to February 7, and from August 12 to the end of the year. He also devoted time to plans for buildings and equipment. Accompanied by Charles H. Edmondson, Mr. Ball made a collecting trip to Molokai in February (p. 7), and during July and August made an expedition to Fanning island (p. 19). An abstract of Mr. Ball's Annual Report is printed on page 26.

Forest B. H. Brown, Botanist, returned to Honolulu on December 16, 1922, after a period of two years spent in the Marquesas and neighboring parts of the Pacific as a member of the Bayard Dominick Expedition. His work has resulted in filling a conspicuous gap in the knowledge of Pacific flora and should lead to the preparation of a standard treatise based on his collections, which comprise 9000 sheets of material and 395 photographs. During the year a paper by Mr. Brown on "The secondary xylem

of Hawaiian trees" (Occasional Papers, Vol. VIII, No. 6) was issued by the Museum.

Elizabeth Wuist Brown, Research Associate in Botany, was a member of the Marquesas party of the Bayard Dominick Expedition for the years 1920-21 and 1921-22. Her attention was given chiefly to investigation of the cryptogamic flora.

The time of Edwin H. Bryan, Jr., Assistant Entomologist, has been given partly to the care and study of the collections of insects and partly to general Museum duties. Considerable progress has been made in the preparation of a paper on Hawaiian Diptera, which includes descriptions of all species recorded in the Territory, and also on a card catalog of the entomological literature in Honolulu. For collecting insects trips were made to the Napali region on Kauai and to parts of Oahu.

C. Montague Cooke, Jr., Malacologist, spent the first half of the year at the Philadelphia Academy of Natural Sciences in dissecting specimens of Endodontidae and Zonitidae, preparatory to the preparation of a monograph on these families. In the Museum laboratory the most important work accomplished was the cataloging of the Wilder collection of 48,291 specimens, one of the largest and most valuable collections of Oahuan Achatinellidae. Field trips were made to the Waianae Mountains, Oahu, and to the islands of Kauai, Maui and Molokai. Through the efforts of Mr. Cooke much valuable shell material has been received during the year.

Henry E. Crampton, Research Associate in Zoology, has continued his investigation of the collections of Partula obtained in 1920 from Guam and the Marianas Islands. The statistical analysis of the material has been entirely completed, and substantial progress has been made in the writing of a monograph.

Charles H. Edmondson, Zoologist, has been engaged in the classification and arrangement of the zoological material stored in the Museum buildings. His field work during the year included collection trips to Molokai and Fanning islands (pp. 6, 19) and investigations of marine fauna at Kahana Bay, Kawailoa, and Waikiki on the island of Oahu. He has arranged for exchanges of identified material with the Australian Museum and the Zoological Survey of India. For the identification of Hawaiian collections, he has enlisted the generous assistance of Dr. Herbert L. Clark of the Museum of Comparative Anatomy, Dr. Henry A. Pilsbry of the Philadelphia Academy of Natural Science, Dr. A. A. Treadwell of Vassar College, and also of Miss Mary J. Rathburn, Dr. Waldo L. Schmitt, Clarence R. Shoemaker and Dr. Paul Bartsch of the National Museum.

The work of Mr. Edmondson at the Marine Biological laboratory of the University of Hawaii is briefly described as follows:

In October a year's record of the daily plankton hauls over a known area on the reef was completed and the materials collected were made available for examination. Studies of the embrynic stages and the life histories of reef organisms have been continued. Advanced students are pursuing studies on the hermit crabs of the Hawaiian islands and on the reaction of corals to extremes of temperature, to sunlight, to silt, to density of water, and to other environmental factors. Records of the growth of corals planted during 1921 were tabulated and provision was made for a continuation of this work until the rate of growth of as many local specimens of corals as possible has been determined. Co-operating with the Department of Botany of the University of Hawaii and with Miss Marie Neal as graduate student of that department, a more thorough biological investigation of the reef at Waikiki has been undertaken. Squares are being laid out from the shore line to the edge of the reef or as far as possible, and intensive studies of plants and animals and the relations of plants to animals will be made within these squares.

The course of twelve semi-popular lectures on phases of marine zoology, begun in 1921, was continued.

Kenneth P. Emory, Assistant Ethnologist, spent the first half of the year in the preparation of a manuscript on the archaeology and ethnology of the island of Lanai. In connection with this work, field trips were made to Kaupo and Lahaina, Maui, and to Molokai. On July 27 Mr. Emory left Honolulu on a year's leave of absence to pursue graduate studies at Harvard University.

Henry W. Fowler, Ichthyologist of the Philadelphia Academy of Science and Bishop Museum Fellow for 1922-1923, devoted his attention to the study, identification and labeling of the Museum collection of fish, which he reports as "embracing upwards of 12,000 specimens and forming the most representative lot of fishes from Oceania that I know of." A preliminary paper descriptive of new forms was prepared for publication and progress made on a more comprehensive study.

Before leaving for the mainland in August, Ruth H. Greiner, Bishop Museum Fellow for 1921-1922, submitted manuscript on Polynesian designs which comprises an extensive study of Hawaiian, Samoan, Tongan, and Maori decorative elements and comparisons with art as developed in other parts of Polynesia and in selected islands of Melanesia.

The time of E. S. Craighill Handy, Ethnologist, was given largely to the preparation of manuscript resulting from his field work in the Marquesas during 1920 and 1921 as a member of the Bayard Dominick Expedition. At the close of the year his papers on "The native culture

of the Marquesas" and "Rediscoveries in Polynesia" were ready for the press; and a manuscript entitled "An interpretative study of the religion of the Polynesian people" was practically finished. A course of lectures on ethnology was delivered by Mr. Handy at the University of Hawaii.

Willowdean C. Handy, Associate in Polynesian Folkways and Volunteer Assistant with the Bayard Dominick Expedition, completed a manuscript on "Tattooing in the Marquesas" (p. 13) and made considerable progress with her studies of Polynesian string figures. Her paper on "The Marquesans: fact vs. fiction" appeared in the Yale Review for July.

Early in April Lieut. Hans G. Hornbostel began his work as Collector and has been unusually successful in obtaining anthropological material from Guam and neighboring islands. (See p. 21 and p. 33).

Elizabeth B. Higgins, Librarian and Editor, has continued to care for the needs of the library and to share the burden of editing manscuript, proof reading, and of distributing publications. During the year a history of the library has been prepared for the Museum files and progress has been made in making a much needed inventory. Excerpts from the report by Miss Higgins appear on pages 36-38.

Norman E. A. Hinds, Instructor in Geology, Harvard University and Bishop Museum Fellow for 1922-23, spent six months on Kauai, continuing his work of the previous year on the geology of that island. A brief abstract of his forthcoming report appeared in the Bulletin of the Geological Society of America volume 33, number 1, 1922.

J. F. Illingworth, Research Associate in Entomology, has given generously of his time in furthering the interests of the Museum. During the year five papers on economic phases of entomology were prepared for the Hawaiian Entomological Society and one for the United States Department of Agriculture. A manuscript on early references to Hawaiian entomology was submitted to the Museum. In a report submitted to the Director, Mr. Illingworth makes the following interesting observations:

The indications are that the Hawaiian fauna, insects as well as men, are immigrants from the south and west. With this idea in mind, I have taken the opportunity to make a comparative study of the insect fauna of Hawaii with that of other parts of the Pacific. For this investigation I have used the vast amount of material collected by me in Fiji and in Australia during four years' residence in Queensland, the well-known Helms collection and other materials in the Bishop Museum, the collections of Mr. D. T. Fullaway loaned by the United States Experiment Station, and collections made by Mr. F. Muir from countries bordering the Pacific loaned by the Hawaiian Sugar Planters' Experiment Station.

A study of flies throws some interesting side lights upon the origin of man in Hawaii. House flies have ever been closely associated with human beings. In fact so much so that they are not found on uninhabited islands, and the United States Exploring Expedition, in 1840, reported that flies were a sure indication of

the presence of natives on an island. I found that the common house fly of Hawaii was not that of Europe and the United States, as formerly supposed, but a variety of a distinctly different species, appearing along the western shores of the Pacific. Since it is known that these flies will follow man, even in small boats, and since there is evidence that house flies were in Hawaii when Captain Cook arrived, one may fairly conclude that they came with the natives along their lines of migration. It is interesting to note that our evidence of the migration of these insects exactly coincides with what is now presumed to have been the line of migration of the earliest peoples reaching the shores of the Hawaiian islands.

In addition to her routine duties, Bertha Metzger, Assistant to the Director, has acted as critic of papers submitted for publication. Assisted by Lahilahi Webb, Thomas G. Thrum, C. F. Gessler, and other members of the staff, she assumed the difficult task of editing the manuscript and reading the proof of the Hawaiian Dictionary. Miss Metzger wrote an article, "Sayings of the South Seas," which was published in the Paradise of the Pacific, December, 1922.

George C. Munro, Associate in Ornithology, has continued his successful search for rare birds. He observes that the native forest birds of Hawaii are still thriving and some of the species, at least, appear to be increasing in number.

Marie C. Neal, Assistant Malacologist, continued her laboratory work of preparing material for study and of arranging specimens for exchange. Much time was given to cataloging the Wilder collection of Hawaiian land shells. The field work of Miss Neal included collecting trips to Hawaii and to the Waianae Mountains of Oahu. In connection with her investigations, graduate work was done in the University of Hawaii.

Carl Skottsberg, Director Botanical Garden, Gothenburg, Sweden, and Bishop Museum Fellow for 1922-23, spent four months in a study of indigenous Hawaiian plants with reference to the general subject of plant distribution in the Pacific. Collections of mosses, hepatics, and lichens were made and distributed among specialists for determination. Dr. Skottsberg prepared a memorandum on the present condition of the herbarium and on the plans for its development.

F. L. Stephens, Professor of Botany, University of Illinois, and Bishop Museum Fellow for 1921-22, reports the practical completion of a manuscript resulting from field study of fungi on the islands of Hawaii, Kauai, Oahu, and Maui.

John F. G. Stokes, Ethnologist, returned to Honolulu in November, after a two years' absence in the Austral Islands as a member of the Bayard Dominick Expedition. His particular field was the islands of Rapa, Rurutu, and Raivavae, where the material culture and archaelogy were studied and anthropometrical data collected. Some time was also given to

Tahiti, Rimatara, and islands in the eastern Tuamotus. Abstracts of selected parts of the preliminary report of Mr. Stokes follow:

In Rurutu the dialect seems phonetically to be the most emasculated among the Polynesians. The consonants 'k,' 'ng,' and the aspirates are lacking.

In Rapa the mortuary customs have some interesting features in connection with the drying of bodies. The sepulchers yielded specimens of garments, one of which, a fragment of the early Rapa dress, is in technique identical with the Maori rain cloak. The hill forts or fortified villages, analogous to the Maori *pa,* show primitive engineering features. Stone fish weirs are common and one of the old *marae* (temples) remains. The clans of former times still exist, but with much intermixture. Land is communal with the clan. The Rapa customs are interesting on account of the absence of certain Polynesian features. It is said that there were no tattooing, no awa drinking, no fish-poisoning, no mat-making, no feather-work, no pigs and no dogs. Other Polynesian characteristics but slightly developed were temples, priestcraft, veneration for chiefs, knowledge of great Polynesian heroes, and stone platforms for houses. The original dialect retained the 'k' and 'ng,' but dropped the 'h.'

Raivavae has a population of 380 and presents an appearance of great prosperity, in strong contrast with Rapa. The material culture has changed to a greater extent than elsewhere in the Austral Group. The island has a special interest on account of its archaeology. Many large stone images hewn out of red tufa remained until the decade 1890-1900, when they were cut into building blocks for a church structure. More than sixty images or fragments of images were found, the largest of which stood eight and a half feet above ground. About sixty temples were noted and it is not improbable that about one hundred of these establishments were formerly maintained. War retreats in the mountains were also found. The Raivavae genealogies indicate a common origin of the chiefs of the Austral Group. In the original dialect the Polynesian 'k' had been dropped, the 'ng' was in process of changing to 'n,' and the 'r' was pronounced as 'l,' 'gh,' or 'g.'

Physical measurements of 335 people were obtained—133 in Rurutu, 113 in Rapa, and 89 in Raivavae.

The customs of the Austral Islanders have been greatly modified through their conversion to Christianity by native missionaries from the Society Group. The latter, themselves Polynesians, imposed upon the people a Tahitian civilization partly modified by the secular teachings of the white missionaries from England. In the process, which has been under way since 1821, a complex has been formed which makes it extremely difficult to differentiate Austral Island ethnology from that of the Society Group. (See also Annual Report of the Director for 1921; Occ. Papers Vol. VIII, No. 5, pp. 206-207, 1922.)

Louis R. Sullivan, Research Associate in Anthropology, in co-operation with the American Museum of Natural History, has continued his investigations of the physical characteristics of the Pacific races. During the year the results of his studies on Tongan somatology were published. (See p. 13.) A manuscript on Marquesan somatology was submitted for publication and considerable progress made on a study of Hawaiian racial relations. A popular article, "New light on Polynesian races," was

prepared for the January (1923) number of Asia. In speaking of Mr. Sullivan's work with the Bayard Dominick Expedition, Charles B. Davenport, Director of the Department of Genetics, Carnegie Institute of Washington, remarks, "I feel that Sullivan's two contributions to Polynesian somatology have advanced the subject more in one year than all the other researches of the past twenty-five years."

John W. Thompson, Preparator, has modeled eighteen fishes, painted thirteen fishes and three eels and has prepared and painted crabs and seaweed accessories for use in a projected marine group. The years of contact which Mr. Thompson has had with the markets while selecting fishes for the collections have placed him in a position to aid Mr. Fowler very considerably in his studies on the fish collections. It is largely to his credit that the Hawaiian fish fauna is so remarkably well represented in the Museum's preserved material, as well as in the excellent series of models.

Thomas G. Thrum, Associate in Hawaiian Folklore, completed the "Geographic place names" for the revision of Andrews' Hawaiian Dictionary. (See p. 25.) He also made a critical analysis of the forty-two manuscripts in the Poepoe Collection and a translation of Kamakau's history of Kamahemeha, which appeared originally in the Ka Nupepa Kuokoa in 1866-1871. Progress was made in a study of the star lore of the ancient Hawaiians, especially with reference to navigation.

Stephen S. Visher, Bishop Museum Fellow for 1921-22, returned to his duties as Professor of Geography, University of Indiana, after a field trip to Honolulu, Fiji, Manila, Hongkong, Shanghai, Kobe, and Tokyo. Progress was made in the preparation of a monograph on the tropical cyclones of the Pacific and their effects. Two Papers—"Tropical cyclones in Australia and the South Pacific and Indian Oceans" and "Tropical cyclones in the Northeast Pacific between Hawaii and Mexico," were published in the Monthly Weather Review (Vol. 50, 1922 pp. 288-297).

In addition to her work as Guide to Exhibits and hostess to an even larger number of visitors than in 1921, Mrs. Lahilahi Webb gave lectures to many classes of school children. She was of invaluable service in editing the Hawaiian Dictionary and to members of the staff in their studies of Hawaiian lore. In the exhibition halls she has been ably assisted by Miss Anna Ho.

Gerrit P. Wilder, Associate in Botany, has added valuable specimens to the Museum collection and continued his work of providing correct labels for the casts of fruits in the exhibition halls. His knowledge of the Hawaiian Bird Reservation has been utilized in planning an expedition for the coming year.

PUBLICATIONS

During 1922 the following publications were issued:

MEMOIRS VOLUME VIII, NUMBER 3. The grasses of Hawaii, by A. S. Hitchcock, 137 pages, 5 plates, 110 figures.
A description of 50 genera of native and introduced grasses.

MEMOIRS VOLUME VIII, NUMBER 4. A contribution to Tongan somatology, by Louis R. Sullivan, 35 pages, 4 plates, 2 figures.
Describes the physical characteristics of 225 Tongans, and discusses the relation of Tongans to Samoans and to Melanesians.

OCCASIONAL PAPERS VOLUME VII, NUMBER 14. Dermaptera and Orthoptera of Hawaii, by Morgan Hebard, 76 pages, 2 plates, 1 figure.
A study based on 688 specimens representing 40 of the 41 genera and all but two of the adventive species recorded for Hawaii.

OCCASIONAL PAPERS VOLUME VIII, NUMBER 2. Hawaiian Dromiidae, by Charles Howard Edmondson, 10 pages, 2 plates.
Discussion of the taxonomic position, characteristics, and distribution of the Dromiidae of Hawaiian waters. One new subspecies is described.

OCCASIONAL PAPERS VOLUME VIII, NUMBER 3. The proverbial sayings of the Tongans, by E. E. V. Collocott and John Havea, 115 pages.
An epitome of Tongan mental reactions as expressed in 633 proverbs given in the Tongan dialect with translation and comment in English.

OCCASIONAL PAPERS VOLUME VIII, NUMBER 4. Tongan astronomy and calendar, by E. E. V. Collocott, 17 pages.
A study of the astronomy and calendar of the early Tongans, and definition of native names and phrases.

OCCASIONAL PAPERS VOLUME VIII, NUMBER 5. Report of the Director for 1921, by Herbert E. Gregory, 39 pages.

OCCASIONAL PAPERS VOLUME VIII, No. 6. The secondary xylem of Hawaiian trees, by Forest Buffen Harkness Brown, 157 pages, 11 figures, 1922.
A treatise of the systematic anatomy of Hawaiian woody plants, with a short preface on the origin of the Hawaiian flora.

BULLETIN 1. Tattooing in the Marquesas, by Willowdean Chatterton Handy, 32 pages, 38 plates.
A study of the art of tattooing, the designs employed, and the nomenclature.

A paper on archaelogical work in Hawaii, by Gerard Fowke, published by the Bureau of American Ethnology (Bull. 76, 1922, 21 pp., 8 plates) is a description of ancient Hawaiian structures, particularly on the island of Molokai. The Museum accepted the opportunity of assisting Mr. Fowke in his field investigation.

The following publications are in press:

MEMOIRS VOLUME IX, NUMBER 1. The Moriori of Chatham Islands, by H. D. Skinner, 1923.
Describes the material culture of Moriori of Chatham Islands.

OCCASIONAL PAPERS VOLUME VIII, NUMBER 7. New or little-known Hawaiian fishes, by Henry W. Fowler, 20 pages, 1923.
Preliminary descriptions of new species of fish in the collections of Bishop Museum, and a list of names of those already described elsewhere.

BULLETIN The native culture in the Marquesas, by E. S. Craghill Handy, 1923.

 A study of the native culture in the Marquesas based on original research during a nine months' residence, supplemented by knowledge derived from printed sources and unpublished manuscripts.

A DICTIONARY OF THE HAWAIIAN LANGUAGE, by Lorrin Andrews, Revised by Henry H. Parker. Published for the Board of Commissioners of Public Archives. (See p. 25.)

TABLE OF CONTENTS AND INDEX FOR OCCASIONAL PAPERS, VOLUME VIII.

The following papers are in the hands of the Publication Committee or of the Editor:

The material culture of the natives of the Marquesas Islands, by Ralph Linton
Tongan Myths and Tales, by Edward Winslow Giffard
Tongan Place Names, by Edward Winslow Giffard
Polynesian design elements, by Ruth H. Greiner
Early references to Hawaiian Entomology, by J. F. Illingworth
Hawaiian legends, by William H. Rice

Papers in preparation include the following:

An archaelogical and ethnological survey of Lanai, by Kenneth P. Emory
The marine shell-bearing Mollusca and Brachipoda of the Hawaiian Islands, by William Healey Dall
An interpretative study of the religion of the Polynesian people, by E. S. Craighill Handy
Tongan society and religion, by Edward Winslow Giffard
Tongan material culture and archaeology, by W. C. McKern
Studies in Hawaiian anthropology, by Louis R. Sullivan
Hawaiian fungi, by F. L. Stevens
A statistical analysis of Partula of Guam and Marianas islands, by Henry E. Crampton
Geology of Kauai, by Norman E. A. Hinds
A study of Hawaiian plants with reference to plant distribution in the Pacific, by Carl Skottsberg
A study of Hawaiian fishes, by Henry W. Fowler
Flora of the Marquesas Islands, by Forest B. H. Brown
Ethnology of Tubuai, by Robert T. Aitken
A study of Hawaiian Diptera, by Edwin H. Bryan, Jr.
An ethnological survey of Rapa, by John F. G. Stokes
Report of the Director for 1922

In the Museum publications three changes have been made: (1) the books and pamphlets heretofore listed as Miscellaneous Publications have become Special Publications, (2) the series of Occasional papers will be discontinued after the completion of Volume VIII, (3) a new series to be known as Bulletins has been established. No change is contemplated in the Memoirs.

During the year, 1894 numbers of the Memoirs were distributed, including 30 complete sets; of Occasional Papers 3782, including 13 complete sets; of Special Publications 903, including 22 complete sets of Fauna Hawaiiensis. The regular distribution of publications at time of issue has varied from 317 to 461.

To the regular exchange list which now numbers 184 the following names have been added: Academy of Science of St. Louis; Mr. Percy S. Allen, Editor of Pacific Islands Handbook; Asia Publishing Company; Auckland Public Library, Art Gallery and Old Colonists' Museum; Australian Central Weather Bureau; Botanical Survey of South Africa; Colorado College; Dove Marine Laboratory; Folk-Lore Society; Formosan Government Research Institute; Matson Navigation Company; Mexico Direccion de Estudios Biologices; Pacific Biological Station; Philippine Bureau of Agriculture; Pomona College; Princeton University Library; Royal Geographical Society; Royal Society of London; Royal Society of Tasmania; Scripps Institution for Biological Research; Sociedade Brasileira de Sciencias; Transvaal Museum; Library, U. S. Department of Agriculture.

The contract to print the publications of the Museum, which terminated April 1, has been re-awarded to the Honolulu Star-Bulletin, Limited.

By vote of the Trustees the Museum staff has undertaken the preparation of a Handbook descriptive of the collections in the exhibition halls and of a pamphlet containing a sketch of the history, scope, and policy of the institution.

SPECIAL TOPICS

EXPEDITIONS

During the first ten years of the Museum activities, no systematic field exploration appears to have been undertaken by the staff. The Trustees, however, early recognized the desirability of building up extensive collections which might serve as basis for scientific study. Their liberal financial support was given for a comprehensive study of the land fauna of Hawaii (1892-1901)—a series of investigations which resulted in the publication of Fauna Hawaiiensis, notable alike for its scientific value and for its demonstration of the advantage of co-operation.

In his report for 1899 the Director expressed the hope that studies similar to those represented by Fauna Hawaiiensis might be extended to regions outside of the Hawaiian Islands. In response to this suggestion provision was made in 1900 for a study of the birds and fishes of Guam by Alvin Seale, which resulted in large additions to the Museum collections (See Report of a mission to Guam: Occ. Papers, Vol. 1, p. 17-128). During 1902 William Alanson Bryan spent one week on the little known Marcus Island and two days on Midway Island making collections which led to the publication of "A monograph of Marcus Island" (Occ. Papers II, No. 1, p. 77-139, 1903) and "A report of a visit to Midway Island" (Occ. Papers II, No. 4, pp. 37-45, 1906). On Mr. Seale's return from Guam his services were again obtained for an expedition to the South

Pacific, which had for its primary purpose the collection of fishes. During the period November 9, 1900 to September 21, 1903, visits were made by Mr. Seale to the Society, Marquesas, Tuamotu, Gambier, Austral, New Hebrides and Solomon island groups and 1550 specimens representing 375 species of fishes were obtained. (See Fishes of the South Pacific: Occ. Papers, Vol. IV, No. 1, pp. 3-89, 1906).

During each year of the period 1909-1913 Charles N. Forbes, Botanist, devoted approximately three consecutive months to systematic exploration on Kauai (1909), Maui (1910), Hawaii (1911), Molokai (1912), and Lanai (1913); and in 1913 Mr. Cooke made an excursion to Palmyra Island. With these exceptions, field work during the period 1903-1919 appears to have consisted of short trips by members of the staff for the purpose of increasing the collections and to procure data needed in the preparation of manuscript for publication.

In general, the records show that the collections belonging to the Museum have been acquired chiefly by gift and purchase and that much of the valuable material contributed by members of the staff has been . gathered incidentally and not infrequently in vacation periods and at the expense of the collector.

It seems unlikely that materials adequate for scientific investigation are to be continuously obtained through the methods heretofore utilized. Gifts of valuable small collections will doubtless increase with the increase in the number of the friends of the Museum; but most of the desirable private collections have already found a permanent place in the halls of scientific institutions, and miscellaneous collections resulting from brief field trips will not serve the needs of investigators dealing with the expanding problems within the scope of the activities of the Museum. Future enlargement of the collections for study and for exhibition must come chiefly from definitely organized field work by the staff, from exchanges, and from institutions associated with the Museum in co-operative exploration.

With these ideas in mind the policy has been adopted of making systematic field surveys in anthropology, botany, and zoology, under arrangements which provide time and funds for the completion of the project in hand. (See Report of the Director for 1919: Occ. Papers, Vol. VII, No. 8, 1920.) The results have been satisfactory. During 1919 a botanical survey of east Maui and a study of the ancient asylum of refuge at Honaunau were completed. During 1920 an ethnological survey of Haleakela was completed, and the field work of the Bayard Dominick Expedition began—a series of investigations which, continued through

1921 and 1922, constitute doubtless the most important anthropological study so far made in Polynesia. (See p. 21). During 1921 the land shell fauna of Guam and Saipan were studied, the fungi of Hawaii were systematically collected and an ethnological survey of Lanai was completed— the first such survey of any Hawaiian island. During 1922 a geological survey of Kauai and a botanical survey of the Marquesas were completed, an expedition was sent to Fanning Island, and remarkably large collections were made in Guam.

Plans for 1923 include a systematic scientific survey of Johnston Island, Wake Island and of fifteen islands and reefs lying between Niihau and Ocean islands; an ethnological expedition to Tahiti; and a collecting expedition to the Marianas and to the Caroline Islands. All these expeditions serve not only to enlarge and to fill gaps in the collections now on hand, but also to meet the needs of other institutions and to furnish data for increasing the value of the Museum publications.

SURVEY OF THE HAWAIIAN BIRD RESERVATION

Preliminary arrangements have been made for a scientific survey of the scattered islands included within the roughly defined Hawaiian Bird Reservation (Latitudes 22°-28°N, Longitude 161°-175° W). Conferences with officials in Washington and at Pearl Harbor indicate the probability that the Navy Department will provide a ship for conducting researches during the months of April, May, and June, 1923, under the auspices of the United States Biological Survey and the Bishop Museum. The position of these islands, the large differences in their topography, shores, and surrounding waters, and the interesting zoological, botanical, and ethnological materials so far obtained from them suggest that the proposed expedition may yield important contributions to science.

THE WHITNEY SOUTH SEAS EXPEDITION

A generous gift of Mr. Harry Payne Whitney has enabled the American Museum of Natural History to organize a zoological expedition on an unusually comprehensive scale. Under the direction of a committee of eminent ornithologists—Dr. Leonard C. Sanford, Dr. Frank M. Chapman and Dr. Robert Cushman Murphy—the field party, in charge of Mr. Rollo H. Beck, established headquarters at Papeete late in 1920. During 1921 extensive collections were made in Tahiti and other islands of the Society group, at Christmas Island, at the Marquesas, and on several islets of the Tuamotu group. During 1922 the schooner "France," purchased by the expedition, was used for continuing investigations in the Marquesas, Austral, and Gambier island groups and at Pitcairn, Henderson, Oeno, Elizabeth and Ducie islands.

The committee in charge of the expedition has formulated its plans and conducted its field operations with a view solely to the advancement of scientific research in the Pacific. To quote from the report of Dr. Murphy:

> While the expedition is primarily ornithological, no opportunity has been lost to obtain desirable material and data in other branches of science, particularly at the many Polynesian islands where the native peoples and fauna are rapidly dying out or are altering materially with changing conditions. With this object in mind, the Museum has co-operated in all possible ways with other institutions that are carrying on research in the Pacific. The Bernice P. Bishop Museum of Honolulu, for example, is now a center of Pacific investigations, coordinated under the administration of Professor Herbert E. Gregory, who is serving as Director. The Committee of the Whitney Expedition has been from the beginning in close touch with Professor Gregory and has sought his advice on many details. The members of the Expedition have been instructed to undertake special lines of collecting which do not interfere with their main objects, to offer transportation whenever possible to the field workers of the Bishop Museum and of other scientific organizations, and in general to further the cause of Pacific investigation by selecting fields of endeavor which lead toward cooperation rather than competition. It has been decided, for instance, to leave the ornithological investigation of the Hawaiian islands and of certain neighboring groups, such as Midway, Johnston, Palmyra and Washington islands, to the Bishop Museum, and to confine the efforts of the Whitney Expedition, for the present at least, to the southerly and easterly islands of Polynesia, from Samoa and the Marquesas southward and eastward to the Austral group and Easter Island. In order that the American Museum of Natural History may obtain a full representation of the avian fauna of the Pacific Basin, however, a comprehensive exchange of material has been arranged, and the Museum has already received from Honolulu an important collection of Hawaiian birds, which gives it a very nearly complete series of the scarce or extinct Drepanididae as well as other interesting and peculiar birds of the archipelago.

The first two years of the Whitney South Sea Expedition indicate the ⸱ remarkable zoological and geographical results to be anticipated. More than three thousand bird skins with representative collections of nests, eggs and stomachs have been obtained; botanical, zoological and ethnological material has been gathered at many islands; and a mass of geographic information has been recorded.

The collections show that the birds of the South Pacific trade wind belt are for the most part specifically and generically distinct from those in the southern "horse latitudes" and that each large insular group and even some small islets have distinctive species. Several of the species of birds collected have been heretofore listed as extinct.

INVESTIGATIONS IN THE SOCIETY ISLANDS

Extensive researches in the Marquesas and the Austral Islands, and reconnaissance studies in Tahiti indicate the need of fuller knowledge of

the islands lying westward. From the Society Islands in particular more precise information is needed of the physical characters of the people, of the sequence of the overlapping immigrations and the cultural differences in the native populations of various islands of the group.

To meet this need provision has been made for undertaking an ethnological survey by a party consisting of E. S. Craighill Handy, Ethnologist; Willowdean C. Handy, Associate in Polynesian Folkways; and Miss Jane Winne, Volunteer Assistant, who will devote her time to recording native music. Local field assistants will be added to the party. For comparative studies Mr. Handy will visit the islands of Upolu, Vavau, Haapai, Nukuolofa, and the Maori settlements in New Zealand.

FANNING ISLAND EXPEDITION

Studies now in progress on the distribution and relationship of certain organisms have made it desirable to investigate the fauna and flora of Fanning Island which lies in Latitude 3°-54' North. The island lies outside of the routes of commercial steamship lines, but is visited at intervals by copra schooners and by the supply ship of the Pacific Cable Board.

With the approval of Mr. J. Milward, Pacific Manager of the Pacific Cable Board, an invitation was received from Captain M. Menmuir to make use of his ship, the "Tangaroa," for transporting men and equipment to Fanning Island. The invitation was gratefully accepted and Stanley C. Ball and Charles H. Edmondson were chosen to represent the Museum.

While on the island, Mr. Ball and Mr. Edmondson enjoyed the hospitality of the Fanning Island Station of the Cable Board and of the copra company, Fanning Island Limited. At the station, Superintendent T. R. Blackley, Deputy Commissioner Mr. Johnson, Mr. Walker, Mr. and Mrs. Sherlock, Mr. Kemp, Dr. Kinney, Mr. Chapman, Mr. Wood and others rendered generous assistance. Superintendent A. R. Foster of the copra company and his assistant, Mr. Ward, provided boats and men and equipment. Mr. William Greig served as host and with Mr. Hugh Greig furnished a native boat crew including the intelligent guide, Kotuku. Their intimate knowledge of the island and of Polynesian languages and customs was the source of valuable information regarding the names and distribution of plants and animals.

The collections obtained at Fanning Island include marine and terrestrail crustaceans, mollusks, echinoderms, insects, and other invertebrates and also skins of land and sea birds and a representative series of plants. Many of the zoological specimens constitute new records for that part of the Pacific.

Supplementing the researches at Fanning Island, the Museum has profited through the generosity of Mr. L. A. Thurston who, in company with Mr. David Thaanum and Mr. Vasconcellos, conducted a survey of Palmyra Island, lying three hundred miles northwest of Fanning Island. Among the fishes and crabs collected are several not heretofore recorded from the Palmyra region; some are new to science.

Reconnaissance of the Napali Coast, Kauai

The Napali district on the island of Kauai, including the valleys of Nualolo, Awawapuhi, and Honopu, is peculiarly difficult of access. Its seaward margin is formed by preceptitious wave-cut cliffs and inland the area is sharply dissected into box-headed canyons and "knife-edge" ridges.

Each of the three ways of access—a "hand hold" trail up the sea cliff at Honopu, the Kamaile cliff trail, and the rope ladder at Nualolo beach —is available only to experienced climbers.

Information obtained from Hawaiians and from the few white men who have visited these valleys indicated that the irrigation systems, house platforms, burial caves and other evidences of former occupation have been undisturbed and that an unusual opportunity was afforded for a study of ancient Hawaiian life. Arrangements were therefore made for a preliminary exploration of Nualolo, Awawapuhi, Honopu and Kalalau valleys—a ten day's reconnaissance—which has revealed much of interest in archaelogy and natural history. By selecting feasible trails and reconstructing the ancient rope ladder, the way has been prepared for a systematic investigation of this little known region.

This exploring expedition was made possible through the skill and enthusiastic interest of Lindsay A. Faye, Lorrin P. Thurston, Herman Von Holt, and Ronald Von Holt.

Collections From Guam

The existence of monolithic ruins on the island of Tinian has been known for a century, and similar objects have from time to time been reported from Rota and from Guam, but the few sling stones and other artifacts which have found their way to museums and the brief descriptions scattered through the literature have given little indication of the richness of those islands as fields for archaelogical study. Through the generosity of Commander J. C. Thompson, of the United States Naval Hospital, Lt. H. G. Hornbostel of the Museum staff was given the opportunity to undertake a systematic exploration of Guam, with a view to obtaining information regarding an ancient people whose position in the group of Pacific races remains to be determined. As the result of this

work the Museum is in possession of maps, diagrams, and descriptive notes of ancient burial grounds, house sites, fishing grounds, and caves, and has added to its collections some 2,000 specimens, including mortars, lamps, adzes, knives and much skeletal material. In the collection is a burial monument with capital weighing about two and a quarter tons.

In carrying on his work Mr. Hornbostel has had the experienced advice of Commander Thompson, and the generous co-operation of the Navy officials who assisted in excavations and in making collections, and assumed the responsibility of transporting the material to Honolulu.

It is planned to extend field work in this region to include the southern islands of the Marianas group and parts of the Carolines.

BAYARD DOMINICK EXPEDITION

At the end of the year the work of the Bayard Dominick Expedition had reached the following stage: the field work had been completed; most of the collections, maps, manuscripts, photographs, and field notes had been arranged for study; three papers had been published; two papers were in press, four papers had been submitted for publication and substantial progress had been made in the preparation of six other papers.

The systematic investigation of the origin, migration, and culture of the Polynesian peoples, which constitutes the program of the Bayard Dominick Expedition, was made possible by a generous gift of Bayard Dominick, Jr., of New York—funds given to Yale University and placed by the University at the disposal of Bishop Museum. During the summer of 1920 four field parties began their work—the first in Tonga, the second in the Marquesas, the third in Rurutu, Raivavai, Tubuai and Rapa of the Austral Islands, the fourth in islands of the Hawaiian group. Through co-operative arrangements with scientists of New Zealand, physical measurements of the Maori and a complete survey of the Moriori of Chatham Islands form part of the program.

In formulating the plans for the expedition, it was recognized that the origin and migrations of a people constitute a problem made up of many diverse elements—a problem which involves contributions not only from physical anthropology, material culture, archaeology, philology and legends, but also from economic botany, geography and zoology. A profitable search for Polynesian origins obviously involves fundamental research in two distinct fields: (1) the source of the physical racial characteristics which have combined to make the different Polynesian types; (2) the source of the original elements in the customs, habits and beliefs—in a word, the culture of the Polynesians. The problem of origin

approaches solution to the extent that original physical characteristics may be correlated with original cultural elements.

Although the results obtained by the members of the Bayard Dominick Expedition have not as yet been subjected to critical analysis and comparison, some interesting general conclusions have been reached.

The Polynesian population consists of at least two basic elements and the failure to recognize them appears to account for the wide diversity of opinion regarding origin and affinities of the Pacific races.

Type A, which may be considered Polynesian proper, is a Caucasoid element with physical characteristics intermediate between some Causasians and some Mongols. It may prove to be a very primitive Causasian type related to the earliest inhabitants of Micronesia, Melanesia, Indonesia, and to the Aino of Japan and to some primitive Americans. It is probably the oldest type in central and eastern Pacific and occupied all the Polynesian islands. At present it is strongest in southern Polynesia.

The characteristic features of Type A are (1) tall stature, (2) moderately long heads, (3) relatively high, narrow faces, (4) relatively high, narrow noses, (5) straight or wavy black hair of medium texture, (6) well-developed moustache and moderate beard on the chin, (7) moderate amount of hair on the body and limbs, (8) light brown skin, (9) incisor rim present occasionally, (10) femur flattened, (11) tibia flattened, (12) ulna flattened, (13) lips above average in thickness.

Type B is the Indonesian element typically developed in the region of the Celebes. It is a Mongoloid type but unlike the Malay, is strongly divergent in the direction of the Negro. Hybrids of Type A and Type B are much more Mongoloid in appearance than is either of the parental types. Type B is strongest in northern and central Polynesia.

The essential physical characteristics of Type B are: (1) shorter stature, (2) shorter heads, (3) low, broad faces, (4) low, broad noses, (5) wavier hair, (6) undeveloped beard, (7) body hair rare except on the legs, (8) darker brown skin, (9) incisor rim rare, (10), (11), (12) femur, tibia and ulna less flattened (data meager, results inferred), (13) lips well above the average in thickness.

Type A, Polynesian, and Type B, Indonesian, are not closely related in a physical sense.

A third element in the Polynesian population is characterized by extremely short heads, narrow faces, narrow noses, light skin and well developed beard and body hair. Representatives of this element have not been found in Polynesia in sufficient numbers to justify specific description. When studied in a region where it is well represented, this element may prove of sufficient importance to be recognized as Type C.

This element has probably contributed some of the Caucasoid traits to Polynesians.

There is a basic Polynesian culture for the present termed Culture "A" over which has been superposed a later culture (Culture "B"). The most important elements of Culture "A" are: (1) a rectangular house with end posts and bed space; (2) a canoe made of five parts; (3) a tanged adze; (4) cooking by means of heated stones in ground ovens; (5) the use of stone pestles for pounding food; (6) the use of wood, gourd, and coconut shell, rather than pottery, for containers; (7) skillful woodworking and carving; (8) tattooing; (9) the making of tapa, or bark cloth; (10) a characteristic relationship system; (11) the custom of adopting and betrothing children; (12) systematic agriculture and fishing, taro and potato cultures; (13) professional craftsmanship and leadership in industry; (14) tribal government of simple patriarchal communism; (15) preserving heads of enemies as trophies, and cannibalism; (16) ancestor worship, the preservation of genealogies, and the hiding of skeletal remains; (17) inspirational diviners; (18) a speculative creation mythology conceived on the principle of dualism, expressed in terms of male and female agencies. Culture "A" is distributed throughout Polynesia, but is most clearly distinguished in New Zealand and the Marquesas—marginal regions little affected by later influences.

As compared with Culture "A," Culture "B" is characterized by a higher social and religious development rather than a higher technical development, and is dominent in northern and central Polynesia. It is considered not as the culture of a race unrelated to the Polynesians, but as the culture of a second migrating wave of a people closely related to those represented by Culture "A." In addition to the elements listed for Culture "A," Culture "B" is characterized by other elements among which are: (19) the oval house; (20) wooden head rests; (21) utensils with legs; (22) organized government; (23) a rigid social classification; (24) complicated systems of land division and ownership; (25) great sacredness of chiefs and elaborate etiquette; (26) organized dancing as a social and religious institution; (27) organized religious ceremonial and priesthood; (28) a generation cult and seasonal rites; (29) haruspication.

It is interesting to note that the basal Polynesian physical type (Type A) is universally distributed, but strongest in the south, and that the original culture (Culture "A", also universally distributed, is clearest in the south (New Zealand) and in the east (the Marquesas). Also physical Type B is strongest in north and central Polynesia, the same region in which elements in Culture "B" are dominant. This demonstrated parallelism of racial types and cultural stratification rests on conclusions arrived

at independently by members of the Museum staff working in widely separated fields with no opportunity for consultation. It is regarded as a very important contribution to the method of attack on the Polynesian problem. Another contribution is the definition of characteristics and elements belonging to the respective types and cultures—a prerequisite to comparative studies.

The archaeological work of the Bayard Dominick Expedition reveals no very ancient human habitation in the central and south Pacific. For the Polynesian settlement the evidence serves to substantiate the conclusions of William Churchill, based on linguistic and cultural study. The following dates are considered reasonable estimates: A.D. o, the first important Polynesian migratory movement; A.D. 600, second migration; and A.D. 1000, a period of great Polynesian expansion.

As regards the sources of these racial types and cultural elements and the routes by which they came to Polynesia, the evidence in hand indicates the region of the Malay archiperago (Indonesia) and southeast Asia as that from which the Polynesian ancestors began their eastward drift. There is no evidence of definite migrations to or from the American continents.

The Bayard Dominick Expedition is the most comprehensive investigation so far made of any Pacific people; it has filled in gaps and expanded the boundaries of the knowledge of the Polynesian race. It is believed that the publications resulting from the two years of intensive study will serve as a basis for intelligent criticism of the observations and theories of previous workers and a guide for later detailed studies.

HAWAIIAN PROVERBS

The paper by E. E. Collocott, "Proverbial sayings of the Tongans" (Occ. Papers, Vol. VIII, No. 3, 1922) has proved to be of interest not only for its intrinsic merit, but also as a demonstration of a method of presenting the philosophy and guiding thoughts of a people. It has seemed, therefore, desirable to arrange for the preparation of similar papers based on material from other groups of the Polynesian race.

For Hawaiian proverbs a nucleus exists in a manuscript by the late Dr. N. B. Emerson, presented to the Museum by Mrs. Sarah B. Emerson. A considerable number of proverbs has been supplied through the generous co-operation of Mr. Theodore Kelsey and his co-workers. Other proverbs and connundrums have been supplied by Mrs. E. A. Nawahi, Mrs. Lahilahi Webb, and Mr. Albert Judd. It is hoped that the Museum will receive contributions from many other sources.

STUDY OF PACIFIC LANGUAGES

During the days of active missionary expansion, 1820-1860, much attention was given to preparing word lists and generalized grammars of various Pacific dialects, and the theories of language relation expounded by Max Müller appear to have led some scholars to undertake philological researches in the language of Polynesia, Melanesia, and Micronesia. For Polynesia the Maori Comparative Dictionary by Tregear (1891), the Maori Dictionary by Williams (1892), the Tongan Vocabulary and Grammar, by Rev. Shirley Baker (1897); the Samoan Grammar and Dictionary, by Rev. George Pratt (revised edition 1911); A Dictionary of the Hawaiian Language, by Lorrin Andrews (1865, revised 1922); the Polynesian Wanderings and Easter Island Rapanui Speech, by William Churchill; and the dictionaries for the dialects of French Oceania, compiled by the Catholic fathers, are standard works. Studies by S. Percy Smith, Sidney Ray and other contributors to the journal of the Polynesian Society have served to elucidate many doubtful points. But increase in the knowledge of the Polynesian and related languages has not kept pace with researches in other branches of anthropology, and the death of William Churchill in 1920 and of S. Percy Smith in 1922 has removed two of the most distinguished students of Polynesian philology.

As anthropological work proceeds, the call becomes insistent for a court of final appeal for spelling, meaning, and origin of words and phrases that inclose within themselves a picture of the migrating ideas and give significance to words which at present represent merely groups of letters or sounds. There is need for trained scholars who will devote a lifetime of effort to fundamental researches in philology of the Polynesian dialects.

Perhaps the first work of such a scholar would be to edit the several dictionaries and the grammars now in manuscript form. Similar studies could then be made of native dialects for which no adequate word lists are in existence.

Since the inadequacy of philological research is felt by all institutions interested in Pacific work, it is not improbable that support could be obtained through some co-operative arrangement.

HAWAIIAN DICTIONARY

In 1913 the Legislature of the Territory of Hawaii made provision for the "compiling, printing, binding, and publishing in book form a Dictionary of the Hawaiian Language" to replace Andrews' Dictionary, which had long been out of print. Supported by legislative grants in 1913, 1917, 1919, amounting to $25,000, revision has been in progress

since 1915, under the direction of the Board of Commissioners of Public Archives, who placed Rev. Henry H. Parker in charge of the work.

Early in 1921 the manuscript cards were transmitted by the Board of Archives to the Bishop Museum, which consented to do the editorial work necessary to prepare the volume for the press and also agreed to furnish a list of Hawaiian geographical names with pronunciation and definition. To cover the cost of printing, the Board placed at the disposal of the Museum the unexpended balance of $4,500.

As the editorial work proceeded it was found that the manuscript was incomplete in several essential features, thus demanding an unexpected amount of work on the part of the Museum staff and of Mr. Joseph S. Emerson, Mr. Stephen Mahaulu, Mr. L. A. Dickey, Mr. Thomas C. White, and Mr. Theodore Kelsey, who gave freely of their store of knowledge.

The Dictionary is substantially a reprint of the work compiled by Mr. Lorrin Andrews in 1865. The value of the older volume has been increased by incorporating the scholarly studies of Lorenzo Lyons, by the addition of diacritical marks, by the elimination of irrelevant matter, and by the rearrangement of words and definitions. The revised Dictionary is obviously incomplete and the way is open for the preparation of a volume that will draw material from all available sources.

REPORT OF THE CURATOR OF COLLECTIONS

The Curator of Collections, Stanley C. Ball, has submitted the following report:

ACCESSIONS 1922

ANTHROPOLOGICAL MATERIAL

Additions to the collections representing Hawaiian physical anthropology include material from Molokai, presented by Mr. F. A. Danforth; from Oahu, presented by Mrs. E. A. Fennel and by Mr. C. A. McWayne; from Kauai, collected by Herbert E. Gregory and Gerrit P. Wilder; and from Lanai, presented by Mr. Hector Munro. Four skulls and other bones were collected in the Austral Islands by John F. G. Stokes and more than a hundred skeletons from Guam were collected and presented to the Museum by Dr. J. C. Thompson and Hans G. Hornbostel.

The ethnological collections have been increased by gifts as follows: Mr. Spencer Bickerton, stone hatchet from Australia; Captain V. A. Brisson, pestle from Rimatara, adz from Pitcairn; Lieutenant Fish, musical bow from Guam; Mrs. W. M. Giffard, Samoan mat; Mrs. Margaret C. Jackson, Russian harness; Mr. A. F. Judd, portion of a Hawaiian bone ornament; Mr. Ernest Kaai, guitar from India and Koran bible from Java; Mr. Kaemona through Mr. Lindsay Faye, stone scraper from Kauai; The Liliuokalani Estate, 3 ancient royal kahilis taken from the Mausoleum; Dr. H. F. Lyon, dancing wand from Solomon Islands; Mr. Joseph Marciel, 2 adz heads from Maui; Miss Mary Y. Moore, metal vase from Java; Mr. G. C. Munro, piece of plaster from Hawaiian oven, Lanai; Mr. William Weinrich, wooden tool for stripping fiber, Mexico; Mrs. Lilly West, Hawaiian tobaccco pipe.

The following persons have loaned specimens to the Museum: Mr. D. Wesley Garber, fish net, sinker and 29 stone adz heads from Samoa; Dr. George Herbert, helmet, 2 spears, 2 wooden bowls and a phallic stone from Hawaii; Mr. Frank Marciel, Hawaiian adz head and polishing stone; Mr. N. G. Smith, kukui lei, brooch and earrings; Mr. William Wagener, Hawaiian stone image.

Ethnological material purchased during 1922 includes the valuable collection of Mrs. Victoria Buffandeau which embraces 8 feather leis, 10 kapas, 19 wooden bowls, 2 cuspidors, finger bowl, pig platter, tobacco pipe, 3 ivory leis, 2 makaloa mats, poi pounder, net for suspending calabash (all Hawaiian), 2 Samoan mats, 12 coconut bowls, a poi pounder and a gourd bowl from Tahiti; from E. Block, 11 war clubs from Samoa and Fiji, sword from Caroline Islands, 3 dishes and a bowl from Fiji, mat dress from Samoa, 3 tapa beaters of which one is triangular in section (locality unknown) and a piece of bark cloth from Uganda, Africa; from the Emma Dreier Estate, a large wooden Hawaiian plate; from Mr. Maihui, net for suspending calabash; from Mr. Nam Ja Sung, collection of Hawaiian stone implements; from Mrs. Helen Widemann, 4 Hawaiian calabashes.

Members of the staff have increased the collections as follows: R. T. Aitken, 180 specimens of native implements, tapas, baskets and materials collected in Tubuai and Raivavae, Austral Islands (see notes on collections); John F. G. Stokes, a large number of artifacts collected chiefly in Rurutu, Raivavae and Rapa (reserved for description in the 1923 Report); Kenneth P. Emory, collected on Lanai, T. H., during 1921, 421 specimens among which may be mentioned several pieces of wood from old houses and canoes, tapa anvil and beater, poi pounders, 5 lamps and a pillow of stone, 19 anchors, 30 sinkers, 8 grindstones, 8 whetstones, 35 bowling stones, 34 adz heads, 37 polishing stones, 4 stones bearing petroglyphs of great age, 33 stone hammers, stone dish, stone for cooking birds, 3 bath rubbing stones and a stone knife. Mr. Emory also collected in 1922 on Molokai a stone hammer, 3 bowling stones, 3 sling stones, 2 adzes, a net sinker and a cowry lure.

Hans G. Hornbostel has had remarkable success in obtaining valuable specimens illustrating the material culture of the Chamorros. The material already received from Guam includes hundreds of sling stones, large numbers of adzes and chisels, hammers, pestles, whetstones, several stone vessels, knives, ornaments, fishing equipment and other artifacts, as well as specimens of the massive stone capitals from the tops of pillars marking burial sites (see p. 21). An exploring party consisting of Herbert E. Gregory, Edwin H. Bryan, Jr., of the Museum staff and Herman Von Holt, Ronard K. Von Holt, Lindsay Faye, and Lorrin P. Thurston, volunteer assistants, brought back from the Nepali coast of Kauai 5 poi pounders, 2 poi boards, 6 cowry lures, 2 sinkers, adz head, stone knife, polishing stone and canoe fragments. C. Montague Cooke and party consisting of C. M. Cooke III, Harrison Cooke and Benjamin Oliveira secured a number of stone and shell implements on the western end of Molokai.

By exchange the Museum has received from Baron N. Kanda of Japan a collection of adzes, arrowheads, pieces of pottery, snow shoes, and 2 stone ornaments (Magatama and Kudatama), illustrating the culture of the ancestors of the present Japanese race, and several adzes and other artifacts from Formosa; from Mr. E. L. Moseley a series of North American Indian relics.

BIRDS

Specimens have been added to the ornithological collection by members of the staff as follows: Stanley C. Ball and Charles H. Edmondson, man-o'-war bird (*Fregata aquila*), booby (*Sula cyanops*), nestling and 2 eggs of the latter, 3 terns (*Procelsterna cerulea*), bristle-thighed curlew (*Numenius tahitiensis*), 3 warblers (*Conopoderas pistor*), nest of the latter, 11 paroquets (*Vini kuhli*) collected on

Fanning Island; E. W. Giffard, 3 shearwaters (*Puffinus chororhynchus*) collected in Tonga; John F. G. Stokes, rail obtained in Austral Islands.

Birds have been presented to the Museum as follows: from Mr. G. P. Cooke, Jr., an apapane (*Himatione sanguinea*) found dead on Molokai; Mr. Hung Lum Chung, 3 finches (*Carpodacus mexicanus obscurus*) shot at Experiment Station; Mr. H. S. Hayward, feathers of red-tailed tropic bird and others; Mr. W. H. Smith, dark-rumped petrel (*Aestrelata phaeopygia*).

INSECTS

The report of Edwin H. Bryan, Jr., Assistant Entomologist, records the accession of 8,445 insects, 5140 of which came from the Hawaiian islands, a larger proportion than during 1921.

Collections by members of the Museum staff include 265 specimens from Fanning Island collected by Stanley C. Ball and Charles H. Edmondson, 923 specimens collected on Kauai by Edwin H. Bryan, Jr., approximately 900 insects obtained from the Austral Islands through John F. G. Stokes, and 298 flies collected in various parts of Hawaii by Otto H. Swezey.

Specimens received in exchange came from the following sources: Mr. E. W. Ferguson, 11 Australian Tabanidae; Mr. E. L. Moseley, 78 insects from Ohio; Mr. W. S. Patton, 47 Muscidae; Mr. A. J. Turner, 67 Australian moths.

The following donations have been gratefully received: 6 specimens from Haleakala, Maui, given by Miss A. M. Alexander; 329 North American and Tahitian insects from Charles H. Edmondson; 41 Hawaiian Diptera, and 35 Hawaiian Bruchidae from the Hawaiian Sugar Planters' Experiment Station; 122 Hawaiian Diptera and 39 other insects from Mr. Walter M. Giffard; 295 Australian specimens from Mr. G. F. Hill; 70 Hawaiian insects from Mr. W. H. Meinecke; 21 North American Drosophilidae from Mr. A. H. Sturtevant; 53 specimens collected for the Museum on Palmyra island by Mr. L. A. Thurston; 68 Hawaiian Diptera from the University of Hawaii.

An important collection of insects has been received from J. F. Illingworth, partly as a gift and partly as a deposit. It embraces 1240 insects collected in Fiji by Mr. Illingworth and determined by him with the aid of other specialists. This collection promises to be of great value in further research in the oceanic field.

The Hawaii Agricultural Experiment Station has lent to the Museum 605 insects collected in Guam by Mr. David T. Fullaway.

Mr. Bryan further reports:

"Besides these accessions, as listed, considerable local material, totaling 3537 specimens, has been collected and turned in by the following members of the staff and friends of the Museum: Stanley C. Ball, Spencer Bickerton, Edwin H. Bryan, Jr., B. Clarke, A. G. Clarke, C. Montague Cooke, Jr., Ruth H. Greiner, Anne Gregory, J. F. Illingworth, A. F.Judd, W. H. Meinecke, E. L. Moseley, Marie C. Neal, Otto H. Swezey, John W. Thompson, Gerrit P. Wilder."

PLANTS

Approximately 40,000 specimens have been added to the botanical collections during the year. Of Hawaiian plants gifts have been received as follows: From Mr. E. L. Caum, type specimens of *Pritchardia kahanae* and *P. mantioides;* Mr. Henry Davis, fruit of the "Waialua" orange; Mr. A. D. Hitchcock, set of mounted grasses; Mr. A. F. Judd, fungi from Molokai and a mounted specimen of the fungus, *Meliola juddiana* Stevens; Dr. J. R. Judd, a set of ferns collected by Mrs. Stewart Dodge in 1874; Mr. W. H. Meinecke, a specimen of silver-sword from Hawaii.

Hawaiian plants received from members of the staff include a large number of rusts and other fungi collected and determined by F. L. Stevens, specimens of Abutilon collected by Otto H. Swezey, and three plants collected on Hawaii by Gerrit P. Wilder.

The large and important collection of approximately 28,000 specimens brought together at the Station of the Board of Agriculture and Forestry and at the University of Hawaii by J. F. Rock was transferred to the Museum by arrangement with these institutions.

From the Austral Islands, Robert T. Aitken and John F. G. Stokes, members of the Bayard Dominick Expedition, brought back approximately 1,600 dried plants and 120 wood samples. A. J. Eames obtained about 1,000 sheets of specimens during his short stay in Samoa in 1920. By far the largest accession is that of 9,000 specimens of dried plants and 120 wood samples collected by Forest B. H. Brown and Elizabeth Wuist Brown during two years of field work in the Marquesas, Tuamotu archipelago and New Zealand.

Collections of plants procured outside of Hawaii include also several hundred specimens collected in southern Polynesia by the Whitney South Seas Expedition and received in exchange from the American Museum of Natural History; 80 specimens collected on Fanning Island by Stanley C. Ball and Charles H. Edmondson of the Bishop Museum staff; 274 plants from Borneo purchased from their collector, Mr. A. E. D. Elmer; 300 specimens collected and donated by Mr. D. Wesley Garber of Samoa, 390 Philippine specimens given by Mr. E. D. Merrill, and 131 Samoan plants collected and presented by Professor W. A. Setchell of the University of California.

SHELLS

From the report of C. Montague Cooke, Jr., Malacologist, the following notes on accessions have been abstracted:

Exchanges have been arranged with the Philadelphia Academy of Natural Sciences, the American Museum of Natural History and the Museum of Comparative Zoology. From the Philadelphia Academy specimens of Pacific zonitoids and endodonts and paratypes of two species of tornatellids were received. From the Museum of Comparative Zoology, 135 lots of shells were received, among them the paratypes of species established by Pease, Gulick, and Newcomb. The type specimens of *Planamastra prostrata* and *P. depressiformis* found in the collection of this Museum proved to be non-Hawaiian species. (See Nautilus, vol. XXXVI, 1922). Mr. W. F. Clapp, Curator of Mollusca, contributed additional material.

From the American Museum 16 lots of shells were received. Probably the rarest species acquired is the *Carelia hyattiana*, of which but seven specimens are known. The one we received has been carefully compared with the type specimen in the collection of the Academy of Natural Sciences of Philadelphia, and there is no doubt that the identification is correct. Other important species from the American Museum are *Amastra petricola* and *pusilla*. The former, as far as I know, has not been collected since Newcomb, in 1850 or 1851, found his original lot, and as these specimens were received by the American Museum from Newcomb, they may be considered as paratypes. The Boston Society of Natural History gave to the Museum a small but very valuable series of Endodontidae, which contains a single specimen of *Thaumatodon stellula* from the Mayo collection.

Collections were made by Marie C. Neal on Kauai, and on Hawaii, in Kohala district and near the Volcano House. The material from Kauai included a new genus of operculate land shells. Collecting expeditions were made by C. Montague Cooke, Jr., to Kauai, Maui, and to the Waianae Mountains, Oahu. Mr. Cooke reports:

"A trip to the eastern end of the Waianae Mountains by Miss Neal and myself, made possible by the kindness of Mr. and Mrs. Von Holt, yielded quite a large number of shells. We were fortunate in finding specimens of *Leptachatina omphalodes*. Only four specimens of this species had even been taken, two of which are unfortunately lost, the remaining two coming to our Museum in the Ancey collection. About 60 specimens of this extremely interesting and rare species were collected, all of them dead; but with the clue to their habitat living specimens may be expected to be found."

On Kauai several new fossil beds were found, and probably one of the most important results of the trip was the rediscovery of *Carelia cochlea*.

Mr. A. Gouveia has found on the island of Hawaii living examples of *Amastra pagodula*, a species which had formerly been known only as a fossil.

Among the uncatalogued material in the Museum is a very small but important collection from the Austral Islands, received through John F. G. Stokes of the Bayard Dominick Expedition. Among the specimens is what is probably a type species of the genus Microcystis. As a number of our Hawaiian Zonitidae were formerly placed in this genus and later separated by Skyes into the genus Philonesia, the relationship of our Hawaiian forms to the central Pacific genus can now be accurately determined. Interesting specimens of Tornatellinidae were also collected on Rapa.

The most valuable uncatalogued acquisition is the Baldwin collection obtained by purchase. For a number of years Mr. D. D. Baldwin was an authority on Hawaiian shells and contributed a few papers describing a number of species. His collection contains paratypes of nearly all his species and his identification of the species of other authors.

Other uncatalogued material has been received from Miss A. M. Alexander (Maui), Stanley C. Ball and Charles H. Edmondson (Molokai, Fanning Islands), H. F. Bergman, and D. Larnach (Oahu), E. H. Bryan, Jr. (Oahu), C. M. Cooke, Jr. (Oahu, Molokai, Kauai), F. A. Danforth (Molokai), K. P. Emory (Lanai), D. W. Garber (Samoa), A. Gouveia (Hawaii), A. F. Judd (Oahu and Molokai), C. S. Judd (Oahu), W. H. Meinecke (Oahu and Hawaii), M. C. Neal (Oahu and Hawaii), Commander Picking (Wake Island), Otto Swezey (Kauai), D. Thaanum (Palmyra), J. C. Thompson (Guam), J. W. Thompson (Oahu), E. D. Baldwin (Oahu and Maui).

The source and the amount of the cataloged material is as follows.

RECEIVED FROM	LOCALITY	HOW RECEIVED	NUMBER OF SPECIMENS	NOS. CATALOG
W. D. Wilder Estate	Oahu, Molokai, Lanai, Maui, Hawaii, Niihau	By purchase	48,291	1,792
C. M.Cooke, Jr. (L. L. Cooke, L. Macfarlane, R. Von Holt, M. Neal)	Oahu, Maui	Collected	14,731	465
M. C. Neal, E. Davis, B. Metzger, E. Day)	Kauai, Hawaii	Collected	2,139	89
O. Sorenson	Hawaii	By gift	1,285	8
E. W. Thwing	Hawaii	By gift	294	11
Museum of Comparative Zoology	Kauai, Oahu, Maui, Molokai Hawaii, Jamaica	By exchange	287	135
D. Thaanum	Oahu, Molokai Maui, Hawaii	*By gift for naming	179	50

A. F. Judd	Hawaii	By gift	124	22
K. P. Emory	Lanai	Collected	48	14
Academy of Natural Sciences of Philadelphia	Kauai, Oahu, Molokai, Hawaii, Rarotonga	By exchange and gift	54	8
Arthur Greenwell	Hawaii	By gift	36	9
American Museum of Natural History	Kauai, Oahu, Molokai, Maui, Lanai	By exchange	28	17
Boston Society of Natural History	Hawaii	By gift	18	5
H. E. Gregory	Hawaii	Collected	18	1
C. S. Judd	Hawaii	By gift	9	2
L. A. Thurston	Hawaii	By gift for naming....	12	3
W. H. Meinecke	Oahu	By gift	3	1
L. A. Thurston or D. Thaanum	Hawaii	By gift for naming....	2	2

ZOOLOGICAL MATERIAL

Charles H. Edmondson, Zoologist, reports that in connection with his work at Kahana Bay, Kawailoa and Waikiki, Oahu, he has collected 314 specimens of crustaceans, 100 specimens of worms, 25 specimens of echinoderms and a number of coelenterates and fishes.

Concerning material secured by three expeditions he writes as follows:

"In February Stanley C. Ball, and I made a short trip to Molokai, during which zoological material was collected on land and on the reef, including insects, lizards, crustaceans, mollusks, and echinoderms. Among the 128 specimens of marine crustaceans are some very rare forms and some new records for this part of the Pacific.

"Zoological collections in the Museum have been considerably increased during the year as a result of an expedition to Palmyra Island by L. A. Thurston and D. Thaanum of Honolulu. Approximately 190 specimens of crustaceans, some of which are new species, about 100 specimens of echinoderms and 80 specimens of fishes besides some specimens of lizards, worms, corals, mollusks, insects and spiders are included in the material presented to the Museum.

"During July and August Stanley C. Ball and I made a general biological survey of Fanning Island. A considerable amount of biological material, both plants and animals, was collected on the land in the lagoon and on the outer reef. The animal forms taken included birds, lizards, myriapods, earthworms, crustaceans, mollusks, echinoderms, fishes, and a few other marine organisms. Approximately 800 specimens of marine crustaceans, nearly 200 specimens of echinoderms and 1000 specimens of shells of marine mollusks are included in the collections from Fanning Island.

"The lagoon at Fanning Island was dredged for bottom deposits, the material of which has been submitted to Dr. J. A. Cushman for the determination of foraminifera. Much tow material was taken from the surface waters of the lagoon. The microorganisms of this material have not yet been determined."

Zoological specimens have been collected by members of the Museum staff as follows: Edwin H. Bryan, Jr., shell of green turtle (*Chelone mydas*); C. Montague Cooke, Jr., 9 parasitic isopods (Cymothoa) from tongue of fish; C. Montague Cooke, Jr., C. M. Cooke, III, and Henry W. Fowler, several fishes from Laie, Oahu: Hawaiian Electric Company, nudibranch mollusk (Doris); J. F. Illingworth, skin of *Rattus rattus*; John F. G. Stokes, rats, lizards, scorpions, and coral from Austral Islands; O. H. Swezey, planarians from Moanalua Valley, Oahu;

John W. Thompson, crabs and sponges from Honolulu harbor and Pearl Harbor; Gerrit P. Wilder, a crab (*Charybdis erythrodactyla*) and a small fish from shores of Oahu.

John W. Thompson purchased in the Honolulu markets and presented to the Museum 17 Hawaiian fishes and 1 from Palmyra, 5 crustaceans, and 1 echinoderm. He has given also a piece of fossil coral and 2 mollusks from China. In behalf of the Museum he has purchased 9 fishes and has been instrumental in obtaining others.

Donations to the zoological collections have been made as follows: Captain V. A. Brisson, coral from Mangareva; Mr. E. M. Ehrhorn, coconut crab (*Birgus latro*) from Palmyra; Kamehameha School students, 3 fishes; Mr. T. Kawaguchi, fish from Palmyra; Mr. Orlando Lyman, porcupine fish (*Diodon histrix*); Commander Picking, mollusk, corals, and hermit crabs from Wake Island; Mr. H. L. Kelley, a frog-fish (Antennarius); Mr. Matsujiro Otani, a trigger fish from Palmyra; Mr. J. P. Ponte, crab (*Dromia rumphii*) caught at Waianae, Oahu; Mr. C. A. Reeves, fish (*Caranx kuhli*) caught off Oahu; Mr. L. A. Thurston, crab (*Ranina serrata*) from Honolulu market; Mr. Manuel Vasconcellos, large eel skin from Palmyra; Mr. J. M. Westgate, an eel caught off Diamond Head, Oahu.

Mr. Edmondson further reports that "As a result of the exchange policy there were added to the crustacean collection 104 specimens from the Australian Museum, and 123 specimens from the Zoological Survey of India. The Museum reciprocated by presenting these institutions with collections of Hawaiian Crustacea from our exchange material."

Other material received in exchange includes 50 lizards, collected by the Whitney South Seas Expedition, given by the American Museum of Natural History; several skins of birds and small mammals, alcoholic specimens of amphibians and mollusks from Eastern North America, and a piece of mammoth skin from Russia given by Mr. E. L. Mosely.

From Mr. Matsujiro Otani the Museum purchased a fine specimen of the moon-fish (*Lampris luna*) caught off Waianae, Oahu.

MISCELLANEOUS MATERIAL

To the collections of miscellaneous material, gifts have been made by various persons as follows:

Mr. R. W. Atkinson, rock fragments containing crystals of olivene; Mr. Arthur Coyne, royal standard and house flag of the Hawaiian Monarchy; Mr. C. P. Iaukea, daguerreotype of Mr. Gorham D. Gilman, 1861; Dr. E. K. Johnstone, oil painting by Princess Kaiulani; Mr. William Wagener, boulder containing prisms of basalt; Mr. William Weinrich, collection of fiber samples and products from many parts of the world; Mrs. Lilly West, wooden cane; Mr. H. M. Whitney, block and die for Hawaiian and United States 13-cent postage stamp, 1854.

By exchange the Museum received from Mr. Spencer Bickerton a Copley medal given by the Royal Society of London to Rt. Hon. Sir J. Banks, and one given to Captain James Cook; from Mr. E. L. Moseley, rock specimens from Ohio and vicinity.

Eight drawings and water color paintings done by J. Webber, artist of the last voyage of Captain James Cook (1776-80), were purchased in London. Each illustrates an event or subject witnessed in Hawaii by Webber. Some of them are reproduced in the atlas accompanying the account of Cook's voyages. Three of

them are unfinished, the sketch lines indicating perhaps that the artist had intended fuller treatment. The titles of the pictures are as follows:

Young woman of the Sandwich Islands (reproduced in atlas, Bishop Museum Library)
Canoe of the Sandwich Islands, the rowers masked (reproduced in atlas)
Sandwich islander—half of face tattooed (unpublished)
Men of the Sandwich Islands dancing (one figure reproduced in atlas)
Sailing canoe, Sandwich Islands (unpublished)
Boxing match between Sandwich Islanders before Captain Cook (unpublished)
Tereboo, King of Owyhee, bringing presents to Captain Cook; (reproduced in atlas)
An offering before Captain Cook, in the Sandwich Islands; (reproduced in atlas).

NOTES ON COLLECTIONS

Attention may be drawn to the large and important collections resulting from the Bayard Dominick Expedition. In addition to the material recorded in the Report of the Curator of Collections for 1921, collections have been received during 1922 from Robert T. Aitken, John F. G. Stokes, Forest B. H. Brown, Elizabeth Wuist Brown, and A. J. Eames—all members of the expedition.

The material brought back by Robert T. Aitken from Tubuai includes a section of a house post carved with a striking design of circular and stellate figures, some remarkable wooden planks carved in bold herringbone pattern, five wooden bowls of characteristic oval form, baskets, hats, fans, canoe parts, fishhooks and sandals. An instructive feature is a series showing stages in the manufacture of sennit from coconut husk to finished product. Among the numerous stone implements are adz heads, chisels, polishing stones and food pounders. The tapa industry is illustrated by a series of tapa beaters of casuarina wood and partly prepared bark of the paper mulberry (*Broussonetia papyrifera*). At Raivavae Mr. Aitken obtained several adzes, tapa beaters, and 13 food pounders showing as many different shapes of handles. In addition to ethnological material, dried specimens of native flora including a series of wood samples were collected.

The large ethnological collections brought by John F. G. Stokes from Rurutu, Raivavae, and Rapa must await special record in the Annual Report for 1923, but mention may be made of approximately 1600 plant specimens and wood samples and other natural history specimens.

The Museum has received a collection of 1000 plants obtained by A. J. Eames in Samoa in 1920.

The largest addition to the botanical collections made by the Bayard Dominick Expedition naturally was contributed by Forest B. H. and Elizabeth Wuist Brown, who had devoted two years almost entirely to a study of the endemic and introduced plants of the Marquesas. While en route Mr. and Mrs. Brown made collections at the Tuamotus, Tahiti, Rarotonga, and New Zealand. The entire collection ambraces about 9000 specimens.

The Museum has been fortunate in the interest displayed in its activities by men in other occupations. Commander J. C. Thompson, stationed at the U. S. Naval Hospital in Guam, has been untiring in his efforts to obtain specimens of the native culture of the Marianas Islands. Through his influence the interest and energy of Mr. and Mrs. H. G. Hornbostal have been enlisted. Mr. Hornbostel became a member of the Museum staff and with the aid of Dr. Thompson and many friends has collected an enormous amount of anthropological material from Guam. This includes over a hundred more or less complete skeletons of a people whose large stature is striking. Several instances of pathologic effects are evident. Among the artifacts mention may be made of 3 large hemispherical stone capitals

which once crowned the tops of pillars in the native burial grounds. Excavations at their feet uncovered quantities of stone and shell adzes, chisels, sling stones and other implements. Several stone dishes are noteworthy, while many objects of more recent origin serve to illustrate methods of by-gone times. Further contributions from this field are anticipated with interest.

The botanical collections in the Museum have been enriched from several sources. Mr. D. Wesley Garber, in carrying out his generous offer to procure for the Museum such specimens and data as his duties at the Naval Hospital in Apia will allow, has already sent in about 300 preserved plants from Samoa. From still farther westward have come two collections that should prove valuable in tracing the origin of the Polynesian flora. Of these, one, consisting of nearly 400 Philippine plants, is a gift from Mr. E. D. Merrill, Director of the Bureau of Science in Manila. The other, purchased from Mr. A. E. D. Elmer, gives our herbarium 274 representative plants from Borneo.

Supplementing the botanical collection made by members of the Bayard Dominick Expedition are several large lots of specimens collected in southern Polynesia by the Whitney South Seas Expedition and forwarded to the Bishop Museum by the American Museum of Natural History in New York. After determination by Forest B. H. Brown the names will be sent to the American Museum, which has retained a duplicate set of the plants.

In the transfer of the J. F. Rock collection from the University of Hawaii, the Museum became the custodian of approximately 2800 well labeled native plants. The importance of this herbarium cannot be too strongly emphasized.

The purchase of the Victoria Buffandeau collection of ethnological material added many old Hawaiian specimens, which are valued both for their quality and for their association with the Kamehameha and Sumner families. Included with these are several objects that once belonged to the royal Pomare line of Tahiti.

Attention may be called to the considerable number of zoological specimens collected and presented by Mr. L. A. Thurston and Mr. David Thaanum. A large proportion of these came from the little-studied island of Palmyra and its surrounding waters. C. Montague Cooke, Jr. has dwelt upon the importance of the D. D. and E. D. Baldwin collection of Hawaiian land and marine shells which was purchased for the Museum. (See p. 30.)

EXHIBITION HALLS

While progress in the exhibition halls has not during the year reached the stage anticipated, some encouragement has been derived from the continued opportunities for studying the impressions made upon visitors by the exhibits as they are. Many have been glad on request to express their estimates of the halls as a whole and to point out in particular those features which met their approval. A few have been willing to explain wherein they have felt that from their standpoint modifications would bring added comfort and ease of comprehension.

In a number of instances the experience of members of the Museum staff, corroborated by teachers who have brought classes of students, has made evident the desirability of changing the location of specimens so as to bring them into closer relation to others with which they might well be associated. In this way certain topics could be more clearly presented, not only to school classes but to the general visitor as well. Something toward this end has already been done.

In order to test its fitness as a background for ethnological specimens the interior of one exhibition case in Hawaiian vestibule was painted cream buff. Besides lending a warmer atmosphere to the environment this treatment promises to provide a fortunate setting for the majority of specimens and to render less troublesome the shadows at the tops and ends of the cases.

Among the fish models added during the year to the large series on display may be mentioned that of the brilliant moonfish, *Lampris luna.* The original was caught in local waters in February. After being on exhibition at Aala Market for several days it was brought to the Museum. Mr. Thompson's reproduction shows the vivid crimson of the fins and the characteristic mottling of silver. As far as can be learned, this specimen is the second caught in Hawaii, its predecessor having been captured about twenty-five years ago. Another notable model is that of a true swordfish, *Xiphias gladius,* cast from a small specimen taken by local fishermen in December.

The Victoria Buffandeau collection of Hawaiian and Tahitian ethnological material described on page 27 was placed on exhibition. A representative group of implements, weapons, vessels and other artifacts received from Guam was installed temporarily in Hawaiian Vestibule. In a nearby case the eight original drawings of Hawaiian subjects made by J. Webber, artist on Captain Cook's third voyage (1776-80) have been on view. Two of the royal kahilis given by the Liliuokalani Estate made an appropriate addition to the throne exhibit in the upper gallery of Hawaiian Hall.

A special effort to entertain the members of the Pan-Pacific Commercial Conference was made on the occasion of their visit in November. During the year a number of distinguished visitors have been conducted through the Exhibition Halls. The use of a book in which the names of visitors were recorded was discontinued at the beginning of the year.

ATTENDANCE

Lahilahi Webb, Guide to Exhibits, reports the attendance of 33,303 visitors to the exhibition halls during 1922—an increase of 2,061 over 1921 and the largest in the history of the Museum. Among the visitors were 5,156 school children, a very satisfactory record compared with the figures for 1921 (1,625)—a result which appears to be due to the effort of the Museum and of the school authorities to make the exhibits of greater usefulness in education.

Distributed among the races the figures for attendance are as follows: Whites (including Portuguese) 17,899 (53.7 percent); Japanese, 6,445 (19.3 percent); Hawaiians, 5,567 (16.7 percent); Chinese, 2,644 (7.9 percent); others 748 (3.2 percent), showing for each race an increase over the corresponding figures for 1921 which were respectively: 16,993; 5,696; 4,847; 2,148; and 629.

For the first time an attempt has been made to distinguish the tourist from the local attendance, excluding school pupils. The numbers recorded, 6,365 and 21,782, are doubtless fairly approximate.

REPORT OF THE LIBRARIAN

From the report of the Librarian, Miss Elizabeth B. Higgins, the following records have been taken:

Special mention should be made of a few of the gifts. Among the manuscripts were the Lawson, MS, relating to the Marquesas, and the Andrews' Comparative Vocabulary of Hawaiian Words, both the gift of Mr. Arthur Alexander. A collection of Hawaiian proverbs, compiled by Dr. Nathaniel Emerson and given by Mrs. Emerson and her son, is an especially valuable acquisition. Through the courtesy of Mr. R. B. Doom of Tahiti, the Museum was granted the privilege of making a copy of the manuscript "History of the Island of Borabora" by Tati Salmon. Among the maps were 13 advance sheets of surveys of the Hawaiian islands, showing the position of artifacts on Hawaii, Maui, and Molokai. The gifts of photographs include 25 views of New Zealand scenery and natives—the gift of Dr. W. T. Brigham; 59 portraits of Honolulu residents (taken about 1870)—the gift of Mrs. Walter Giffard; 59 portraits of about the same date—the gift of Mr. Albert F. Judd; 14 Hawaiian photographs of ethnological interest—the gift of Mr. Theodore Kelsey; 12 views of Wake Island—the gift of Commander Picking of the U. S. subtender "Beaver"; 14 portraits of early residents of Hawaii—the gift of Col. C. P. Iaukea; 48 portraits and views in an album—the gift of Mrs. L. Webb.

The gifts of pamphlets included 128 separates and papers on subjects within the Museum field—the gift of the Director; 103 papers on entomology—the gift of J. F. Illingworth; 8 entomological papers (author's separates)—the gift of Mr. Gerald Hill; 12 papers on marine zoology—the gift of Mr. James Hornell; and 22 author's separates, papers on insects of Australia—the gift of Mr. Eustace W. Ferguson.

The gifts of books included a complete set of the Proceedings of the Washington Academy of Sciences—the gift of the Smithsonian Institution and a glossary of the Rarotongan language—gift of the Carnegie Institution.

For valuable gifts of books, pamphlets, photographs and manuscripts the Museum is indebted to the following:

Mr. A. C. Alexander, 2 manuscripts; Argentine Republic Government, 1 pamphlet; Australian Government, 5 volumes; Australian Museum, 6 volumes, 5 pamphlets, and 1 manuscript; Mr. Frank C. Baker, 8 separates; Mr. Elsdon Best, 4 separates; Bishop Estate office, 1 manuscript; Dr. W. T. Brigham, 3 pamphlets and 25 photographs; Mr. Edwin H. Bryan, Jr., 19 pamphlets; California State Library, 4 pamphlets; Carnegie Institution of Washington, 1 volume; Carnegie Institution of Washington—Geophysical Laboratory, 8 pamphlets; Mr. Frederick Chapman, 5 separates; Dr. Charles Chilton, 1 volume; Chosen Government, 1 volume; Cincinnati Museum, 1 pamphlet; Colombo Museum, 1 volume; Dr. C. Montague Cooke, Jr., 1 separate; Czechoslovak Republic, 6 volumes and 7 pamphlets; Mr. Hans Damm, 1 separate; Detroit Institute of Arts, 5 pamphlets; Mr. R. B. Doom, 1 manuscript; Dr. Charles H. Edmondson, 1 separate; Mrs. Sarah E. and Mr. Arthur W. Emerson, 1 manuscript; Mr. Carl Elschner, 1 pamphlet; Mr. Kenneth P. Emory, 3 pamphlets; Mr. Johannes Felix, 2 separates; Mr. Eustace W.

Ferguson, 22 separates; Mr. Frederic W. Goding, 3 pamphlets; Mrs. Walter M. Giffard, 60 photographs; Mr. George K. Greene, 3 pamphlets and 1 volume; Dr. H. E. Gregory, 128 pamphlets and 1 map; Miss Ruth Greiner, 7 maps; Hawaiian Government, 1 pamphlet; Mr. Gerald F. Hill, 8 separates; Mr. James Hornell, 2 volumes and 12 pamphlets; Colonel C. P. Iaukea, 1 pamphlet, 4 manuscripts, and 14 photographs; Dr. J. F. Illingworth, 103 pamphlets, 1 book, and 1 manuscript; Commodore A. C. James, 1 volume; Japan Imperial Earthquake Investigation Committee, 3 pamphlets; Japan National Research Council, 6 pamphlets; Mr. A. F. Judd, 59 photographs; Mr. C. S. Judd, 2 photographs; Mr. Theodore Kelsey, 14 photographs; Library of Hawaii, 1 volume; Louisiana Museum, 1 pamphlet; Dr. H. L. Lyon, 15 pamphlets; Mississippi Agricultural Experiment Station, 3 pamphlets; Mr. M. D. Monsarrat, 2 manuscripts and 1 pamphlet; National Research Council, 2 pamphlets; New Bedford Library, 1 pamphlet; New York Zoological Society, 11 pamphlets; New Zealand Government Statistician, 4 volumes; Norwich Castle Museum, 1 pamphlet; Messrs. M. and H. H. Peach, 1 pamphlet; Dr. R. C. L. Perkins, 2 separates; Commander Picking, 12 photographs; Portland Society of Natural History, 1 pamphlet; Rochdale Literary Society, 1 volume; Royal Ontario Museum, 1 pamphlet; Mr. Otto Schlagenhaufen, 1 pamphlet; Dr. Carl Skottsberg, 7 pamphlets; Mr. W. J. Smithies, 1 photograph; Smithsonian Institution, 11 volumes and 4 pamphlets; Mr. Thomas Thomsen, 2 pamphlets; Mr. Stephen Taber, 1 separate; Mr. Thomas G. Thrum, 2 volumes and 1 separate; Mr. Alfredo J. Torcelli, 1 volume; United States Geological Survey, 6 pamphlets and 13 maps; Mr. Henry Lorénz Viereck, 1 volume; Mr. Max Weber and Dr. L. F. deBeaufort, 1 volume; Yale University, 4 pamphlets.

EXCHANGES

In addition to the current volumes regularly received from institutions on an exchange basis, a number of sets, more or less complete, have been received from the institutions added to the Museum exchange list during the year and during 1921. Among these sets were 27 volumes of the Biological Bulletin of the Marine Biological Laboratory at Woods Hole; 8 volumes of Hayata's Icones plantarum Formosanarum from the Formosan Government; 19 volumes of the University Studies of the University of Nebraska; 25 volumes of the Bulletin of the Paris Museum of Natural History—a complete set to date; 10 volumes each of the two series of the Review of Applied Entomology—complete set; 12 early volumes from the Vienna Natural History Museum to complete the set of Annalen; 8 volumes of Mémoires of the Brussels Royal Museum of Natural History—a complete set; 27 volumes from The Societa Italiana di Scienze Naturali de Milan; and 10 volumes of the Journal of Zoology from Pomona College, California.

The number of serial publications to be currently received has been increased by 23 by reason of the new exchanges. Classified by subjects the new serials are: geography and history 5; natural history, 7; botany, 3; zoology, 7; folk-lore, 1. The list of new exchanges may be found on page 15.

Besides the volumes and parts received as regular exchanges from societies and institutions, a considerable number of accessions have come in by special exchange—that is to say, by special arrangement for special items. For example the Editor of Stewart's Handbook of the Pacific Islands has sent a number of the handbooks in return for Museum publications that he desired. Special exchanges

of this sort have also been made with Mr. Spencer Bickerton for photographs and books relating to the Pacific, with Prof. C. A. Kofoid for zoological books, and with Mr. Cyril Smith for a set of Wilkes Exploring Expedition. Other similar exchanges have been made.

PURCHASES

The books acquired by purchase in 1922 have been chiefly of general reference, maps, atlases, a gazetteer, and zoological books and pamphlets. The atlases have been much needed. The scientific journals currently received by subscription are 22, including 13 American and 9 foreign periodicals. The subjects represented are general science 3, anthropology and archaeology 3, botany 7, geography 2, library science 1, zoology 6.

A summary of accessions in 1922 is shown in the following table:

	Volumes	Parts and Pamphlets	Photographs	Maps	Manuscripts
Exchange	351	1453	17	25	
Purchase	65	25		4	
Gift	33	535	234		14
	449	2013	251	29	14

LOANS AND DEPOSITS

In 1921 Mr. A. F. Judd placed on deposit at the Museum his collection of Hawaiiana. A card index has been made of 280 of the books. These are now available for use. Mrs. Victoria Buffandeau has placed on deposit a number of manuscripts relating to the history of the Sumner family.

A valuable loan was received from the Carnegie Institution of Washington in manuscripts, papers, maps, literary notes and other materials including 38 items bequeathed to the Carnegie Institution by Mr. William Churchill. One item of this loan is 30 boxes of cards representing the progress Mr. Churchill had made toward the preparation of a Samoan-English Dictionary. The manuscript dictionary is considered by the Carnegie Institution the most valuable portion of the bequest.

CIRCULATION AND USE OF BOOKS

The number of books taken out of the library for use by the members of the staff and others has largely increased in the past two years. Several Museum associates living on the mainland and elsewhere have had the use of books for long periods and books have been borrowed by Honolulu libraries. In 1922 the zoological books and the accounts of voyages were most in use.

TATTOOING IN THE MARQUESAS

BY

WILLOWDEAN CHATTERSON HANDY

BERNICE P. BISHOP MUSEUM
BULLETIN 1

BAYARD DOMINICK EXPEDITION
PUBLICATION NUMBER 1

HONOLULU, HAWAII
PUBLISHED BY THE MUSEUM
1922

EARLY REFERENCES TO HAWAIIAN ENTOMOLOGY

BY

J. F. ILLINGWORTH

Bernice P. Bishop Museum
Bulletin

HONOLULU, HAWAII
PUBLISHED BY THE MUSEUM

HAWAIIAN LEGENDS

BY

WILLIAM HYDE RICE

Bernice P. Bishop Museum

Honolulu

HONOLULU, HAWAII

Published by the Museum

1923

REPORT
OF THE DIRECTOR FOR
1922

BY

HERBERT E. GREGORY

Bernice P. Bishop Museum

Honolulu, Hawaii
Published by the Museum
1923

BERNICE P. BISHOP MUSEUM

The Bernice P. Bishop Museum is a memorial to the Princess Pauahi (1831-1884), last of the Kamehameha family of the Chiefs of Hawaii. It was founded in 1889 by her husband, Charles Reed Bishop (1822-1915), who for nearly 60 years took a prominent part in the business and public affairs of Hawaii.

The Museum is devoted to the subjects of archaeology and kindred antiquities, ethnology, and natural history. The collections of the Museum include exhibition and study material from Polynesia and from other Pacific islands, but the Hawaiian collections are the largest and the most important.

The Museum staff is engaged in caring for the collections, and in investigating scientific problems which come within the scope of its activities. When funds are available, expeditions are sent out to various parts of the Pacific.

The publications of

BERNICE P. BISHOP MUSEUM

include

MEMOIRS, Volumes I-VIII.
OCCASIONAL PAPERS, Volumes I-VIII
SPECIAL PUBLICATIONS, Numbers 1-9

A descriptive list of publications with prices will be mailed on application to the Librarian.

DATE DUE

DEMCO 38-297

CPSIA information can be obtained
at www.ICGtesting.com
Printed in the USA
LVOW13*0029071017

551544LV00011B/340/P